Balboa Park AND THE 1915 EXPOSITION

Balboa Park AND THE 1915 EXPOSITION

RICHARD W. AMERO

EDITED BY MICHAEL KELLY

THE History PRESS

Published by The History Press
Charleston, SC 29403
www.historypress.net

Copyright © 2013 by The Committee of One Hundred
All rights reserved

First published 2013
Second printing 2014

Manufactured in the United States

ISBN 978.1.62619.345.1

Library of Congress Cataloging-in-Publication Data

Amero, Richard W., 1924-2012.
Balboa Park and the 1915 Exposition / Richard W. Amero ; Michael Kelly, editor.
pages cm
ISBN 978-1-62619-345-1
1. Panama-California Exposition (1915 : San Diego, Calif.) 2. Panama-California International Exposition (1916 : San Diego, Calif.) 3. Architecture--California--San Diego--History--20th century. 4. Balboa Park (San Diego, Calif.)--History--20th century. 5. San Diego, Calif.--Civilization. I. Kelly, Michael, M.D., editor. II. Title.
T872.B1A44 2013
607'.34794985--dc23
2013045772

Notice: The information in this book is true and complete to the best of our knowledge. It is offered without guarantee on the part of the author or The History Press. The author and The History Press disclaim all liability in connection with the use of this book.

All rights reserved. No part of this book may be reproduced or transmitted in any form whatsoever without prior written permission from the publisher except in the case of brief quotations embodied in critical articles and reviews.

Contents

Foreword, by Welton Jones 7
Preface, by Michael Kelly 11

1. Making of the Panama-California Exposition: 1909–1915 13
2. The Panama-California Exposition Gets Underway 54
3. San Diego's Year of Glory: 1915 80
4. The Panama-California Exposition Goes International: 1916 113
5. Exposition Mop-Up: 1917 135
6. First Americans Come to Balboa Park 153
7. East Meets West in Balboa Park 180
8. The California Building: San Diego Museum/Museum of Man 197
9. John Charles Olmsted's Wrangle with the Panama-California Exposition Corporation 220
10. Architectural Derivations of Panama-California Exposition Buildings 231

Notes 247
Index 279
About the Author 287
About the Editor 288

Foreword

Like an anonymous monk in a vast medieval library, Richard Amero labored for years, tracking the rich inheritance and cataloguing the scattered records of San Diego's enduring civic prize, the fantasy exaltations of the Panama-California Exposition that became the city's green and glorious Balboa Park.

Living memories were already fading and ephemera disintegrating when Amero first walked the paths and pastures (his phrase) of a decaying, navy-worn Balboa Park just after World War II. He was new in town, and he spent a lot of time looking and listening. A bench at Horton Plaza downtown, he sometimes said, was his graduate school. But after he griped about park neglect in some letters to the editors, he found himself drawn to the San Diego Historical Society and what was to become his life's work.

A native of Gloucester, Massachusetts, Amero had served as an eighteen-year-old army clerk in England, France and Belgium before starting his real life, courtesy of the GI Bill, as a 1950 graduate (in English and history) from Bard College in New York. His divorced mother had resettled from Massachusetts to Lemon Grove, so he came looking for work in the busy aircraft industry. Convair snapped up the college graduate, but he wasn't content there. Nor at Solar. It was San Diego Gas & Electric that finally offered him a plausible day job in 1952, so he stayed with the company for forty years, progressing from laborer to technical analyst while his real career work bloomed nearby in Balboa Park.

Foreword

His initial self-assigned task was to dig up and restore an accurate history of the park, beginning before the 1915 exposition. Proud of his ability to separate fact from fiction, he first had to harvest all the raw material. This he did, at a time when the researcher's tools were pencil, paper and patience, by simply working, long, hard and alone. Microfilm was the new thing; faxes came later. Most of Amero's notes were typed by hand from original sources.

The result of all this volunteer research eventually filled over 250 loose-leaf binders with notes. The historical society (now the San Diego History Center) had to find a special room just to hold the collection.

But the notes weren't all—not even most—of his work. As he formed his discovered truths, he started using them to tell the real story of the park and the exposition. Published in the *Journal of San Diego History*, area newspapers and magazines and, later, on the Internet, his writing eventually took on the tone of holy writ, backed as it was by overwhelming corroboration. Sometimes, his perception was at odds with establishment versions, but his integrity and his rigid, meticulous respect for the pure fact backed by all existing record usually won the day. He was an inspiration and a resource to all explorers, professional and otherwise, of San Diego history.

The main thrust of the collection assembled in this book is the Panama-California Exposition of 1915–16. But Amero didn't stop there. He was equally exhaustive with the California Pacific International Exposition in 1935–36 and, indeed, everything thereafter right up to his death in 2012. When computers were eased into historic research, Amero was among the earliest of adopters. Machines helped him, when his real world narrowed through illness, to expand the universe of his mind further into ancillary interests such as Japanese culture, opera, public parks and gardens.

He tried to be guided in life by Henry David Thoreau, minus what he called Thoreau's "anti-socialism." His other heroes were William Wordsworth, Ralph Waldo Emerson, Walt Whitman, Socrates, the New England Transcendentalists and the historic Buddha. Locally, he was an admirer of Kate Sessions, George W. Marston, Samuel Parsons Jr. and John Nolen. He particularly was fond of realtor and entrepreneur Colonel "Charlie" Collier, though he wished the tireless drumbeater of 1915 could have been more passive, in the spirit of Lao Tzu, Confucius, Po Chui and Thoreau.

As for himself, Amero liked to quote Tennessee Williams: "I am human and nothing human is alien to me."

So it is now and will always be impossible to discuss the history of Balboa Park without referring to the splendid heritage of Richard Amero's life's work.

—Welton Jones

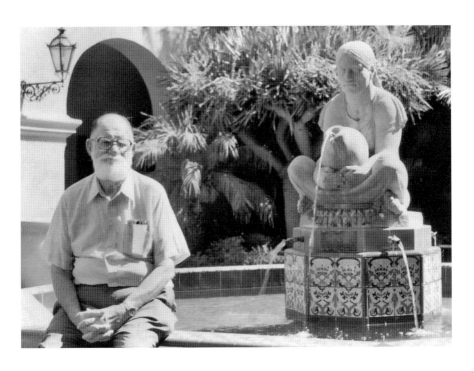

Richard W. Amero (1924–2012)

Preface

In 2010, the Committee of One Hundred honored Richard Amero with its Gertrude Gilbert Award for his work in preserving Balboa Park history.

Committed by his nature to lifelong learning, Richard reveled in books. His interests varied widely, and his writing ensued in energetic lockstep. In time, Balboa Park and its two expositions became the greatest lure of all. Over a dozen years, he wrote and rewrote sections as this book developed. New material was discovered; chapters were added or combined; citations were sought out and included. While Richard envisioned a single book, which he wished to call "The First, Second, and Enduring Expositions in Balboa Park, San Diego," he had managed to write too much for just one book. Not long before his death, he requested and I agreed, on behalf of the Committee of One Hundred, to see that his work was published. Author and journalist Roger Showley put me in touch with The History Press.

The Panama-California Exposition Digital Archive was recently established to preserve the history of the 1915–16 Exposition, inspired by the collection of material that Richard contributed to the San Diego History Center—more than 250 binders of clippings and articles on

Preface

Balboa Park. The Panama-California Exposition Digital Archive in turn provided nearly all of the images that illustrate this book. Here is the story of the first of the "Enduring Expositions" held in San Diego's Balboa Park.

—Michael Kelly

CHAPTER 1

Making of the Panama-California Exposition

1909–1915

On July 9, 1909, G. Aubrey Davidson, founder of the Southern Trust and Commerce Bank and president of the San Diego Chamber of Commerce, said San Diego should stage an exposition in 1915 to celebrate the completion of the Panama Canal. He told his fellow chamber of commerce members that San Diego would be the first American port of call north of the Panama Canal on the Pacific coast. An exposition would call attention to the city and bolster an economy still shaky from the Wall Street Panic of 1907. The chamber of commerce authorized Davidson to appoint a committee to look into his idea.[1] Because the idea began with him, Davidson is called the "father of the exposition."[2]

On September 3, 1909, a special chamber of commerce committee formed the Panama-California Exposition Company and sent articles of incorporation to the secretary of state in Sacramento.[3]

In 1910, San Diego had a population of 39,578; San Diego County, 81,665; Los Angeles, 319,198; and San Francisco, 416,912. San Diego's scant population, the smallest of any city ever to attempt holding an international exposition, testified to the city's pluck and vitality.[4]

The Board of Directors of the Panama-California Exposition Company, on September 10, 1909, elected U.S. Grant Jr. to be president of the company and John D. Spreckels as the first vice-president. Grant, son of the former U.S. president, was part-owner of the U.S. Grant Hotel. Spreckels, son of sugar king Claus Spreckels, was owner of San Diego real estate, hotels, newspapers, banks and utility, water, transit and railroad companies.

Right: G. Aubrey Davidson, March 14, 1909. *Bill Davidson Collection, Panama-California Exposition Digital Archive.*

Below: Cabrillo Bridge and view of Exposition buildings. *Michael Kelly Collection, Panama-California Exposition Digital Archive.*

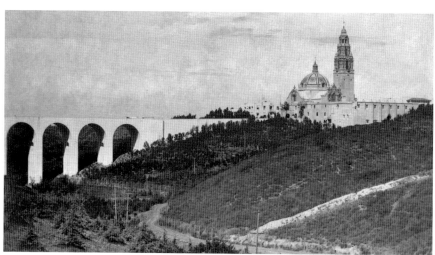

A.G. Spalding was chosen second vice-president, L.S. Mc Lure third vice-president and G. Aubrey Davidson fourth vice-president.[5]

The most important appointment made by the directors was that of real-estate developer Colonel David "Charlie" Collier to be director-general. "Colonel" was an honorary title given to Collier by California governor James M. Gillett in 1907.[6]

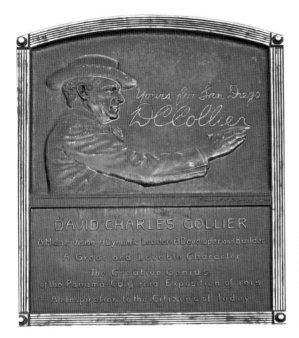

Plaque commemorating David Charles "Charlie" Collier, located inside the west gate of the Plaza de California. *The Committee of One Hundred Collection, Panama-California Exposition Digital Archive.*

Collier shaped Exposition policies. He chose City Park as the site, Mission revival as the architectural style and human progress as the theme.[7] He lobbied at his own expense for the exposition before the California state legislature and the U.S. Congress and traveled to South America for the same purpose.[8]

Collier's choice of the mission past to provide the background of the Panama-California Exposition and to serve as a foil to the successful present was in keeping with the elaborate creation of a romantic view of Spanish missions, priests and Indian converts, a view that was extended to include Mexican rancheros, a later presence after the missions had been secularized and the Indians left to their own devices. The villains in the piece were the American settlers who deprived the rancheros of their holdings and resorted to the wholesale slaughter of Indians. The makers of the idyllic Spanish-Mexican myth included Helen Hunt Jackson, Charles Lummis, George Wharton James and John Steven McGroaty. Promoters of Southern California were quick to realize the potential of the Spanish mission/Mexican ranchero myth that suffused the past in a romantic, pastoral haze in which the inhabitants—until the Americans arrived—lived in a state of blissful harmony. The irony is that so many Americans bought into the myth. Was it to expunge their feelings of guilt or simply because of a personal wish to prefer the ideal to the real,

19, the House approved the resolution.[18] May 1911 was not an auspicious time to think about Exposition contributions from Mexico and Central America. Mexico was in the throes of a civil war against long-term president Porfirio Diaz. On April 11, cross-border fighting between federal troops and insurrectionists had resulted in the wounding of five Americans near Douglas, Arizona. To prepare for any contingency, President Taft had mobilized military and naval forces along the southwestern border. The situation in Nicaragua and Honduras was more stable, as "puppet" governments had been installed through the exercise of "dollar diplomacy" and the deployment of U.S. soldiers and marines. It was not likely that the American bankers, who shored up these governments, would find it in their interests to pay for exhibits in San Diego.

The pendulum swung the other way in January 1912, when a Senate committee turned down San Diego's request.[19] The next month, President Taft invited foreign countries to exhibit at San Francisco only.[20] San Diego's hopes plummeted.

Influential San Franciscans had exerted pressure on Congress and on President Taft to forestall San Diego's bid for a second California exposition. They promised to give their support to Taft in his struggle with the Progressive factions of the Republican Party led by Theodore Roosevelt.[21]

Joseph W. Sefton Jr., vice-president of the San Diego Savings Bank and acting director-general in Collier's absence, snarled that San Francisco had given San Diego "a knife in the back."[22]

In a homecoming speech at the U.S. Grant Hotel on February 28, Collier rallied the exposition's drooping supporters, saying, "We never for a moment depended on congressional action. The work will go on just as if the action at Washington had been the reverse of what it has been."[23]

In the August 1912 primary election, Samuel C. Evans of Riverside defeated Lewis Kirby of San Diego for the Republican nomination for the House of Representatives. San Diego Republicans shifted their support to Democrat William Kettner. State Progressives and Republicans united in support of Theodore Roosevelt for president and California governor Hiram Johnson for vice president. Taft's name was not on the general election ballot. On November 5, Roosevelt carried the state by a margin of only 174. San Diego County voted for Woodrow Wilson, the Democrat nominee for president, by a margin of about 1,600. San Francisco's promises to Taft had yielded nothing.[24] Historian Joseph L. Gardner has stated that Taft had not expected to win the national election but ran anyway as he, a former judge, was horrified by Roosevelt's support of

the recall of state judicial decisions.²⁵ Roosevelt, too, thought the success of his candidacy was hopeless.²⁶ In a nutshell, Taft ran to defeat Roosevelt, and Roosevelt ran because he was Roosevelt.

Kettner was elected to the House by a margin of about 1,500. On May 23, 1913, an accommodating President Wilson signed Kettner's bill authorizing government departments to permit the free admission of exhibits for the San Diego exposition.²⁷

Again possessed by exposition fever, San Diego voters on July 1, 1913, by more than sixteen to one, approved issuing a second set of park improvement bonds for $850,000.²⁸ Of this money, $135,000 was set aside to build the San Diego Stadium, east of the high school.

William Kettner. *Library of Congress. 17484.*

On November 9, 1910, the Buildings and Grounds Committee chaired by George W. Marston selected landscape architects John C. Olmsted and Frederick Law Olmsted Jr. of Brookline, Massachusetts, to lay out the exposition grounds.²⁹ The Olmsteds had prepared ground plans for the 1905 Lewis and Clark Exposition in Portland, Oregon, and the 1909 Alaska-Yukon-Pacific Exposition in Seattle, Washington. The committee had considered Chicago architect Daniel Burnham and East Coast landscape architects Samuel Parsons Jr. and John Nolen before deciding on the Olmsteds.³⁰ The exposition was to be held on a southwestern part of City Park near the high school.

On January 5, 1911, the Buildings and Grounds Committee engaged Frank P. Allen Jr. of Seattle as director of works.³¹ Allen had been manager of Seattle's 1909 Alaska-Yukon-Pacific Exposition. There he had achieved a minor miracle by completing the buildings before the exposition opened. In May 1911, a park board appointed by Mayor James Wadham opposed paying Allen $25,000 a year and proposed hiring general contractors instead. It questioned using park improvement money for temporary construction.³² Allen's authority was confirmed by a new park board following the resignation of the old board on June 24.³³

For supervisory architect, the Buildings and Grounds Committee hoped to get John Galen Howard, who had been supervisory architect of the exposition in Seattle and who had designed Mediterranean-Renaissance buildings for the University of California at Berkeley.[34] As Howard was not interested, the committee, on January 27, 1911, chose New York architect Bertram Goodhue.[35] Goodhue had applied for the position at the prompting of the Olmsteds. The committee also appointed San Diego architect Irving Gill to assist Goodhue and to design either an auditorium or a fine arts building.[36]

Even before Goodhue had been appointed, Collier had decided to use Indian, Mission and Pueblo styles at the San Diego exposition instead of the neoclassical styles regularly used at international expositions.[37] Irving Gill knew Mission and Pueblo styles well enough to use them for improvisations, but Goodhue's celebrity status and familiarity with opulent Spanish Baroque relegated the simpler styles of the American Southwest to second place.

John C. Olmsted was delighted with the southwestern site because of its proximity to developed sections of the city; views of the city and harbor from its higher elevations; irregular topography, which allowed opportunities for dramatic placement of buildings; and location away from the natural beauty in the interior of the park.[38] Frank P. Allen Jr. thought the grading to accommodate roads, terraces and buildings and the two bridges needed to span Cabrillo and Spanish Canyons would exceed the meager appropriations available. Despite Olmsted's objections, he advocated shifting the exposition to the Laurel Street entrance on the west side. Collier and Sefton supported Allen. As the Spreckels' interests wanted to run a tram line through the park, Olmsted was convinced they were the "invisible hand" behind plans to relocate the exposition.[39]

The name City Park was too lackluster to serve as the name for the site of the Panama-California Exposition. Accordingly, on October 27, 1910, park commissioners Thomas O'Hallaran, Moses A. Luce and Leroy A. Wright, at a meeting with exposition representatives George W. Marston, Howard M. Kutchin and D.C. Collier, chose the name "Balboa Park" for San Diego's pleasure ground.[40] On November 1, the park commissioners adopted the name.[41] The California state legislature ratified their decision on March 24, 1911, in the same piece of legislation that authorized the use of the park for an exposition.[42]

The name Balboa seemed appropriate since Vasco Núñez de Balboa was the first European in the New World to see the Pacific Ocean, whose waters would soon be joined with the Atlantic's upon the completion of the Panama Canal, an event the Exposition was to commemorate. As with the

Balboa Park and the 1915 Exposition

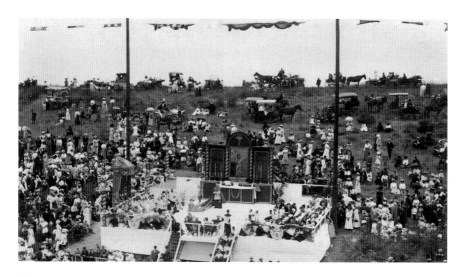

High Mass celebrated in a canyon northeast of San Diego High School on July 19, 1911. Bishop Conaty of Los Angeles gave the sermon. *Michael Kelly Collection, Panama-California Exposition Digital Archive.*

Columbian Exposition of 1893, no one at the time mentioned the negative aspects of the European subjugation of the New World.

Exposition groundbreaking ceremonies began on July 19, 1911, with a military mass in a shallow canyon about 1,300 feet northeast of San Diego High School at the Olmsted-planned site for the exposition.[43] Apparently this canyon was an extension of the same canyon that later provided the foundation for the San Diego Balboa Stadium. The occasion followed by three days the anniversary of the High Mass sung by Father Junipero Serra, on July 16, 1769, on his founding of Mission San Diego de Alcala. Four Franciscan priests and fifty acolytes assisted Father Benedict, provincial of the Franciscan order, before a raised open-air altar. Bishop Thomas James Conaty of Los Angeles gave the sermon, in which he praised Father Serra and predicted a golden future for San Diego.

The afternoon program began with a military parade along D Street (today's Broadway) and on to the site of the morning mass. Here, after an introduction by exposition president U.S. Grant Jr., Reverend Edward F. Hallenbeck of the First Presbyterian Church gave the invocation. A triple quartette sang the "Exposition Ode."

Joseph W. Sefton Jr. welcomed the guests. Lee C. Gates, representing Governor Hiram Johnson, extolled the glories of California. John Barrett spoke for President Taft. Then Sefton loosened the earth with a silver

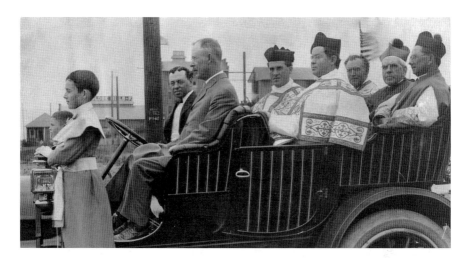

Church procession, July 19, 1911. Bishop Conaty sits at rear center. *Michael Kelly Collection, Panama-California Exposition Digital Archive.*

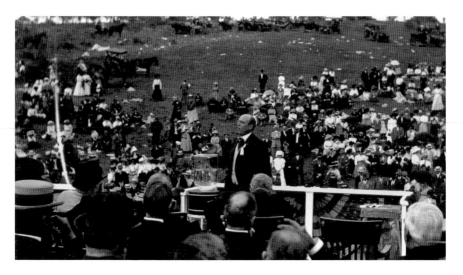

John Barrett, Taft's representative, delivering his address. *Ralph Bowman Collection. Panama-California Exposition Digital Archive.*

spade and passed the spade to Barrett, who turned the first sod. Guests and officials took turns with the spade before it was returned to Sefton, who turned the last sod.

Barrett, this time representing the Pan-American Union, gave the principal address, in which he stressed the cultural and economic importance of Latin America to San Diego and to the United States.

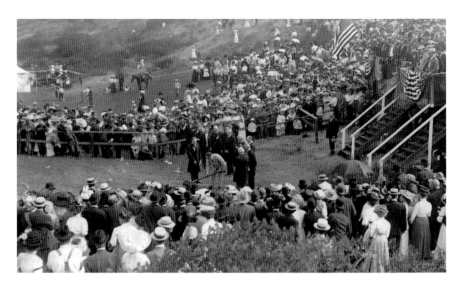

"Turning ground," groundbreaking celebration. *Ralph Bowman Collection, Panama-California Exposition Digital Archive.*

After Barrett's talk, attendants unfurled the flag of the United States while the band played the national anthem. President Taft, in Washington, D.C., pressed a button that unfurled the flag of the president of the United States while the band played "Hail Columbia." Then attendants unfurled the flags of the South American countries as the band played a medley of their national airs.

In the evening, King Cabrillo (in real life, Morley Stayton) arrived on his caravel at the Santa Fe wharf, accompanied by a fleet of decorated boats and barges and the shooting of skyrockets. Officials escorted him to the front of the San Diego County Courthouse, where newly crowned Queen Ramona (in real life, Helene Richards) awaited him. King Cabrillo and Queen Ramona continued to the Isthmus, or fun zone, in an area south of D Street between Front and State Streets and encompassing E and F Streets. Here they and the jubilant throng that followed them enjoyed shows featuring Asian dancers, bronco busters from the Wild West, Mexican rebels from the May–June military engagement at Tijuana, trapeze artists and a trained moose, horse and orangutan. Historian Matthew F. Bokovoy made much of the "marriage" of Cabrillo and Ramona as representing a fusion of the Caucasian and Indian races.[44]

On the morning of the second day, floats representing the Woman's Christian Temperance Union, the Equal Suffrage Movement and the

Balboa Park and the 1915 Exposition

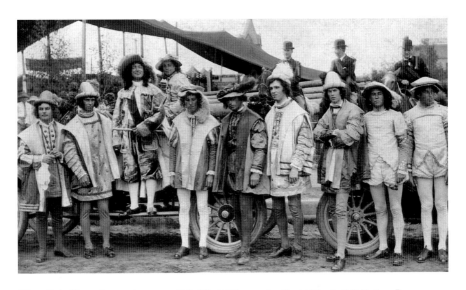

King Cabrillo and attendants at a July 20, 1911 parade. *David Marshall Collection, Panama-California Exposition Digital Archive.*

American Women's League and trucks and automobiles covered with flowers paraded down D Street. In the afternoon, athletes, sponsored by the San Diego Rowing Club, swam, rowed and raced tub-boats in the harbor, and the San Diego Aero Club began an aviation meet at the Coronado polo grounds.

In the evening, floats representing ten historic scenes followed the same route as the morning's parade. The floats included Aztec priests sacrificing to the god of war; Balboa taking possession of the Pacific for the king of Spain; the downfall of Montezuma and the triumph of Cortes; Cabrillo's caravel; Father Serra planting the cross at the Presidio in San Diego; King Neptune presiding at the wedding of the Atlantic and Pacific Oceans; and San Diego—past, present and future.

The evening concluded with a banquet at the U.S. Grant Hotel in honor of John Barrett, attended by 150 of the city's foremost male citizens.

On the morning of the third day, representatives of the city and industries put on a parade with fire department wagons and equipment, the first horse-drawn street railway car used in San Diego and floats from the Longshoremen's Union, the Moose Lodge, the Ladies of the Grand Army of the Republic and other fraternal organizations.

In the afternoon, Queen Ramona received guests in the Palm Room of the U.S. Grant Hotel. Motorboat races in the harbor and a Lipton Cup yacht

Balboa Park and the 1915 Exposition

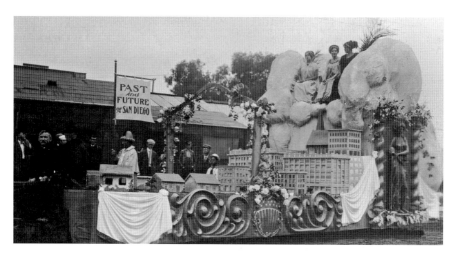

Past, Present and Future of San Diego float at the groundbreaking celebration, 1911. *Michael Kelly Collection, Panama-California Exposition Digital Archive.*

Float of the Loyal Order of the Moose. *Michael Kelly Collection, Panama-California Exposition Digital Archive.*

race off the coast thrilled onlookers. In Coronado, aviator Glenn L. Martin, who had not yet qualified for a pilot's license, took two falls, damaging a Curtiss-type biplane he had made himself and equipped with a sixty-horsepower engine. Suspecting that public transportation could not handle crowds expected Saturday at Tent City and the aviation meet, sponsors of the meet canceled the last day's show.

A grand ball at the U.S. Grant Hotel rounded out the third day's activities.

On the morning of the last day, citizens outdid themselves by producing a stunning mission pageant under the direction of Henry Kabierske of Chicago and of Edwin H. Clough of San Diego. Floats depicted the twenty-one California missions in their actual decrepit condition. People representing the saints preceded floats of missions named after them. Boys held canopies over the saints' heads, and girls scattered flowers in their paths. The pageant had some of the awe-inspiring quality of the famous *Semana Santa* of Seville, Spain. Nearly one thousand volunteers impersonated saints, friars, soldiers and Indians.

In the afternoon, the Southern California Yacht Association closed its first regatta off San Diego. The *Aeolus*, piloted by Frank Wyatt, led the fleet to win a solid gold Exposition Cup, made by Joseph Jessop & Sons, the premier trophy of the regatta.

In the evening, a masked street ball in a fenced-off section of the Isthmus on Union Street, between D and E Streets, concluded the four-day carnival. About three hundred people paid the one-dollar admission price to waltz and two-step on the asphalt. Outside the dance enclosure, a wilder spirit prevailed. Police threw confetti. Pranksters worked feather ticklers, slapsticks, cowbells and canes. A woman did the hootchy-kootchy on a table in Sargent's Palace Grill, located at Fourth Avenue at the

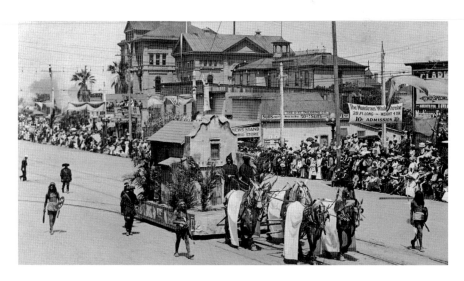

Mission San Diego float, passing San Diego Court House, July 21, 1911. *Michael Kelly Collection, Panama-California Exposition Digital Archive.*

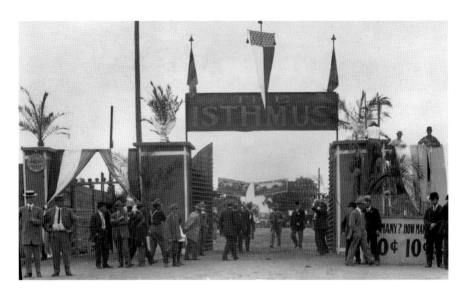

Entrance to the Isthmus in downtown San Diego during the groundbreaking celebration. Named for the location of the Panama Canal, the "fun zone" or midway at the 1915 Exposition was also called the Isthmus. *Ralph Bowman Collection, Panama-California Exposition Digital Archive.*

southwest corner abutting the Plaza (today Horton Plaza Park), causing fun-seekers outside to stampede the restaurant.

A reporter for the *San Diego Union* estimated that sixty thousand persons had passed through the Isthmus gates at D and Union Streets during the four days, with fifteen thousand of these on the last night.[45]

Following U.S. Grant Jr.'s resignation as Exposition president on November 22, 1911, directors appointed Colonel D.C. Collier president and Joseph W. Sefton Jr. director-general.[46]

Responding to John C. Olmsted's protests, the Buildings and Grounds Committee in July voted to support his plan to locate the Exposition at the southern site.[47] Meanwhile, Collier had begun a campaign for more space than the southern site could supply. He claimed he had promises for exhibits from countries in Central and South America. At this juncture, Goodhue, who had resented Olmsted's criticisms of his designs, entered the fray with a plan for the exposition in the Viscaino or central mesa of the park. The approach over a bridge spanning Cabrillo Canyon would incorporate the same dramatic features as the Alcantara bridge of Toledo, Spain.[48] Elated, he wrote to Olmsted, "I don't know in any American public park of any effect that could compete with the

bridge, the permanent buildings and the mall terminated by the statue of Balboa."[49]

Goodhue's plan allowed access to the grounds from what was to become Park Boulevard on the east, thus making it possible to build the electric railway desired by the Spreckels' Companies along the right of way, which could be extended easily to soon-to-be-developed tracts in Normal Heights and East San Diego.[50]

Though George W. Marston, Thomas O'Hallaran, Moses A. Luce and Julius Wangenheim on the Buildings and Grounds Committee supported him, Olmsted realized he had been outmaneuvered. On September 1, 1911, speaking for himself and his brother, Frederick Law Olmsted Jr., he wired his resignation with the dire warning, "This is contrary to our advice and will interfere with other portions of the design proposed for Balboa Park by us. We regret that our professional responsibility as park designers will not permit us to assist in ruining Balboa Park. We tender, herewith, therefore, our resignation."[51]

Goodhue's disagreement with Olmsted was philosophical as well as personal, and he said, "Since you told me that you regarded building as a disfigurement…and I in turn said that to use landscape architecture was merely the proper means of letting down from pure artifice, i.e., architecture to pure nature in natural landscape—I have felt the difference in our points of view was so great as to be irreconcilable."[52]

Goodhue realized he had secured his position through the intercession of the Olmsteds and that he would have to work with them on other projects. He, therefore, offered to resign.[53]

Frank P. Allen Jr., who had worked with John C. Olmsted on the Alaska-Yukon-Pacific Exposition, seemed genuinely hurt by Olmsted's resignation. He was under no delusion that one-time exposition buildings were going to be greater assets to the park than the landscape. He urged Olmsted to stay on the job, saying, "The only way in which this Exposition can achieve success is by having grounds and buildings of unusual and very exceptional artistic merit and I do not think this can be done without your assistance."[54]

Olmsted was not to be dissuaded. Though his theoretical authority over Allen and Goodhue had been bypassed, he did not spend time regretting his disastrous Balboa Park experience. Thereafter, his letters to Goodhue were models of decorum.

Besides his roles as manager, engineer and architect, Allen took over the preparation of ground plans for the exposition after Samuel Parsons Jr. had applied for the job and had been turned down.[55] Allen wisely left the

choice of plants to Paul Thiene, the exposition gardener. He did not know everything, though sometimes he tried to convey that impression. Southern California Counties commissioners hired their own landscape gardener, Captain Edward F. Gray, to design and plant the formal gardens directly to the north of their building.[56]

Soon after the Olmsteds resigned, Irving Gill walked out. His nephew, Louis Gill, told Esther McCoy his uncle had discovered graft in the purchase of building supplies in Allen's department.[57] During the fracas with Mayor Wadham, the choice of Allen had been criticized by the San Diego Labor Council. It is not known if this was a factor in Gill's departure. He was replaced by Carleton M. Winslow, from Goodhue's New York office, who arrived on September 5, 1911, one day before Goodhue's plan, as drawn by Allen, was published in the newspapers.[58] Not having the sanction of a contract, Winslow's status was ambiguous.

Before Gill had left, he had seen Goodhue's sketches of buildings for the Exposition. Since he, along with the Olmsteds, believed architecture should complement rather than overwhelm its surroundings, he could not have regarded Goodhue's Spanish fantasies with enthusiasm. In 1913, Gill again joined up with the Olmsteds in the development of the town of Torrance, California.[59]

Historians Matthew Bokokoy, Mike Davis, Jim Miller and Robert Rydell have commented that in the first six months of 1912, the Industrial Workers of the World (IWW), a labor organization, espoused a form of anarcho-syndicalism at the corner of Fifth Avenue and E Street.[60] Their defiance of San Diego's conservative establishment, attempts to unionize unskilled workers and support of the Magonista rebellion against the dictatorship of Porfirio Diaz in neighboring Tijuana led to citizen vigilante suppression, abetted by the police department and by editorials in the John D. Spreckels-owned *San Diego Union* and *Evening Tribune*. The competing *San Diego Sun*, owned by E.W. Scripps, and the *San Diego Herald*, owned by Abraham Sauer, and a few courageous members of the community—including Ed Fletcher, Samuel F. Fox and George W. Marston—supported the free-speech movement but not necessarily the IWW.[61] On November 10, two months after the deportation of free-speech agitators, San Diego police chief Keno Wilson arrested 138 prostitutes in the Stingaree District near Fifth Avenue and H Street (now Market).[62] To churchgoers and some businesspeople, the IWW incendiaries and the vice that flourished in the wharf section of San Diego impeded federal recognition of the San Diego Exposition and gave the wrong image of the city to people who were to

be enticed to visit the Exposition. Davey Jones, a spokesperson for the IWW, suggested a further reason for the unlawful and violent reaction to the recruiting efforts of the IWW: namely, that a city with a restless and demanding labor force is not a city that encourages outside (and inside) capital investment.[63] While one can perceive many hidden motives in the city and police retaliation against the IWW and the members of the "world's oldest profession"—such as the desire to keep migrant and unskilled workers and foreigners in their place and to appear spotlessly clean—it is also understandable that the "movers and shakers" of the City of San Diego did not want to air their dirty linen in public.

Bertram Goodhue had developed a liking for Spanish Colonial architecture and for Muslim gardens as a result of trips to Mexico and Persia. A believer in "art for art's sake," he made many drawings of buildings and scenery suffused in a romantic haze. After he established his New York office and his successes as a designer of Gothic Revival churches mounted, he put his knowledge of Spanish Churrigueresque to use in designs for the Holy Trinity Church in Havana, Cuba, and the Hotel Colon in Panama and re-created his impressions of the gardens of Shiraz and Isfahan on the grounds of the Gillespie House in Montecito, California.[64]

With the assistance of Carleton M. Winslow and Clarence Stein from his New York office and of Frank P. Allen Jr. in San Diego, Goodhue conjured up a fairytale city in Balboa Park of cloud-capped towers, gorgeous palaces and solemn temples. He personally designed the permanent California Quadrangle and sketched the Southern California Counties Building. He supplied Winslow with drawings and photographs of buildings in Mexico and Spain and reviewed his designs for the temporary buildings. His control over Allen's work was, however, constrained by distance, discord and dislike.[65] As in Seattle, Allen's contract in San Diego covered the construction but not the design of exposition buildings.

Bertram Grosvenor Goodhue. *Courtesy of Nicholas Goodhue.*

Balboa Park and the 1915 Exposition

The Balboa Park buildings contained reminiscences of missions and churches in Southern California and Mexico and of palaces and homes in Mexico, Spain and Italy. Muslim details, such as minaret-like towers, reflecting pools, colored tile inlays and human-size urns, highlighted the buildings. Arcades, arches, bells, colonnades, domes, fountains, pergolas, towers with contrasting silhouettes, views through gates of shaded patios and vistas exposing broad panoramas provided variety. A low-lying cornice line and closely spaced buildings helped preserve a sense of continuity.[66]

Goodhue, Winslow and Allen hoped the eclectic Spanish-style buildings and mix of ornamental planting they were introducing would offer a festive, country-like alternative to the cold, formalized Renaissance and neoclassical styles that American architects had been using at fairs and in cities since the dazzling success of the World Columbian Exposition of 1893 in Chicago.[67]

The San Diego Exposition, on a mesa three hundred feet above sea level, would be seen from all sides. As spectacular as the view inward might be, the view outward would be even more spectacular.

The exposition had a practical and also a romantic purpose. Manufactured products entertained better when shown being made rather than as finished objects. Scientific displays entertained better when illustrated by working models. A citrus orchard was more interesting than a pile of oranges. A vacuum cleaner, water pump or reaper at work was more interesting than the same objects standing still.[68]

The fair would illustrate opportunity. It would show city people—through farm machinery in operation, through fields under intensive cultivation and through a demonstration farm home—how easy it would be to make a good living on small farms in the Southwest.

Through modern farming and irrigation, the southwestern desert could become, in the words of the inscription around the base of the dome of the California Building, taken from the Latin Vulgate of St. Jerome, "TERRAM FRUMENTI HORDIE, AC VINARUM, IN QUA FICUS ET MALOGRANATA ET OLIVETA NASCUNTUR, TERRAM OLEI AC MELLIS" ("A land of wheat and barley, of vines and fig trees, and pomegranates; a land of olive oil and honey").[69]

Unlike other expositions, San Diego's would stay open all year. Its glistening white buildings would be set off by continually blooming, subtropical trees and flowers. A magical wonderland was thus created that had no counterpart in Spain or Mexico. Critics in Mexico called the combination of nature and architecture in Balboa Park "Hollywood Spanish," but this put-down did not deter wealthy Mexican landowners from putting up imitations of

Balboa Park and the 1915 Exposition

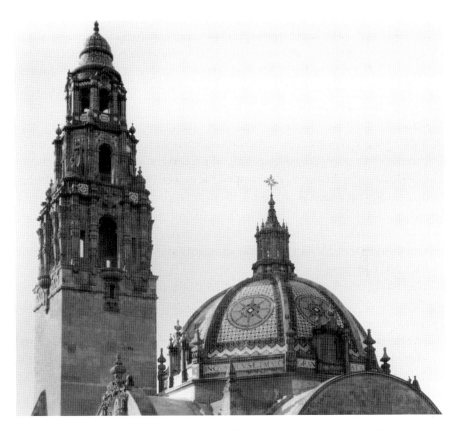

The Latin inscription on the dome of the California Building translates to: "A land of wheat and barley, of vines and fig trees, and pomegranates; a land of olive oil and honey." Detail of photo by Oakes. *John Earl Collection, Panama-California Exposition Digital Archive.*

the Balboa Park buildings in their own country, most notably in an area adjoining Chapultepec Park in Mexico City.

To the publicity department, the Exposition's main function was to show how industrial, agricultural and commercial achievement could give rise to beautiful cities, homes and gardens in which the poetry (but not the pain) of the past would be recaptured. A publicity agent described the Exposition's intoxicating mixture of aestheticism, materialism and nostalgia:

> *It is hard to pull oneself back to the twentieth century for it is wondrous sweet to dwell in the romance of the old days, to peer down the cloister and try to see the shadowy shapes of the conquistadores creeping up the dell from their caravel at anchor in the Harbor of the Sun.*

No other land has quite that atmosphere. No other land has the romance and lazy dreaming of this sort. No other land has such splendor of waving palms and slim acacias and lofty eucalyptus, such a riot of crimson and purple and gold, such brilliant sky or flashing seas or rearing peaks, and perpetual comfort of weather in the perfect harmony which exists on the mesa in San Diego. It is a land where God is kind. It is a land of loveliness that makes men kind. And, decked in such fair garments, it beckons the stranger in other lands and bids him come. It is opportunity.[70]

In January 1913, the Exposition officers consisted of D.C. Collier, president; John D. Spreckels, first vice-president; G.A. Davidson, second vice-president; L.S. McLure, third vice-president; George Burnham, fourth vice-president; and Frank P. Allen Jr., director-general.[71]

In July 1913, directors elected H.O. Davis director-general.[72] Davis, a rancher from Yuba City, had visited San Diego to arrange for an exhibit for Sutter County. Exposition backers immediately recognized him as a fellow booster.[73]

As spokesperson for the Exposition, Davis used a barrage of statistics to show how easily farms could be operated in the virgin Southwest. He proved to his satisfaction that goods could be shipped to and from Southern California, Utah, Nevada, all of Arizona, the western half of New Mexico and the southwest corner of Colorado cheaper via the Panama Canal and San Diego than by rail from the east.[74] He estimated the potential farmland in the region at forty-four million acres, which would make 700,000 possible farms with probable revenue of more than $800 million per year.[75] International Harvester Company was impressed enough by Davis's reasoning to set up a five-acre exhibit.

The staging of "Carnival Cabrillo" from Wednesday evening, September 24, to September 27, 1913, borrowed features from the groundbreaking celebration for the Panama-California Exposition but did not match it in overall excitement. Morley Stayton, King Cabrillo at the groundbreaking celebration, came back as King of the Carnival. He acted as grand marshal at the opening carnival parade that marched twice around Wonderland Park in Ocean Beach on Wednesday evening. Some of the floats and costumes left over from the groundbreaking parades were reused.[76]

The event was suffused with blarney. Despite its fulsome pronouncements, the chief purpose of the carnival was to interject hilarity into the community. People went to the carnival to have fun. Members of the Elks and other lodges interjected novelties into the programs that were supposed to keep

people "busy laughing all evening" but were of the type that have sometimes been known to result in brawls and black eyes.[77]

Daytime ceremonies were held at Point Loma, Balboa Park and Presidio Hill and evening celebrations at Wonderland Park in Ocean Beach. At these places, the streets were decorated with pennants and Spanish and American flags. The awkward episode of the Spanish-American War of 1898 was conveniently put aside. Guests and dignitaries dedicated a proposed monument to Juan Rodriguez Cabrillo on September 25 at the tip of Point Loma. The monument would be ready for a second "Carnival Cabrillo" the following year. Money to pay for the monument was to come from the same place where the undiscovered bones of Cabrillo lay on San Miguel Island that were to be buried in a crypt beneath the monument. A Lord of Misrule if there ever was one, Senator John D. Works of California disrupted the fest by declaring the United States should intervene in Mexico, where "our American men are daily murdered and our American women outraged."[78] For the record, Mexican bandits—some under the control of Pancho Villa, some not—were marauding along the southwestern border of the United States, and President Woodrow Wilson was refusing to recognize the usurping government of Victoriano Huerta.

The third day of the celebration was named "Balboa" in honor of Vasco Núñez de Balboa, the first European to see the Pacific Ocean, and as an acknowledgment of the Panama-California Exposition, which was to be held in Balboa Park, San Diego, beginning January 1, 1915. Citizens were to erect a monument to Balboa costing $15,000 at the east end of El Prado that would be surrounded by a semicircle of columns. Believing that mentioning the sum needed to pay for the monument would produce the donations, promoters of the monument considered it unnecessary to specify a source of funds.[79]

In the spirit of make-believe that surrounded the occasion, Congressman R.L. Henry, representing President Woodrow Wilson, sprinkled dirt from the Culebra cut in Panama and poured water from the Pacific Ocean on the soil where the monument was to be built; the attorney general from Arizona said the state might vote $75,000 for the San Diego Exposition (a commitment that turned into smoke); and Senator Works said he didn't really mean that the United States should "intervene" in Mexico, saying that a landing of American troops to protect American lives and property would be enough.[80] In a manner not quite as he intended, Work's prophecy came true on April 21, 1914, when United States forces landed at Veracruz, Mexico, to prevent the

Balboa Park and the 1915 Exposition

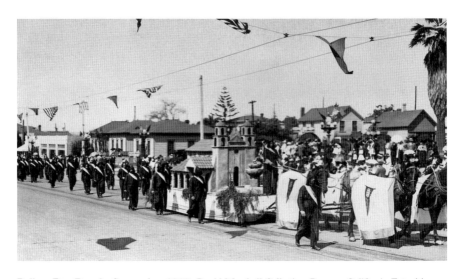

Balboa Day Parade, September 1913. *David Marshall Collection, Panama-California Exposition Digital Archive.*

landing of munitions from Germany. Despite the effort, the German ship unloaded the cargo at another port.

Acting on a suggestion from Colonel Charlie Collier, a cross made of tiles from an abandoned Spanish settlement was actually put up on Presidio Hill on the fourth or last day of the carnival as the focus for a mass.[81] The cross still stands on Presidio Hill, overlooking San Diego's Old Town.

Collier was named president-general of the carnival, though he did not attend as he was busy promoting the Exposition on the East Coast. Members of the Order of Panama, founded by Collier, dressed in flowing regalia of plumes, sombreros, helmets and capes and with swords and bucklers, added a touch of pageantry and humor to the parades, ceremonies, banquets and escapades.

A masked ball and confetti battle took place at Wonderland Park on Saturday evening. An estimated thirty thousand people passed through the park's gates—an attendance that, if accurate, was twice the number that participated in the July 22, 1911 closure of the groundbreaking gala. Not all of the people competed for awards by dancing to ragtime music at the pavilion. Carnival policemen made mock arrests, forcing their victims to empty their pockets while hustling them outside. Fittingly, red lights at streetcorners led motorists to the attractions that lay ahead.[82]

On March 5, 1914, while on the East Coast, Collier discovered his money had run out and resigned as president.[83] On March 20, directors elected G.

Aubrey Davidson president, Frank J. Belcher Jr. second vice-president and Henry H. Jones third vice-president. They continued John D. Spreckels as first vice-president and George Burnham as fourth vice-president.[84]

Allen soon discovered that getting the 614-acre central site he and Goodhue had chosen ready for an exposition was not going to be easy. Scrub had to be scraped off the surface, irregularities of contour smoothed and more than 100,000 holes drilled or blasted in the hardpan for planting of saplings.[85]

Between 1904 and 1909 landscape architect Samuel Parsons Jr., engineer George Cooke and gardener John McLean had cleared of scrub, graded, blasted holes and planted Pound (Cabrillo) Canyon and the central (Viscaino) mesa and had mapped winding paths throughout. To prepare this area for a bridge, straight roads and buildings, Allen had to undo much of the work done by his predecessors.

A plant-propagating yard, built in 1910, covered twenty-three acres on the former Howard Tract, north of the high school, and contained more than one million plants. A mill, located midway on the exposition grounds, turned out plant boxes and lumber used in construction.[86]

Park superintendent John Morley (hired November 17, 1911) directed grading and planting in the canyons at the fringes of the Exposition.[87] Under Morley's supervision, Park Avenue (today's Sixth Avenue) was extended from Date Street to Juniper; West Park Boulevard (today's Balboa Drive) was planted; Pound or Cabrillo Canyon Road (today's Cabrillo Freeway) was regraded and a sewer system installed; and Midland Drive (today's Park Boulevard) was relocated.[88] A $10,000 bond issue for City Park roads, approved by the voters on March 12, 1907,[89] and a $50,000 assessment in 1912 against owners of business property on Sixth Avenue and north of the park[90] made these improvements possible.

A powder magazine, Water Department buildings, the city pound and machine shops were moved from the park.[91] An aviary, holding the collection of Joseph W. Sefton Sr., built in 1909, extended from Juniper Street and Park Avenue to West Park Boulevard. In 1914, crews built a new aviary and pens for deer, bear, buffalo and goat on the west slopes of Cabrillo Canyon and converted a canyon south of the Howard Tract into an elk enclosure.[92] Morley set out the first rose garden in the park on the west slopes of Cabrillo Canyon. Some 6,500 roses grew in beds closed off at the south by a 180-foot pergola and surrounded by lawns, palms and poinsettias. From this garden, the visitor saw the white walls, gleaming domes and varied towers of the distant exposition.[93]

Balboa Park and the 1915 Exposition

Allen oversaw the planting of Cabrillo, Palm and Spanish Canyons. He approved planting Blackwood acacias along El Prado, the main esplanade, and flowering and trellised plants on arcades and faces of buildings. Guided by photographs in Sylvester Baxter's book on Spanish Colonial architecture,[94] Allen brought the plants, flowers and vines rich people in Spain and Mexico used to decorate their patios out to the streets where everyone might enjoy their beauty. Nursery superintendent Paul Thiene chose the plantings in the botanic gardens.[95]

In 1912, crews laid building foundations, smoothed rough spots and planted walkways. They erected a wire fence around the grounds and planted vines at its base; seeded lawns and put in sprinkler systems; and planted about fifty thousand trees, including seven hundred orange, lemon and grapefruit trees in the citrus orchards. By January 1914, they had laid twenty miles of iron pipe, ten miles of storm drain and about ten miles of sewer connections and electric conduit.[96]

Spanish Canyon began near today's Reuben H. Fleet Space Theater and angled southwesterly toward Cabrillo Canyon. John C. Olmsted named both canyons. In 1912, Allen planned to fill Spanish Canyon and its branches with fifty million gallons of water.[97] The water would be used by the city fire department, by the exposition as an aquatic setting and by seaplanes as a landing place. When foreign governments failed to put up buildings, Allen scaled down his plan and planted the canyon with acacias and quick-growing grasses.

Proving that his reputation as an efficiency engineer was justified, Allen staggered building schedules so that scaffolds and equipment could be used on several projects. He used the same floor and roof schemes on many buildings. Crews built frames on the grounds, fitted them together, swung them into place with electric crane swings and bolted them home.[98]

The Administration Building, on the west slope of Cabrillo Canyon in line with Laurel Street, was the first to go up. It was begun on November 6, 1911, and completed in March 1912.[99] A mill and lumber yard near the building provided materials. Carleton Winslow stated that he designed the Administration Building with help in its "practical requirements" from Allen.[100] Those who claim the building is the work of Irving Gill base this claim on a resemblance to Gill's flat roof, planar wall and straightedge buildings. Nonetheless, blueprints and newspaper articles indicate that Winslow created the building.

To keep a workforce that would stay on the job, one hundred small bunkhouses for four persons each were put up east of Midland Drive.

Left: *California Garden* magazine, published in San Diego, visited Exposition nurseries in its August 1913 issue. *California Garden and Balboa Park Online Collaborative.*

Below: West entrance to Plaza de California. Administration Building on left. *Michael Kelly Collection, Panama-California Exposition Digital Archive.*

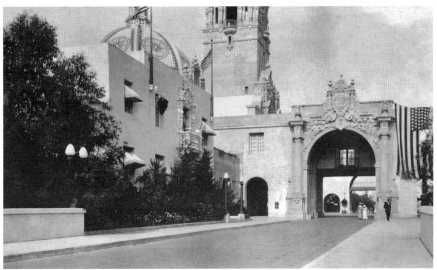

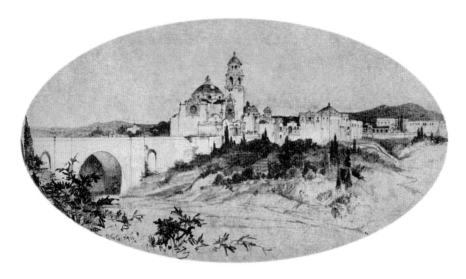

Sketch by Bertram Goodhue (initialed BGG, 1911). Note only three arches in the bridge. *The Committee of One Hundred Collection, Panama-California Exposition Digital Archive.*

A hospital for twenty-six patients, near the Pepper Grove, opened on December 5, 1912.[101] Blueprints showing Goodhue as architect meant that an anonymous draftsman working for him or for Allen may have drawn the design. A manufacturing company donated equipment for the surgery room and paid for its shipment to San Diego.

Goodhue designed a bridge to span Cabrillo Canyon with three gigantic arches, similar to the Alcantara Bridge in Toledo, Spain.[102] As Allen and Goodhue had undercut John C. Olmsted, so now Allen undercut Goodhue. He persuaded San Diego park commissioners that Goodhue's design was too costly and prepared plans for a seven-arch, aqueduct bridge, with the assistance of engineer Thomas B. Hunter, which he said was cheaper and, no doubt, better. Goodhue was outraged by Allen's meddling, but since Allen was on site and could plead the necessity of economy, he inevitably won the support of the holders of the purse strings.

Work on the bridge commenced in September 1912 and ended on April 12, 1914, when the first car was driven across with Franklin D. Roosevelt, assistant secretary of the navy; G. Aubrey Davidson; and Mayor Charles F. O'Neall as passengers.[103] Allen used 7,700 cubic yards of concrete and 450 tons of steel to construct the bridge. It was held up by steel T-frames and reinforced concrete piers. The bridge was 40 feet wide, 450 feet long and 120 feet high at its highest point.[104] It cost $225,154.89, which was $75,154.89

over Allen's estimate of $150,000.00 and $52,154.89 over the lowest bid of $173,000.00 received for Goodhue's bridge.[105]

The main exposition entrance was at Laurel Street and West Park Boulevard. Buildings rose east of Cabrillo Bridge: Administration, California State, Fine Arts, Science and Education, Indian Arts, Sacramento Valley, Home Economy, Foreign Arts, Botanical, Varied Industries and Food Products, Commerce and Industries and Southern California Counties Buildings followed one another along El Prado to the East Gate. "Prado" is usually translated as "meadow" or "lawn"; however, in Madrid, Spain (and in Balboa Park), it has the secondary meaning of city walk as in "Paseo del Prado" in Madrid or, in reference to the famous museum that borders the Paseo, "El Prado."

Governor Hiram Johnson, on March 31, 1911, signed a $250,000 appropriation bill for construction of a state building for the Panama-California Exposition.[106] On July 1, 1912, $50,000 would be available for plans and foundation work. On June 7, 1913, Johnson signed a second bill releasing the additional $200,000.[107] He appointed Thomas O'Hallaran, George W. Marston and Louis J. Wilde to the building committee. After Wilde resigned, he appointed Russel C. Allen. Marston was president of the committee and O'Hallaran secretary.[108]

In November 1911, exposition directors adopted Goodhue's plans for the California State Building and Quadrangle. Lieutenant governor J.A. Wallace laid the cornerstone on September 12, 1913.[109] An unsuccessful

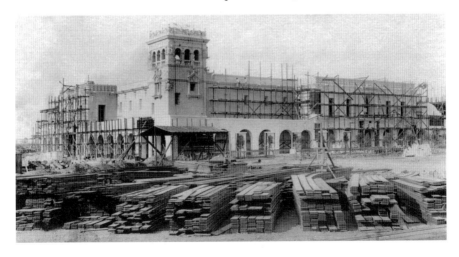

Home Economy Building under construction. *Ralph Bowman Collection, Panama-California Exposition Digital Archive.*

attempt was made in 1990 to locate the cornerstone, which contains some original architectural drawings for the Exposition.[110]

The California Quadrangle marked the entrance into the Exposition after passing through the West Gate. A *San Diego Union* reporter hailed the California Building as second in beauty only to the State Capitol in Sacramento.[111] It had a Greek-cross plan, with a rotunda and dome at the crossing and minor domes and half-domes at the side. A tower at the southeast corner rose 180 feet. Walter Nordhoff of National City fired the tiles used on the domes and tower.[112] F. Wurster Construction Company of San Diego put up the building, using reinforced concrete and hollow (Guastavino) tiles in domes and vaults.

In late 1913, as an offshoot of his squabbles with Allen, Goodhue instructed Winslow to devote his time exclusively to the execution of the California and Fine Arts Buildings, projects for which he was personally responsible.[113] The Piccirilli Brothers of New York City created cast-stone ornament on the tower and façade of the California Building and on the two gates framing the Quadrangle.[114] These they sent to Tracy Art and Brick Stone Company of Chula Vista for final execution.[115]

Figures on the façade constitute a hall of fame. They are Fathers Junípero Serra, Luís Jayme and Antonio de la Ascención; explorers Juan Rodríguez Cabrillo and Sebastian Vizcaíno; and busts of Governor Gaspar de Portolà, explorer George Vancouver and Kings Charles V and Philip III of Spain.[116]

By setting idealized—if vacuous—depictions of past notables in three-quarters life size, dressed in swirling clothes, against a background of wriggling ornament and broken entablatures, Goodhue and the Piccirillis created a Spanish Revival façade rich in texture and effect. The tower, with its slender, graceful profile and modulated levels, is more impressive than the façade, so much so that today the building is commonly called the California Tower. Both façade and tower have been copied often by American architects. Competing for attention with façade and tower, the colorful central dome,

Opposite: Façade of California Building. Figures include Fathers Junípero Serra, Luís Jayme and Antonio de la Ascención; explorers Juan Rodríguez Cabrillo and Sebastián Vizcaíno; and busts of Governor Gaspar de Portolà, explorer George Vancouver and Kings Charles V and Philip III of Spain. Coats-of-arms of Spain and Mexico are located near the top. California's state seal is above the entrance. *Photograph provided by the San Diego Museum of Man.*

Balboa Park and the 1915 Exposition

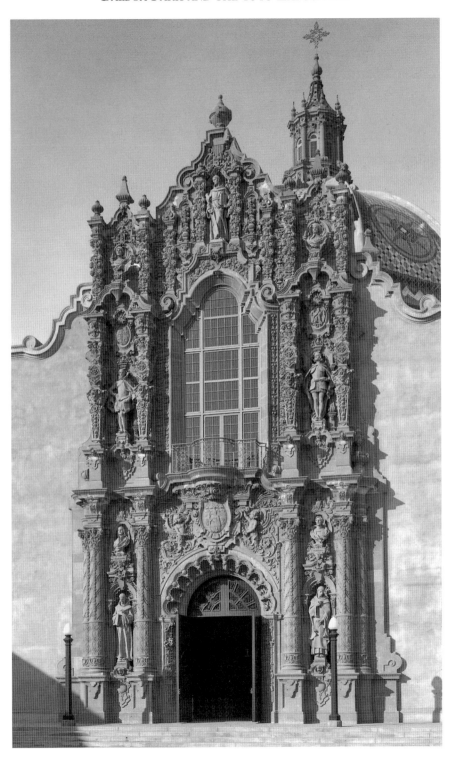

with its starburst design, is patterned after the great dome of the Church of Santa Prisca and San Sebastian at Taxco, Mexico. Other structural and design features were taken freely from many sources.[117]

On October 2, 1914, the State of California presented the California Building to the exposition.[118] Meant to be permanent, the building was one of four intended to remain after the temporary structures had been torn down. The others were the Fine Arts and Botanical Buildings and the Organ Pavilion. Goodhue was under the delusion (shared by no one except himself) that after the Exposition, the central mesa was to become a system of formal gardens and parterres without buildings in the manner of Vaux-le-Vicomte and Versailles.[119]

Brown and De Cew Construction Company of San Diego built the Fine Arts Building, on the south side of the California Quadrangle, after Goodhue's designs. It cost the City of San Diego $104,243.95.[120] As with the bridge, exposition officials—principally D.C. Collier—rejected Goodhue's first $150,000 plan as too expensive. The side facing the Quadrangle has an arcaded corridor, a wood-beam ceiling and a tile roof. Arches spring from square shafts with simply molded capitals. Richard Pourade gave their source as an arcade adjoining the Church of El Carmen in Celaya, Mexico.[121] A blank wall at the back of the arcade was left for fresco decoration. The plain walls and long, low-lying lines of the Fine Arts Building act as a foil for the richly decorated, sky-piercing California Building.

The interior of the Fine Arts Building was more assertive than its exterior. Four-part groin vaulting enclosing high clerestory windows lent spaciousness and uneven lighting to the main gallery. Cherubs—representing music, painting, sculpture and ceramics—stood in front of a balcony on the east end.

Goodhue had a bronze wall fountain, designed by the Piccirilli brothers, set in a niche lined with blue-and-white glazed tiles in a staircase hall below the east balcony. At the opposite end of the gallery, beneath a circular balcony supported by a corbel bearing the seal of the city of San Diego, a door opened into the main entrance hall. Here a wrought-iron and brass lantern hung from a coffered ceiling. At the rear of the hall, a narrow door led to a balcony from which visitors looked down into the St. Francis Chapel, dedicated to St. Francis of Assisi. The saint was represented showing the stigmata on a bas-relief to the right of the altar and by an inscription on the main beam supporting the balcony: "SCTE FRANCISCE, PATER SERAPHICE MISSIONUM ALTAE CALIFORNIA PATRONE, ORA PRO NOBIS" ("Holy Francis, Seraphic Father, Patron of the Missions in Upper California, pray for us").

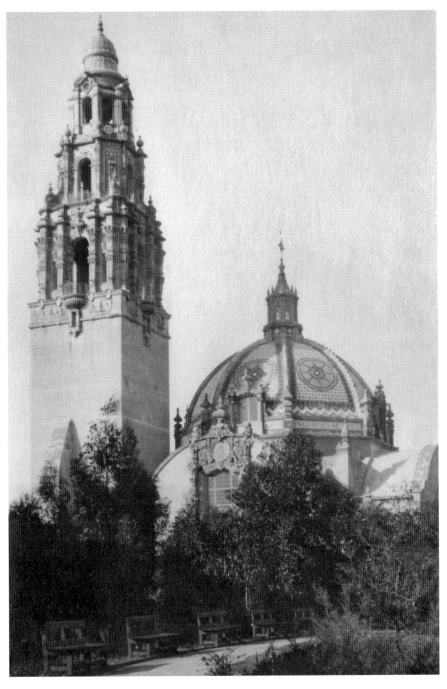

California Building, 1915. *Michael Kelly Collection, Panama-California Exposition Digital Archive.*

Goodhue designed the St. Francis Chapel. Mack, Jenny and Tyler, decorators of New York City, assembled a painted *reredos* standing in a shallow, vaulted chancel. Statues of San Diego de Alcala and St. Francis Xavier, on the right and left, flank a statue of Mary and Child in the

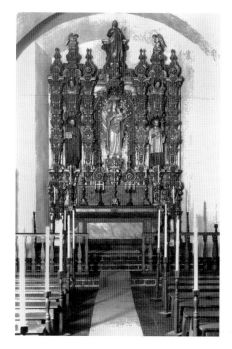

center. Heads above the side statues depict Santa Clara of Assisi and Santa Ysabel of Hungary. Farther to the right and left, heads depict Bishops San Luis of Tolosa and San Buenaventura of Albano. To make sense, the right side should have been given to Franciscans and the left to Jesuits, of whom St. Francis Xavier was the sole representative.

An "Ecce Homo" painting, donated to the chapel by Goodhue; a crucifix; candlesticks; a wrought-iron lectern holding a Bible in German; a wooden statue of San Antonio de Padua; and a pulpit conveyed the impression of a private chapel assembled from disparate elements for a Spanish nobleman of eclectic

Top: Interior of St. Francis Chapel in the Fine Arts Building. *David Marshall Collection, Panama-California Exposition Digital Archive.*

Bottom: San Joaquin Valley Building. *David Marshall Collection, Panama-California Exposition Digital Archive.*

tastes. The City of San Diego owns the chapel and furnishings. As the chapel is within its compound, the Museum of Man is supposed to keep it open during normal museum hours, but it does not do so. No inventory was ever made of the objects installed in 1915, and many have since disappeared.

A belfry above the chancel on the outside contains a bell from Granada, Spain.[122] It is not used. Moorish buttresses on Mission San Gabriel in Los Angeles are reproduced on the sturdy buttresses on the outside south walls of the chapel and Fine Arts Building. They were much photographed in 1915. Today, eucalyptus and cyclone fencing hide them from view.

Despite Allen's assertions, Goodhue had from the beginning planned the major and minor axes of the central site plan and the unfolding of open spaces beyond long, shaded corridors. Clarence Stein, Goodhue's draftsman, thought the charm and variety of the San Diego Exposition stemmed from this contrast of narrow streets and great plazas.[123] Goodhue and Stein were so captivated by the interplay of enclosed and open spaces at the San Diego Exposition that they used the same idea in their layout for the mining town of Tyrone, New Mexico. Goodhue also used arcades, surprise vistas and alternating spaces in his plans for the California Institute of Technology in Pasadena.

Goodhue's first central site plan called for a music pavilion on the north side of the Plaza de Panama.[124] Hoping to put a Motor Transportation Building on this choice site, officials decided to put the organ John D. and his brother Adolph B. Spreckels had offered to the city in 1913 north of the California Building, facing south.[125] After Brazil reneged on its building at the southern end of the esplanade connecting to the Plaza de Panama, officials moved the Organ Pavilion to this site, where it is today and where the sun shines directly in the faces of spectators. The Spreckels brothers paid the Austin Organ Company $33,500 for the electric-pneumatic organ and F. Wurster Construction Company $66,500 for construction of the pavilion.

The long, flamboyant San Joaquin Valley Building on the east and the plain, blockish Kern and Tulare Counties Building on the west faced the esplanade. At the foot of the esplanade, a neoclassical-style Salt Lake and Union Pacific Building on the east and a Mission-style Alameda and Santa Clara Counties Building on the west flanked the Organ Pavilion.[126]

The Botanical Building, at the north end of a cross-axis between the Home Economy and the Varied Industries and Food Products Building, faced a long reflecting pool and a sightline framed by the Foreign Arts Building and the Commerce and Industries Building.

Balboa Park and the 1915 Exposition

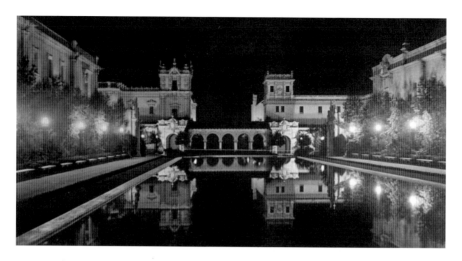

Moonlight on the lagoon, 1915. Herbert Fitch, photographer. *David Marshall Collection, Panama-California Exposition Digital Archive.*

The building had an interesting genesis. In September 1911, Alfred D. Robinson, president of the San Diego Floral Society, conceived the idea of a giant lath palace in the center of an enormous botanic garden.[127] It was to be similar to lath enclosures in Point Loma and Coronado, only bigger. Irving Gill wrote approvingly of these plans, but Carleton Winslow thought differently.[128] In early 1912, Winslow drew up plans for a massive, Spanish Renaissance greenhouse.[129]

As finally designed by Winslow, with help from Frank P. Allen Jr. and Thomas B. Hunter, the Botanical Building was more lath house than Spanish palace. It consisted of a narrow rectangle with a dominant central dome and with two short barrel vaults on each side. Steel frames, bridging the vaults, held up stained and bent redwood lath. Palms, bamboo, banana trees and aralia grew in the main building. Vitis, isolepsis, crotons, dracaenas, philodendrons and anthuriums grew inside a glass wing in the back.[130]

In his designs for the Botanical Building and its two lagoons, Winslow adapted Spanish and Persian models to produce a placid, pleasing scene.

Carol Greentree pointed out that the Botanical Building has features in common with the Umbracle in Barcelona, Spain, designed by Josep Fontsere in 1884 as a conservatory.[131] The building was remodeled as a pavilion for the 1888 International Exhibition and restored to its original function after the exhibition. Located in the Parc de la Ciutadella, the Umbracle consists of a tunnel-like structure made up of five bays. The bays, formed by cast-iron half arches, are in two stories, which lead up to a crowning arch or

nave.¹³² Horizontal louvers, joining the arcades, provide shade for ferns and palms. Brick arches at the north–south ends, topped by severe rectilinear turrets, allow ingress.¹³³

The Balboa Park building has only one interior arched space that is shaded by vertical rather than horizontal laths. Its entrances, set within a stucco and concrete arcade of Persian character, are in the center or longitudinal side of the building. A sweeping dome surmounted by a cupola and finials above the arcade contrasts with barrel vaulting on either side and provides a focus for lily ponds in front of the building. There is no evidence to support the contention that Winslow, Allen and Hunter were aware of the Barcelona building. Allen's original estimate for constructing the Botanical Building was $30,000.00. Final costs came to $53,386.23, or an overrun of $22,386.23.¹³⁴

The Japanese Tea Association erected a tea garden and pavilion in a corner a few steps to the northeast of the Botanical Building. Gardeners from Japan planted bamboo, wisteria, bonsai, cedar and ginkgo trees in the garden. Winding paths led to a moon bridge whose semicircular shape was reflected in a stream beneath. Carved folo birds on the gable ends of the teahouse, carp in the stream, pebbles on the paths and lanterns placed strategically to light the way conveyed the charm of Old Japan.¹³⁵ K. Tamai, a Japanese architect, used ornate temples in Kyoto as the source for the tea

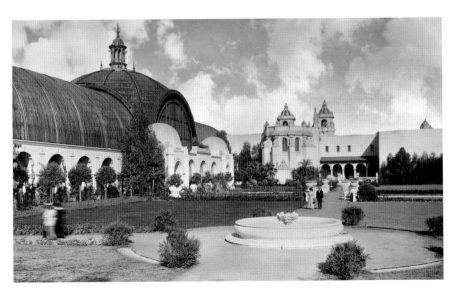

Botanical Building and the west apse and arcade of the Food Products Building. *Panama-California Exposition Digital Archive.*

pavilion. It has nothing in common with small, rustic teahouses. Japanese workers assembled the sections in San Diego without nails. The pavilion was the only building on the grounds to represent a foreign country.

People debarking from electric railway cars at a station opposite the Plaza de Balboa, on the eastern end of El Prado, hastened to visit exhibit buildings to the west or popular amusement attractions to the north. If the statue of Balboa that Goodhue had wanted had been set up on the Plaza, perhaps incoming people would have lingered. For reasons of economy, the statue was omitted. Unlike other expositions, San Diego's was noticeably lacking in figure sculpture.[136]

Two parallel north–south roads on the east side led to the north or Isthmus Gate. They were joined by a short strip called Calle Colon on the south and another called Calle Ancon on the north. One road, the Alameda, was bordered by agricultural exhibits and by International Harvester, Lipton Tea, Nevada and Standard Oil pavilions. The other road, the Isthmus, to the east of the Alameda, was bordered by amusement stands.

The Santa Fe Railway put up an Indian Village on a five-acre mesa between the Alameda and the Isthmus, at the north end of the exposition. As Indian villages had been built at expositions in Chicago, Buffalo and Saint Louis, the idea of having one in Balboa Park was not novel. The Santa Fe Railway's participating in the project was, however, unusual. Executives

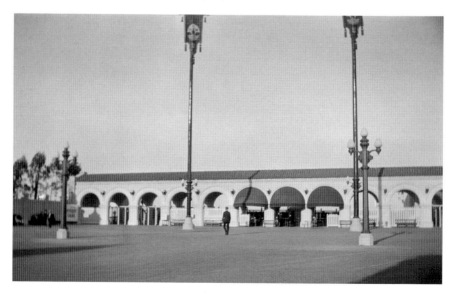

Trolley station at the Exposition. Allen Wright, photographer. *San Diego Public Library Collection, Panama-California Exposition Digital Archive.*

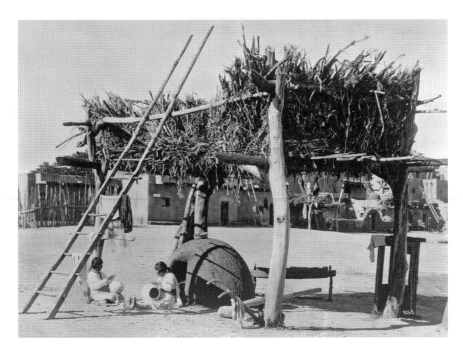

Zuni women making pottery under a drying platform. *Library of Congress LC-USZ62-137656.*

probably thought the sight of Indians from New Mexico and Arizona living in replicas of their homes would induce tourists to visit the real thing.

Indians from San Ildefonso Pueblo in New Mexico created the exhibit, using cholla, sagebrush, yucca, cedar posts and sandstone. Jesse L. Nusbaum supervised construction. Two large, stepped-back, simulated adobe buildings on the eastern side of a mesa faced ritual kivas. On the western side, hogans and dwellings resembling rock formations in Arizona's Painted Desert faced a courtyard and corrals for animals. The entire exhibit cost about $150,000.[137]

Except for Nevada, the state buildings were put up on a plateau southwest of the Organ Pavilion. These were Kansas, Utah, Washington, Montana and New Mexico.

Mrs. Jesse C. Knox operated a potpourri rose garden a short distance from the state buildings.[138]

On December 15, 1914, the Second Battalion of the Fourth Regiment, U.S. Marines, set up a tent city and parade ground adjoining the rose garden at the exposition's south end. At the invitation of exposition president G. Aubrey Davidson, Colonel Joseph H. Pendleton, commander of the U.S.

Balboa Park and the 1915 Exposition

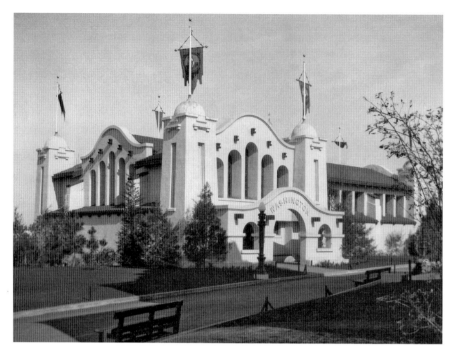

Washington State Building. *David Marshall Collection, Panama-California Exposition Digital Archive.*

Marine Corps, Fourth Regiment, established his headquarters on the balcony floor of the Science and Education Building.[139]

Home Economy, Indian Arts, Science and Education, Botanical, Varied Industries and Food Products and Southern California Counties Buildings were under construction in 1913. Work on other buildings began in 1914.[140] After construction was underway, onlookers were allowed to enter the grounds and watch building progress on payment of a twenty-five-cent admission.[141]

All buildings were ready one month before the opening. Allen's estimate for their erection had been $2 million. In November 1914, he reported his total outlay as $1.8 million. In addition, he estimated the value of his free services outside the Work Department at $350,000.[142] An audit of pre-Exposition operations, concluded by Palethorpe, McBride and Probert of Los Angeles, on March 29, 1915, gave the total charges for construction of the Division of Works as $1,937,445.03.[143]

In 1909, William Clayton, manager of the Spreckels-owned San Diego Electric Railway Company, said the company would "at a time not too far

distant take steps to run a line through the City Park."[144] To speed up this plan, the company in 1914 began a double-track to the exposition, starting at Twelfth and Ash Streets. The line stopped before a multi-arched station at the east gate. In 1917, the company extended the line to Upas Street.[145] Skeptics think Spreckels, rather than Collier, chose the central mesa for the exposition because it provided him with an excuse to extend his railroad line through the park.[146]

In the last week of 1914, troops A, B, D and M of the First Cavalry, U.S. Army, occupied a model camp on the west slope of Switzer (today Florida) Canyon, to the east of the North or Isthmus Gate.[147] Shortly after 9:00 p.m. on December 31, 1914, John D. Spreckels, standing on the stage of the Organ Pavilion, said to John F. Forward Jr., president of the Park Commission, "I beg you to accept this gift on behalf of the people of San Diego." Forward replied, "In the name of the people of San Diego and of those untold multitudes who in all the coming years shall stand before this glorious organ and be moved by its infinite voices, I thank you." Next, Samuel M. Shortridge, of San Francisco, extolled the power of music and the generosity of John D. and Adolph B. Spreckels. The San Diego Popular Orchestra, with 50 members conducted by Chesley Mills, presented the overture of Offenbach's *Orpheus in the Underworld* and a People's Chorus of 250 members, led by Willibald Lehmann, sang selections from Haydn's oratorio *The Creation*. Then Dr. Humphrey J. Stewart, who had been engaged at Spreckels's expense, gave the first of many organ recitals. He began with a processional march from *Montezuma*, which he had composed, and ended with "Unfold Ye Portals" from Gounod's *Redemption*, with the chorus and orchestra joining in.[148]

At 11:00 p.m., exposition bandsmen, dressed in uniforms of blue, red and yellow, played dance tunes in front of the Sacramento Valley Building, facing the Plaza de Panama. They concluded with a rendition of the National Anthem, with U.S. Army and Navy men joining in the singing, while the flags of the United States and Spain were unfurled. Afterward, Colonel Collier, as master of ceremonies, told those assembled, "Our hopes never wavered, our efforts did not lessen. We have stood together like one people should. We encountered all the trials and tribulations ever before those who attempt to blaze a new trail or attempt what seems impossible. That which five years ago was a hazy dream is today a reality, and San Diego keeps her promise to the world."[149]

Collier was followed by Carl D. Ferris of the Park Commission, Mayor Charles F. O'Neall, George W. Marston, Governor Hiram Johnson and G.

Balboa Park and the 1915 Exposition

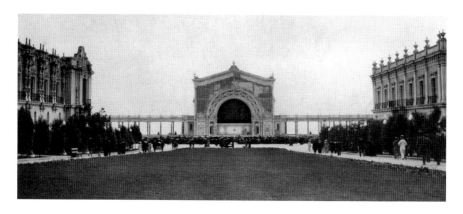

Esplanade leads to the Spreckels Organ Pavilion, flanked by the Kern and Tulare Counties Building on the right and San Joaquin Valley Counties Building at left. *David Marshall Collection, Panama-California Exposition Digital Archive.*

Aubrey Davidson. Marston praised the California Building and the state it represented:

> *On this rise of Balboa Park we here today dedicate the California Building to noble uses—the study of life, the history of man, the sciences and the arts, the high things of the mind and spirit. Through the genius of a great architect, Bertram Goodhue, a temple of such nobility and beauty has arisen from this ground that one might ascribe upon its door, "Let only the reverent and thoughtful enter here."*
>
> *Behold the spreading dome, catching the light of the rising and setting sun. Look upward to the glorious tower rising so serenely in the sky; observe with quiet thoughtfulness the figures of saints and heroes which adorn the southern front. Do they not set forth the past and present of California life? Are they not the true symbols of her glowing history and her wonderful today?*[150]

At the stroke of midnight, Pacific Time (3:00 a.m. Eastern Time), President Woodrow Wilson pressed a telegraph button in Washington, D.C., fashioned of the first five-dollar gold piece contributed toward the Exposition. The flash, captured by a wire at the Western Union Office in the Science and Education Building, turned on the electric power at the Exposition. Instantly, a light attached to a balloon 1,500 feet above the Plaza de Panama came on, illuminating a three-mile area in the sky and casting a ruddy glow over the gleaming white Exposition buildings. Lights

Balboa Park and the 1915 Exposition

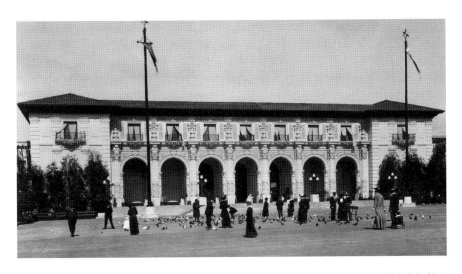

Sacramento Valley Building. *Michael Kelly Collection, Panama-California Exposition Digital Archive.*

blared on in full intensity, revealing the silhouettes of buildings. Mortar men about the grounds began firing missiles that spent themselves in white clouds of dropping smoke. Red carbide fires sprang from seven thousand sticks concealed in the shrubbery around the buildings. Eight powerful searchlights from the cruiser USS *San Diego*, flagship of the Pacific fleet, anchored off the foot of Market Street, threw their beams on the tower of the California Building, while thousands of incandescent lights outlined the ship from bow to stern. Bonfires on summits of hills in San Diego and farther away on summits in the Cuyamacas, Palomar and San Miguel Mountains burst into flames. About one thousand mines on the Exposition grounds exploded as guns at Fort Rosecrans and on the USS *San Diego*, nine torpedo destroyers, two submarines and a repair ship in the harbor saluted. Gatesmen threw the gates open as sirens wailed, steam pipes shrieked, whistles blew, cowbells rang, rattles shook, confetti streamed down, silk and straw hats went up and cheers arose from the throngs.

Atop the Spreckels Organ Pavilion, making use of the power that turned on the lights, the gates of the Panama Canal swung open in a fireworks display. A ship named *1915* started through the canal, waves breaking before its bow. Before the fireworks had dimmed, letters broke forth through the shooting flame that read, "The land divided—the world united—San Diego—the first port of call."[151]

San Diego had kept its promise to itself and to the world.

CHAPTER 2

The Panama-California Exposition Gets Underway

> *I love you, California, you're the greatest state of all*
> *I love you in the winter, summer, spring, and in the fall.*
> *I love your fertile valleys; your dear mountains I adore,*
> *I love your grand old ocean and I love her rugged shore.*
> —From California state song, lyrics by Francis Bernard Silverwood

After five years of unrelenting effort, San Diego celebrated the official opening of the Panama-California Exposition on January 1, 1915. At midnight on December 31, President Woodrow Wilson, in Washington, D.C., pressed a Western Union telegraph key. The signal turned on every light on the grounds and touched off a display of fireworks. The gates to the Exposition swung open. A crush of from 31,836 to 42,486 people on the grounds cheered, waved banners, threw confetti, sang "I Love You California" and snake-danced their way to the Isthmus or fun street.[1]

Among the guests who took part in the official but sparsely attended ceremonies beginning at eleven thirty the following morning were Secretary of the Treasury William Gibbs McAdoo, commander of the U.S. Pacific Fleet Rear Admiral T.B. Howard, director general of the Pan-American Union John Barrett and Spanish delegate Count del Valle de Salazar.[2]

In his speech to the guests, wearied from the festivities of the night before, G. Aubrey Davidson, president of the Panama-California Exposition Company, declared the Exposition's purpose was to build an empire

Balboa Park and the 1915 Exposition

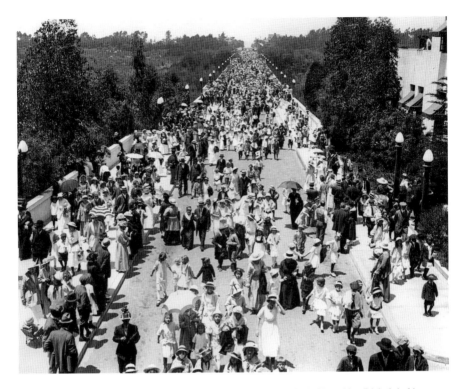

Opening Day crowd crossing Cabrillo Bridge. *Panama-California Exposition Digital Archive.*

extending from the back country of the Pacific slope to the west shores of the Missouri River.[3]

At one point, Davidson said, "Here is pictured in this happy combination of splendid temples, the story of the friars, the thrilling tale of the pioneers, the orderly conquest of commerce, coupled with the hopes of an El Dorado where life can expand in this fragrant land of opportunity. It is indeed a permanent city and every building fits into the picture."

Secretary McAdoo, President Wilson's personal representative and son-in-law, lauded the Exposition's emphasis on Latin America for helping to bring about "a closer union of all the nations and peoples of the Americas."[4]

A gigantic automobile parade along Broadway in the afternoon called attention to a Point Loma road race to be held January 9. Despite the competition offered by the parade, 15,120 people on the Exposition grounds had their first real chance to see what the Exposition was all about.[5]

Balboa Park and the 1915 Exposition

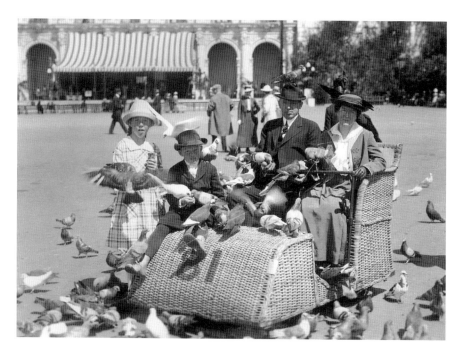

Fair visitors pose in electriquette on the Plaza de Panama. *Michael Kelly Collection, Panama-California Exposition Digital Archive.*

Opening day visitors quickly rented all two hundred of the small wicker motor chairs or "electriquettes" available from a stand on the Isthmus and used them for whirlwind tours of the grounds. The electriquettes carried two or three persons and traveled at a top speed of three and a half miles per hour.[6]

Seven states had put up buildings for the San Diego Exposition: California, Utah, New Mexico, Nevada, Washington, Montana and Kansas. Three of these states—Washington, Montana and Kansas—are not part of the Southwest, but Arizona, which is, declined to participate. The State of California did not put exhibits in its building. Instead, twenty-eight out of a total of fifty-eight California counties put exhibits in the Sacramento Valley Counties Building, the San Joaquin Valley Counties Building, the Kern and Tulare Counties Building, the Alameda and Santa Clara Counties Building and the Southern California Counties Building.[7]

Considering that the California counties also exhibited at the 1915 Panama-Pacific International Exposition in San Francisco, as did twenty-eight states and territories of the United States and twenty-two foreign nations, the exhibit aspects of San Diego's Exposition were not sensational.[8]

Balboa Park and the 1915 Exposition

The Exposition covered 640 acres surrounded by rose-trellised fences. Entrances were on the west across the Cabrillo Bridge, on the north at the back of the Isthmus and on the east end of the main avenue, El Prado, for passengers of the San Diego Electric Railway. Guidebooks referred to the east as the south entrance. Automobile parking was available on payment of a fee at the north and south entrances. The west entrance, leading across Cabrillo Bridge, was used by pedestrians, but automobiles driven by important people were allowed in.[9]

El Prado blended semitropical planting with Spanish, Moorish, Mexican, Italian and Persian architecture to create a vision seen before that time only in paintings of imaginary cities. Landscaping was more perfunctory around the state buildings on the south plateau.[10]

The New Mexico Building attracted attention because its plain, sturdy massing was unlike the heavily textured buildings on El Prado.[11] This building was the second of three replicas of the Mission of San Estevan at Acoma, the first being a warehouse at Morley, Colorado, and the third being the Museum of Fine Arts in Santa Fe. The auditorium, or church-like portion of the New Mexico Building was intended to accommodate a series of paintings by Donald Beauregard illustrating the life of St. Francis of Assisi and the martyrdom of Franciscan priests in New Mexico. Beauregard's death rendered this project impossible. The murals were ultimately completed by Kenneth Chapman and Carlos Vierra and were hung in the auditorium of the Santa Fe Museum of Fine Arts, built to look like the New Mexico Building in Balboa Park. A New Mexico mission series painted by Karl Fleischer and paintings by Ernest Blumenschein, Victor Higgins, Bert Phillips, Joseph Sharp and Walter Ufer were used to replace the Beauregard panels in San Diego.[12]

The El Prado symphony of green vines and bright flowers climbing over soft white walls, of florid sculptured ornament around building openings and of striped blue and orange draperies hanging from doors and windows delighted spectators. Red bougainvillea pranced along El Prado while purple bougainvillea danced in the Plaza de Panama. Clipped black acacias in front of buildings imposed order on the riotous blooms. Rose, clematis, jasmine and honeysuckle, growing inside the grass-covered patios of the Science and Education Building, entranced passersby. Opposite, in a formal English garden, unaccountably called "Montezuma," red geraniums, white marguerites and multicolored columbines heightened the visitor's pleasure.[13]

Working at night, head nurseryman Paul Thiene supervised the planting of plants, shrubs, trees and vines. He made sure that their colors were complementary and that their growth was uniform. In case some of the plants failed to bloom, Thiene kept about ten thousand geraniums ready for replacement in the nursery.[14]

Unlike buildings designed by Frank P. Allen Jr., Bertram Goodhue kept his signature California Building and Fine Arts Building and the wings enclosing them bare of flowering plants. To Goodhue, the shapes and volumes of buildings were more important than the plants that obscured them from view.[15]

The scale of the San Diego Exposition was small and its atmosphere friendly. Though it was likely that first-day visitors were too preoccupied to enjoy them, footpaths, shaded by acacia, pepper and eucalyptus trees, wound behind buildings. Seats and ledges were within easy reach. Trees in Palm Canyon, near the west end of El Prado; grasses in Spanish Canyon, near the east end of El Prado; and flowers in formal and informal gardens near the California, Fine Arts, Indian Arts and Southern California Counties Buildings offered visitors contact with nature.[16]

A wildflower bed running northeast from the California Building sparkled with yellow mustard, baby blue eyes, white forget-me-nots, purple lupines and wild Canterbury Bells.[17]

A Botanical Building, made of redwood lath and steel trusses painted to match the redwood, was dramatically recessed on the north side of El Prado. The vaulted main building was fronted by a white-stucco arcade with two Persian-style domes to mark entrances and highlighted in Persian fashion by a reflecting lagoon. Bamboo, palm, aralia and pitcher-shaped, insect-eating nepenthes grew inside the front, lath-enclosed structure and in the glass greenhouse in back.[18]

An ornate Japanese temple with an elaborate hip-and-gable roof, east of the Botanical Building, was used as a teahouse. It was bordered by a flowing stream with large carp swimming in it, a half-moon bridge, a bronze crane and stone lanterns, emerging from a background of cedar and wisteria.[19]

At night, the stunning daytime colors gave way to black-and-white chiaroscuro. Electric lights outlined the silhouette of the Spreckels Organ Pavilion. Along the main avenue, more than one thousand lamps with pear-shaped globes on stately pillars and bracket lamps and braziers in the arcades gave the buildings a soft glow.[20] The haunting Churrigueresque relief of the Prado buildings was at its best at night under a full moon.

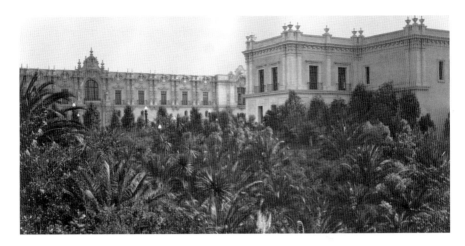

Palm Canyon in foreground, San Joaquin Valley Counties Building (left) and Kern and Tulare Counties Building (right). *Michael Kelly Collection, Panama-California Exposition Digital Archive.*

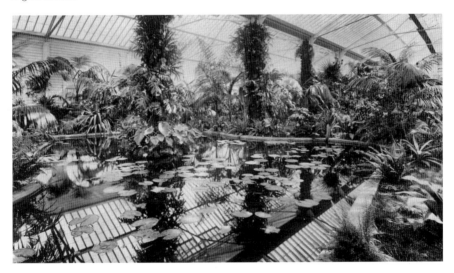

Inside the glass greenhouse behind the Botanical Building. *David Marshall Collection, Panama-California Exposition Digital Archive.*

A 2,500-foot pleasure street, called the Isthmus, running from the formal gardens behind the Southern California Counties Building to the north gate, could have been called "the Cynosure," for it was the primary goal of opening-day visitors. Most of its attractions were ready. These included a China Town, with an underground opium den where effigies in wax showed the horrors of addiction; a replica of a Pala gem mine; a

ride called "The Toadstool," consisting of a whirring disc on which few could keep their balance; another ride called "Climbing the Yelps," which simulated a descent into an erupting volcano; a Ferris wheel; a roller coaster in Anfalulu Land, nearly 6,000 feet in length and equipped with a sound apparatus that ground out "We Don't Know Where We're Going but We're On Our Way"; a historic display called "The Story of the Missions"; an ostrich farm in a building modeled after an Egyptian pyramid; a motion picture studio where films of scenes along the Isthmus were made daily; a Hawaiian Village with the entrance in the shape of a volcano like Kilauea; and an aquarium presided over by King Neptune, consisting of tanks of ocean water in one of which a helmeted diver rescued a waxen damsel from a sunken stateroom.[21]

Concessions not ready on opening day but ready by the end of the month included a dance hall called "The Divided Dime," where a couple could dance for five cents; a 250-foot replica of the Panama Canal with ships moving up and down in the locks; and a "War of the Worlds" fantasy in which New York City in the year 2000 was destroyed by Asians and Africans who arrived in battleships and airplanes.[22]

About three hundred Indians from Apache, Navajo, Supai, Tewa and Tiwa tribes resided in replicas of tepees, mounds or pueblos, built by the Santa Fe Railway near the north gate. The Indians wove rugs and

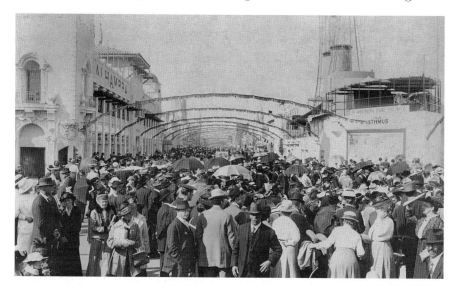

Visitors crowd the entrance to the Isthmus. *Panama-California Exposition Digital Archive.*

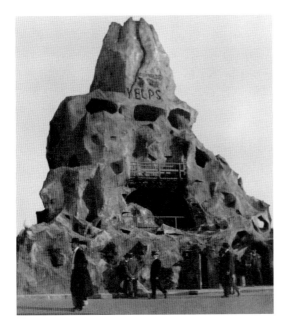

Left: "Climbing the Yelps," an attraction on the Isthmus. *David Marshall Collection, Panama-California Exposition Digital Archive.*

Below: Postcard with handwritten message on the back: "The crew of the U.S.S. *Isthmus*, who are the actors in the War of the Worlds. Orchestra on lower deck. E.L.M on left end in white suit." *Panama-California Exposition Digital Archive.*

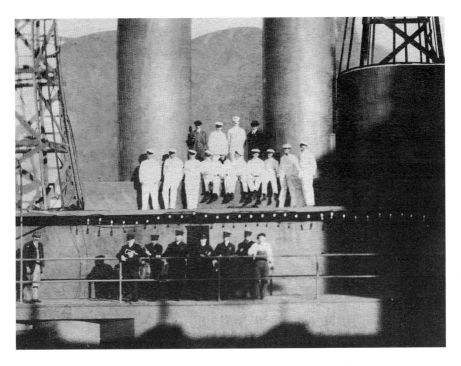

blankets, shaped pottery, pounded silver and copper into jewelry and ornaments, performed ceremonial dances and offered prayers to their gods from a sunken and ground-level kiva.[23] Ever on the alert, critic Geddes Smith noted the steamer trunks and kitchen clocks inside the Indians' primitive homes.[24]

Besides living demonstrations of Indians, the Exposition offered living demonstrations of five hundred U.S. Marines in a tent city on the brow of a hill south of the state buildings on the lower plateau and a squadron of the First Cavalry, U.S. Army, in a model camp on the west slope of Florida Canyon, outside Exposition grounds. Marines and cavalrymen were getting settled on opening day and preparing themselves for the parades, drills and band concerts they would give throughout the year.[25]

Some first-day visitors must have left their electriquettes long enough to look at indoor exhibits. If they did, they were rewarded for the fifty-cent (adult) and twenty-five-cent (child) admission they paid to enter the Exposition. Displays inside the California Building, just beyond the West Gate, documented the culture of the Maya Indians. In the central auditorium, huge palms provided a backdrop for reproductions of four stelae and two monoliths from Quirigua in Guatemala. Sculptured friezes by Jean Beman Smith and Sally James Farnham and paintings of scenes from Maya life by Carlos Vierra looked down from walls and balconies.[26]

The Fine Arts Building, on the south side of the Plaza de California, offered American paintings by William Glackens, Robert Henri, George Luks, Maurice Prendergast, Joseph Sharp and John Sloan, exponents in various ways of American Impressionism, the Ash Can School of American realism and the scenery around Taos, New Mexico.[27] New York art critic Christian Brinton thought the paintings were inferior in design and feeling to the Indian pottery, rugs, baskets and utensils in the other buildings.[28] Jean Stern, executive director of the Irvine Museum in California, has suggested that Robert Henri purposely chose the American artists for the inaugural exhibit because they reflected distinctly American influences and techniques in contrast to the European artists whose work was shown at the revolutionary Armory Show of 1913 in New York City.[29] As a reflection, perhaps of their rough realism, none of the paintings on exhibit was sold. In 1962, the San Diego Fine Arts Gallery in Balboa Park attempted to re-create the 1915 exhibit with minimal success, as only thirteen of the original forty-nine entries could be found.[30]

On the lower floor of the Fine Arts Building, the Pioneer Society of San Diego exhibited an Indian raft made of tule and balsa, a large photographic

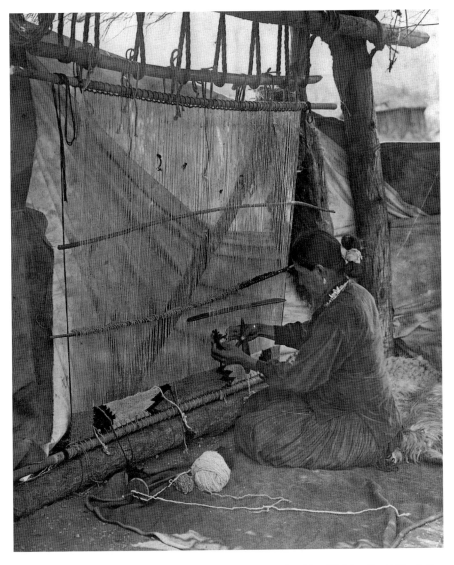

This Indian woman is weaving a blanket at a loom. Photo by Allen Wright. *David Marshall Collection, Panama-California Exposition Digital Archive.*

view of San Diego in 1869, court records dating from 1850 and portraits of men and women connected with the early history of San Diego.[31]

As one entered El Prado, the Science and Education Building on the north and the Indian Arts Building on the south, beyond the Montezuma Gardens, continued the anthropological themes introduced in the

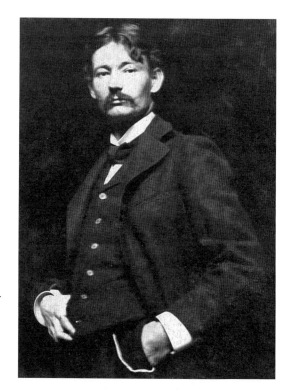

Right: Robert Henri, 1897. Unknown photographer. *Wikipedia*.

Below: Fair visitors in an electriquette on the Plaza de Panama with pigeons. *Michael Kelly Collection, Panama-California Exposition Digital Archive.*

California Building. Dr. Edgar L. Hewett, of the Archaeological Institute of America, and Dr. Ales Hrdlicka, of the U.S. National Museum, selected exhibits in these buildings during trips they or scientists commissioned by them made to southeastern Europe, Siberia, Mongolia, the Philippines, Africa, Peru and Guatemala.[32]

Robert W. Rydell and Matthew F. Bokovoy have cast a jaundiced eye on the roles played by Drs. Hewett and Hrdlicka at the Panama-California Exposition, with Rydell coming down on Hrdlicka and Bokovoy on Hewett. Rydell quoted Hewett as saying at the Race Betterment Congress held at the Panama-Pacific Exposition in San Francisco in August 1915 that Mexicans "imperil in some measure the health of the human race in its onward march." Bokovoy rephrased this fragmentary sentence to mean "immigration" imperiled "in some measure the health of the [white] race in its onward march," a sentiment, if Rydell is to be believed, that Hewett did not express.[33] Still, it is possible that in 1915 Hewett had an antipathy to "mestizos" or lower-class Mexicans. However, since his main focus was archaeology, he did not repeat this statement publicly after 1915, nor is it recorded that he addressed any more "Race Betterment Congresses." The peculiar status of the Spanish-speaking people in New Mexico, who regarded themselves as the descendants of the original Spanish inhabitants, may have been a factor in Hewett's denigration of "mixed-bloods." Both Hewett and Hrdlicka illustrate how the concept of Social Darwinism, almost universally held by academics at the turn of the twentieth century, impacted their thinking. As men evolved from lesser species, so societies evolved from a stage of hunting-gathering to the industrial civilization of today. Far from being impartial, most scientists in the 1900s considered the latest stage of civilization to be the best. Much the same evaluative process took place in regard to ethnicity, with white Anglo-Saxon Protestant racial types being considered superior to others.

As people who lived within the scientific ethos of their time, Hewett and Hrdlicka shared similar views, though, in Hewett's case, he had moral, ethical and aesthetic misgivings. If Hewett sometimes thought WASPs were superior because they had more drive and ambition, such thoughts were balanced by his sympathetic identification with indigenous people. In Hrdlicka's case, he was a physical anthropologist whose specialty was anthropometry. As such, he tried to be objective. When he prepared the exhibits for the San Diego Exposition, the ideas for which he became recognized as a leader in physical anthropology were in a formative stage. He thought Homo sapiens derived from Neanderthals, an idea that anthropologists generally discredit today,

and that American Indians came across the Bering Strait after the last Ice Age, a migration that anthropologists generally regard today as occurring during the Ice Age. If one were to look hard enough, he or she might find evidence of these ideas in the displays Hrdlicka set up in San Diego, though ordinary onlookers did not come away with these inferences. Whatever his sentiments were at the time, today Hrdlicka is vilified by many Native American tribes for digging up the graves of their ancestors. As for Hewett, to say he was an apologist for imperialism or the exploitation of minorities overstates the case.[34]

Nevertheless, a caveat regarding Hrdlicka is in order, as the more one reads, the more Rydell's broad claims make sense. Dr. Kate Spilde has shown how the U.S. Department of Justice hired Hrdlicka and Professor Albert Jenks of the University of Minnesota to determine how many Chippewa Indians at the White Earth Reservation in Minnesota could be classified as culturally advanced "mixed-bloods" who could sell their allotments and rights to communal lands to non-Indian timber interests. By examining the Chippewas' skin, hair, noses and feet, Spilde stated, the physical anthropologists "provided the government with the evidence they needed to justify the extraction of tribal resources by public and private outsiders."[35] Physical anthropologist Michael L. Blakey came to a similar conclusion when he wrote that after measuring the skulls of seventy-six African Americans at Howard University, Hrdlicka concluded that full-blooded Negroes "appeared to be of inferior mentality."[36] If this is not international imperialism, i.e. the subordination of colonial people to the ends of their masters, it sounds like national and domestic imperialism. By acting as a client for people with ulterior motives, Hrdlicka became vulnerable to the charge that the conclusions he reached were affected by obstinacy and self-interest.[37]

In opposition to the theories of Anglo-Saxon superiority espoused by eugenicists Charles Davenport and Madison Grant, Hrdlicka developed a variation of the "melting pot" theory in which he claimed that like old-comers to the United States—English, Irish and Scotch—newcomers from Central and Southeastern Europe "have been undergoing a gradual physical improvement, leading in stature and other respects in the direction of the type of Old Americans." In other words, descendants of all immigrants were approaching a distinctly American identity or norm. Despite this difference with eugenicists, Hrdlicka became a member of the Eugenics Society in the 1920s, and he sought the financial (but not editorial) help of Davenport and Grant in the publication of the *American Journal of Physical Anthropology*,

a journal that he founded in 1918. He hesitated to express his "egalitarian" thoughts in public, and in 1923, he declined an invitation to testify before a House Committee on Immigration Policies.

The following wonderful *corrido* quoted by Fray Angelico Chavez in *My Penitente Land* describes the universal inclination of people who are well off to look down on those who are not and to disclaim any responsibility for their condition:

El que nace desgraciado
desde la cuna comienza
desde la cuna comienza
a vivir martirizado.

Anyone born disadvantaged
starts out from the cradle
starts out from the cradle
to be stepped on and unwanted.[38]

Ten painted plaster bust models of precursors of present-day man by Belgian sculptor Louis Mascre, in the Science and Education Building, illustrated the evolution of man. These imaginative busts were replicas of colored originals, created between 1909 and 1914, under the direction of curator Aime Rutot, for the Royal Institute of Natural Sciences of Belgium in Brussels. The Museum of Aquitaine, in Bordeaux, France, displays a third group. Frank Micka (Mischa) and Joseph Andrews made plaster sets of forty-five male and forty-five female busts, cast from living subjects, that portrayed man's development from birth to senescence in white, Indian and black races. Micka also made plaster busts of seventy-five Native Americans from facial casts. These included Blackfoot, Sioux, Omaha, Apache and Osage. Some of the busts have been retained by the San Diego Museum of Man; others are kept in the National Museum of Natural History in Washington, D.C., where descendants of the original subjects can see them and ask for copies. An exhibit of sixty skulls from Peru showed pre-Columbian trephining. Addressing a contemporary Progressive issue, panels donated by child welfare organizations advocated the prevention of infant mortality and the abolition of child labor.[39] The didactic nature of this display departed from the descriptive character of the Hewett/Hrdlicka exhibits.

The Indian Arts Building, as the name implied, concentrated on interpreting the life of American Indians. A series of diagrams depicted

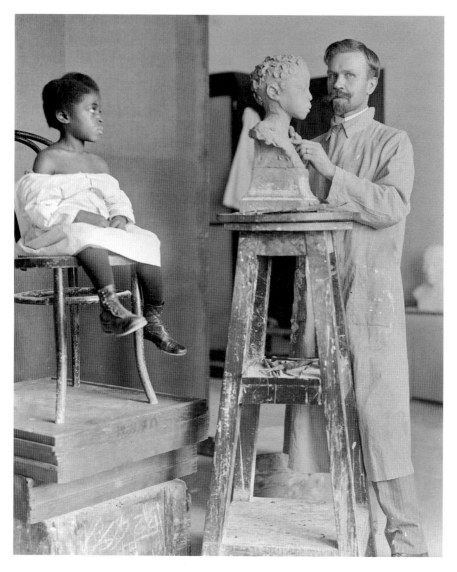

Young girl poses for sculptor Frank Mischa, 1914. Harris & Ewing, photographer. *Library of Congress photo LC-H261-4347.*

Indian symbolism, eleven large murals by Gerald Cassidy showed the habitations of Cliff Dwellers[40] and photographs by Edward S. Curtis and Roland W. Reed presented romanticized views of the Indians. Reed, whose photographs were influenced by Curtis's histrionic and perfectionist style, showed life-size photographs of Blackfoot Indians, which became so popular

that he set up a studio in San Diego to sell copper-plate engraved copies.[41] In presenting idealized versions of Native Americans as they supposedly lived in an Acadian pre–contact with whites stage, neither Curtis nor Reed was true to the living conditions of contemporary Indians. They took pains to eliminate evidences of modernity, including the baggy trousers or calico dresses the Indians wore, instead of the costumes that they put on for ceremonial occasions or that were foisted on them by "image makers." Native Americans in the photographs were as much "poseurs" as the representatives of Southwest Indian tribes at the Indian Village/Painted Desert near the north gate.

The Plaza de Panama was the hub of the Panama-California Exposition. It extended south by means of an esplanade to the Plaza de los Estados, in front of the Organ Pavilion. On special occasions, such as the opening night ceremony, a sea of humanity filled the area. When it was not being used by dignitaries for speeches, by the armed services for drills, by acrobats and athletes for sports, by bands for concerts, by soldiers, sailors and civilians for dances or by exhibitors for shows, the Plaza de Panama was filled with strolling musicians, guards dressed as Spanish grenadiers, ladies with bright parasols, children and adults feeding pigeons and electriquettes going in all directions.[42]

Balboa Guards. Ralph Bowman Collection. *Panama-California Exposition Digital Archive.*

Feeding the pigeons on the Plaza de Panama. Photograph by Allen Wright. *San Diego Public Library Collection, Panama-California Exposition Digital Archive.*

The Sacramento Valley Building occupied the place of honor at the head of the Plaza de Panama. It was a long, symmetrical, Italian-Renaissance building with a deep alcove, set above rows of steps and festooned with gay rococo ornament. While other buildings around the Plaza differed in elevation and style from the Sacramento Building, they made good neighbors.[43]

By the time the visitor had reached the Plaza de Panama from the west, he had passed beyond the educational exhibits. The commercial, state and county exhibits that remained put their stress on practical matters.

Kyosan Kai Company of Japan placed rare collections of cloisonné, chinaware, cabinets, tapestries and screens in the Foreign and Domestic Arts Building on the southeast side of the Plaza de Panama. A gigantic case of carved cherry with inlaid wood in the center, containing finely carved ivories, was valued at $10,000. The same company also operated a Chinese exhibit in the building, featuring bronzes, silks and paintings,[44] and the Tea Pavilion and the Streets of Joy concession on the Isthmus where patrons enjoyed

Balboa Park and the 1915 Exposition

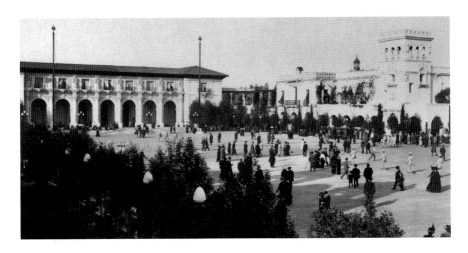

Plaza de Panama. The Sacramento Valley Building (left) was replaced in 1926 by the Fine Arts Gallery; the Home Economy Building was replaced by the Timken in 1965. *Panama-California Exposition Digital Archive.*

the scenery of Old Japan, admired women dressed in kimonos, listened to musicians play the samisen and played games of chance.[45]

Something was amiss in the exhibits in the Home Economy Building, across El Prado from the Foreign and Domestic Arts Building. Except for a mention in the Guidebook, the exhibits were not described in newspapers. In contrast to the "arts" in the Foreign and Domestic Arts Building, exhibits in the Home Economy Building featured the latest in sinks, stoves, vacuum cleaners and refrigerators. Curiously, in a building catering to women, one of the biggest exhibits was entitled "Cigars."[46]

The U.S. Navy, a major exhibitor in the Commerce and Industries Building near the east end of El Prado, showed fieldpieces, Gatling guns, rifles, a collection of shells and machetes, diving suits and models of the armored cruiser *San Diego* and the dreadnought *North Dakota*.[47] The U.S. Mint, in the same building, displayed a currency machine that turned out engraved Exposition emblems in silk and a coin machine that turned out thousands of metal souvenir Exposition coins.[48]

Manufacturing companies put industrial exhibits in the Commerce and Industries Building and the Varied Industries and Food Products Building, on opposite sides of El Prado. Moreland Motor Truck Company in the Commerce and Industries Building showed how a new gasifier in its trucks could ignite a spray of distillate fuel and keep the engine going.[49] In the Varied Industries and Food Products Building, Pioneer Paper Company

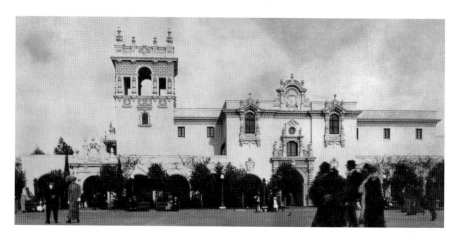

The Foreign Arts Building, shown in 1915, is now the reconstructed House of Hospitality. *David Marshall Collection, Panama-California Exposition Digital Archive.*

subjected roofing paper to intense heat to illustrate its lasting qualities,[50] Globe Mills Company baked bread,[51] Genesee Pure Food Company packed products with the aid of machinery[52] and Towle Products Company made maple syrup and sugar inside a log cabin.[53] Free samples given away by exhibitors ensured large crowds in front of displays.

New Mexico offered lectures and movies in the auditorium of its building and displayed gold ore and large blocks of meerschaum in its mineral exhibit.[54] On the second floor, the newly established U.S. Forestry Service showed what it was doing to conserve forests.[55] In the Utah Building, a bas-relief of the state weighing five tons and a depiction of an irrigation project fascinated visitors.[56] A miniature oil well in the Kern and Tulare Counties Building extracted oil from the earth.[57] Exhibits in other state and county buildings consisted of fruits and vegetables arranged in colorful piles and grain stored in glass-fronted bins or arched sheaves. The Southern California Counties exhibits were most like those of a country fair, with showcases of china painting, hemstitched aprons, an inlaid table made of 2,866 pieces of wood, cows made of creamery butter and elephants made of English walnuts.[58]

The Southern California Counties Commission, consisting of representatives from Los Angeles, San Bernardino, San Diego, Imperial, Ventura, Orange and Riverside Counties, maintained a formal garden; citrus orchards containing about seven hundred orange, lemon and grapefruit trees; a five-acre model farm and bungalow; and a three-acre demonstration

A milkmaid and a cow made of butter in a refrigerated display at the Southern California Counties Building. *Michael Kelly Collection, Panama-California Exposition Digital Archive.*

field north of its main El Prado exhibit building and east of the Alameda. Nearby, Lipton Tea installed a plantation with workers from Ceylon, and International Harvester put up an exhibit building, planted a citrus orchard and demonstrated tractors, harvesters, stackers, manure spreaders, plows and water sprayers in the orchard or on a five-acre demonstration field, sown with cereals and grasses, whichever was appropriate.[59] The so-called tractor field at the northeast end of Alameda, adjacent to the Painted Desert, was used for cavalry drills, athletic events, military and civilian encampments,

fireworks displays and as an aviation field. Newspaper accounts do not indicate that it was used as "a tractor field." A pump in the International Harvester orchard raised water so it could be used to irrigate citrus trees, one of the few instances of machine irrigation at the Exposition.

Diverting water from the Colorado River made Isaiah's prophecy of fertility in a desert landscape possible.[60] In 1911, novelist Harold Bell Wright dramatized this diversion in *The Winning of Barbara Worth*, in which he depicted the irrigation of Imperial Valley (Imperial County since 1907). Amazingly, San Diego County waited until 1947 before it connected to the Colorado River Aqueduct of the Metropolitan Water District of Southern California.[61] During the 1915–16 San Diego Exposition, the City of San Diego Water Utilities Department used water from the city's and county's local watershed to irrigate the model farm and International Harvester's orchards and demonstration fields.[62] The supply of water for the city and county may have been adequate then, but it became increasingly less reliable as the population grew and periods of drought took their inevitable toll.

Displays of agricultural know-how at the San Diego Exposition attempted to win converts to the back-to-the-land movement.[63] Though the philosophy of the Little Landers of San Ysidro, as promulgated by William Ellsworth Smythe, was being promoted, Little Landers were not represented.[64] C.L.

International Harvester Building on the Alameda. *Michael Kelly Collection, Panama-California Exposition Digital Archive.*

Wilson, who managed the model farm for the Southern California Counties Commission, held up the prospect of success with an important proviso: "After being in charge of the model farm at the Exposition for two years, I have no hesitancy in saying that from seven acres of good California land a profit of from $2,000 to $2,500 a year can be taken by a man who understands his business."[65]

Many Little Landers were novices at farming; others were too old to do the work necessary. A pumping system from the Tijuana River, financed by the Citizens Savings Bank of San Diego, was inadequate and expensive. Farmers who got the best land were at odds with farmers in less desirable locations. Speculators had begun converting farmland into residential lots. Insurgency in Mexico scared away investors. A state commission on land colonization and rural credits issued a report in 1916 criticizing the concepts and management of the enterprise. Many would-be farmers took outside jobs to supplement their income. Lacking the intensive farm skills of Japanese farmers, aspiring American middle-class tillers of the soil found one acre of land to be too small. Indeed, the uneven results of the Little Lander experiment and its collapse in 1918 provided evidence that contradicted Smythe and Wilson's assertions that small subsistence farmers could become rich in an area where large agricultural landholdings were the rule rather than the exception.[66]

Skeptical of exaggerated booster claims, Mathew F. Bokovoy pointed out, "It was difficult…to discern whether the model farm was a progressive experiment intended to rationalize intensive farming, or if it was a developer-led scheme (suburbanization) to promote the small agricultural communities in San Diego and Imperial Counties."[67] If not a scheme, certainly the result for the former agricultural communities of El Cajon, Chula Vista, Lemon Grove and San Ysidro are now well-developed urban and suburban communities. (How the observation applies to Imperial County is, however, not as transparent, though, of course, the county has more communities in 2006 than it had in 1915).

Café Cristobal at the entrance to the Alameda and the Alhambra Cafeteria at the entrance to the Isthmus were the Exposition's main restaurants. The Cristobal was the Exposition's social center, where celebrities were feted and "society night" dances were held. Between courses, patrons did the one-step and foxtrot to the music of Professor E.C. Kammermeyer's ten-piece orchestra. Over two thousand people tried to get reservations for the opening night New Year's Eve celebration. This created a problem as the café had seats for only six hundred.[68] Somehow, the café managed to hold

and serve an early dinner for more than one thousand beautifully gowned women, naval officers in full dress and male guests in formal attire.[69] Most of the diners left the café to attend the organ dedication at the Spreckels Organ Pavilion beginning at 9:00 p.m. and the inaugural ceremonies in the Plaza de Panama beginning at 11:00 p.m.

The official banquet at the Cristobal on the evening of January 1 was for males only. Attendance was down to about 500. Simultaneously with the men's banquet, about 350 women held their own meeting at the U.S. Grant Hotel in downtown San Diego. Here they entertained the wives of visiting celebrities after they had found out the Alhambra Cafeteria could not be adapted for such a function. Another 3,500 women, who were not invited, crowded the hotel lobby and the street outside. The men's dinner was replete with camaraderie, toasting, long speeches and the singing of an unauthorized version of "It's a Long Way to Tipperary," which ended: "It's a long way to San Diego but we're all right there."[70] The women, led by Mrs. Earl A. Garrettson, substituted short introductions, the singing of sentimental lyrics by talented vocalists and the dancing of five pretty girls dressed as wood nymphs.[71]

The Spanish-style Alhambra Cafeteria, designed by Max E. Parker, designer of many concession buildings, had a seating capacity of 1,200 and catered to those who wanted their meals quickly. Diners could view a rose-covered pergola and the citrus orchards on the west and the formal gardens of the Southern California Counties on the south.[72]

Exposition directors were reluctant to allow women representation in the direction of the Exposition. This obstinacy led Miss Alice Klauber to form the San Diego County Women's Association and to notify the board that if provision were not made for women during 1915, the association would advertise the fact in every women's club in the United States.[73] Not surprisingly, the board came around.[74]

San Diego women wanted to provide restrooms and comfort facilities for women and children, to protect single women from the perils of the city and to entertain Exposition visitors.[75] These concerns led to the development of several women-oriented rooms on the grounds. The Woman's Christian Temperance Union maintained a room for women in the Science and Education Building; the Young Women's Christian Association, a room in the Varied Industries Building; the Christian Science Church, a room in the Commerce and Industries Building; and the Southern California Counties Committee, a room in their building. Women frequently used rooms in the Model Bungalow for gatherings.

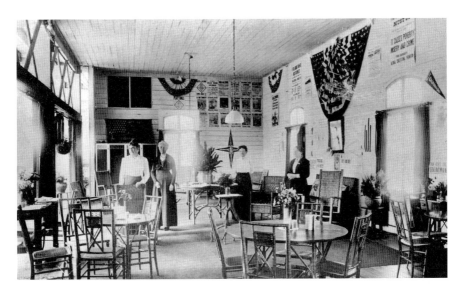

Woman's Christian Temperance Union (WCTU) room for women in the Science and Education Building. *Michael Kelly Collection, Panama-California Exposition Digital Archive.*

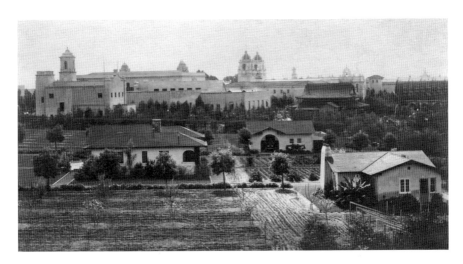

A model bungalow was located in the model farm, just north of the Botanical Building and Japanese Teahouse. Detail of photo by Oakes. *John Earl Collection, Panama-California Exposition Digital Archive.*

The two rooms at the Exposition that evoked the most comment were the rooms of the Daughters of the American Revolution—described in the *San Diego Union* as being in the upper balcony of the Arts and Crafts, or Indian Arts Building,[76] and in the *Los Angeles Times* as being in the Fine Arts Building[77] and the Official Women's Board Headquarters on the west side and upper balcony of the California Quadrangle. Being in a Spanish mission–style building did not deter the DAR from converting their room into an American colonial sitting room. Under the supervision of Mrs. Horace B. Day, chapter members made seats, rugs, curtains and replicas of rare antiques that looked as if they belonged in Williamsburg, Virginia. Members hoped their room would become the official reception room for visitors.[78]

The DAR was doomed to disappointment, for the most striking interior in the Exposition was in the room occupied by the Women's Official Board, sequel to Alice Klauber's association. The success of this room was due to Miss Klauber. Using the colors of an old Indian rug, she painted the walls in shades of gray and black and used a persimmon red dye on hangings and cushions. She employed real persimmons, ripe pumpkins and French marigolds as motifs. A rosewood piano case in the room that had been converted into a handsome desk inspired a reporter to write: "It is safe to say that by the time the Exposition is over, there won't be an old piano left in the west, they will all be writing desks."[79]

Persimmon Room of Women's Official Board. The rosewood piano case at left was converted into a desk. *Panama-California Exposition Digital Archive.*

Under the direction of Mrs. George M. McKenzie, head of the social committee, two San Diego women acted as hostesses in the "Persimmon Room" every day of the year, including opening day, when the Women's Official Board extended its hospitality to Mrs. William G. McAdoo, wife of the secretary of the treasury and daughter of President Wilson.[80]

The Women's Board also maintained a silent room on the lower level of their headquarters. Here a nurse in charge watched over women resting on cots.[81]

San Diego women did much to make the Exposition an endearing experience. Men made the buildings, but women decorated them. Alice Klauber oversaw art exhibits and lectures, and Gertrude Gilbert, head of the Amphion Music Club, arranged for the appearance of concert artists.[82]

One of the most distinctive features of an Exposition rich in distinctive features was the Organ Pavilion at the south end of the esplanade connecting to the Plaza de Panama. Like their father, Claus Spreckels, who in 1900 gave an outdoor Music Temple to Golden Gate Park in San Francisco,[83] John D. and Adolph B. Spreckels gave the Organ Pavilion in Balboa Park to "the people of San Diego." John D. Spreckels also hired Dr. Humphrey J. Stewart, a distinguished organist and composer, to give daily concerts throughout 1915.[84] These concerts continued, at the expense of the Spreckelses' interests, until September 1, 1929.[85]

Speaking to a reporter as he listened to the opening strains of "Adeste Fideles" during a practice session before the official 7:00 p.m. Exposition opening on December 31, 1914, John D. Spreckels said his gift of the organ to San Diego was the finest achievement of his life.[86]

The people who entered the grounds on New Year's Eve on December 31, 1914, and opening day, January 1, 1915, had every reason to be proud. San Diego's Panama-California Exposition of 1915 was not the World's Fair it had set out to be in 1909, yet it had not become so diminished that its original idea was lost. The determined men and women who participated in the San Diego Exposition—the financiers who raised the money; the architects who designed and the workers who constructed the buildings; the gardeners who planted the grounds; the people from the counties, states and businesses who put up exhibits; the concessionaires on the Isthmus who provided fast-paced hilarity; and the people of San Diego and of the Southwest who attended the Exposition's daily events—transformed the Exposition from a regional and transitory fair into an event that has outlived the memory of many larger and wealthier expositions and has left a lasting mark on the Southwest.[87]

CHAPTER 3

San Diego's Year of Glory

1915

The year 1915 was San Diego's most notable in the twentieth century. The Panama-California Exposition held in San Diego that year put the small town in the southwest corner of the United States on the map and convinced some people, but not all, that its name was spelled San Diego and not Santiago.

After its crowd-packed January 1, 1915 opening, the Exposition went into a slump. Of the 180,270 people who visited the Exposition in January, about 100,000 entered the gates during the first week.[1] The books showed a net loss of $3,000.[2] Rain may have deterred some visitors, but a national economic depression dissuaded others. Officials were inept in coping with the situation. They allowed barkers to spiel on the Isthmus, lowered children's admissions to 10 cents on Saturdays and dropped annual adult tickets from $25 to $10[3] but also ordered main buildings to be closed on Sundays, kept regular adult admissions at 50 cents on weekdays and 25 cents after 6:00 p.m. and on Sundays[4] and charged people with cameras an additional 25 cents.[5] Managers of state and county buildings disregarded Exposition rules and set their own hours.[6]

An "Exposition Road Race" held on Saturday morning, January 9, at Point Loma attracted 50,000 people. Winners of the race, including Earl Cooper, who averaged slightly over sixty-five miles per hour, received their prizes in the afternoon at the Plaza de Panama.[7] The holding of such a popular event simultaneously with the Exposition was a miscalculation, for attendance at the Exposition that day was only 6,112.[8]

Balboa Park and the 1915 Exposition

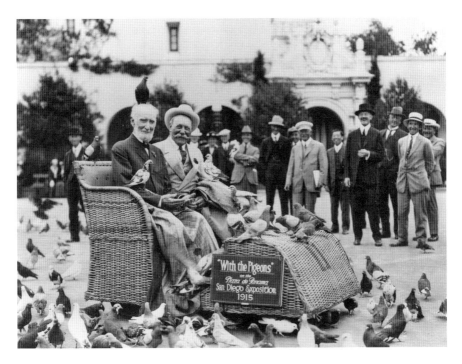

Former Speaker of the U.S. House of Representatives Joseph G. "Uncle Joe" Cannon and John D. Spreckels in an electriquette on the Plaza de Panama on June 1, 1915. *Panama-California Exposition Digital Archive.*

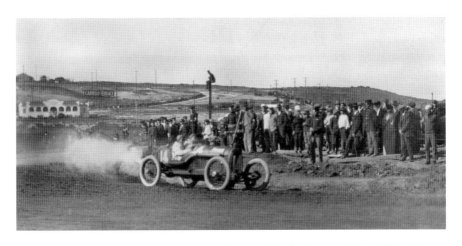

Road race on Point Loma. *Rosemary Ann Phelan Photo Collection, Panama-California Exposition Digital Archive.*

On Saturday, January 16, the Exposition celebrated Stockholders' Day and San Francisco Day, the latter to honor about 125 delegates from San Francisco's Panama-Pacific International Exposition. Merchants released employees and schools released pupils to greet the delegates. Total attendance came to 14,793.[9]

February was devoted to quelling rumors that the Exposition was about to close.[10] Attendance declined to 133,162,[11] but due to a reduction in expenses, the Exposition showed a net profit of $13,000.[12] During this period of gloom, a finance committee, chaired by Julius Wangenheim, got John D. Spreckels to sign a guarantee loan to the Exposition of $100,000. The money did not have to be used, as attendance picked up.[13]

To stimulate business, concessionaires on the Isthmus built a stage at the north end of the street and began offering free vaudeville shows.[14]

Visitors began coming by train[15] and on a Great Northern Pacific Steamship Company passenger steamer by way of the Panama Canal, but the rains continued.[16] A much ballyhooed "Straw Hat Day," scheduled for February 2,[17] was postponed to February 11, when the San Diego Consolidated Gas and Electric Company's whistle announced to all who could hear it that the sun was shining.[18]

The next striking event that month was a cavalry review on February 12, before Exposition president G. Aubrey Davidson on Park Avenue (Sixth Street), between Laurel and Upas Streets, outside the Exposition grounds. Sixteen platoons of First Cavalry awed spectators with a display of superb horseback riding.[19]

A two-day Chinese New Year celebration on February 13 and 14, arranged by Quon Mane, a leader of the local Chinese community, centered on the Isthmus, where a three-hundred-foot dragon with gleaming eyes and smoke pouring from its mouth made its way along the street as firecrackers exploded around it. About five hundred Americans of Chinese descent from San Diego, Los Angeles and San Francisco participated in the festivities.[20]

In honor of George Washington's birthday, the State of Washington held a potlatch in its building and gave away apples, cider and gingersnaps.[21] In the evening the Women's Board of the Exposition sponsored a two-hour dance in the Plaza de Panama. Couples danced to the music of the Exposition's Spanish band while spectators watched from the arcades.[22]

In March, attendance had grown to 153,042,[23] still below the January level, but the net profit had reached $24,467.97.[24] The increased attendance reflected the lowering of railroad rates from the East Coast, which went into effect after March 1.[25] A League for the Preservation of Exposition Buildings held its first

Balboa Park and the 1915 Exposition

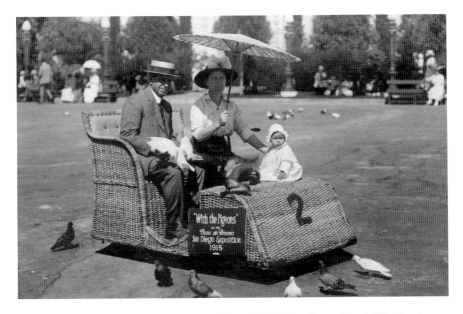

Handwritten on back of this postcard photo: "Aug. 9–1915. The day we heard 'Billy' Sunday preach. Aunt Esther from Marcus, Jean, and Marcia Elizabeth." *John Earl Collection, Panama-California Exposition Digital Archive.*

meeting March 9.[26] Dr. Edgar L. Hewett was already planning to perpetuate the anthropological exhibits in the buildings where they were located.[27]

W.C. Bobbs, president of Bobbs Merrill Publishing Company, suggested using buildings and grounds for an agricultural fair, a plan that was actually implemented from 1919 to 1930.[28]

The Tewa Indians, whom Dr. Hewett had brought to the Indian Arts Building from New Mexico in late February to give demonstrations of pottery making and blanket weaving, announced they could not live in the building and were allowed to join other Indians in the Indian Village/Painted Desert. They continued to give demonstrations in the Indian Arts Building.[29]

To take care of the six hundred acres of Balboa Park beautified for the Exposition, on March 23, citizens passed an amendment to raise their contribution to city parks from a minimum of five cents and a maximum of eight cents per $100 of assessed valuation to a minimum of eight cents and a maximum of twelve cents.[30]

On the afternoon of March 23, about twenty thousand people paid tribute to opera singer Madame Ernestine Schumann-Heink at the Organ Pavilion. Six thousand schoolchildren sang "America" for the diva, who sat

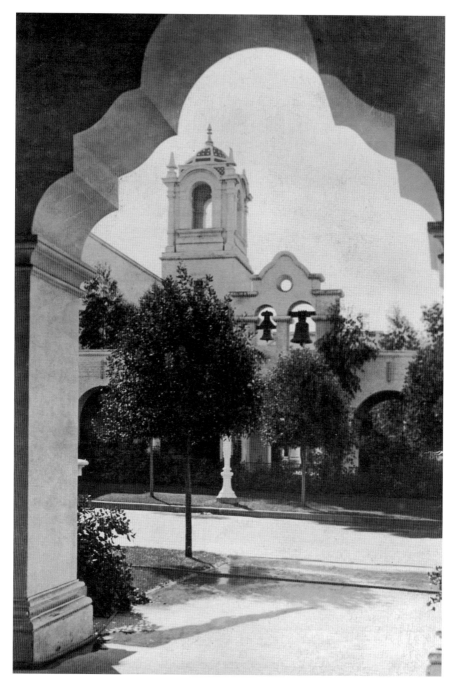

The mission bells of the Indian Arts Building as seen through the Moorish entrance to the Science and Education Building. *David Marshall Collection, Panama-California Exposition Digital Archive.*

in the audience. Mayor Charles F. O'Neall gave her an honorary citizenship award.[31] In return, Madame Schumann-Heink promised to give a free concert for schoolchildren in June.[32]

On March 28, vice president of the United States Thomas R. Marshall, Secretary of the Interior Franklin K. Lane and Assistant Secretary of the Navy Franklin D. Roosevelt reviewed troops of the First Cavalry on the Plaza de Panama.[33] The horses had their iron shoes filed to prevent damage to the pavement.[34] Roosevelt promised reporters San Diego would become a supply and liberty port for the U.S. Navy.[35]

The military provided the main interest in April with a sham battle on the fairgrounds on April 6 by cavalry and marines for Lubin movies,[36] a review at the cavalry camp on April 14 for Congressman William Kettner[37] and a cavalry review on the tractor field, west of the Alameda, on April 24.[38]

On April 4, Easter Sunday, some six hundred children hunted for about one thousand eggs hidden in the shrubbery, trees and grass of Pepper Grove.[39]

A relieved president Davidson reported on April 11 that the Exposition had made a profit of $40,000 during its first three months.[40]

A boisterous '49 Camp on the Isthmus threw open its log gates in April. Supposedly re-creating the lawless atmosphere of mining towns in California during the gold rush, the camp was crowded with patrons anxious to dance and to gamble with play money.[41] About twenty "ladies" in the camp danced and flirted with visitors.[42] Judging from the consternation the camp caused among "the pillars" of San Diego, the camp was the most popular attraction on the Isthmus, which is to say, the most popular attraction at the Exposition. A new dance hall, with fifteen thousand square feet of space, also opened on the Isthmus.[43]

Giuseppe Creatore and his band arrived on April 24 for a two-week engagement.[44] This was one of many bands to play on the grounds, a roster that included the Australian Boys Band,[45] the Pacific Electric Band,[46] the Ford Motor Band[47] and the Los Angeles Silver Star Band.[48] The Exposition also had four bands on loan from local military installations: the Thirteenth Artillery Corps Band, the Fourth Regiment Marine Band, the First Cavalry Band and a thirty-piece Spanish Band, whose cost was borne by the Exposition Entertainment Committee. Concessions, such as the Cristobal Café and Hawaiian Village, and dance halls on the Isthmus had their own orchestras.

In late April, Mrs. Uriel Sebree of the Women's Board started a day nursery behind the California Building, to care for babies and youngsters

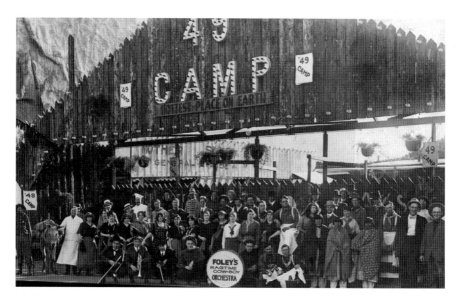

'49 Camp on the Isthmus. *David Marshall Collection, Panama-California Exposition Digital Archive.*

while their parents were enjoying the sights. She coaxed businesses and individuals in the city to donate portable houses and play equipment.[49] Before the year was over, more than nine hundred babies and children had been left in the nursery.[50]

Attendance in April came to 151,148, which did not seem enough to justify President Davidson's jubilant declarations.[51]

Early in May, Colonel Esteban Cantu managed to stifle independence-seeking factions in Baja California. He had gone from military chief to governor of the territory with the consent of newly inaugurated President Venustiano Carranza. While hostilities were not over in other parts of Mexico, they had ceased in Baja California, San Diego's neighbor to the south. Opposition to United States involvement in the European war was still strong in the country; however, sympathy with England, resentment of the German invasion of Belgium, the recurrence of German U-boat attacks on merchant ships and indications of German collusion with anti-American factions in Mexico seemed to bring American involvement in the European war closer.

On May 3, a troupe of Spanish musicians and dancers enlivened the plazas, patios and balconies of the Exposition.[52] Women in the troupe had a habit of addressing their most ardent love passages to modest-appearing

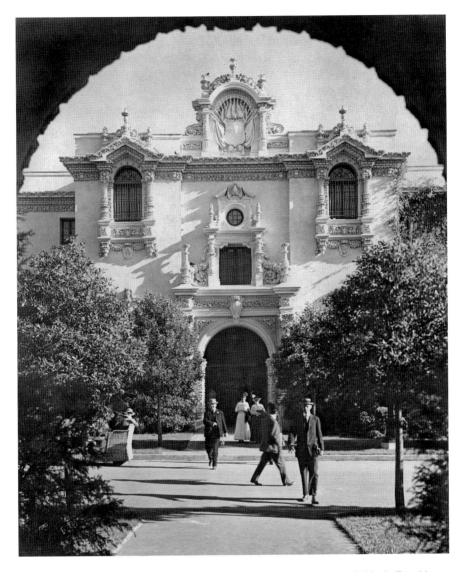

Entrance to the Foreign Arts Building. *David Marshall Collection, Panama-California Exposition Digital Archive.*

young men in the audience, to the mock consternation of the male guitarists who escorted them.[53]

Coast artillery companies from Fort Rosecrans and Marine Corps and Cavalry at the Exposition held a field meet on May 8 on the parade grounds of the marine encampment.[54] On May 22, the Ad Club of San

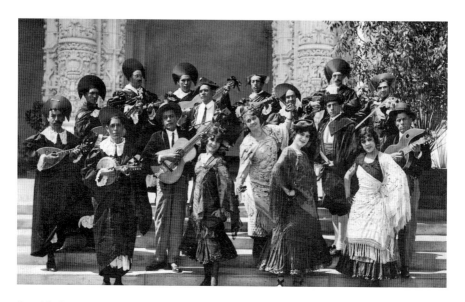

Spanish dancers and musicians at the Exposition. *Michael Kelly Collection, Panama-California Exposition Digital Archive.*

Diego sponsored a military-civilian parade from downtown San Diego to El Prado with Colonel Joseph H. Pendleton as field marshal.[55] That same day, two thousand delegates from Los Angeles rollicked on the Isthmus,[56] and thespians from the San Diego School of Expression enacted scenes from *Alcestis, Everyman, Romeo and Juliet* and *The Rivals* on the lawn south of Montezuma Garden.[57]

Jose Guadalupe Estudillo of San Jacinto was the Exposition's honored guest on May 26. He was a member of one of the oldest families in San Diego and had been president of the San Diego Board of Trustees on May 26, 1868, when the trustees set aside 1,400 acres of pueblo land as a park. Estudillo recalled he supported the proposal because he wanted to keep the land off the market.[58]

On Dedication Day, May 31, an athletic stadium, built with Exposition bond money, opened east of San Diego High School, outside the Exposition grounds. The stadium was commonly referred to as "Balboa Stadium," though its management was a source of cooperation and sometimes friction between the San Diego Board of Education and the San Diego Park Department. Some twenty thousand people took advantage of the free admission to watch a track and field program.[59]

About 179,440 people attended the fair in May.[60]

Gertrude Gilbert, chairperson of the Women's Music Committee, chose Mrs. J.L. Selby to sing "My Soul" and "One Hundred Years From Now" by Grossmont resident Carrie Jacobs Bond at the Organ Pavilion on June 2. Afterward, at a tea in the Women's Headquarters, Miss Bond sang "A Perfect Day," her best known composition.[61] A Men's Entertainment Committee organized a daytime military parade from Broadway to the Exposition and an evening outdoor ball in the Plaza de Panama in honor of Admiral Thomas Benton Howard, commander of the Pacific Fleet, June 8.[62] Teddy Tetzloff won a speed contest of fifty yards in eight seconds flat during a Maxwell car race on the tractor field on June 12.[63]

Acting on complaints from churchgoing people, District Attorney D.V. Mahoney arrested S.A. Burnside, manager of the '49 Camp, on June 17 for conducting a gambling operation.[64] That same day, three hundred marines from the Twenty-fifth, Twenty-sixth and Twenty-eighth Companies of the Second Battalion, Fourth Regiment, left the Exposition on the cruiser USS *Colorado* for Guaymas, Mexico. Their mission was to persuade Yaqui Indians to stop molesting Americans. The Twenty-seventh Company stayed at the Exposition.[65]

Composer Mrs. H.H.A. Beach of Boston, guest of Gertrude Gilbert, listened to Mrs. L.L. Rowan of San Diego sing her songs "Dearie" and "Ecstasy" at the Organ Pavilion on June 28. Later at the Women's Headquarters, Mrs. Rowan sang "Oh, Were My Love" and "The Years at the Spring," also by Mrs. Beach.[66]

The biggest event in June occurred at the Organ Pavilion on the evening of June 23. Madame Schumann-Heink, a Grossmont resident and San Diego booster, sang before more than twenty thousand people. At her request, children under sixteen were admitted free to the grounds. This kindly woman radiated happiness and tenderness. Nowhere did she show this faculty better than at her Balboa Park performances. Her selections included folk songs for children and art songs for adults. A reporter for the *San Diego Union* liked the intensity and dignity with which she sang "Heimweh" ("Longing for Home") by Hugo Wolf and the humor she introduced into an anonymous ballad, "Spinnerliedchen," about a girl who would spin only to catch a lover. The gracious singer said the thundering applause was "positively the greatest tribute I have ever received in my life."[67]

About 166,135 people visited the Exposition in June.[68]

In July, the Exposition took off. Some 61,414 people visited the fair during a three-day Independence celebration on July 3, 4 and 5. Tiny Broadwick leaped from an airplane at an altitude of three thousand feet on

Child's annual pass belonging to Sam Hamill. Years later, as an architect, Hamill redesigned the Foreign Arts Building as the House of Hospitality (now reconstructed) for the 1935 exposition. *Courtesy Robert Serrano.*

all three days, fireworks exploded above the grounds every afternoon and evening and children marched in a "Spirit of '76" parade on the afternoon of July 5.[69]

A summer school opened at the Exposition on July 5 and ran to August 13.[70] Dr. Edgar L. Hewett lectured on archaeology, John Harrington spoke on linguistics, William T. Skilling talked on agriculture and Dr. F.A. Martin described the history and geography of Central and South America. The lecturers used scientific and anthropological exhibits in the buildings and horticultural and agricultural displays on the grounds. The Andrew Carnegie

Endowment for International Peace underwrote lectures on Central and South America and lectures on current international problems. Students paid $7.50 for the term, which included admission to the Exposition.[71]

The Brazilian exhibit, put together by commercial interests at the instigation of Dr. Eugenio Dahne, opened July 6 in the Commerce and Industries Building. More people visited this exhibit than any of the other commercial exhibits. Staff workers decorated a two-story native house of a rubber gatherer in the Amazon with heads and skins of Brazilian deer, wild boar, jaguar, wild cat, otter, sloth, stuffed monkeys, birds and other animals and with collections of Indian bows, arrows, clubs and lances. Waitresses served visitors free coffee, made from freshly roasted beans, and mate, made from the leaves of a tree. Waitresses also sold chocolate, cigars, cocoa, guarana, manioc flour, nuts, rubber, tobacco and woods but did not give away samples.[72]

Coloratura Ellen Beach Yaw sang at the Organ Pavilion on July 3 and July 24;[73] lyric soprano Marcella Craft sang on July 14;[74] and baritone James Hugh Allen sang on July 30.[75] Tsianina Redfeather Blackstone, of Cherokee-Creek extraction, sang songs by her accompanist, Charles Wakefield Cadman, including "I Hear a Thrust at Eve" and "The Land of the Sky Blue Water," at the Organ Pavilion on July 6.[76] Dr. Hewett stopped by to invite Tsianina to see the Indian exhibits. He confided to her his feeling toward Indians, saying, "My mother made me promise her when I grew to manhood, I would give all my efforts towards doing something for the American Indian that would let the world see him as he is, and not as the wild-west shows, cheap fiction and moving pictures present him."[77]

To make sure July had enough melody, the Yuma Indian Band gave concerts on the Plaza de Panama in the afternoon and on the Isthmus in the evening of July 18,[78] and the two-hundred-voice Mormon Tabernacle Choir, from Ogden, Utah, gave three free concerts at the Organ Pavilion on July 16, 17 and 18. The choir endeared itself to the audience by singing the popular "I Love You California."[79]

On Education Day, July 12, Maria Montessori, educator and physician from Rome, Italy, and P.P. Claxton, United States commissioner of education, spoke at the conclusion of Dr. Humphrey Stewart's daily organ recital. Madame Montessori described in Italian her theory that children should direct their own education while an interpreter translated her words. She spoke with the enthusiasm of a believer. In a calmer manner, Claxton said children should get a sound education so they might someday earn a good living.[80]

More than seven thousand Elks visited the Exposition on July 16. An Elks drill team won a prize on the Plaza de Panama in the afternoon.[81] Spurred on by high spirits, the Elks inundated the Isthmus in the evening, barking for concessionaires and throwing serpentine at one another.[82]

William Jennings Bryan, the "Great Commoner," spoke on "The Causeless War" at the Organ Pavilion on July 17, a speech he had already given at the Panama-Pacific Exposition in San Francisco on July 4 and was to repeat many times thereafter. His audience included members of the Royal Order of Moose, in San Diego for a two-week's convention.[83] Bryan had resigned as secretary of state on June 8 because he feared President Woodrow Wilson was leading the United States closer to war with Germany. Bryan was no longer the brilliant orator of the "Cross of Gold" speech at the Democratic convention of 1896. Slightly stooped with thinning hair, jowls and a broad girth, he had what one observer called "a frossy look."[84] Nevertheless, he could still hold an audience by his pose of lofty idealism and his frequent allusions to the Bible and the Prince of Peace. By listening to him, the sanctimonious became even more sanctimonious. Arguing for neutrality and against commitment to either

View to the south from a vine-covered pergola south of the Montezuma Garden. *David Marshall Collection, Panama-California Exposition Digital Archive.*

side, he said, "They are fighting over questions which do not affect our welfare or destiny…An American must have more interest in one of the belligerents than he has in the United States if he desires to see us dragged into the conflict as the ally or opponent of either side."[85] Ironically, like Theodore Roosevelt and President Woodrow Wilson, he advocated, but did not address in his Balboa Park speech, many populist or Progressive programs, such as workers' rights, women's suffrage and direct election of senators, though, at the same time, he was more prescient and radical than the other two. He proposed nationalization of the railroads, formation of an international peacekeeping authority and prohibition. When the U.S. Congress declared war on April 4, 1917, Bryan abandoned his pacifist stance and became a staunch supporter of the war effort.

Evoking the wrath of patrons, District Attorney Spencer Marsh, on July 17, closed the bank for sale of scrip at the '49 Camp, effectively shutting down the gaming tables and roulette wheel.[86]

Taos Indians from the Indian Village stole motion pictures of sacred festivals from the New Mexico Building on July 24. They believed their showing to be contrary to the laws of their tribe. The note the Indians left read: "Bad mediceen—indians have bad luck—all sick. Pichers of race must burn—indians all get well."[87]

Former colonel and president Theodore Roosevelt, the man who made the Panama Canal possible, spoke at the Organ Pavilion on the evening of July 27. He scored talkers of peace, opposed international arbitration and advocated a standing army of 200,000. While Roosevelt could on occasion be specific, most of his speeches dealt in generalities and were profuse with moral and patriotic platitudes. It was difficult to pin him down, as one member of the audience found out when he inquired, "Do you believe in war with Mexico?" It was a subject of concern in San Diego and the Southwest, though not so pressing at the time as the possibility of war with Germany, in response to the May 9, 1915 German U-Boat sinking of the *Lusitania*, an unarmed British merchant ship containing 128 American citizens, and to more recent attacks on U.S. merchant ships. Internecine strife was going on in Mexico at the time between the Constitutionalist forces of Carranza/Obregon and the Conventionist forces of Villa/Zapata and Pancho Villa.

Departing from his prepared speech, Roosevelt answered his interlocutor, "I believe in enforcing peace with Mexico. I believe in doing what we did in Cuba. I believe it is our duty to make peace in Mexico and leave that nation as prosperous as we have made Cuba."[88] His reply was more like a circumlocution than an answer to the question.

Aside from his blustering character, elaborate gestures, high-pitched voice, staccato outbursts and display of firmly set teeth—a cartoonist's delight—what the audience liked most about Roosevelt were his "Rooseveltisms," such as the following regarding the United States' problems with Mexico: "A man said to his assistant, 'You have stepped on my feet, you have tweaked me by the nose, you have spit in my face. Beware, do not go too far, lest you raise the lion in me.'"[89]

He was the most popular speaker at the Exposition. It was said of Roosevelt that he was so charming that he had audiences on his side before he opened his mouth. As adept as Bryan in finding biblical parallels, the God he cited was the God of Battles rather than the God of Peace. Like Bryan, he urged San Diego to keep the Exposition going for another year, adding, "I feel you are doing an immense amount from an educational standpoint for the United States in the way you are developing the old California architecture and the architecture of the Presidio, and I want especially to congratulate New Mexico on having adopted and developed the American form of architecture."[90]

Roosevelt greeted many Indians at the Indian Village/Painted Desert compound whom he knew personally and had special words of praise for "Theodore Roosevelt Trujillo," a newly arrived baby the Indians had named after their former "Great White Father."[91]

The first battleship squadron, composed of the USS *Missouri*, *Ohio* and *Wisconsin*, entered San Diego Harbor on the morning of July 28, with 850 Annapolis midshipmen on board.[92] That same morning, two battalions of midshipmen passed in review before Colonel Roosevelt in the Plaza de Panama. Exposition directors held a ball in the Plaza de Panama in the evening at which the middies made up part of the one thousand spectators who looked on and the five hundred couples who danced on the Plaza.[93]

The month ended with the celebration of Japanese Day on July 30. A committee of one hundred Japanese Americans decorated buildings and grounds with about ten thousand Japanese lanterns. In the morning, two Japanese aviators flew over the grounds, dropping Japanese coins wrapped in tissue paper. In the afternoon, Japanese athletes engaged in a tug-of-war, a lantern race, a spoon and chopstick race and a fencing battle-royal in the Plaza de Panama. In the evening, Japanese Americans, carrying lanterns and dressed in native and modern garb, paraded across Cabrillo Bridge to the tractor field.[94] At a banquet in Café Cristobal, G. Yusa, president of the Japanese Association of Southern California, told the Caucasians there assembled, "No matter what criticism may be made, no matter what

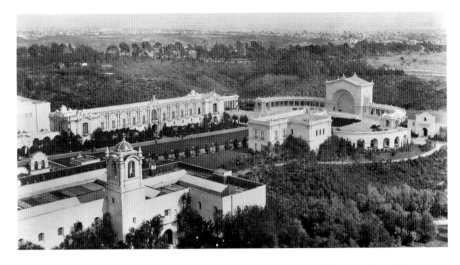

View from the tower of the California Building. *Clockwise from top left*: a portion of the Foreign Arts Building, San Joaquin Valley Counties Building, Salt Lake and Union Pacific Railways, Spreckels Organ Pavilion, Alameda and Santa Clara Counties Building, a curved arcade, Kern and Tulare Counties Building and Indian Arts (Arts and Crafts) Building. *Panama-California Exposition Digital Archive.*

racial prejudice may exist, no matter what anti-alien law may be passed by the crooked politicians, no matter what color of hair, skin or eyes, we are just as loyal to this country and just as sincere boosters of Southern California as you gentlemen."[95]

About 301,937 persons attended the Exposition in July.[96]

While no national figure of the stature of Bryan and Roosevelt visited the Exposition in August, several attractions kept attendance high. H.O. Davis resigned as director-general on August 1. E.J. Chapin, who had been director of exhibits, succeeded him.[97] On the evening of August 3, the 146-member Chicago Haydn Society sang at the Organ Pavilion.[98] W. Seymour, a critic for the *San Diego Union*, complained that the sounds of electriquettes, children and babies prevented him from hearing the *pianissimo* passages.[99]

For three days from August 5 to August 7, Russian actress Alia Nazimova headed the cast in a production of *War Brides*, by Marion Craig Wentworth, at the Organ Pavilion, a devastating drama of the agony suffered by women during war.[100]

The Ford Motor Band, consisting of fifty pieces and fifty-four performers, who were electricians, upholsterers, mechanics and clerks as well as musicians, gave two concerts at the Organ Pavilion on August 8 and 9. They played a march called "The Ford" by Sickel at both concerts. The *San Diego Union*

described the music as "the popular sort that sets feet to patting and making people declare, 'You, old world, are not so bad after all.'"[101]

Ex–baseball player and evangelist Billy Sunday writhed, twisted, jumped, perspired, scolded, howled and entertained at the Organ Pavilion on August 9.[102] While his faith in Jesus was undoubtedly sincere, he spoke, in the lingo of a former star player for the Chicago White Sox, of stealing home for the Lord. His folksy manner and moments of self-mockery—"I am a hayseed of the hayseeds…and I expect to go to heaven just the same"—struck a chord with unlettered, less sophisticated members of his audience.[103]

On August 10, three companies of the Second Battalion, Fourth Regiment, U.S. Marines, returned to the fair from the west coast of Mexico on the USS *Colorado* after it had been determined a landing would not be necessary.[104]

Aviator Art Smith performed loop-the-loops over the tractor field on August 11 and 12.[105]

Troops B and M of the First Cavalry, U.S. Army, under the command of Captain George Van Horn Moseley, departed for Calexico on August 20 to discourage depredations along the border by followers of Pancho Villa. Troops A and D, left in Balboa Park, continued their parade, drill and concert duties for the Exposition.[106]

Indians from the Pala and Rincon reservations set up camp on the tractor field for five days beginning on August 25.[107] They were there supposedly to celebrate the Fiesta of San Luis Rey. A *San Diego Union* reporter referred to San Luis Rey as "a Spanish padre of the old Mission days,"[108] a designation Saint Louis IX, king of France, might have found disconcerting. On the first day of their encampment, the Indians attended an outdoor mass, composed by Exposition organist Dr. Stewart and sung by the clergy and choir of St. Joseph's Church of San Diego.[109] For the rest of their time, they played peon for prizes donated by the Exposition management, took part in war dances and engaged in foot races.[110] Five Indian policemen, two Exposition guards, a government special officer and Father George Boyle, the reservation chaplain, kept watch over the Indians.[111]

Social critic and historian Matthew F. Bokovoy signaled out "Indian Night," August 29, for special mention. The mixture of Kumeyaay Indians—Indians from the tribes of Arizona and New Mexico—and white tourists, who were asked to wear what they considered to be Indian garb and to dance with the Indians, seemed to Bokovoy to suggest an epiphany in which nobody was inferior or superior and everyone lived, for the moment at least, on an exalted plane of understanding.[112] In the spirit of Ulysses's remark in Act III, Scene 3 of William Shakespeare's *Troilus and*

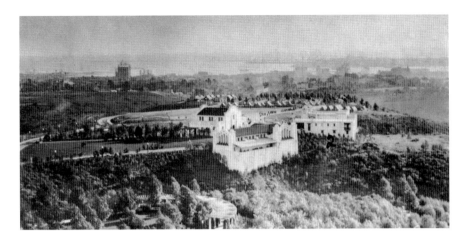

Tents of marine encampment lie just beyond State Buildings: Washington (near), New Mexico (right) and Montana (left). Note curved pergola in foreground. *Rosemary Ann Phelan Photo Collection, Panama-California Exposition Digital Archive.*

Cressida, "One touch of nature makes the whole world ken," he found the celebration to be a revelation of common humanity.

Spanish tenor Florencio Constantino sang before an audience of five thousand at the Organ Pavilion on August 25.[113] He included old Basque songs in his recital because, he said, they had been sung by Spanish missionaries. Constantino achieved a success at the Exposition second only to San Diego's most loved singer, Schumann-Heink. Writing for the *San Diego Union*, music critic W.B. Seymour resorted to hyperbole when he said, "Of Constantino's voice, it is almost needless to speak. The sweetness of his tones, his wonderful breath control, his remarkable phrasing, his dramatic interpretations, and his clean-cut enunciation have been praised for years by authorities in matters musical. Although few of his hearers understood what the singer was singing, they could not fail to be charmed by his voice, his artistry and his personality."[114]

Singing in the open air and without amplification, Constantino remarked after the concert, "I missed what you call acoustics at first. Everything is far away and no come back like in a building."

Attendance at the fair in August came to 229,604 people.[115]

September began with a three-day celebration on September 4, 5 and 6 in honor of Labor Day.[116] Scheduled events included an electriquette costume parade,[117] competitive drills by the Fraternal Brotherhood on the Plaza de Panama, a concert by the Hampton Institute Negro quartet and double parachute jumps by Tiny Broadwick.[118]

Balboa Park and the 1915 Exposition

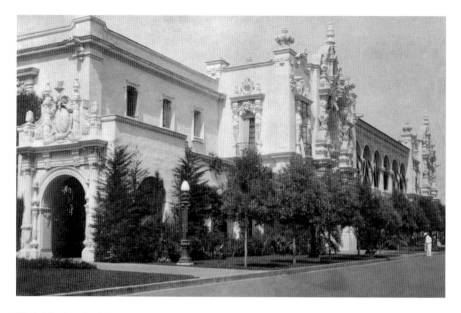

Varied Industries Building. Photo by Oakes. *Rosemary Ann Phelan Photo Collection, Panama-California Exposition Digital Archive.*

An observance of the sixty-fifth anniversary of California's Admission Day took place on September 9.[119] In the morning, a great parade with floats depicting periods of California history wound its way from Broadway to the Plaza de Panama.[120] Chief Iodine, eighty-nine years old and a former scout of John C. Fremont, rode a bronco at the head of the parade. Gold rush prospectors N.E. Gilson, Silas St. Johns and Amos Weed rode in an old Wells Fargo Express Company stagecoach.[121] A gymkhana at the tractor field in the afternoon consisted of potato, sack, umbrella, egg, animal and shoe races.[122] An outdoor ball at the Plaza de Panama in the evening concluded the day's celebration.[123]

On Movie Day on September 10, silent film stars Francis X. Bushman and Beverly Bayne, as king and queen, participated in a parade along El Prado, a coronation at the Organ Pavilion, a dinner at the Cristobal and an open-air ball in the Plaza de Panama.[124]

Major General George W. Goethals gave talks describing the construction of the Panama Canal on September 13, one to children at the Panama Canal concession in the afternoon and another later in the day at the Organ Pavilion.[125] In honor of General Goethals's engineering achievement, Exposition managers allowed children to attend his talk without paying admission.[126]

Former president William Howard Taft—all three hundred plus pounds of him—spoke to 7,189 people at the Organ Pavilion on September 16. With 18,870 for Theodore Roosevelt and 18,264 for Bryan, Taft came in third in the contest for listeners.[127] He praised the Spanish architecture and favored keeping treaty obligations and creating an international congress. His program was similar to Roosevelt's, but he presented it with more dignity and less exuberance.[128] Taft was considered "stuffy" as a speaker, unlike the polished Bryan and the effervescent Roosevelt.[129] A lawyer and judge, he also tended to be more conservative than Roosevelt, Bryan or Wilson. A lover of precedent and a believer in property rights and the necessity of large corporations, his tendency was to see both sides of an issue and to procrastinate at a time when quick decisions were required. He had a loud guffaw and often laughed and belittled himself, certainly not characteristics of the self-righteous Bryan or the self-assured Roosevelt. Here is how Taft described his two adversaries:

> *I do not agree with Mr. Bryan in his view that we should not have any preparation. It seems to me that we have a great civilization here that is far forward in the ranks of Christianity——that we are trustees for that civilization that has been handed to us and that it is our duty to take such steps as shall protect it from danger or destruction.*
>
> *Mr. Roosevelt, on the other hand, is strictly in favor of defense. I do not know whether he agrees with me as to the amount needed or not. I differ with Mr. Roosevelt in his attitude toward the desirability of making treaties. Mr. Roosevelt seems to think that every person who defends the treaties of peace in some way or another has a personal fear of war and he indulges in that kind of argument that does not make any progress in convincing the person to whom it is addressed because it ventures to impeach either his motives or his judgment.*[130]

Marines jousted in afternoon field events on Marine Day on September 18 and danced in the evening at an open-air ball.[131] Also on September 18, announcing plans to preserve "temporary" Exposition buildings to house exhibits, the San Diego Museum Association filed articles of incorporation. George W. Marston was elected president of the association.[132]

Exposition officials pulled out all stops for motion-picture producer Sigmund Lubin on September 24.[133] They escorted him through the grounds and entertained him at a banquet in the Cristobal. He responded, as his hosts hoped he would, by promising to locate a studio in the city.[134]

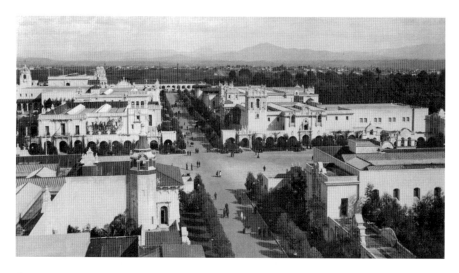

Overview of Exposition from tower of California Building. Photo by Oakes. *David Marshall Collection, Panama-California Exposition Digital Archive.*

New Mexico contralto Claudia Albright charmed an audience at the Organ Pavilion on September 30 with selections in English, German, French and Italian.[135]

Approximately 170,074 people visited the fair in September.[136]

On October 2, Reverend E.L. Lowe married Alice C. Hoffman and Clifford A Sheller at the top of the Ferris wheel on the Isthmus.[137] No connection supposedly existed between this event and the observance of Bible Day at the Organ Pavilion on the same day.[138]

On Invalids' Day on October 14, volunteers drove automobiles loaded with the disabled into the Exposition, where they watched marines drill on the parade grounds, applauded a concert at the Organ Pavilion and enjoyed attractions at the Indian Village.[139]

Civilian packers attached to the First Cavalry showed visiting members of the American Railway Association how fast they could pack and unpack mules on October 15.[140]

Momentum to continue the Exposition increased. On October 14, Mayor Edwin M. Capps announced his support. Businesspeople in Los Angeles began a campaign for $75,000 in cash and $75,000 in guaranty pledges to make a second year possible.[141]

Mayor Capps, on October 16, said he wanted to put an army-navy school on forty acres of Balboa Park.[142]

A chorus of more than one hundred voices sang a solemn high mass in D minor, composed by Dr. Stewart, at the Organ Pavilion on Catholic Day on October 24. A company of U.S. Marines, two thousand lay members, fifty-six altar boys and twenty-five clergymen participated in the mass.[143]

In the afternoon, Father James A. Callahan of Our Lady of Angels Church in Los Angeles baptized "Theodore Roosevelt" and "San Diego," newly arrived babies at the Indian Village/Painted Desert.[144]

The most exciting day of this particular month was October 29, when inventor Thomas A. Edison, in his sixty-eighth year, and automobile manufacturer Henry Ford, in his fifty-second year, visited the fair together.[145] Edison was in favor of and Ford against national preparedness for war.[146] When the automobile bearing the pair entered the Plaza de Panama, about twelve thousand schoolchildren buried Edison in flowers. Edison declined comments to the press, except to say, "I'm solid for children." Ford, on the other hand, was effusive in his comments against war.[147]

The visitor counts in October reached 133,000.[148]

The red-jacketed, plaid-skirted Kilties Band performed Scottish songs, highland flings, Irish jigs, operatic selections, waltzes, sentimental solos and patriotic medleys from October 23 to November 6.[149] Overcome

One of three faun fountains outside the Science and Education Building. *David Marshall Collection, Panama-California Exposition Digital Archive.*

with admiration, a *San Diego Union* reporter wrote, "No musical event at the Exposition has afforded more pleasure…than the concerts given…by this organization."[150] Tenor Florencio Constantino returned to sing at the Organ Pavilion on November 11. As amplification had not been introduced, a strong breeze blowing in the wrong direction prevented an estimated ten thousand people at the Pavilion from hearing *pianissimo* passages.[151]

To arouse interest in the Exposition and to prove San Diego should become the terminus of a southern national highway, a cross-country automobile tour left San Diego on November 2.[152] The caravan journeyed on the newly built plank road over the sand hills of Imperial County and across the bridge at Yuma. It arrived in Washington, D.C., twenty-three and a half days later.[153]

On November 4, a stunt man on the Isthmus thrilled onlookers by leaping from a bicycle at a great height into a tank of water and then into a tank of flaming gasoline.[154]

Schoolchildren prepared 2,700 exhibits of afterschool work for display on November 11, 12 and 13 in the public service hall of the Commerce and Industries Building. Exhibits included pet animals, models of vessels, an electric theater and miniature automobiles and airplanes.[155]

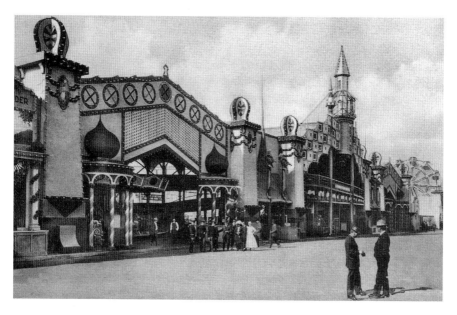

Thompson's Scenic Railway on the Isthmus. Ferris wheel at right. *Rosemary Ann Phelan Photo Collection, Panama-California Exposition Digital Archive.*

Balboa Park and the 1915 Exposition

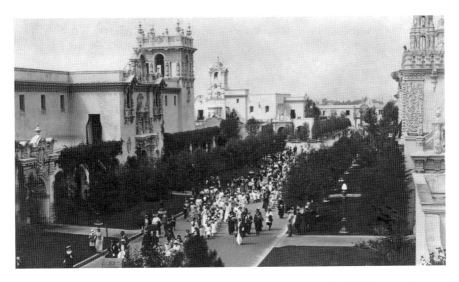

Children's Day, November 12, 1915. *Michael Kelly Collection, Panama-California Exposition Digital Archive.*

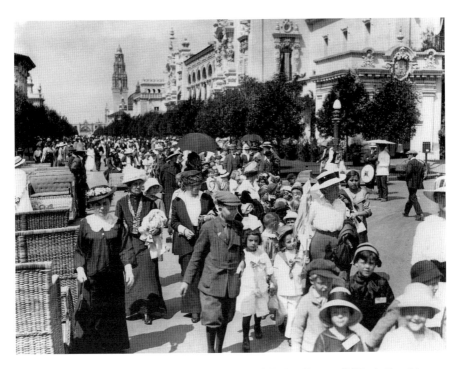

Children's Day, November 12, 1915. *David Marshall Collection, Panama-California Exposition Digital Archive.*

Schoolchildren rode electriquettes and depicted fairies, flowers and flies during a pageant on the Plaza de Panama on Children's Day on November 12.[156]

The Liberty Bell from Philadelphia arrived at the Santa Fe Depot on the afternoon of November 12. A combined civilian/military escort loaded it on a special car and took it to the Exposition. A platform had been set up to receive it in the Plaza de Panama. The precious relic stayed there until the afternoon of November 14.[157] Bells and whistles sounding over the city at 8:30 a.m. on November 13 signaled the start of the official reception. Between 1:00 and 2:00 p.m., twelve thousand schoolchildren, admitted to the grounds free, placed floral tributes on the platform. At 2:00 p.m., George W. Marston introduced Mayor Capps and dignitaries from Pennsylvania—the Liberty Bell's home state—who spoke in praise of liberty. The San Diego Choral Society concluded the program by singing patriotic songs.[158]

San Diego Day, November 17, brought forth an outpouring of civic spirit.[159] The day began with an organ recital by Dr. Stewart, followed by a parade of decorated automobiles from the north gate to the Plaza

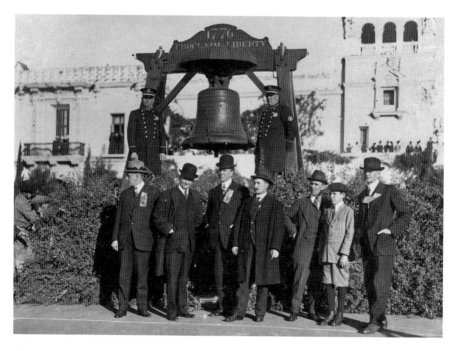

Exposition president G. Aubrey Davidson is the tall man standing directly under the Liberty Bell at the Plaza de Panama on November 13, 1915. *Panama-California Exposition Digital Archive.*

Nevada State Building. *Rosemary Ann Phelan Photo Collection, Panama-California Exposition Digital Archive.*

de Panama. Bands representing East San Diego, the Thirteenth Coast Artillery Corps and the Fourth Regiment, U.S. Marine Corps, performed in the Plaza de Panama and at other locations. The Modern Woodmen of America executed special drills, and gymnasts from the Young Men's Christian Association and the Turnverein of Southern California exercised on the parallel bar and skipped rope in the Plaza de Panama. Amateur teams played baseball on the diamond at the marine camp, and the Raja Yoga orchestra and chorus performed at the Organ Pavilion. To amuse children who might find the parade, sports and concerts too "adult," the Exposition sponsored potato and sack races, pie-eating contests and other games at the Isthmus.[160]

At the Organ Pavilion in the evening, Justice J. Edward Keating concluded a mock Spanish wedding by proclaiming that youngsters Manuel Madriguel and Maria Concepcion Gonzalez were husband and wife.[161] Some nine hundred people ate homegrown produce and danced at the Cristobal Café, the largest gathering since New Year's Eve. A masked ball on the Isthmus brought the day's events to a rousing close. According to a turnstile count, 16,746 people paid to enjoy or participate in the day's activities.[162]

The city allowed the '49 Camp to reopen on November 18. Sheriff Conklin was to keep careful watch to see that the games complied with state laws forbidding gambling for money.[163]

Aviatrix Katherine Stinson did the loop-the-loop over the Isthmus eight times from a 1,500-foot altitude while raining rosebuds upon spectators on the afternoon of November 20.[164]

The tally of visitors to the Exposition in November came to 149,066.[165] This was not the case in December, which was so slow that newspapers neglected to report the month's attendance. Officials were preoccupied with preparations for the Panama-California International Exposition, which was to open symbolically on January 1, 1916.[166]

Music programs consisted of a band concert at 1:30 p.m., followed by an organ recital at 2:45 p.m.

Some events did take place, if for no other reason than to support the claim that San Diego had held the first year-round Exposition. The board of directors allowed children in free on the afternoon of December 2 and everybody in for free in the evening. A Yama-Yama costume parade, the playing of music by a twenty-piece band and outdoor dancing on the Isthmus attracted tourists and those San Diegans who had not become surfeited with Exposition thrills.[167]

The San Diego Floral Association conducted tours of the grounds on December 4. The formal rose garden on the west side of the Cabrillo Bridge and the canna fields behind the California Building were in gorgeous bloom.[168]

Bowing to the demands of war hawks such as Theodore Roosevelt, and over the protests of William Jennings Bryan, on December 7, President Wilson asked Congress for a standing army of 142,000 and a reserve of 400,000. Even with these accretions, the nation was lamentably unprepared for war. Also on December 7, John Campbell Hamilton-Gordon, the Seventh Earl of Aberdeen, described his experiences as viceroy of Ireland from 1905 to 1915 in the Commerce and Industries Building. His wife, Lady Aberdeen, also spoke on "The Triumph of Civic Awakening." Admission to the talks cost fifty cents, with proceeds going to Irish relief.[169]

President G. Aubrey Davidson informed the chamber of commerce on December 14 that the continuation of the Exposition was not his doing.[170] Julius Wangenheim later confirmed this statement.[171] Since repeating the Exposition was too much for most of the 1915 Board of Directors, they resigned.

Promises of financial aid from Los Angeles businesspeople; railroad company executives; Harrison Gray Otis, owner of the *Los Angeles Times*; Guy Barham, owner of the *Los Angeles Herald*; newspaper owner William Randolph Hearst; and chamber of commerce officials outside San Diego

Balboa Park and the 1915 Exposition

Children on the Plaza de Panama. *Michael Kelly Collection, Panama-California Exposition Digital Archive.*

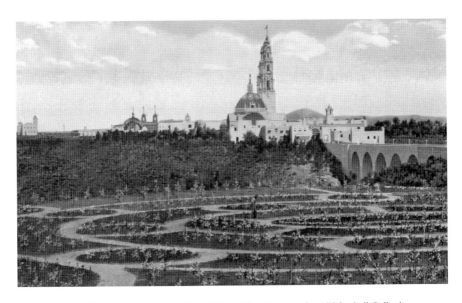

Rose garden in foreground on west side of Cabrillo Canyon. *David Marshall Collection, Panama-California Exposition Digital Archive.*

convinced Davidson to change his mind.[172] With support from Mayor Capps, Louis J. Wilde, Carl H. Heilbron and George Burnham, Davidson supervised the transforming of the Panama-California Exposition Corporation into the Panama-California International Exposition Corporation.[173]

The exact financing of the 1916 Exposition is unclear, as an outside consultant was not hired to examine the books at the end of 1916, newspaper reports were inaccurate and Exposition president Davidson and Exposition Secretary Penfold gave different figures.[174]

As near as can be determined, Los Angeles subscribers gave $75,000 and a like sum in a guarantee fund to meet deficits.[175] San Diego subscribers pledged $50,000.00.[176] Audit books ending March 31, 1917, state $43,256.50 was received from the Los Angeles guaranty fund.[177] The City of San Diego made no special contribution to the 1916 Exposition other than covering some fire, police, water, lighting and street maintenance costs, for which it expected to be reimbursed.[178] The State of California approved transferring $50,000.00 out of surplus Panama-Pacific International Exposition funds to maintain the California Building.[179] Congressman Kettner persuaded the U.S. Congress to give the 1916 Exposition $76,000.00, the government's unexpended balance from the Panama-Pacific International Exposition.[180]

Letters of intent to incorporate the Panama-California International Exposition were filed on December 22,[181] and the state issued a new charter on December 27.[182] The newly constituted Board of Exposition Directors, consisting of nine directors from Los Angeles, one from Riverside, two from Coronado and nineteen from San Diego, elected Davidson president on December 28.[183]

While the board was being set up, Davidson and his aides were persuading exhibitors at the San Francisco Fair and the U.S. government to transfer or install new exhibits at San Diego. Canada, Italy, the Netherlands, Russia and Germany agreed to come to San Diego, and the U.S. government agreed to take over the Sacramento Valley Building and erect a building for the Bureau of Fisheries at the south end of the Isthmus.[184]

At an Exposition stockholders' meeting on December 20, stockholders voted to convey the Exposition grounds and buildings to the City of San Diego. By this action, the city became the holding company and the new Exposition Corporation the operating company of the 1916 Exposition.[185]

As about $200,000 in unpaid subscriptions for the 1915 Exposition were outstanding, Attorney Lane Webber, acting on the direction of C.H. Tingey, auditor of the Exposition, sued in the District Court to collect the delinquent

Congressman William Kettner (standing). Mrs. Kettner seated in electriquette with General Black and pigeons at the Exposition, 1915. *David Marshall Collection, Panama-California Exposition Digital Archive.*

payments.[186] Stockholders who honored their pledges received no return on their investments, as whatever surplus was left at the close of 1915 was turned over to the 1916 Exposition. The 1915 stockholders expressed a hope that 1916 stockholders would give them free family tickets.[187] Newspapers do not show if the request was granted.

Responding to a petition from George W. Marston, the Board of Park Commissioners, on December 21, agreed to set aside the Science of Man Building for the San Diego Museum Association to use during 1916 and the California and Fine Arts Buildings for the association to use after 1916.[188]

Under the presidency of Mrs. Ivor N. Lawson, the Women's Board of the Exposition had coordinated the many activities of the Exposition in 1915. Mrs. George McKenzie, who supervised afternoon teas, and Mrs. Jarvis Doyle, who managed the house committee, helped to reinforce the Exposition's warm and caring atmosphere.[189]

To climax their year of events, the Women's Board prepared a gala December 25 Christmas party.[190] Working alongside the women, the Shriners

Alhambra Cafeteria and War of the Worlds exhibit at the southern end of the Isthmus. *Rosemary Ann Phelan Photo Collection, Panama-California Exposition Digital Archive.*

from the Al Bahr shrine set up a sixty-foot pine from Cuyamaca in front of the organ and hung hundreds of stockings stuffed with candy and toys on its branches.[191] On Christmas morning, the Shriners gave the stockings to 4,500 children and then took them to see the War of the Worlds show on the Isthmus and Indian Village.[192]

In the afternoon, Dr. Stewart played Christmas music on the organ. In the evening, three vested choirs sang carols from the balconies of the Home Economy, Science of Man and Indian Arts Buildings on the Plaza de Panama. Afterward, they gathered on the steps of the Sacramento Valley Building and, carrying lighted tapers, went to the organ, where they continued their program.[193] The event marked the first citywide Christmas celebration in San Diego since pioneer Mexican settlers in Old Town performed *La Pastorela*.[194]

December 31, the last day of the Panama-California Exposition, began with a combined review of officers and men of the Second Battalion, Fourth Regiment, U.S. Marines; the First Cavalry; and the Coast Artillery held in the Plaza de Panama. Concessionaires on the Isthmus allowed everyone free entrance to rides and shows. They arranged for the newsboys of San Diego to box on the bandstand in the evening. After the bouts, the Rosette Mexican Quintet and the Coast Artillery Band provided music for outdoor dancing. At the Cristobal Café, a follies' girl show and Asian dancers gave

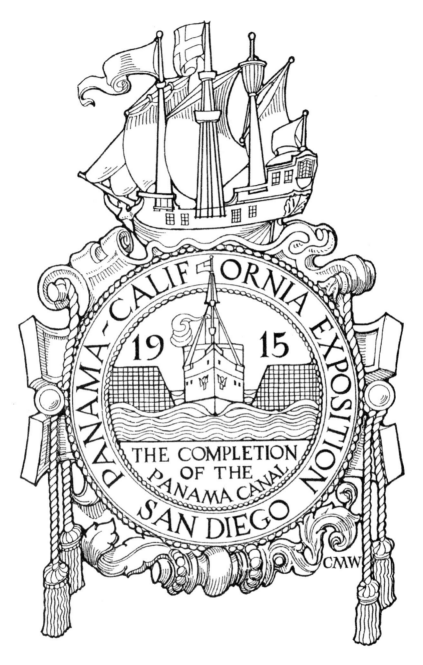

One of several logos for the Panama-California Exposition. Design by Carleton Monroe Winslow. *Panama-California Exposition Digital Archive.*

way at midnight to a tableau depicting the passing of 1915 and the coming of 1916.[195]

As the evening drew to a close, a monster display of aerial bombs and noisemakers above the grounds culminated in a grand outburst at midnight.[196] About 17,074 people witnessed the passing of the old year and the coming of the new.

A final tally showed 2,050,030 admissions by tickets and passes during 1915—and this from a city whose population was roughly 50,000! An audit of the books from the inception of the Exposition in 1910 to April 30, 1916, by W.J. Palethorpe showed profits during 1915 of $233,721.81. As part of this money went to pay indebtedness and deficits, the Exposition treasurer turned over a net surplus of $56,570 to the 1916 Exposition on April 30.[197]

San Diegans on December 31, 1915, could look back with satisfaction over a year of concerted community effort and collective celebration unprecedented in the city's history. They could see corollary benefits from the Exposition in the improvements of their park, downtown and harbor. And they had great expectations that the 1916 Exposition would enlarge their cornucopia of benefits.

To some, the passing of 1915 evoked pathos. Their emotions at the end of such an extraordinary year mixed sorrow with joy. Yet the fleeting, poignant images they had seen had passed into their subconscious where, as memories, they became a fertile source of delight and wonder.

Whither is fled the visionary gleam?
Where is it now, the glory and the dream?[198]

CHAPTER 4

The Panama-California Exposition Goes International

1916

Opening day ceremonies for the Panama-California International Exposition on January 1, 1916, began in the morning with a military parade from the foot of Broadway to the Plaza de Panama. President G. Aubrey Davidson, Exposition officials and army and navy officers reviewed the parade from the steps of the U.S. Government Building, which had been the Sacramento Valley Building in 1915. At noon, Davidson gave a luncheon for officers of the army and navy at the Cristobal Café. In the afternoon, over fifteen thousand people heard Madame Ernestine Schumann-Heink and Madame Ellen Beach Yaw sing at the Organ Pavilion.[1]

San Diego's Exposition was now "international," which meant it was everything the 1915 publicity department said it wasn't. President Davidson outlined the Exposition's expanded role, saying, "The eyes of the world are focused on the Sun City and the honor not only of the great state of California, but of the great West are placed in our keeping."[2]

The schedule in January and February consisted of band and organ concerts in the afternoon and occasional guard mounts in the Plaza de Panama and drills at the marine camp. A few of the California county, state and commercial buildings stayed open, but the main buildings were closed for remodeling.[3]

San Diego's expectations for 1916 were high, yet problems were emerging. The war in Europe was becoming increasingly destructive, bandits were

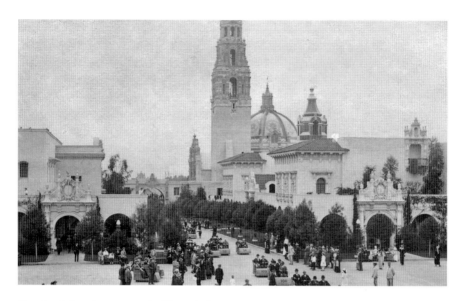

Parade of electriquettes on the Plaza de Panama. *Michael Kelly Collection, Panama-California Exposition Digital Archive.*

harassing Americans along the southern border and in Mexico, domestic travel was declining, commercial travel through the Panama Canal was not as great as had been expected, the beach communities and Tijuana had developed attractions appealing to visitors and downtown merchants had begun to complain about Exposition competition.[4] In mid-January, excessive rainfall caused tremendous damage, breaking dams and destroying bridges.[5] Troops at the Exposition were sent to flooded areas to protect people and property.[6]

To improve the city's image, Davidson asked children and adults to write letters telling of San Diego's healthy condition.[7]

Buildings opened as soon as new exhibits were installed. First among them, the Science and Education Building had its archaeological and cultural history halls ready on February 6 with new exhibits of Eskimos from Alaska and Caribbean Indians from British Guiana.[8]

The Foreign Arts Building held commercial exhibits carried over from 1915 and new exhibits from the Netherlands and Switzerland.[9] The U.S. Government Building (the former Sacramento Valley Building) contained displays of the Treasury, War, Navy and Interior Departments.[10] In addition, the United States moved a forestry exhibit to the 1915 Nevada Building[11] and placed a fish tank and a hatchery exhibit in a newly built Fisheries Building.[12]

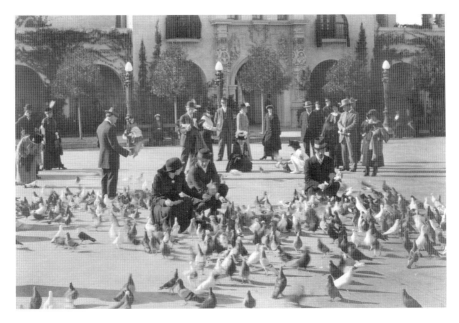

Feeding the pigeons on the Plaza de Panama was an attraction for young and old. *Michael Kelly Collection, Panama-California Exposition Digital Archive.*

United States government exhibit in the former Sacramento Valley Building, 1916. *Panama-California Exposition Digital Archive.*

Outstanding among new displays were the exhibit from Canada in the Canadian Building (former Commerce and Industries Building) and exhibits from France in the California and the Fine Arts Buildings. Canada's exhibit featured scenes of Canadian harbors, a miniature train that stopped before elevators for loads of grain and live beavers working on a dam.[13] The French exhibit consisted of four Gobelin tapestries depicting Alexander the Great's campaigns, Tournay carpets and vase statuary by Rodin in the rotunda of the California Building and mannquins showing Parisian dresses in the upper balcony.[14] The Luxemburg art collection in the Fine Arts Building from the Luxemburg Museum in Paris included paintings by Detaille, Henner, Carriere, Monet, Degas, Morot and Breton.[15]

The first plan for the Pan-Pacific Building (former Home Economy Building) called for exhibits from Alaska, Hawaii, the Philippines, Siam, New Zealand, New South Wales, China and South American countries bordering the Pacific Ocean, most of which would come from the recently closed Panama-Pacific International Exposition in San Francisco. The Pacific Coast Steamship Company, Oceanic Steamship Company, T.K.K. Steamship Company and the Union Line would set up smaller displays telling visitors how to get to the countries on exhibit. Movies would show local resources, and natives would play the music of their homelands.[16] Not all of this happened. Meager newspaper accounts indicate that Alaska, Hawaii and the Philippines set up striking exhibits. Managers of the Hawaii exhibit also operated a coffee shop. A concessionaire from Italy sold cameos; another, who managed a "Holy Land" exhibit, sold jewelry, rugs, laces, religious carvings and crosses. Clearly, to paraphrase T.S. Eliot, between the idea and the reality fell the shadow.

The Palace of Mines (the former Washington State Building) opened with exhibits from mines in Southern California, Utah, New Mexico and Montana.[17] The Point Loma Theosophical Society purchased and remodeled the Kansas State Building.[18]

New attractions on the Isthmus came from the Panama-Pacific International Exposition's "Zone." These included the Robinson Wild Animal Show, Elizabeth the Lilliputian, "the thinking horse" Captain, the undulating picture "Stella" and the girl shows "Paris after Midnight" and "Sultan's Harem."[19]

Also new were an ice rink in the 1915 Alhambra Cafeteria, a City of Jerusalem and an alligator farm on the Isthmus.[20] Animal trainer G. Kaufman looked after animals from the defunct Wonderland Amusement Park in Ocean Beach at the north end of the Isthmus.[21]

Leap Year Court was so called because of the extra day in 1916. Sculptures of a bear surmounted by a goddess and two large cupids, gifts to San Diego from the Sacramento Valley Commission, decorated the court.[22]

Troops A, D, K and L of the First Cavalry left the Exposition for border patrol duty in Arizona on March 13.[23] Bandits, led by the infamous Pancho Villa, had ransacked the town of Columbus, New Mexico, and killed eighteen Americans on March 9, resulting in a retaliatory response that ensued on March 15, when General Pershing led an expeditionary force into Mexico. The First Cavalry was not part of the force.

The Royal Italian Band, under conductor Alfredo Tommasino, gave its first concert on Saturday evening, March 4, in the Plaza de Panama.[24]

Some 45,259 people attended official Exposition Dedication Day ceremonies on March 18.[25] Secretary of the Navy Josephus Daniels pressed a button in Washington, D.C., at noon that resulted in the ringing of a great gong in the Plaza de Panama and the unfurling of flags of eighteen foreign nations.[26] Secretary of the Interior Franklin K. Lane, in the Plaza de Panama, lauded San Diego in a speech carried by a new sound system from Magna-vox.[27] A banquet at the Cristobal, a carnival on the Isthmus and an open-air ball on the Plaza de Panama rounded out the day.[28]

A fifty-mile automobile race, consisting of forty-four laps, took place on the Isthmus on March 25.[29]

On April Fools' Day, a boy rode an ostrich from the Ostrich Farm, girls from the Isthmus attraction "Paris after Midnight" waved from floats and camels and horses from the animal show added their exotic colors to a parade down Broadway.[30]

A battalion of the Twenty-first Infantry, consisting of three companies of 266 men and a band, set up camp on the Tractor-Aviation Field in early April.[31]

On April 21, District Attorney Spencer Marsh informed Exposition secretary Penfold of his intention to close "Sultan's Harem" because of "indecent exposure."[32] Penfold retorted, "It is my honest conviction that the opinion formed by a particular individual as to the decency or indecency of the show directly reflects the mental attitude of that individual."[33]

Walter Damrosch conducted the New York Symphony Orchestra at the Organ Pavilion on April 22 and 23. To get such a distinguished orchestra, the Exposition had to guarantee the orchestra $3,250. The sale of seats at seventy-five cents apiece for each concert enabled the Exposition to break even.[34]

In honor of the 300th anniversary of Shakespeare's death, five hundred schoolchildren at the Organ Pavilion, on the afternoon of April 29, put on

United States Chicle Co. exhibit inside an Exposition building. Photograph by Allen Wright. *San Diego Public Library Collection. Panama-California Exposition Digital Archive.*

a pageant of Shakespearean characters.[35] That same evening, students from the School of Dramatic Expression acted in scenes from *Romeo and Juliet* and *The Taming of the Shrew*.[36]

While records are not clear, it appears that in early April, the most overtly racist of attractions on the Isthmus in 1915, "Underground China Town," was replaced by a new exhibit called "Underground World." It seems likely that, as in San Francisco, the Southern California Chinese community was so infuriated by the 1915 exhibit that they compelled its cancellation. The San Francisco exhibit was replaced by "Underground Slumming," with Caucasian instead of Chinese actors. Because of the similarity of names it is possible that the San Francisco exhibit was either moved to San Diego or that Exposition officials simply borrowed the idea. They chose Frederick

Harrison as the hop-head who, in his dreams, saw a "Dance of the Red Poppy" that was gratuitously reenacted for the benefit of onlookers.[37]

In May, the Ford Motor Company mounted an exhibit on the Tractor-Aviation Field.[38] An art collection from the Netherlands replaced the Luxemburg collection at the Fine Arts Gallery. Onlookers were amazed by the realism of a painting titled *Head of a Cow* by Henrikus Alexander Van Ingen.[39]

Three companies of the First Battalion of the Twenty-first Infantry left for Nogales, Arizona, on May 10 to hunt for Mexican bandits.[40] As a result of this action and General Pershing's ongoing expedition into Mexico, President Venustiano Carranza, on June 21, ordered his troops to attack

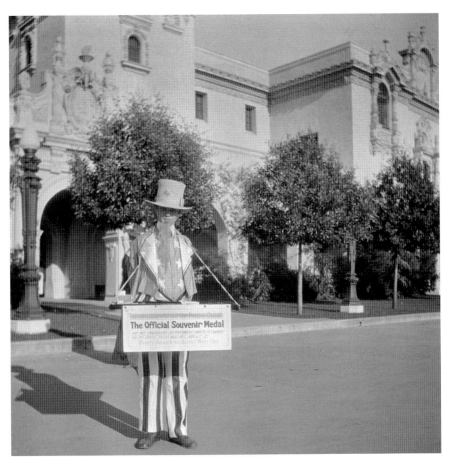

Young "Uncle Sam" sells Panama Canal souvenir medals. Photograph by Allen Wright. *San Diego Public Library Collection. Panama-California Exposition Digital Archive.*

Americans. Undeterred, President Woodrow Wilson refused to rescind Pershing's Expedition until order was restored along the border.

On the evening of May 17, students from San Diego High School acted scenes from *As You Like It* on the east side of the lagoon in front of the Botanical Building. The classical background and fountain provided suitable scenery, but the moon, which would have made everything glow, did not appear.[41]

Pied Piper Day on May 27 was the big event of that month. Wearing clothes similar to those in Maxfield Parrish's painting of the story, attorney Hubert Collins of Coronado emerged from Cabrillo Canyon to demand payment of the mayor and council of Hamelin for ridding the town of rats. (The analogous situation of Hatfield the Rainmaker, who had been denied payment by the San Diego City Council, was alluded to in the dialogue. Hatfield had contracted with the city to end a drought and received credit for the rain and the damage it caused.) After being refused payment, the Piper summoned an estimated thirteen thousand children to follow him by playing on his flute. He led the children over Cabrillo Bridge, across El Prado to the Isthmus. The Piper and the children disappeared into the Panama Canal Building, which stood for the mountain into which the children of Hamelin vanished. Here a show of thunder and lightning, hobgoblins and gnomes gave the children frantic thrills. The children came out on the other side of the building and continued to the Tractor-Aviation Field, where they were entertained by a vaudeville show and Indian dances.[42]

Directors spent June trying to counteract statements from E.T. Earl, publisher of the *Los Angeles Tribune*, that they were promoting gambling, horse racing and assorted vices in Tijuana. Earl's motive in making this charge is not clear, but he may have been seeking an excuse to default on his subscription pledge of $5,000.[43] According to Lawrence D. Taylor, Earl's argument cut both ways because he also charged that "the racetrack gambling hell of Tijuana" was drawing visitors away from the Panama Canal Exposition of 1915–16.[44]

To encourage greater local participation in the Exposition, directors offered season tickets at a low price of five dollars each.[45]

A book titled *The Architecture and the Gardens of the San Diego Exposition* came out in June. For the first time, San Diegans discovered that Bertram Goodhue, architect-in-charge, considered Exposition work by Frank P. Allen Jr. and Carleton Winslow to be temporary, coarse, theatrical and uninspired. Goodhue insisted that their buildings be torn down.[46] Goodhue believed that the buildings he designed should be the only permanent ones.

The Fourth Regiment of U.S. Marines left the Exposition on June 5 to forestall European (possibly German) intervention and to put down a rebellion in Santo Domingo.[47] President Wilson had imposed a protectorate on Santo Domingo to safeguard American life, property and investment while proclaiming his desire to establish a stable, democratic government. The same reasoning had been used to justify a 1912–27 intervention in Nicaragua and a 1915–34 intervention in Haiti. It was also used to explain the abortive six-month occupation of Veracruz, Mexico, in 1914, supposedly instigated because President Victoriano Huerta refused to order a twenty-one-gun salute to the American flag. The United States imposed a military government on Santo Domingo for eight years until the marines withdrew in 1924.

On the evening of June 8, a touring company put on *The Servant in the House* by Charles Rann Kennedy at the Organ Pavilion. Tyrone Power Sr. acted the part of a worker in sewers who progressed from sinner to saint and showed other characters the folly of their ways.[48]

Students from the State Normal School produced *Admetus*, by Irving Outcalt, on the evenings of June 16 and 19. The nights were mild, the moon luminous and the Organ Pavilion's classic setting in harmony with the story of Alkestis, wife of Admetus, who gave herself to death in place of her husband and was restored to life through the efforts of Heracles.[49]

About sixteen thousand people watched the Turnverein of Southern California perform acrobatics at the marine parade grounds in the morning and on the Plaza de Panama on the afternoon of German Day on June 25.[50]

U.S. Naval surgeon G.S. Thompson, who helped organize the San Diego Museum and the Zoological Society of San Diego, came out with a novel idea on June 20. He said, "The one legal ground that a private museum corporation has that will permit it to occupy city-owned buildings in a public park is that the museum authorities maintain exhibits that will be free, i.e., without admission charges, and open at all times to the public."[51]

Independence celebrations got underway on July 3 when the Pathfinder, a twin six-cylinder automobile, started on a transcontinental trip from the Plaza de Panama to Philadelphia.[52] Jack Little, in a Maxwell automobile, leaped over ten barrels of burning oil on the Tractor-Aviation Field,[53] and 1,600 militiamen of the newly arrived Oregon National Guard were greeted at an open-air ball on the Plaza de Panama.[54]

July 4 began with a civilian preparedness parade from Broadway to the Plaza de Panama.[55] Europe being in the throes of World War I, preparedness supporters were fervent that the United States should be ready to take

Afana Brothers show a masterpiece representing the Last Supper carved from mother-of-pearl. *Michael Kelly Collection, Panama-California Exposition Digital Archive.*

on foreign and domestic enemies. D.C. Collier read the Declaration of Independence on the Plaza, and schoolchildren put on a flag drill. Coloratura Ellen Beach Yaw sang at the Organ Pavilion. George Gray dived through fire on the Isthmus, and Jumping Jack Little in his Maxwell car leaped over some more barrels. Fireworks illuminated the night sky.[56]

To keep boys from the Oregon National Guard from being scandalized, District Attorney Spencer Marsh closed "Paris after Midnight" and "Streets of Algeria" on July 6.[57]

Carl Heilbron began advocating turning the temporary Exposition buildings into a military academy.[58] Reverend R.D. Hollington, of the First Methodist Church, favored using the buildings for a community center or a university campus.[59]

John F. Forward Jr. tried to dampen such schemes by declaring, "This plan of locating county and city buildings at the Exposition is bunk, piffle and slush. The park was set aside for use of the people and it was specifically stated it was to be used for park purposes only."[60]

Bernice de Pasquali, coloratura soprano from the Metropolitan Opera, gave a concert for more than ten thousand persons at the Organ Pavilion on

Balboa Park and the 1915 Exposition

Crowd on Plaza de Panama, July 4, 1916. *David Marshall Collection, Panama-California Exposition Digital Archive.*

the afternoon of July 23. Her singing of "Thou Brilliant Bird," from David's opera *The Pearl of Brazil*, left her audience gasping.[61]

Attendance in July peaked at 209,485 people, making it the highest monthly attendance of the year. Some 45,259 people paid to enter the grounds on July 4, almost the same total as the 42,433 people who visited the Exposition in the whole month of February.[62]

The Entertainment Committee sponsored a highflying kite contest over the Aviation Field on Kite Day, August 2. A lucky contestant for first prize won a burro, born and bred in the Indian Village. Leagues ahead of the other flyers in dexterity and skill of design, the Chinese Club of San Diego put on a spectacular show but refrained from competing for prizes.[63]

Dancers Ruth St. Denis and Ted Shawn performed a pageant titled "The Life and After-Life of Greece, India and Egypt" at the Organ Pavilion on the evening of August 5. A wild orgy in honor of Bacchus in the Greek section provided vicarious thrills for the liberated and not-so-liberated portions of the audience.[64]

The John Trask collection of American paintings opened in the Fine Arts Gallery on August 6. Cecilia Beaux's bold brushwork and lively characterization in her portrait of *Dorothea and Francesa* evoked comment.[65]

On August 11, the chamber of commerce appointed George W. Marston, Carl Heilbron and W.S. Dorland to look into the physical condition of the Exposition buildings and determine the cost of their upkeep.[66]

Boy and dog wear top hats; background shows the model farm's citrus grove and roller coaster. Photograph by Allen Wright. *San Diego Public Library Collection. Panama-California Exposition Digital Archive.*

A drill team from Los Angeles presented arms to the sound of bugles as the host and chalice were raised during a military mass at the Organ Pavilion on Catholic Sunday, August 13.[67]

Billy Webber, "the human fly," took an hour and a half to scale the California Tower on the evening of August 14.[68]

In a speech at the Organ Pavilion on the afternoon of August 22, New York governor Charles Evans Hughes, Republican candidate for president of the United States, criticized the Wilson administration for lowering tariffs and interfering in Mexican affairs and praised American industry, labor, women and children. Exposition directors allowed the public in free beginning at 12:30 p.m. The *San Diego Union* reported forty thousand people in the audience, a figure considerably larger than the twenty-five thousand reported by the *Los Angeles Times*. Whichever number is correct, Hughes outdrew all other speakers at the Organ Pavilion in 1915 and 1916. His whiskers, regular white teeth and dignified demeanor drew more attention than his dry, laborious speech.[69]

Exposition architect Frank P. Allen Jr. told the Preservation Committee on September 1 that all buildings should come down except for the California Building and "possibly" the Administration Building. He claimed the park should be used for recreation, not for buildings.[70] (Interestingly, Allen took a similar position in Seattle at the conclusion of the Alaska-Yukon-Pacific Exposition when he urged that Exposition grounds be turned into a public park.)[71] The committee voted to remove the Canadian Building, the Varied Industries Building and the Cristobal Café.[72]

The Preservation Committee appeared to be unaware that Congressman William Kettner was trying to persuade the U.S. government to take over the entire Exposition compound for use as a U.S. Marine base at the conclusion of the fair.[73]

Over eleven thousand people were present to observe the sixty-sixth anniversary of California's admission to the Union on September 9. The celebration began with a parade from Broadway to the Exposition. Judge John F. Davis of San Francisco extolled the glories of California at the Organ Pavilion. Drills, musical concerts and a women's reception enlivened the afternoon. A dinner at the Cristobal and an open-air ball on the Plaza de Panama closed the day.[74]

Salt water taffy distributed on the Plaza de Panama, compliments of the Star & Crescent Boat Co. Photograph by Allen Wright. *San Diego Public Library Collection. Panama-California Exposition Digital Archive.*

Despite the presence of American troops on Mexican soil seeking to capture bandit and rebel Francisco ("Pancho") Villa, the Exposition celebrated Mexico's Independence Day on September 16 with a mock bullfight, games, sports, a piñata party and the inevitable open-air ball.[75] Venustiano Carranza, who had been recognized as president of Mexico by Woodrow Wilson on October 19, 1915, and Colonel Esteban Cantu, who governed Baja California as an autonomous district from late December 1914 to August 20, 1920, declined to attend. Carranza left the honor of representing the Republic to Tedore Fresierres, consul of Mexico in San Diego.[76] Cantu, as military chief and governor, helped make Tijuana a mecca for American tourists with such attractions as bullfighting, cockfighting, gambling, horse track racing, prizefighting, prostitution, opium dealing and the sale of liquor. He was assisted in some of these enterprises by American entrepreneurs James W. Coffroth, Baron H. Long and Adolph B. Spreckels, brother of San Diego tycoon John D.[77]

That same day (September 16), while driving down Park Avenue, Dr. Harry M. Wegeforth heard the roaring of lions at the Isthmus and remarked to his brother Paul, "Wouldn't it be splendid if San Diego had a zoo!" Later, on October 2, Dr. Fred Baker, a physician, opened his home for the first meeting of the newly organized Zoological Society of San Diego.[78]

The Second Battalion of the Twenty-first Infantry arrived from Vancouver on September 22 and set up quarters on the Tractor-Aviation Field. Military was once more on the grounds.[79]

On September 23, Indians at the Painted Desert performed eagle, corn and butterfly dances and then invited onlookers to a feast of corn, squash and barbecued goat.[80]

Frank P. Allen Jr. told a reporter for the *Evening Tribune* on October 3 that the Exposition buildings would soon become unsightly and unsafe, and the plants that grew around them were already concealing their façades. He offered to lay out a new ground plan without charge.[81]

Senator J. Hamilton Lewis, Democrat of Illinois, blasted Republicans before about 1,500 people in the War of the Worlds Building on the evening of October 6. Since he was not a candidate for the presidency, as was Governor Hughes, the Exposition did not allow people in free to hear him.[82]

On October 21, the Hearst International Film Service filmed the action as the Second Battalion of the Twenty-first Infantry stormed the Painted Desert and forced the Indians to surrender.[83] According to the official film script, the desert harbored about four thousand warriors before the battle, of whom only twelve were left when the slaughter had

Bishop & Co. of Los Angeles exhibits a model of its cracker ovens in the Food Products and Varied Industries Building. Photograph by Allen Wright. *San Diego Public Library Collection. Panama-California Exposition Digital Archive.*

ceased. The pictures made were to be shown in weekly periodicals and woven into screen dramas.[84]

Flyer Joe Boquel began an engagement on October 28 by doing evolutions above the Tractor-Aviation Field.[85] Before taking off the next night, he had engine problems. During his gyrations, a San Diegan blinded him by focusing a searchlight on his plane.[86]

Movie star Mabel Normand and fifty schoolchildren buried a revolver and a rifle in Montezuma Gardens on Peace Day on October 30 to show their dislike of war.[87] Though shocked by the carnage in Europe where the Battle of Somme was raging, many Americans thought the United States should stay out of the conflict. By using the campaign slogan, "He kept us out of war," Democrats ensured the reelection of Woodrow Wilson on November 9 with 3.2 percent more of the popular vote than his opponent, Charles Evans Hughes, and 23 more electoral votes (total 277). Showing some of the inner gloom he kept from the public, Wilson is reputed to have said, "They talk of me as if I were a god. Any little German lieutenant can put us into war by some calculated outrage."[88]

On November 3, G.A. Davidson asked the Park Board for authority to continue the Exposition for three months in 1917. Exhibitors wanted the extension to take advantage of an anticipated influx of eastern tourists. Wisely, they had secured the support of Mayor Edwin Capps.[89]

While doing a "corkscrew" on November 4, Joe Boquel flew his airplane into the ground near Cabrillo Bridge, causing his death. The accident happened five minutes before he was to have been awarded an Exposition gold medal.[90]

Mother Goose Day, November 25, was the most exciting day of the month. Playground Department employees Cornelia Strobhar and Hulda Hanker trained about 150 children to enact the stories of Mother Goose. Characters included Jack and Jill; Peter, Peter, Pumpkin Eater; King Cole; and Mother Goose.[91]

The month ended with a Thanksgiving Service on November 30 at the Organ Pavilion.[92] Dr. Stewart was the organist and Ellen Beach Yaw the soloist.[93] Dr. Charles Locke, of the First Methodist Church of Los Angeles, said the United States was justified in conquering enemies and in expanding because its mission was "to proclaim liberty and peace throughout the land."[94] This carte-blanche statement leads one to wonder who the adversaries were that the United States was to conquer. Were they Indians, Wobblies, Mexicans or Germans? At various times, Presidents McKinley, Roosevelt, Taft and Wilson said the same thing.

The Parent Teachers' Association sponsored a three-day Children's Fair, beginning on December 1. Over seven thousand exhibits in the Casino on the Isthmus covered arts, crafts, electrical and mechanical appliances, millinery, toys, woodwork and kindergarten pasteboard creations.[95]

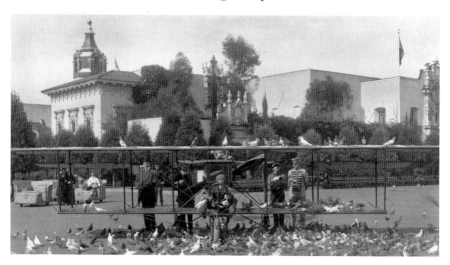

Stunt pilot Joe Boquel in Plaza de Panama, November 1916. He was killed when his plane crashed near Cabrillo Bridge days later. *David Marshall Collection, Panama-California Exposition Digital Archive.*

Children feeding pigeons on Plaza de Panama. Note the three boxes of Kellogg's Toasted Corn Flakes. *Michael Kelly Collection, Panama-California Exposition Digital Archive.*

The Park Board, on December 3, decided the Southern California Counties Building could be used as an auditorium and the Nevada Building as a natural history museum.[96] The following day, the board approved the Exposition's request for a ninety-day extension until April 1.[97] Professional opinion and Preservation Committee recommendations being in favor, the board, on December 11, approved the demolition of the Canadian Building and the El Prado portion of the Varied Industries Building.[98]

On December 9, using trenches, land mines, guns, searchlights, barbed wire, light bombs and antiaircraft guns, troops of the Second Battalion of the Twenty-first Infantry successfully defended their camp near the Aviation Field from simulated attacks by sailors from the cruisers USS *San Diego* and *Frederick* and aviators in four planes from the government station on North Island.[99]

On the afternoon of December 10, Douglas Fairbanks Sr. used the California Building as a backdrop for a film called *The Liberator*, a movie dealing with conspiracies and insurrections in Paragonia, a mythical Central American country. (A mythical name was chosen, as a real Central American country would have protested against the film's condescending treatment of its people and internal affairs.) In the scene, Fairbanks and his bride, daughter of the president of the country who had been deposed

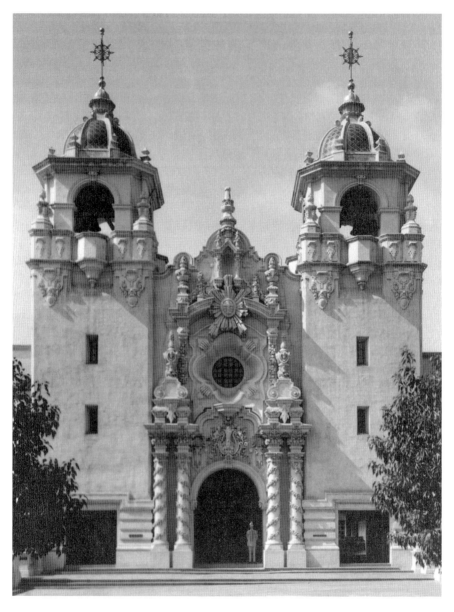

Varied Industries and Food Products Building, east entrance. *Michael Kelly Collection, Panama-California Exposition Digital Archive.*

by anti-American generals, come out of a church (the California Building) followed by the bride's father and a Negro servant. Miss Anita Loos of San Diego, who wrote the script, sided with her valiant American hero, who single-handedly subdued loathsome mestizo generals and restored refined Spanish aristocrats to power.[100] In a more subtle way, was not the revival Spanish colonial setting of the San Diego Exposition also a reflection of Golden and Silver Ages in Latin America, when the superlative achievements in art, architecture and rich ways of living of a ruling class were based on the labor and resources of an abused people? It was because of this legacy that Mexican novelist and essayist Carlos Fuentes characterized the connection between Spain and its former colonies in the New World as a "love-hate relationship."[101]

The School Department and the Exposition joined forces to entertain about fifteen thousand schoolchildren with games, sports, talks, music and box lunches at the fair on December 15, the last day of school in 1916.[102] During Bird House Day on December 16, schoolchildren exhibited bird houses of all shapes and sizes. The children represented song sparrow, towhee, titmouse and wren in a program at the Organ Pavilion.[103]

On Christmas night, quartets sang carols from balconies on the Plaza de Panama before walking to the Organ Pavilion. To illustrate the carols and readings from the Bible, volunteers at the pavilion posed as living pictures of the Nativity story.[104]

During the Exposition's last five days, officials looked back over two years of activity and honored the people and institutions who had made it possible. On Army and Navy Day on December 27, the Exposition's Entertainment Committee gave enlisted men of the armed services a picnic lunch at Pepper Grove and officers a more impressive midday meal in the Cristobal Café.[105] In the afternoon, Tommasino's band honored author George Wharton James by giving a concert of grand opera music at the Organ Pavilion. As the featured lecturer of the 1916 season, James had given many talks in the San Joaquin Building on literary subjects.[106]

Prominent San Diego citizens eulogized John D. Spreckels at the Organ Pavilion and at a lunch and dinner on December 28.[107] During one of the sessions, George W. Marston made a major political blunder when he said, "I consider the giving of this instrument [the Spreckels organ] greater than building railroads or steamships. We who live in San Diego can live without means of transportation, but we cannot live without music."[108] A tribute to D.C. Collier on December 29 followed the same schedule as that given for Spreckels.[109]

Left: Cover of the menu for Christmas Eve dinner at the Cristobal Café, 1916. *David Marshall Collection, Panama-California Exposition Digital Archive.*

Below: Interior of San Joaquin Valley Counties Building. *David Marshall Collection, Panama-California Exposition Digital Archive.*

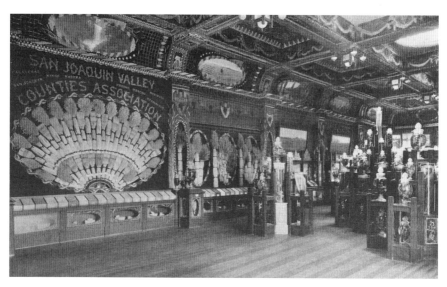

About 250 schoolchildren presented a floral pageant at the Organ Pavilion on Sunday afternoon, December 30, directed by Cornelia Strobhar and Hulda Hanker. Seven-year-old Billy Whitten, as Peter Pan, presided over fairies, butterflies, canaries, daisies, bees, poinsettias and poppies.[110]

Exposition directors on December 31 presented Alfredo Tommasino, leader, and Louis Gasdia, manager of the Exposition band, with gold medals at the Organ Pavilion.[111] Since the directors had spent so much time congratulating themselves, it was fitting that they should acknowledge two of their most valuable employees.

On the Exposition's last day, January 1, 1917, directors honored their president, G. Aubrey Davidson. Without Davidson, there would have been no Exposition, for he conceived the idea and, for two years, received important visitors and managed affairs.[112] In the morning, Davidson reviewed a parade of soldiers, sailors and marines on the Plaza de Panama. Following the review, Carl Heilbron, vice-president of the Exposition, presented Davidson with a gold watch.[113] He received more honors as a guest in the Women's Official Reception Room in the afternoon and as a guest at a dinner in the Cristobal Café in the evening.[114]

A series of climactic events on the last day left an indelible impression on the nearly thirty thousand people on the grounds.[115] As indulging in simulated warfare had proven to be a great crowd-pleaser, the First Battalion of the Twenty-first Infantry cut its way through wire entanglements and crawled through exploding mine fields to capture a fort held by the Second Battalion on the Tractor-Aviation Field.[116]

President Davidson presented opera singer Madame Schumann-Heink with a jeweled medal during the closing program at the Organ Pavilion, beginning at 11:30 p.m. As the contralto sang "Auld Lang Syne" at midnight, lights at the pavilion and in the Plaza de Panama went out. When the last strains of the song ended, a pyrotechnic piece atop the organ spelled out in glowing colors "WORLD PEACE—1917." While Schumann-Heink led a chorus in singing "The Star-Spangled Banner," bombs exploded above the incandescent letters, releasing flags of all nations.[117]

Paid attendance during the second year of the Exposition came to 1,697,886, which represented a decline of 352,144 people, or 17 percent, from the paid attendance of 2,050,030 in 1915.[118]

The 1915 Exposition closed with a net surplus of $56,570.[119] At the close of 1916, the Exposition had a net of $34,000 and two unpaid guarantee subscriptions aggregating $10,000.[120] In contrast to the 24-month San

Austrian-born American opera singer Ernestine Schumann-Heink, 1916. Signed Moffett, Chicago. *Wikipedia image from Library of Congress.*

Diego Exposition, the 1915 San Francisco Exposition lasted 9.6 months, attracted 18,876,438 people and netted $2,401,931.[121]

San Francisco's Exposition attracted more people and made more money, but its impact on California was not as great as San Diego's. The massive Beaux-Arts architecture at San Francisco, a repeat from previous expositions, was losing its appeal. Even the innovations at San Francisco, such as the interior linkage of courts, vibrant colors and indirect lighting, were not enough to carry the Imperial style forward. During the 1920s, movie stars and moguls built homes in the small-scaled, dynamic and heavily textured Spanish Colonial style of the San Diego Exposition. The influence of San Diego's fair became so widespread that even San Francisco was affected, as evidenced by the Spanish Churrigueresque–style church next to Mission Dolores.

Bertram Goodhue had taken the romantic views of the Spanish and Mexican periods present in the writings of Helen Hunt Jackson, Charles Fletcher Lummis, George Wharton James and Gertrude Atherton and had shifted them to a new, even more unhistorical plane. The dons and donnas of rancheros in early nineteenth-century California had become grandees from vice-regal Mexico's Silver Age living in palaces, cathedrals and plazas.[122] It was an attractive fantasy of a refined, artistic, courteous and genteel civilization that was a far cry from the cold, gigantesque classic beauty, sepulchral melancholy and eerie infernal lighting of San Francisco's Exposition.[123] To George Wharton James, the vast and ponderous San Francisco Exposition was an overpowering, muscular Greek athlete, while the small-scale and friendly San Diego Exposition was a young and attractive maiden.[124]

In esthetic and psychological terms that cannot be measured by turnstiles and cash registers, the San Diego Exposition surpassed San Francisco's, for its fantasy was not based on escapism only, but also on the hope of a better and richer life for Californians then alive and yet to come.

CHAPTER 5
Exposition Mop-Up
1917

As the Panama-California International Exposition wound down, San Diegans prepared plans to perpetuate its buildings and exhibits. The question "What would follow?" was heard on all sides.[1] People hoped that during the three-month post-Exposition period, this question would be answered.

Despite chamber of commerce rhetoric, the first three months of the year are the wettest in San Diego. The year 1917 was no exception. Rain or no rain, the Exposition continued from January 1 to March 31 to allow for "clean-up" (perhaps "mop-up" would be more accurate).[2] Exhibits were reduced, special events were few, Isthmus shows were gone and the sale of goods by exhibitors was stopped.[3]

Businesspeople hoped the model farm would continue as "an advertisement," but they did not suggest how it would be financed. Supposedly, C.L. Wilson, manager of the farm, would stay on.[4]

Structures along the Isthmus, as well as the San Joaquin, Varied Industries and Canadian Buildings, were to be torn down when they were vacated.[5]

The California Building with French exhibits, the Canadian Building with Canadian exhibits, the U.S. Government Building and the Fisheries Building with U.S. government exhibits, the Fine Arts Building, the Salt Lake and Union Pacific Building, Japanese Tea Garden, Isthmus Zoo and Panama Canal Extravaganza stayed open.[6]

San Diego Museum exhibits were permanent. Most of them stayed in the Science and Education Building, but some were moved across the street into

Balboa Park and the 1915 Exposition

Above: Sweeping detail by entrance to the Isthmus near trolley station, circa 1917–18. *Rosemary Ann Phelan Photo Collection, Panama-California Exposition Digital Archive.*

Opposite: California Building. *Michael Kelly Collection, Panama-California Exposition Digital Archive.*

the empty Russian and Brazil Building. Directors understood the museum would "be maintained by membership fees and paid admissions on certain days of the week."[7]

Dr. Humphrey J. Stewart continued to give daily organ concerts with expenses being paid by John D. Spreckels. Tommasino and his band stayed on. The future of the band hinged on whether San Diegans were willing to get up a fund to keep it. The Second Battalion of the Twenty-first Infantry continued to give daily field drills on the Aviation Field and weekly band concerts on the Plaza de Panama.[8]

The Exposition Corporation charged twenty-five cents for adult admission, twenty-five cents for automobiles and ten cents for children. The money was to cover the cost of lighting the buildings and grounds. To further reduce lighting cost, the grounds were open from 8:00 a.m. to 5:00 p.m. only. Carl Ferris, Exposition vice-president, talked guilelessly of continuing the admission charge at ten cents after April 1.[9]

The 1916 Board of Directors carried itself over.[10] With the help of the board, W.S. Dorland, president of the chamber of commerce, organized men's and women's committees to welcome visitors.[11]

The Southern California Counties Commission gave its buildings and grounds and the model farm and model bungalow to the city for one dollar on January 3.[12] That same day, International Harvester gave its building

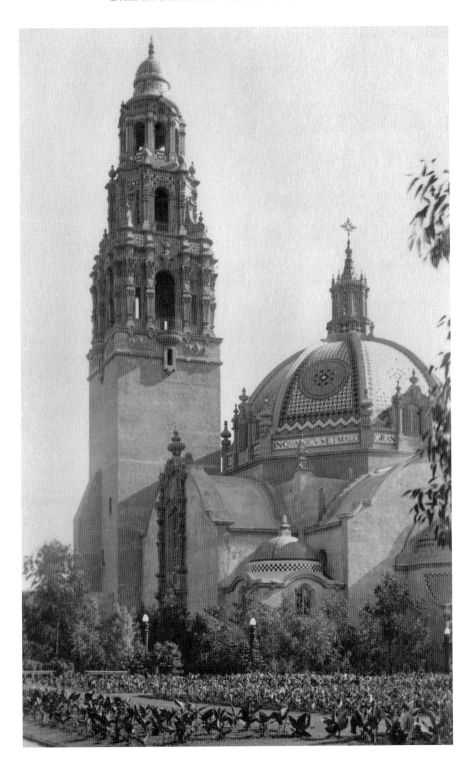

Balboa Park and the 1915 Exposition

Model bungalow. *Rosemary Ann Phelan Photo Collection, Panama-California Exposition Digital Archive.*

to the city free with the understanding that it would always be known as the "Harvester Building." The gift took the Park Commission by surprise, as it had no plans for the building's use.[13] Before the month was over, the Japanese Exhibit Association and the Lipton Tea Company also gave their buildings to the city.[14]

On the afternoon of January 2, Madame Schumann-Heink presented colors to officers and men of the Second Battalion of the Twenty-first Regiment at the Plaza de Panama, the first review since the formal New Year's closure of the Exposition.[15] In mid-January, Madame Schumann-Heink announced a plan to make San Diego home to an American festival, like the Bayreuth music festival held in Germany since 1876. She declared that a festival of grand opera and music would be held at the Spreckels Organ Pavilion in July and deposited $10,000 as a guarantee of her good faith. Her comments were clearly upbeat when she said, "For years people of culture and wealth have traveled to Europe to hear grand opera under the most ideal conditions then extant. But the best that Europe could boast is crude beside what we have here—one of the most beautiful parks in the world, glorious architecture and landscape gardening, the most beautiful Exposition the world has ever seen, the only outdoor organ in the world, [and] the most perfect climate in the world."[16]

Students in the Junior College, then an adjunct of San Diego High School with an enrollment of seventy, declared they wanted the college to take over the Southern California Counties Building.[17] Not to be undone, the Montessori Education Association asked for an exposition building in which to conduct a Montessori school.[18]

In a letter to the *San Diego Sun* on January 11, Elizabeth S. Miller protested the post-Exposition period and said Balboa Park "should be developed strictly along public park lines for public park purposes."[19] A.D. Robinson, editor of *The California Garden*, piped in, "Were we a Park Commissioner, which the good sense of mayors and our good luck has prevented, we would deem it a prime necessity in parceling out the loaves and fishes from the exposition basket that every one fell to a legitimate parking use."[20] H.J. Penfold, secretary of the Exposition, took the offensive by arguing that all Exposition buildings should be retained because it would cost money to tear them down and somebody might need them.[21]

The Park Board on January 20 ignored the chamber of commerce's advice and notified the Pollard Picture Play Company to vacate its studio on the Isthmus.[22]

Of all requests for Exposition property, the military's was the most certain of success. On January 10, the Park Board allowed the Twenty-first Infantry to move into the Indian Village and the Young Men's Christian Association to convert the former International Harvester Building into a service facility for officers and enlisted men.[23] The board on January 22 turned over the Utah, Montana and Washington Buildings and former marine camp to the U.S. Marines for temporary occupancy until the marine base at Dutch Flats was be completed.[24]

As the Exposition was being dismantled, indications appeared that all was not sweetness and light. On January 17, Roscoe Hazard, owner of Pioneer Truck Company, ordered the driver of a five-ton truck to batter a way through the Exposition gates in protest of a ruling prohibiting horse-drawn vehicles on the grounds.[25] Further discontent surfaced when City Auditor Moody objected to an increase of 10 percent in park employee wages and of Park Superintendent John Morley's salary from $275 to $300 a month.[26] Mayor Capps added his criticism of the park superintendent's gift of floral decorations for the private wedding of the daughter of a member of the Park Commission.[27] A writer in the *San Diego Union* speculated that Capps was trying to humiliate George W. Marston, who was president of the Park Board.[28]

Dr. Harry Wegeforth announced in late January that the Zoological Society of San Diego was fully organized. It would buy animals from the Isthmus Zoo and put animal cages in the Pepper Grove as soon as it raised $10,000. To help get this sum, he said he would sell annual membership cards to children for 50 cents and to adults for $5.[29]

The San Diego Museum Association also began a quest for one thousand members who would pay an annual fee of $5.00. Life memberships could

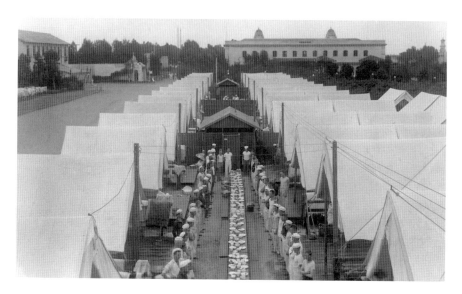

Isolation camp, U.S. Naval Training Station, San Diego, California, 1917. *U.S. National Archives and Records Administration.*

The Young Men's Christian Association converted the former International Harvester Building into a service facility for officers and enlisted men. *Rosemary Ann Phelan Photo Collection, Panama-California Exposition Digital Archive.*

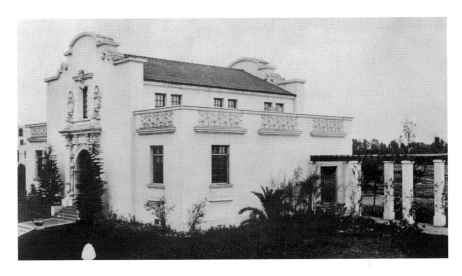

Montana State Building. *Rosemary Ann Phelan Photo Collection, Panama-California Exposition Digital Archive.*

be purchased for $100.00 each.[30] On January 9, G.A. Davidson succeeded George W. Marston as president of the San Diego Museum.[31] Dr. Edgar L. Hewett stayed on as director.[32]

H.J. Penfold announced January attendance as 29,676.[33] This number did not include the 30,000 at the January 1 closing. Considering only 35,440 attended the Exposition in January 1916, the 1917 figure was respectable.[34]

Mayor Capps on February 5 approved a pay increase for park employees from $2.50 to $2.75 a day but rejected the $25.00 per month increase for Superintendent Morley.[35]

The Twenty-first Infantry escorted members of the Grand Army of the Republic, Spanish War Veterans, Woman's Relief Corps, Ladies of the Grand Army and Ladies Auxiliary of the Spanish War Veterans to the Plaza de Panama on Abraham Lincoln's birthday on February 12. Soldiers and civilians passed in review before officers who stood on steps in front of the U.S. Government Building.[36]

The Exposition Corporation intended to wreck the Panama Canal Extravaganza in the middle of February; however, because of an unexpected rise in attendance, the corporation decided to keep the attraction open until the end of the post-Exposition period.[37]

Officials hoped Washington's birthday on February 22 would be the first major event of the post-Exposition period. Unfortunately, rain forced them to postpone the celebration to February 25. Along with schoolchildren from

San Diego County, who were allowed in free, Miss San Diego (Miss Marian Vogdes) marched across Cabrillo Bridge. For the benefit of the children and their parents, soldiers from the Second Battalion of the Twenty-first Infantry gave a manual rifle drill on the Plaza de Panama. Judge W.J. Mossholder, an officer of the Sons of the American Revolution, praised the American colonialists who wrested their independence from Great Britain. He was followed by soloists who sang songs stressing love of country and of freedom.[38]

In mid-February, jeweler Joseph Jessop moved his archery collection into the U.S. Government Building.[39] To get the collection, the Park Board accepted Jessop's proposal to locate an archery range south of the Organ Pavilion.[40]

Its collections having been enlarged with mineral specimens from the Montana Building, the San Diego Society of Natural History, the oldest scientific organization in Southern California, moved from Hotel Cecil in downtown San Diego to the Nevada Building on the Alameda.[41]

By declaring that the Southern California Counties Building and the San Joaquin Building were dangerous and would have to come down, Fire Chief Almgren and Building Inspector Field upset many candidates with schemes for reusing the buildings.[42]

In a letter to Dr. Hewett dated February 20, Carleton M. Winslow, the only major Exposition architect who had not expressed an opinion regarding the Exposition buildings, asserted most of the temporary buildings would have to come down. He granted reprieves to the Indian Village and the Administration, Russia and Brazil and Science and Education Buildings. Though he claimed he designed the Administration Building, Winslow disliked its many windows and the ornament over its front door. Nonetheless, he thought the building should be kept because "it helped the permanent group from the West." Of the other two buildings to escape the general demolition, he agreed with Dr. Hewett that they met the needs of the San Diego Museum Association. Moreover, the cost of repairing them would be small.

Winslow considered the California and Fine Arts Buildings "not adequate to the needs of the San Diego Museum" but did not suggest other uses. He leveled his most severe criticism at the Organ Pavilion, which he described as "unsightly in the extreme." He proposed relocating a new pavilion at the head of the Plaza de Panama, facing south "to bring the sun to the backs of the audience and into the face of the performers." The solution is not ideal, for if the performers suffer, the enjoyment of the audience is going to be affected.[43]

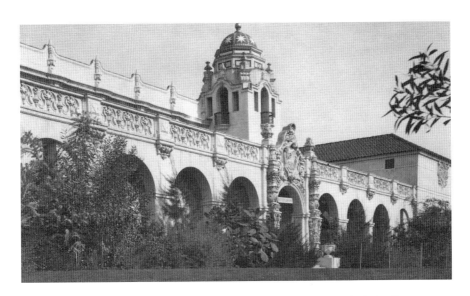

The front of the Southern California Counties Building. *Michael Kelly Collection, Panama-California Exposition Digital Archive.*

Winslow caused a rumpus because, as he had moved to Los Angeles, he was no longer a San Diego architect. While he was still living in San Diego, the Park Board commissioned him to design a bear den and aviary in the park. City Auditor Moody and Mayor Capps were critical of the Park Board in general, and of George W. Marston in particular, this time for hiring a non-local architect.[44]

San Diego wives, mothers and daughters held a Women's Day on March 1. They dined at the Cristobal, watched a drill at the Plaza de Panama and listened to Mrs. Earl Garrettson at the Organ Pavilion.[45] While her words may have been no more than complimentary platitudes, one regrets that newspapers did not give the gist of her speech.

Although few were on hand to hear her, the Australian soprano Nellie Melba played the organ and sang "Ave Maria" from Verdi's *Otello* at the Organ Pavilion on March 7 during a chance meeting with Dr. Stewart.[46]

A depiction of the early days in San Diego during Hotel Day on March 8 was the most stunning staged event of the post-Exposition period. R.C. Godfrey, technical director for Pollard Pictures, reproduced a scene of the lobby of the Old Horton House at the Organ Pavilion. H.B. Frisbie, manager of the Hotel Barstow, drove an old stagecoach, lent by Thomas P. Getz, from the Kansas Building to the re-created Horton House, where

guests from the hotel got off. George W. Marston, once a clerk in the real Horton House, welcomed the guests, and Orrin L. Chaffin, manager of the U.S. Grant Hotel, assigned them rooms. Bellboys Sam Porter of the San Diego Hotel, Charles White of the Sandford and William Kemps of the Maryland stumbled over one another trying to be of service. As part of the program, speakers, singers and entertainers were paged and brought to the lobby, where they performed. When speakers talked too long, the clerk rang a bell, bellboys screamed and the stagecoach came rolling up to haul them away.[47]

The Exposition gave a barbecue at the Tractor Field on March 14 for seven hundred men from the First and Second Battalions of the Twenty-first Regiment.[48]

In a letter in the *San Diego Union* on March 18, Reverend R.D. Hollington called Balboa Park "the most beautiful civic center and public pleasure grounds in the nation." Hollington was firm that "no association, organization or firm will be permitted to exist or control one building or one foot of ground in this park that is not for the benefit of all the citizens in San Diego."[49]

Unfortunately, thieves, who were decidedly not seeking to benefit all the citizens in San Diego, broke into the California Building on or about March 19 and stole two paintings of Egyptian subjects painted by M. Guignon.[50]

In late March, political rivals George W. Marston and Louis J. Wilde signed a petition asking the War Department to set up a training camp at the Exposition for applicants for military service.[51] While the primary motive of these city stalwarts was to benefit San Diego with new military installations, they were not unmindful of the release by the British of the Zimmerman telegram on February 24 disclosing German attempts to inveigle Mexico into a war with the United States and of the sinking of three American ships by German submarines on March 18.

At a time when the Exposition Beautiful was receding in public interest, the fact that George W. Marston was a champion of the City Beautiful movement worked against him in his campaign for mayor.[52] Since Marston had the support of Exposition backers G. Aubrey Davidson, John F. Forward Jr. and D.C. Collier, those people to whom the Exposition was not a panacea, including ex-mayors D.C. Reed and James E. Wadham and incumbent mayor Edwin Capps, sided with Louis J. Wilde, an energetic banker whose connection with the Exposition was remote.[53]

An entertainment at the Organ Pavilion on March 31 marked the withdrawal of Exposition management from park affairs. Twenty-three-

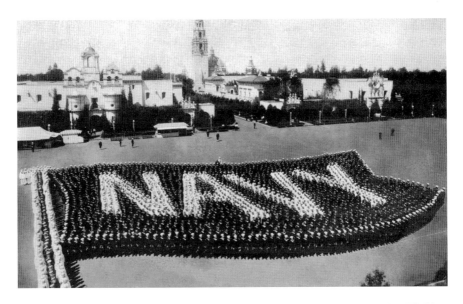

After the Exposition ended, Balboa Park became the Naval Training Camp during World War I. This living flag on the Plaza de Panama was composed of 3,400 sailors. *Rosemary Ann Phelan Photo Collection. Panama-California Exposition Digital Archive.*

year-old mezzo-soprano Tsianina Redfeather Blackstone, wearing a beaded headband and buckskin dress, sang songs of Charles Wakefield Cadman, who accompanied her on the piano. These included "The Place of Breaking Light," "From the Land of the Sky Blue Water" and "Ho, Ye Warriors on the Warpath." Tickets cost twenty-five cents each.[54]

The formal farewell took place at an evening dance in the Cristobal to which four hundred guests with reservations were admitted.[55] Sensing that the public was being excluded from the farewell celebration, the Exposition management decided to reduce the admission fee to ten cents for adults and free for children, to keep the gates open until 10:00 p.m. and to hold an open-air dance on the Plaza de Panama from 7:30 p.m. to 9:30 p.m., with music supplied by the Twenty-first Infantry Band.[56]

Two events occurred in April that shifted San Diego's attention away from Balboa Park and temporarily stopped plans to transform Exposition buildings and grounds into a public park. These were the election of Louis J. Wilde as mayor on April 3[57] and the entry of the United States into World War I on April 6,[58] which followed by four days the German U-boat sinking of the U.S. warship *Aztec*. Anticipating the formal declaration of war, the Park Board on April 5 authorized Colonel D.C. Collier to go to

Balboa Park and the 1915 Exposition

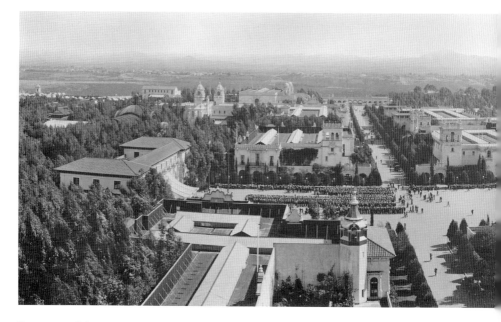

Panorama of the Exposition site in 1917, as Naval Training Camp. Photo by O.A. Tunnell. *Joy Ledford Collection, Panama-California Exposition Digital Archive.*

Washington, D.C., to offer the War Department free use of Exposition buildings and grounds.[59]

An auditor's report dated March 31 showed a net profit of $38,406.10, including net assets of $13,879.10, a revenue surplus of $16,054.27 and cash-on-hand of $8,473.39.[60] Final accounting of receipts and expenditures is not clear. It is not known how many subscribers fulfilled their pledges and how much of the profits were distributed to stockholders and the Park Board.

Wheeler J. Bailey, chair of the Finance Committee of the San Diego Museum, reported on August 1 that the Exposition still had about $6,500 on its books. Bailey said 50 percent of the stockholders had agreed to release their entitlements to the Museum Association.[61] By the end of July, stockholders had transferred $416,855 in certificates to the museum. Records show they signed over another batch of $253,340 in September.[62]

As late as June 1919, President Davidson was still trying to settle the Exposition's obligation with the Park Board. The board was willing to strike from its records charges to the Exposition for maintenance in 1916, with the proviso that if Los Angeles stockholders returned money to the Exposition, it would be given to the board.[63]

BALBOA PARK AND THE 1915 EXPOSITION

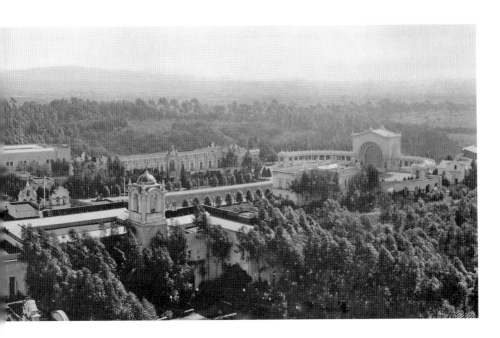

Looking back almost one hundred years after the event, some observations can be made about San Diego's extraordinary two-year Exposition. The Exposition cost about $3 million and left San Diego with about $2 million in physical improvements—buildings, landscaping, roadways and infrastructure. It acquainted visitors with the resources of the Southwest and stimulated investment and settlement; it brought famous people to San Diego; it accelerated the growth of military installations and the improvement of the harbor; it set new standards in architecture and city planning; it developed an appreciation for music; and it promoted San Diego as a center for archaeological and anthropological exhibits.[64] The San Francisco Exposition cost about $15 million and left only the Palace of Fine Arts.[65]

On the negative side, the Exposition introduced divisions in San Diego's political life that still exist. The dichotomy between Louis J. Wilde's fast-growth and George W. Marston's slow-growth ideas still polarizes the community. The need for free, open recreational space still clashes with the need of some people for more restricted spaces or with their unwillingness to give people without means any open space at all.

Before the Exposition, Balboa Park had landscaped strips on its west and south sides; sections covered with sage, greasewood and wild flowers; groves

of trees growing in Cabrillo Canyon and on the central mesa; a road system for leisurely carriage traffic; a series of picturesque canyons; an assortment of birds, bees, butterflies and wildlife; and awesome views of mountains, bay and ocean.

After the Exposition, Balboa Park had lost many of its natural advantages and had obtained in their place a permanent Exposition covering 625 acres in its center, where art, science, education, dance and theater flourished. However, unlike birds, flowers and bees, the amenities of civilization came with a price. Balboa Park also got exotic planting, which grew so fast that it crowded out indigenous species and hid the buildings. Topiary along El Prado was not kept up. It was short-lived, in any case, and soon reverted to chaos. As trees died or the bougainvillea and clematis became too burdensome to keep up, they were replaced with adventitious plantings at variance with the 1915 design.

On the positive side, John Morley, laboring outside the central mesa, saw to it that sagebrush gave way to grass and shade trees. Morley concentrated on English-style landscaping, while Frank Marsh, superintendent of playgrounds, equipped the Golden Hill section of the park with facilities for sports, dance, drama, storytelling and clay modeling and conducted an annual May Day Festival at Park Avenue, between Juniper and Kalmia, in Balboa Park for the entertainment of children.[66]

Though the playground movement was strong in San Diego, the Park Board ignored a suggestion by Marian Pounds, a member of the Board of Health, to convert an Exposition building into a gymnasium and to establish golf links, tennis courts and athletic fields in the park as "playgrounds for grownups."[67]

University of California professor of decorative design Eugen Neuhaus admired several features of the 1915 fair that no longer exist. A list of vanished glories would include the small pond at the base of Cabrillo Bridge; the boxed cypresses in the Plaza de California; the Blackwood acacias along El Prado; the walkways behind buildings; the clearing north of the California Building; the lawn behind Montezuma Gardens; the neoclassical-style pergola in the Botanic Gardens; the white walls of temporary buildings; the bignonia, bougainvillea and clematis that covered walls; the arcades and patios of the Science and Education Building; the sheltered porch of the Sacramento Valley Building; the Plateresque tower and second-story pergola of the Home Economy Building; the suffused lighting that enhanced the deep architectural relief; and the peacocks, bush fowl and guinea hens that ran freely in the Plaza de Panama.[68]

Many distracting elements have been introduced since 1916 that do not reinforce the image of a vast estate built by a rich Spanish grandee in days gone by.[69]

San Diego's decision to turn its principal park into a "city" featuring buildings rather than into a park featuring plants was not unique. Many cities have used their parks similarly. Some have avoided the conflict by choosing non-park lands for expositions.

In urging the Board of Directors of the Panama-Pacific International Exposition to choose some other location for the Exposition besides Golden Gate Park, William Hammond Hall, original architect of the park, wrote, "It is the natural form of the grounds and the natural-like growths upon them which constitute the chief charm of the park, as any and every park must depend on the dominating influence of these qualities for its high ranking as such."[70]

Realizing that masses of buildings would jeopardize the character of their park, residents of New York City in 1881 defeated former president Ulysses S. Grant's plan to put a World's Fair in Central Park.[71]

Landscape architect Frederick Law Olmsted Sr. chose Jackson Park on the shores of Lake Michigan in Chicago to be the site for the 1893 World Columbian Exposition. Twenty years before, Olmsted had prepared plans to turn the site into a park; however, these plans were never implemented. Olmsted planned a system of waterways, lagoons, islands, hills and knolls with the understanding that, except for a Palace of Fine Arts (now the Museum of Science and Industry), the rest of the park would revert to a landscaped appearance.[72]

Businesspeople put expositions in parks because parks provide land that "costs nothing" and is used by people considered to be of little importance, such as the old, the young and the poor. Outdoor scenery and wildlife are of doubtful monetary value. Anyway, blotting them out in one place does not mean blotting them out everywhere. Powerful people retained the following buildings put in parks after the Expositions were over that called them into being: Memorial Hall, built for the 1876 Centennial Exposition in Fairmount Park, Philadelphia; the Fine Arts Building and the Japanese Tea Garden, built for the 1894 Midwinter Exposition in Golden Gate Park, San Francisco; the replica of the Parthenon, built for the 1897 Tennessee Centennial Exposition in Centennial Park, Nashville; the New York State Building, built for the 1901 Pan-American Exposition in Delaware Park, Buffalo; and the Fine Arts Building, built for the 1904 Louisiana Purchase Exposition in Forest Park, St. Louis.

Balboa Park and the 1915 Exposition

Planners leased land around Guild's Lake in northwest Portland, Oregon, on which to build the 1905 Lewis and Clark Exposition. When the Exposition was over, many buildings mysteriously burned. Buyers moved others off site. The sole reminder of the Exposition, a log cabin, burned down in 1963. Developers filled Guild's Lake with rock and gravel in 1912. Afterward, they turned the flats and higher ground into an industrial site.

Sponsors of the 1907 Jamestown Tercentennial Exposition in Norfolk, Virginia, planned to use its forty-four state, government and exhibit buildings as the core of a "colonial" suburb. These plans went awry when receivers took over the buildings. The U.S. government purchased the buildings and grounds in 1916. Since then, the Hampton Roads Naval Operations Base has occupied the site.

Seattle's Exposition promoters located the 1909 Alaska-Yukon-Pacific Exposition on the shores of Lake Washington and Union Bay. The 355-acre parcel belonged to the University of Washington, which then consisted of three buildings outside the Exposition's perimeter. When the Exposition closed, its landscaped grounds and more than twenty temporary and three permanent buildings became part of the university.[73]

Ironically, the gift to the University of Washington of so many buildings proved to be a mixed blessing, for they interfered with a planned program of campus development, were expensive to adapt, presented constant maintenance problems and brought serious deterioration to the campus.[74]

Seeing how other cities had enhanced their economies and acquired substantial improvements by holding expositions bolstered the optimism of San Diego businesspeople. Merchants and bankers in a small town in the southwest corner of the United States dreamed that an exotic Spanish colonial city surrounded by lush subtropical plants would be more appealing than any Exposition city yet created. It would attract people, promote culture and stimulate business. Even a failure, as at Jamestown, had a positive side, for it showed that the U.S. Navy and Marine Corps would be willing to pick up the pieces. Despite quibbles from "knockers," boosters, who wanted to make money and to bring about change, chose the best sections of Balboa Park for temporary exposition buildings and argued later for the conversion of these buildings to commercial, cultural, civic and military ends.

John C. Olmsted, landscape architect for the Panama-California Exposition, resigned on September 1, 1911, because he placed a higher value on the park as open rather than civic space and because he knew that an attempt to combine the two would produce a hybrid that would

not serve either goal well. Olmsted's night letter (a telegram sent at a reduced rate at night and then delivered in the morning) of August 10, 1911, follows:

> *Understand exposition site is to be discussed further. We hope you realize that no advantage for exposition that has been claimed for central site can possibly compensate for ruining the most important part of Balboa Park. All permanent improvements at the site would be utterly inharmonious with any rational landscape development of that part of park. All such formalities should be confined to outer margins of park. This principle would be satisfactorily accomplished at proposed southern site. Our study of scores of large parks justifies us in asserting with the utmost confidence that Balboa Park if left free and open in central part will be worth far more in the long run than any advantage can be secured to the exposition by changing it to the central location. The exposition and especially the permanent buildings are south of Spanish Canyon and bulk of temporary buildings at central site, some of the latter would inevitably be retained, as at Seattle, for proposed agricultural college and other uses and plazas. Straight roads and walks, fountains and other ground improvements must be made permanent there if paid for out of park funds and would be utterly incongruous with naturalistic treatment appropriate for that locality.*[75]

When people refer to Balboa Park as "the jewel of San Diego," they generally have in mind the remnants of the 1915 Panama-California Exposition that survive on El Prado. To many people, these wedding-cake buildings, the contrasts between shaded arcades and sunny plazas and the variety of people and entertainers on El Prado afford a diverting experience. It is not, however, a park experience. People do not wander through woodlands nor play and relax on greensward. Those people who go to El Prado on weekends seeking amusement are not overly concerned with the loss of personal spaces or with difficulties encountered in parking their automobiles.

John Burchard, late dean of humanities at the Massachusetts Institute of Technology, thought the complex of buildings along El Prado in Balboa Park was the nearest approximation in the United States to the Tivoli Gardens in Copenhagen, "although, despite the Zoo, these are weighted heavily on the cultural and international side."[76] He expressed this thought before today's amusement, theme and marineland parks proliferated, offering food, trees, paths, flowers, marching bands and fireworks.

Balboa Park and the 1915 Exposition

Though architecture critic Ada Louise Huxtable has written, "You can't go home, or to the great World's Fairs again,"[77] she was only partially correct. In San Diego, the Exposition goes on, and people from everywhere flock to Balboa Park to see its attractions.

CHAPTER 6

First Americans Come to Balboa Park

When our democracy is impelled by the Spirit of God to deal honestly, justly and fairly with our own American Indian, American Negro, American Chinese, American Japanese and all other American citizens, we shall have a democracy that will never die, it will flow as a clean, clear river to cover the earth as the waters cover the sea.
—*Tsianina Redfeather*

Colonel David Charles Collier, mastermind of San Diego's 1915 Panama-California Exposition, thought up the idea of an ethnology exhibit for the Exposition that would present the indigenous background of the Americas.[1] After discussing the matter with businesspeople and scholars, he decided to concentrate on the archaeological and cultural resources of the Southwest.[2] He chose the Southwest for interpretation, rather than San Diego County or California, for by so doing, people with means in the southwestern states could be persuaded to send exhibits. Attempts were made to convince these people that San Diego would become the "first port-of-call" for ships coming through the soon-to-be-completed Panama Canal, and therefore the port to which they could send goods for shipment to national and international destinations.[3]

As it turned out, New Mexico, Nevada, Utah and Kansas were receptive to Collier's assurances. Arizona, Colorado, Oklahoma and Texas declined. After all, San Francisco was holding a government-sanctioned exposition at the same time. It was reasonable for southwestern states to recognize

the dynamic and colorful northern city, which then had a population ten times that of San Diego. New Mexico, the exception, chose to exhibit only at San Diego. Having a railway system that began in Chicago and ended in both San Francisco and San Diego, the Santa Fe Railway sent exhibits to both fairs.[4] The six-acre exhibit at San Francisco contained a Grand Canyon panorama, an exhibit building and a small Indian Village, consisting mainly of holes in the sides and top of simulated cliffs. A coach took visitors for a thirty-five-minute ride on a standard gauge rail along the sides of the miniature canyon, stopping at seven stations that disclosed different views of the canyon. Beginning in 1901, the Grand Canyon Railway, a spur of the Santa Fe, took passengers from Winslow, Arizona, to the south rim of the canyon, where they lodged in the luxurious El Tovar Hotel, developed and operated by the Fred Harvey Company, a dependency of the Santa Fe Railway.[5]

Collier secured New Mexico not only through the force of his flamboyant personality, but also because he had intrigued Dr. Edgar L. Hewett, founding president of the School of American Archaeology (later known as the School of American Research). Realizing that Hewett's educational ideas were pragmatic versions of his own imaginative schemes, and deferring to his administrative ability and knowledge, Collier got him appointed director of exhibits.[6] Hewett controlled the ethnological character of the Exposition.[7]

As a result of Hewett's intervention, officials in New Mexico agreed to set up a special exhibit—the largest of the state exhibits—in a modified replica of the Mission Church of San Esteban del Rey at Acoma, easily the most impressive architecturally of the Exposition's state buildings.[8] Hewett also acquired exhibits for the Indian Arts, Science and Education, Fine Arts and California State Buildings. The last, despite its name, was devoted to the display of Maya artifacts, stelae and monuments.[9]

Dr. Ales Hrdlicka and other physical anthropologists in the National Museum in Washington, D.C., helped obtain exhibits for the Science and Education Building. Inspired by the evolutionary theories of Charles Darwin, these anthropologists considered "mixed" races to be superior to pure, and the white race, a composite of many pre-historic strains—to which they belonged—to be the most superior of all. Hrdlicka was born in Bohemia. He was not of white Anglo Saxon stock, and he did not endorse theories of Nordic or Anglo-Saxon superiority. By means of casts of skeletal remains and skulls of aboriginal peoples, busts of primates and Java, Neanderthal and Cro-Magnon man and facial molds of Indians, Negroes and whites from birth to death, exhibits lent credence to the idea that selective breeding

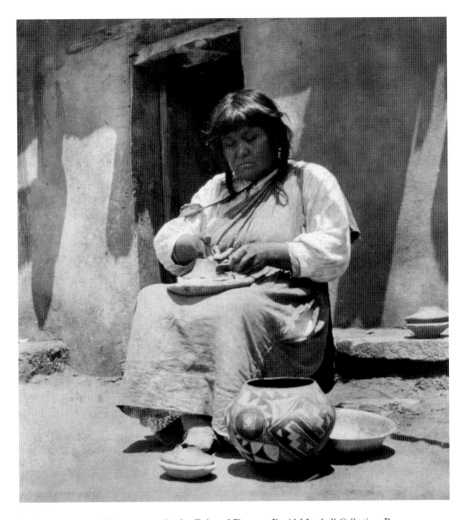

Indian woman making pottery in the Painted Desert. *David Marshall Collection, Panama-California Exposition Digital Archive.*

would produce stronger, more intelligent human beings. Weak, defective and "backward" peoples would disappear under such an enlightened acceleration of evolutionary progress.

Ales Hrdlicka was a middle-of-the road proponent of the pseudo-science of eugenics that was in vogue in the early '20s. Whether he agreed with cultural anthropologist Franz Boas's view that no one race is superior to another is difficult to determine, as some of his statements indicate qualified agreement. He preferred hybrid races to pure and did not subscribe to the

notion of Nordic or Anglo-Saxon superiority. He would probably concede that the term "race"—which he used to distinguish white people from yellow-brown and black—is an abstraction that covers a multitude of more or less uniform characteristics. He had doubts, however, about certain racial subgroups, as these approached the status of being "pure." Bureau of Indian Affairs agent Archie Phinney used Hrdlicka's statement, "There is probably not a full-blooded Indian in this continent today," to bolster his argument of changing the one-fourth exclusion rule to one-half—thus reducing the number of Native Americans who could qualify for tribal or reservation membership. Even more extreme was his prejudice against Negroes. African American physical anthropologist Michael L. Blakey wrote that Hrdlicka considered Negroes to be so inferior to whites that mixtures of the two would result in the degeneration of the white race. Hrdlicka corroborated this view when, in the book *Human Races*, he wrote, "If such a union occurs between two mentally unequal races, such as the white and the black, the children are an improvement of the belated parent, though not equaling the more gifted one." He expressed his horror of miscegenation most forcefully at a Race Betterment Conference in 1928. David Duke, one of the leading racial segregationists in America, has cited Hrdlicka's claims to back up his anti-social opinions, despite African American successes in medicine, scientific research, business, music and art. In view of these findings, Matthew F. Bokovoy's attempt to dismiss Hrdlicka's role in promoting racial animosity is not convincing.[10]

As an archaeologist whose focus was on the past rather than the future, Hewett did not advocate the emergence of a superior race. Indeed, he found grace, simplicity and spiritual profundity in ancient and living Indians, qualities he did not find among aggressive and acquisitive white people. It was no accident, therefore, that the Indian Arts and New Mexico Buildings presented an affirmative view of Southwestern Indian achievement. Even exhibits in the California State Building reflected Hewett's curiosity about the symbolism and historical uses of the Maya ruins in Central America. Hewett had been in charge of expeditions to Quirigua in Guatemala before the Exposition started. Consequently, it was a stroke of luck that San Diego got plaster casts of Quirigua stelae and monuments, which today are in better shape than their originals.[11]

Working together, Collier and Hewett persuaded Edward P. Ripley, president of the Santa Fe Railway, to set up an exhibit of living Indians in surroundings that looked like those in their native lands. By sharing their different points of view, these men managed to create an idyllic picture of

Native Americans as a gentle, colorful, primitive people who lived close to the earth. Indians may have been on display, but they did not cater to white people's prejudices as did the abused Igorots, from the Philippines, at other United States expositions.[12]

Hewett suggested that the Santa Fe exhibit highlight the accomplishments of Indians. He recommended that his colleague, Jesse L. Nusbaum, be hired as superintendent of construction. In 1912, Nusbaum, as supervisor, and Julian Martinez, as foreman, remodeled the Palace of the Governors in Santa Fe. Julian, a Tewa Indian from San Ildefonso, was the husband of the famous potter Maria Martinez. Nusbaum and Martinez set up an Indian Village exhibit for the Panama-California Exposition.

Indian workers and actors at the Exposition thought well of Hewett and Nusbaum. Their feelings toward the Santa Fe Railway were more complicated. On one hand, the railway paid for their services; on the other, the railway asked them to act as "show" Indians. While on display, they were expected to be ideal, heroic, picturesque, romantic and primitive—an archetypical embodiment that would fascinate onlookers who were anything but ideal, heroic, picturesque, romantic and primitive.[13] In general, the Indians lived up to the "noble savage" image they helped to create, though occasionally they mocked onlookers and lapsed into rowdiness.

Newspapers called the Santa Fe exhibit the "Painted Desert," but people called it the "Indian Village." As with most Exposition proposals, the first plan was grandiose. According to Collier, who talked habitually in hyperbole, there would be "the last great composite picture of the Indian tribes of the Pacific Coast," ranging from Southern California to Tierra del Fuego.[14]

Hewett's description was a degree less extravagant:

> *In their war paint and feathers, with their ponies, their war dances, medicine men and other of their queer customs, the Indians will be shown perhaps as never before. They will live exactly as they do on their reservations, sleeping in wigwams and cooking in the open. Every tribe will be represented. Some of them are fast dying out and this may be the last chance to see them as they were before the white man pushed them onto the limited reservations they now occupy.*[15]

While Hewett had ambivalent feelings over whether the Indians were a "vanishing race," he thought steps should be taken to keep them from losing their culture. Like the Indians, he did not approve of the assimilation goals of the Bureau of Indian Affairs.[16]

Balboa Park and the 1915 Exposition

Taos pueblo with hornos (outdoor ovens) in foreground. *David Marshall Collection, Panama-California Exposition Digital Archive.*

Though Hewett and Collier might have wanted it otherwise, it was unlikely that the Santa Fe Railway—or any other sponsor—would have been interested in assembling a "Grand Congress of Indians."

At Collier's urging, president Ripley, in October 1913, agreed to set up seven hundred to eight hundred Indians from tribes living along the railway "in a great community house."[17] The idea was not original, as Indians had lived in make-believe versions of their homes at fairs in Chicago (1893), Buffalo (1901), St. Louis (1904),[18] Portland (1905), Jamestown (1907) and Seattle (1909). Most of these exhibits emphasized the customs of local Indians, but due to the interest produced by the discovery in 1888 of the cliffs and domiciles in Mesa Verde, replicas of cliff dwellings were featured in Chicago, St. Louis and San Diego. Ripley's plan was unrealizable because so many Indians from so many places could never live harmoniously in a "great community house."

Knowing that the picture of handsome, dignified, taciturn and exotic Indians in colorful robes, backdropped by the blue skies, multihued hills and vast spaces of the Southwest could be converted into a magnet to draw tourists, Ripley was eager to convey this image to the American people. Since 1907, the Santa Fe Railway Company had sent calendars with pictures of the Southwest across the country and had paid lecturers to extol the charms of the region.[19] Ripley was not a crusader for Indians, but he recognized that the beauty they represented in themselves, in their crafts and in their

settings would appeal to passengers on his railway.[20] Ripley and William H. Simpson, general passenger agent for the Santa Fe Railway, may not have believed in the myth of a vanishing race, but they realized that the idea added poignancy to the presence of Indians and that the contrast of a pre-industrial anachronistic culture with a modern automated industrial culture would dazzle spectators.

A typed, transcribed article written before the Exposition in *Prospectus for the Panama-California Exposition, 1915,* conveyed the idea that visitors were to look on the Indians as backward and primitive and to compare their methods of agriculture with those at the model farm, International Harvester and other exhibits located nearby. One can only guess at the reaction of visitors. Doubtless there were some who saw in the simplistic Pueblo Indian life before them an opportunity to gloat. The irony is that the Indians knew they were pretending. True, they had retained the religious orientation of their culture, but they were already on the way—their own way—to adapting to the modern world.[21]

Another anonymous writer in the *Prospectus* described a planned concession on the Isthmus in even more demeaning terms. This was of an "old-time plantation" with "an array of coal black mammies preparing real corn pone while a group of black boys in the corner sing negro melodies to the accompaniment of the banjo and the lively capering of a few frizzle-headed pickaninnies." It is refreshing to note that no such concession appeared on the Isthmus in 1915 or 1916.

In January 1914, Edward Chambers, vice-president of the Santa Fe Railway, looked over the site for the Indian exhibit at the north end of the Panama-California Exposition. Pleased with what he saw, he expressed his confidence that the six-acre exhibit and the depot the Santa Fe Railway was building in San Diego would bring thousands to visit the city in 1915.[22]

The *San Diego Union,* in March 1914, attributed the design of the Santa Fe Railway exhibit to Herman Schweizer, director of the Indian Department of the Fred Harvey system in the Southwest, a dependency that provided food, hotel and sightseeing services along the Santa Fe Railway.[23] On the other hand, Chris Wilson, author of *The Myth of Santa Fe,* attributed the design to Kenneth Chapman, who created a scale model that Jesse Nusbaum followed in construction.[24]

The *Union* article described the future exhibit:

> Passing through the low adobe entrance, the visitor will find himself in the plaza of an old Indian pueblo, of the type familiar in Arizona and New

Mexico, only far more complete. He will see their strange dwellings, one surmounting another, two or three stories high, with paths worn hollow in the bricks and the crude wooden stepladders to the rooms fronting on the corridors above.

He will see the subterranean council chambers, also reached by ladders, where the solemn and secret rites of the tribe are performed by priests and medicine men on religious anniversaries and where all vital affairs are discussed by the chiefs and elders. These council chambers, by the way, are ordinarily never accessible to the average white man.

Beyond the main settlement, on lower ground, and divided from it by a gradual elevation, are several smaller groups, Navajos, Hopis and Mohaves. Here the character of the country will be different. There will be a narrow stream of water, perhaps, or pools with clumps of brush and little truck gardens.[25]

The *San Diego Tribune*, in 1914, estimated the cost of the project at $100,000;[26] the *Santa Fe Magazine*, in 1915, gave the cost as $250,000;[27] and the *San Diego Union*, in 1920, stated the cost was $150,000.[28]

The railway company placed a model of its plan for the Indian Village in the window of its office in the U.S. Grant Hotel in downtown San Diego and additional models in agencies of the railway in other cities.[29]

Nusbaum supervised twenty-three Indians, most of whom were from the San Ildefonso Pueblo in New Mexico's Rio Grande Valley. Indians leveled and smoothed a mesa rising above a canyon on the east.[30] Matthew F. Bokovoy pointed out that, unlike their "terrible living conditions" at the St. Louis Fair in 1904, the San Ildefonso Indians "modified" the design of their "pseudo Pueblo" into "something resembling home."[31]

The Painted Desert, on the west side of the compound, contrasted with a Pueblo-style Indian Village on the east. Semi-nomadic Navajos in the "desert" lived in hogans, Apaches in dome-shaped wickiups and Havasupais in brush-covered shacks with dirt-covered roofs. A cliff house, whose walls looked as though they had been blackened by centuries of smoke, harkened back to the prehistoric Anasazi, who are believed to be the ancestors of Hopi and Pueblo Indians.[32] Navajo hogans were divided into summer and winter varieties, the summer being constructed of cottonwood and leaves, the winter of cedar and earth.[33]

The real Painted Desert is an extension of the Petrified Forest in Arizona. It is on the Santa Fe Railway's line, east of Holbrook. Its name comes from the many-colored mineralized stratifications of its steep

Cliff dwellers in the Painted Desert. *David Marshall Collection, Panama-California Exposition Digital Archive.*

hills. Neither Painted Desert nor Petrified Forest were represented at the Panama-California Exposition. No fossilized remnants of ancient trees with crystallized cavities of amethyst, onyx, quartz and topaz were used, as newspapers would have reported it if they were. The only attempt at stratified coloring was on the walls of a magically transported cliff house. To make matters worse, a reporter called the Cliff House the "home" of the Mountain Apaches, who lived in the White Mountains of Arizona, approximately ninety miles to the south.[34]

The Indians found a layer of clay below the surface of the Painted Desert.³⁵ They converted the clay into adobe for use on buildings and on a wall surrounding the compound. They also made thatch out of leaves, stems and branches for use on roofs. Nusbaum told non-Indian carpenters, who constructed the buildings, not to make their work look too skillful.³⁶ Even so, the workers depended on traditional wood framing, rather than adobe bricks, to hold up the buildings. To give the buildings an authentic appearance, they put wooden bolts or leather thongs on doors in place of hinges, hewed windows with an adze and compacted the earth for floors.³⁷

A reporter for the *San Diego Union* was astonished to find that Florentino Martinez, a spokesperson for the San Ildefonso Indians, spoke excellent English.³⁸ The same reporter promoted Julian Martinez, another English-speaking Indian, to the rank of "chief." Julian was a painter and potter. His wife, Maria Martinez, joined him later at the Exposition. Maria invented her well-known black-on-black pottery with matte designs in 1919.³⁹ Crescencio Martinez, a member of the group, was a painter in water colors.⁴⁰ Considering that the Indian population of San Ildefonso in 1915 was about one hundred, their showing at San Diego was phenomenal.⁴¹

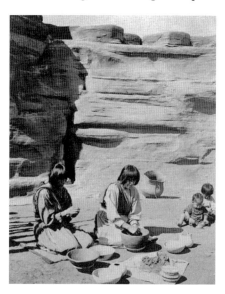

Women making pottery in the Painted Desert. *David Marshall Collection, Panama-California Exposition Digital Archive.*

Main buildings in the Indian Village looked like the terraced pueblos of Taos and Zuni. As these buildings had been made by non-Indian workers and as they differed from the one- and two-story buildings at San Ildefonso, the Indians doubted they would stand.⁴² The terraced structures faced one another across a plaza. Two kivas—one for the summer kinship group, the other for the winter—a trading post, small buildings representing a Hopi village and ground-hugging houses, like those in San Ildefonso, occupied spaces near the main buildings. One kiva was submerged, and the other was partially above ground.⁴³ Indians entered them through ladders on the roof.

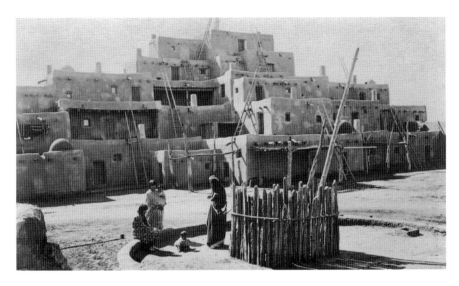

Women and children by the entrance to an underground estufa (or kiva). *Michael Kelly Collection, Panama-California Exposition Digital Archive.*

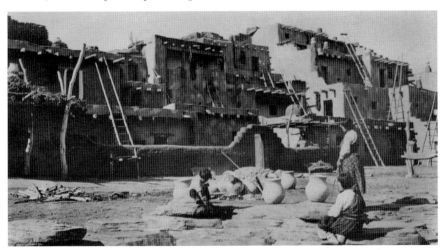

Woman and children with Zuni pueblo in background. *Michael Kelly Collection, Panama-California Exposition Digital Archive.*

Indians hung peppers, fruits and vegetables from overhangs of buildings. They worked and played in the plaza. Here they cooked over fireplaces and in bread ovens, herded cattle, sheep, goats and horses into corrals and cured hay and wood on racks. The cactus, sage, plows, cartwheels and rusty tools lying about on the plaza and desert were elements of stage scenery and not reflections on the housekeeping habits of the Indians.[44]

Lacking from the demonstration of Indian culture (but not noticeably so, since reporters did not mention it) were the plots where corn, beans and squash—the staples of the Indian vegetable diet—were raised, using the "dry" farming techniques of the western pueblos or the communal irrigation techniques of the eastern Upper Rio Grande pueblos. That the so-called primitive Indians were sophisticated and ecologically aware in their farming methods is generally conceded by anthropologists today, though it was haughtily assumed otherwise in the early 1900s.[45]

Sculptor Harry Baumann made "artificial stone" out of cement over chicken wire for rock outcroppings in front of the Taos pueblo and for the misplaced Cliff House next to the Painted Desert. Nusbaum said the rocks looked so much like the real thing that the only way to tell the difference was to bite them.[46]

The Santa Fe Railway Company imported cactus, cedar posts and rocks from Arizona.[47] The Indians used the posts to fence the corrals and to fill gaps in the walls around the compound. Herman Schweizer, the Santa Fe representative in charge of maintenance and displays, achieved a coup just before the Exposition's January 1, 1915 opening, when, with the help of J.L. Hubbel from Gallop, he smuggled in a carload of sheep, thus outwitting animal inspection authorities.[48]

Indians behaved like happy and outgoing people when Nusbaum was with them, but they kept their distance from visitors. The *Union* reported, "With Nusbaum they laugh and play like school boys sometimes, but with the average visitor the number of subjects appertaining to themselves upon which their minds are good-natured blanks is appalling."[49]

In November 1914, the Indians performed the Dog, Eagle and Sioux War Dances for visiting writer Elbert Hubbard in the aboveground kiva. In the Dog Dance, two female dancers hold leashes attached to the belts of two male dancers who are painted black from head to toe. Imitating dogs, the males gesture menacingly at one another as they step forward and backward. At the end of the dance, they drop to their knees and fight for a loaf of bread. The dance may have been a Sioux Peace Dance in which two warriors engage in combat to decide the outcome of a battle. It is possible the San Ildefonso Indians learned this dance during their stay at the 1904 St. Louis Louisiana Purchase Exposition.[50] In war and peace dances of this type, males wear feathered headdresses and paint themselves black. Women wear modest headbands with three feathers attached. The Eagle Dance, one of the most popular Pueblo dances, will be described later.

Nusbaum used the occasion to explain the significance of the kiva:

There is considerable Indian lore attached to the kiva, of which I will give you one version. Tradition has it that the Indians started in a dark world underground and traveled up through the ages to the light. This first stage, which was very damp and cold, is represented by a lower chamber below the main kiva. In emerging from it they are supposed to have come up through what is known as the sipapu, a small hole in the floor. Then they found themselves in a lighter world, represented by the kiva proper. The next step was up into the world in which we live now, which is represented by the roof of the kiva.

But on coming out into the world, the light was so bright that it hurt their eyes. So they returned for a time, and took with them lightning with which they kindled a fire. After becoming accustomed to the light, they returned to the world and remained there. The top of the original kivas used to be above on a level with the ground, but later development brought them to about the level we have here.[51]

After the Exposition opened in January 1915, Nusbaum returned to Santa Fe to take charge of the construction of the Santa Fe Art Museum, an adaptation of the New Mexico Building in Balboa Park.[52] Architect Isaac Hamilton Rapp used the Mission Church of San Esteban del Rey at Acoma Pueblo as his model for these two buildings and for the Colorado Supply Company Warehouse in Morley, Colorado, the first of the series.[53]

D.E. Smith, manager of the Hopi House at the Grand Canyon of Arizona for the Fred Harvey System, took over in San Diego as manager of the Santa Fe Railway exhibit.[54]

We do not know how many Indians lived in the compound. The *San Diego Union* stated there were about two hundred Indians on and sometimes off the grounds, as the Indians wandered about the city whenever they could.[55] During one such visit to downtown San Diego, Ka-ka-ki, a ninety-year-old Apache, who claimed to have been one of Geronimo's scouts, made several trips on an elevator and bought a five-cent bar of soap and a bottle of cheap perfume. Indians with him insisted on buying articles one at a time in order to see the pneumatic chute deliver the change.[56] In the evenings, Indians enjoyed being thrown off the revolving Toadstool, a ride on the Isthmus.[57]

Reporters counted seven tribes on the Painted Desert. These were Apache, Navajo, Havasupai, Hopi, Tewa from San Ildefonso, Keres from

Left: Estufa in Taos, New Mexico, from a stereoview. *W.H. Jackson & Co., Denver, Colorado, photographer.*

Below: Mission San Esteban Rey at Acoma Pueblo, 1941. Ansel Adams, photographer. *National Archives. 79-AA-A03.*

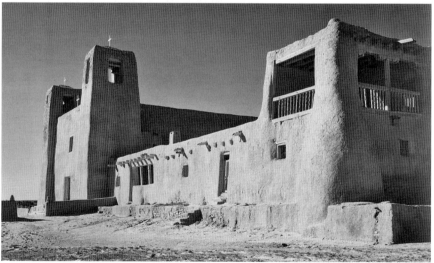

Acoma and Tiwa from Isleta and Taos.[58] The Zuni, the most secretive of Pueblo Indians, were not represented. Hewett imported nine adults, two boys and three babies from San Ildefonso to show themselves and make crafts in the Indian Arts Building. This group insisted on living in the Painted Desert, where they felt more at home and where clay for making pots was available.[59]

As each tribal group of Indians kept to themselves, a reporter took this as a sign of "rivalry" between the tribes.[60] As a comparable group of whites

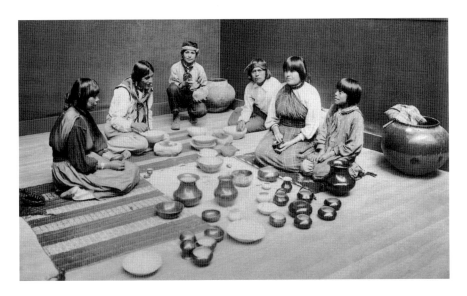

Pottery demonstration at the Indian Arts Building. *David Marshall Collection, Panama-California Exposition Digital Archive.*

would exhibit the same behavior on first contact, the aloofness of the Indians was not that different. It takes time for people to "break the ice."

The Indians soon adjusted to a routine. Navajo women sorted and carded wool and wove it into blankets and rugs. Navajo men pounded out copper and silver ornaments.[61] Pueblo women shaped pottery.[62] Clerks at the trading post gave the Indians clothes, groceries and money for the goods they made. The Indian barter system had already taken a back seat to the needs of a cash economy.[63] In the evenings, men and women on both sides of the mesa conducted ceremonies inside and outside the kivas.[64]

Maria Martinez brought sacks of sand and clay from San Ildefonso. Her first assignment was to make pots with bottoms knocked out for the chimneys of pueblos. As these were bigger than the pots she usually made, she had to discover a new method of coiling. Julian decorated his wife's pots after they had been fired, using designs found on shards during excavations of Anasazi settlements. With money she received from the railway and from selling pots, Maria bought a cooking stove and a sewing machine and built a room in her home in San Ildefonso in which to sell pots.[65]

Julian relished his role as a "tourist Indian." When white women asked him if he were married, he replied, "Me no got wife, lady. Me look for one. You marry with me, huh?" Maria got back at him when they went to look

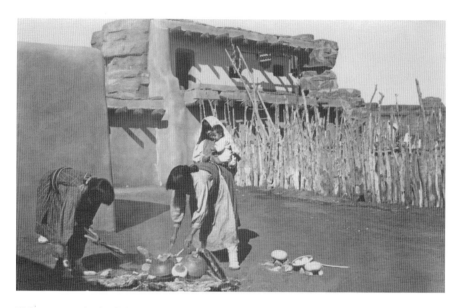

Firing pottery in the Painted Desert. *Michael Kelly Collection, Panama-California Exposition Digital Archive.*

at monkeys in cages near their compound. Julian said, "They're just like people, but different. I like looking at them." Maria responded, "Well, I don't. I can look at you, and I don't see so much difference."[66]

Proud of his mustache of twenty-seven separate hairs, Megalite, a Navajo medicine man, claimed he was the only Indian ever to grow a mustache.[67]

Ignoring a taboo against dancing away from their village, the San Ildefonso Indians performed many Pueblo dances, but they left out the sacred parts. They danced the Eagle Dance more than the others. As with all Pueblo dances, the Eagle Dance represented a prayer and a blessing. The Indians considered the eagle to be a messenger that brought water from the sky to nourish the earth.[68] Julian and Florentino Martinez wore white caps with beaks, rows of eagle feathers down each arm and decorated shields on their backs as they pivoted with arms held out to suggest the bird in flight.

The Buffalo Dance—described incorrectly in the *San Diego Union* as a Hopi dance—had a magical purpose. While wearing masks of buffalo, elk and antelope, the dancers moved in the measured pace of the animals they represented as they pantomimed the stalking, shooting and death of sacrificial game. As a woman—the Buffalo mother—took part in the dance, it was not a surprise when the male dancers invited motion picture actress Grace Darling to join in.[69]

A more serious taboo occurred when Waldo C. Twitchell, assistant manager of the New Mexico Building, allowed the showing of a film taken surreptitiously depicting the Corn Dance at Taos during the Harvest Festival of San Geronimo. Indians from the Taos pueblo broke into the New Mexico Building at night and made off with the sacrilegious film. Not feeling rebuked, Twitchell sent to the Museum of New Mexico in Santa Fe for a copy of the film. He attributed the Indian zeal to "religious superstition," a malady from which he was immune.

Charles Montgomery considered the theft of the newsreels of the Fiesta de San Geronimo to be a "hoax," concocted by the director of the New Mexico Building to generate publicity; however, Matthew F. Bokovoy adduces many reasons arguing for the authenticity of the theft. This writer supports the Bokovoy version.[70]

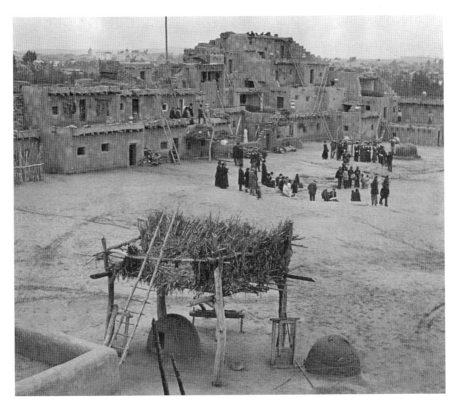

Fairgoers observing a performance with the Zuni pueblo in background, 1915. Detail from Keystone stereoview #17695. *Panama-California Exposition Digital Archive.*

Edward P. Dozier has suggested the Indians concealed aspects of their dances as European-Americans, not understanding their significance, tried to suppress them.[71] Such was probably the case with the Corn Dance. *Koshares* or clowns acting as invisible spirits of the deceased could not be seen by other dancers, but they were very much seen by spectators. Among other pranks, they made fun of the reputed size of sexual organs of individuals in the audience. Being sensitive on this score, European-Americans forbade further performances of the "obscene" dances.[72]

Artists came in such large numbers to the Painted Desert to sketch the Indians that at times they took up most of the space for spectators.[73] Foremost among them was Robert Henri, who lived in New York City. Alice Klauber, chairperson in charge of the Exposition's art department, had invited him to San Diego.[74] Henri arranged for an exhibit of American impressionists and artists of the "Ash Can School" at the Exposition's art gallery. Encouraged by Dr. Hewett, in 1916, Henri set up a summer studio in Santa Fe. He was among the first of the "second generation" of eastern artists to come to New Mexico,[75] bringing in his wake such well-known members of the then progressive wing of American art as Paul Burlin, George Bellows and Leon Kroll.[76]

In a lecture to his Art Students League class in the fall of 1916, Henri explained his motivation in producing canvases of Yen Tsi Di and Po-Tse in San Diego and Po-Tse-Nu-Tsa in Santa Fe, saying, "I was not interested in these people to sentimentalize over them, to mourn over the fact that we have destroyed the Indian…I am looking at each individual with the eager hope of finding there something of the dignity of life, the humor, the humanity, the kindness, something of the order that will rescue the race and the nation."[77]

Hopi women offered cornmeal to the Great Spirit before they allowed visitors to take their pictures. Visitors could recognize maidens in the tribe as they wore their hair in two large whorls over the ears.[78] However, the women a reporter saw with the unique coiffure nursing babies were clearly ignoring the custom.[79]

Manager Smith took about one hundred Indians to Ocean Beach in San Diego. For the first time, they saw the ocean. At first, they were afraid the ocean would sweep them away. Finding that this did not happen, they set about collecting seashells to use in the making of ornaments. A reporter who tagged along wrote that the Indians thought the shells had a value "equal to twenty to thirty head of sheep." When he asked an old Indian why he sprayed salt water on his chest, the Indian replied with a harsh-sounding word that Smith translated as, "None of your damned business."[80]

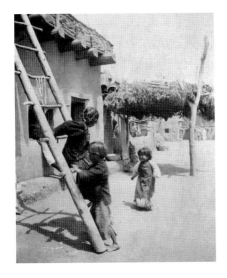

Native American children playing at the Painted Desert. *David Marshall Collection, Panama-California Exposition Digital Archive.*

Ray Cooper, an Australian sheepshearer, pitted his skill against Ko-Wa-To at the Painted Desert. Cooper used a machine and Ko-Wa-To sheared by hand. The Indians claimed their man won the contest because while Cooper sheared two sheep to Ko-Wa-To's one, he drew blood, a violation of a rule of the contest.[81]

In June 1915, See-Wu-Qui-Vista, a seventeen-year-old Acoma Indian, gave birth to a boy. Twenty-six Hopi men, women and children insisted on congratulating the mother, which showed the Indians could be neighborly when they wanted to be. The infant's parents named their offspring "San Diego."[82] Ex-president Theodore Roosevelt named another baby, born to Maria Trujillo on July 1, "Theodore Roosevelt Trujillo" during his visit to the Painted Desert on July 20.[83] Roosevelt knew many Indians on the grounds by name as he had met them before in New Mexico.[84]

The Santa Fe Railway continued to sponsor the Painted Desert in 1916, when the Panama-California International Exposition, as it had been renamed, continued for a second year. Press releases had tapered off as San Diegans were beginning to take the Exposition for granted.

The New York Motion Picture Company filmed scenes for *The Castilian* (released as *The Captive God*) on the Painted Desert in February. Director Charles Swickard instructed the Indians to defend their homes from Spanish attack. The events were supposed to have taken place in the time of Montezuma, and the Painted Desert was being used as a substitute for an Aztec town. (Could the producers have been thinking of Tenochtitlan?)[85]

Three Indian boys raced their burros through the village in honor of a visit by Santa Fe Railway president Ripley in April. A Navajo lad offered his goat to Ripley, who was not eager to pat boy or goat.[86]

The Hotel del Coronado played host to Hopis, Navajos and Acomas in May. The Indians romped up and down the beach, ate popcorn, looked at horses in the stables and gathered around an aviary containing canaries in the hotel's patio.[87]

No other items about Indians appeared until Thanksgiving Day—theirs, not the Americans—September 23, when the tribes got together for a barbecue of goats, corn and squash to which they invited visitors. While the *San Diego Union* was not specific, the Hopi appeared to have hosted the feast. Red Clay, a boy, executed movements from the Eagle Dance in which the eagle left its high crag, soared aloft and settled finally in its nest with feathers fluttering over its brood. The Squash Dance followed in which Indians thanked the Great Powers that had provided them with food. Men wore headdresses of squash and stomped in unison while facing women who, kneeling before them, supplied the rhythm by scraping notched sticks together.[88] The Butterfly Dance, described as "a ragtime movement of joy,"[89] concluded the dance portion of the program. Traditionally, Pueblo Indians performed the Butterfly Dance in the spring to honor women and procreation. Female dancers wore two rows of feathers on their backs representing butterflies. The short, shuffling steps they and their male partners made to the right and left suggested butterflies fluttering from side to side.[90]

Hopi reserved September for women's dances in honor of the harvest and fertility. Having some characteristics of the Basket Dance, these dances involved the giving away of food and presents. Since Secretary of the Interior Albert B. Fall disapproved of such largess, he tried unsuccessfully in 1922 to persuade the U.S. Congress to pass a law forbidding the dances.[91] Hopi women's dances were not given in San Diego, perhaps because there were not enough dancers.

A *San Diego Union* reporter's remarks about the Eagle Dance were symptomatic of the uncomprehending attitudes of Americans toward Indian religious ceremonies that have led to attempts to suppress them: "His crude imagination easily makes the eagle a messenger of the Great Spirit whose power has moulded the bowl (of the Universe). Despite all the training of civilization he still does homage to this superstition with the dance of his ancestors."[92]

While the dances were going on, Hopi women cooked corn, squash and mutton in baskets by placing hot stones on the bottom, the food next and a layer of clay as a seal on top. After they opened the cooker, the feast was ready.[93]

The U.S. Army Twenty-first Infantry, stationed at the Exposition, feigned an attack on the Painted Desert in October, in which the Indians were beaten. A *San Diego Union* reporter stated the name of the "chief" in charge of the Indians—actually a man with the last name of Brown—was "Chief Knock-

em-stiff Brown." Such flippancy showed a deplorable lack of understanding of the Indian Village after two years of attempted education. That Brown would have allowed this grotesque mistreatment of his charges shows the gulf between the humane aspirations of Dr. Hewett and Nusbaum and the commercial goals of a business enterprise. Movie cameramen captured the action for showing in screen dramas.[94]

The Santa Fe Railway gave the Painted Desert to the City of San Diego in January 1917. The Indians went back to their homes, where they held themselves in readiness for calls to future fairs. Fairs, however, were suspended due to the United States' entrance into World War I on April 6, 1917.

The Twenty-first Infantry Regiment, under the command of Colonel J.P. O'Neill, converted the vacated Indian Village into an officers' quarters.[95] Enlisted men continued to live in tents on nearby Tractor Field or along the north-central borders of the park on a site formerly occupied by the U.S. Army First Cavalry.[96] The Twenty-first Infantry Regiment had arrived at the Panama-California International Exposition in April 1916. It became so popular because of its participation in band concerts, ballroom dances, patriotic exercises and parades that the *San Diego Union* called the regiment "San Diego's Own,"[97] forgetting it had already given that title to the Fourth Regiment, U.S. Marine Corps.[98]

During the war, the Twenty-first Infantry looked for spies along the international border, trained soldiers for new regiments, conducted drives for recruits, helped sell Liberty Bonds and taught San Diego's Home Guard how to subdue potential enemies.[99] Someone in the War Department in Washington, D.C., must have approved naming the camp after Walter R.

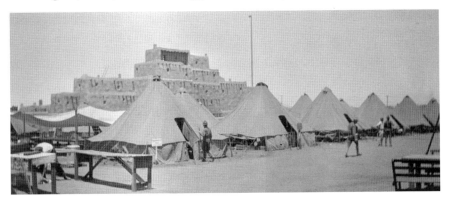

The Twenty-first Infantry moved into the Painted Desert in early 1917. Photograph by Allen Wright. *San Diego Public Library Collection. Panama-California Exposition Digital Archive.*

Taliaferro, a U.S. Army aviator who had been killed in an accident.[100] In August 1918, the War Department transferred the Twenty-first Regiment to Camp Kearny to prepare for active service as part of the Sixteenth Division. A remnant may have remained at Camp Taliaferro until hostilities ceased on November 11, 1918. Whether they were at Camp Kearny or in Balboa Park, commanding officers issued orders confining soldiers to quarters during the 1918 flu quarantine.[101]

The Twenty-first Infantry made few changes to the Painted Desert. They cleared debris from the mesa and took down corrals but left the Cliff House intact.[102] The San Diego Museum Association got the five-acre compound in March 1919 (one acre seems to have been lost).[103] Dr. Hewett, director of the museum, planned to keep the Indian Village open as a center for boys' and girls' Indian woodcraft activities, as outlined in a book of Indian games written by Ernest Thompson Seton.[104] Seton knew some chants, dances and games of the Ojibwa in Ontario, the Omaha in Nebraska and the Sioux in the Dakotas, but he knew little about the customs of Indians in New Mexico and Arizona.[105]

The San Diego County Council of the Boy Scouts took possession of the Indian Village on June 4, 1920.[106] In 1927, the Scouts raised $35,000 to put the buildings in good condition and to add a swimming pool, mess hall, camping facilities, wash rack and showers.[107] In 1935, when the Scouts surrendered the compound to San Diego's California Pacific International Exposition, they retained about three hundred square feet of land, including the mess hall and swimming pool.[108]

The California Pacific International Exposition's reuse of the compound as an Indian Village was farcical. Concessionaires were ignorant of Indian accomplishments. Their sole purpose was to make money. Shows were on the same level of crassness as the raucous attractions at the adjacent Midway. Despite scenarios inappropriate to the setting—fortune-telling Indians, songs written by white people sung by Indians, children doing silly dances called "Little Deer" and "Little Badger," sailors doing foxtrots with Indian women, a Kickapoo magician running swords through a box with an Indian woman inside and a young person with the non-Indian name of "Jean Peters" in a pit full of snakes—the shows were not crowd-pleasers. While the Exposition continued into 1936, officials did not renew the contract for a second season of carnival attractions in the Indian Village.[109]

The Scouts again relinquished the facility on December 29, 1941, to the Twentieth Regiment, U.S. Army, an antiaircraft regiment. The regiment used the Indian Village as a headquarters and supply depot for antiaircraft

The San Diego County Council of the Boy Scouts took over the Painted Desert in 1920. *David Marshall Collection, Panama-California Exposition Digital Archive.*

batteries along the coast. The Third Battalion commandeered the Spanish Village, a short distance to the south. Though it was infested with rats, fifteen officers slept in the Spanish Village. About seventy enlisted men were luckier as they slept in barracks put up on the grounds.[110]

The Boy Scouts may not have known it in December 1941, but they had said goodbye to Indian Village. Their attempts to keep Indian traditions alive during their occupancy seldom exceeded the level of games, such as hand-slapping, hand-wrestling, rubbing sticks together to make fire, singing while sitting around a fire and imitating bird and animal calls. Such games were probably rare occurrences.[111]

In 1946, after the U.S. Army moved out, the San Diego Fire Department burned down the six wood and stucco structures that were still standing.[112] Shelving a plan to landscape the area, the city directed a contractor to prepare the grounds for a Veterans War Memorial Building, after rejecting plans to put the building at the upper end of Cedar Street or on El Prado in Balboa Park.[113] Workers put the building up in 1948. Since voters had shown in 1945 that they were unwilling to pay for the construction of the building, the city used for this purpose $300,000 from the sale of Camp Callan, a U.S. Army artillery training facility, which, during the war, had been located on Torrey Pines Mesa.[114]

Survivors of the Boy Scouts, who occupied the most unusual Boy Scout Camp in the world[115] for twenty years, look back fondly on their time in the Indian Village. Nonetheless, the lasting significance of the Painted Desert derives from its use in the 1915–16 Exposition. For a time, visitors to San Diego could see real Indians living in surroundings that resembled those in their homelands. These Indians stirred their affections. Psychoanalysts might find the explanation for this attraction to come from the collective unconscious of European-Americans. Perhaps there was a time in the past

when their ancestors lived in harmony with Earth, Sky and Stars; a time when Grandmother Spider helped emergent people to find homes at the navel of the world; when Monster Slayer and his brother slew monsters; when rains fell, crops ripened and people rejoiced; when everyone walked in beauty; and when Animal, Bird, Plant and Place Spirits taught people to cure illnesses, protect crops, vanquish enemies and dispose of the dead.[116] Was it from within their collective unconscious or from the vividness of their imaginations that visitors thought such things might be possible?

To attract tourists to the pueblos of Isleta, Laguna, Acoma, Zuni and Hopi near its main line, the Santa Fe Railway promoted an image of the Indians as heroic icons. The railway commissioned artists to produce paintings of Southwest Indians in picturesque settings for reproduction in calendars and magazines; promoted the sale of Indian pots, blankets and baskets in Fred Harvey restaurants and hotels; and hired writers and lecturers to describe

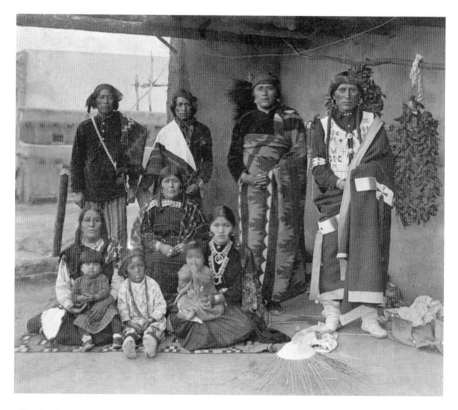

"By the Zuni Pueblo in the Painted Desert," from Keystone stereoview #17682. *David Marshall Collection, Panama-California Exposition Digital Archive.*

the "land of enchantment."[117] As the ultimate in poetic metamorphosis, the railway named its trains Navajo, Chief and Super Chief so patrons would think they possessed the glamour and quiet-strength of their names and were not just smoke-bellowing, fire-breathing, earsplitting machines.[118]

The Pueblo Indians were not paragons of virtue. They had been mistreated for centuries by white men. Yet because of the respect they inspired in archaeologists like Dr. Hewett and in artists like Robert Henri, they were beginning to realize their capacity for creativity and to appreciate the culture that had sustained them in the past.[119]

American artists at Santa Fe and Taos, such as Gustave Baumann, Gerald Cassidy, Marsden Hartley, Robert Henri, John Sloan and Carlos Vierra, and Indian artists, such as Crescencio Martinez, Awa Tsireh, Fred Kabotie and Ma-Pe-Wi, working with Dr. Hewett created images of handsome and noble Indians that were not synthetic, since the Indians were there to substantiate their depictions. They were reminders that there was a race on the American continent that had evaded, in Dr. Hewett's words, "the evolutionary processes in the European races to the white skin, the contentious spirit, the passion for individual glory, [and] the determination to rule."[120] The Indians' grasp of natural realities suggested to city dwellers, separated from nature, an alternate way of living, although one more suitable for contemplation than imitation. By showing Indians that they could be admired as human beings and as artists, Dr. Hewett and the Santa Fe and Taos artists built up the Indians' self-esteem, an esteem that had been undermined for four hundred years by conquerors from Spain, Mexico and the United States.[121]

The 1915–16 Exposition spurred the growth of San Diego and California in ways that have been discussed many times.[122] Overlooked—except by people in Santa Fe—was its effect in promoting Indian art, in developing the Santa Fe Museum of Art, in fashioning the Santa Fe style and in shaping the Santa Fe Fiesta. These accomplishments grew out of the Painted Desert, the mission/Pueblo-style New Mexico Building and displays of southwestern arts and crafts in the Indian Arts Building.[123]

Chris Wilson gave the popularity of the "pseudo-pueblo" style an ironical twist when he stated that "museum [of New Mexico] staff realized that the tourists they hoped to attract to Santa Fe yearned more for contact with Pueblo Indians than with Hispanics."

Dr. Hewett remained in San Diego from 1917 to 1928 as director of the San Diego Museum and from 1919 to 1927 as a professor of archaeology at San Diego State College.[124] He alternated his services between San Diego and Santa Fe, where he served as president of the School of American

Balboa Park and the 1915 Exposition

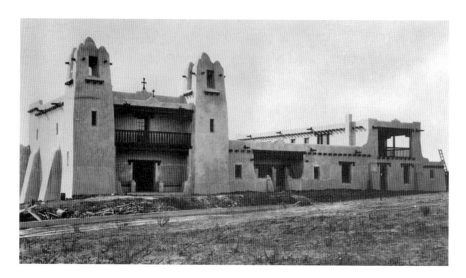

New Mexico Building under construction. *David Marshall Collection, Panama-California Exposition Digital Archive.*

Research, beginning in 1907, and as director of the Museum of New Mexico, beginning in 1909, until his death in 1946. He was a lecturer; writer; editor; publicist; fundraiser; archaeologist in charge of excavations at Tyuoni, Frijoles Canyon and Chetro Ketl; and leading force behind the writing and passage of the U.S. Congressional Antiquities Act of 1906, which protected ancient ruins on public lands.[125]

Hewett saw how by staging the Panama-California Exposition, the small city of San Diego could use a backdrop of picturesque Spanish-style buildings, a cast of costumed actors and a variety of displays and amusements to entice tourists to visit and to buy. Guided by advice from realtor Colonel Collier, architect William Templeton Johnson and artist Alice Klauber, he brought the message of renewal to Santa Fe.[126] Whatever he did, Hewett's main motive was to promote the Indians as Indians in lands given to them by spiritual powers to whom they were inextricably bound.[127]

> *Within and around the earth*
> *Within and around the hills*
> *Within and around the mountains*
> *Your authority returns to you.*
> —*Tewa verse*[128]

BALBOA PARK AND THE 1915 EXPOSITION

Indians in an electriquette. *David Marshall Collection, Panama-California Exposition Digital Archive.*

It is the attribute of belonging to one another and to the earth, sky and powers beyond that fascinated mobile European-Americans. The Indians seemed to live in contented kinship with animals, plants, rocks and trees. They did not own nature; it was the other way around. When overburdened, money-conscious, property-obsessed, status-seeking, future-preoccupied, existentially tormented European-Americans looked at Indians living by the rhythms of the seasons as they had done before European-Americans had arrived and at their multicolored, vast, unspoiled land, they saw a vision of an innocent America as it must have been before dams, factories, fences, machines, mines and weapons of mass destruction had scarred its surface and wounded its soul, and they were filled with admiration and amazement.[129]

CHAPTER 7

East Meets West in Balboa Park

Japan was the first nation to set up exhibits at the 1915 Panama-Pacific International Exposition in San Francisco. Its six-acre exhibit, the largest sponsored by a foreign country, consisted of five main buildings, nine summerhouses, a lagoon, a stream crossed by tiny bridges, a small mountain down which plunged a cascade and thousands of trees and plants.[1] A reception building copied the Kinkaku, or Golden Pavilion, at Rukuonji, Kyoto, without the third story. A small lagoon near the pavilion reflected its slender pillars and graceful curves. The Golden Pavilion is the most reproduced of Japanese buildings. A more accurate facsimile had been put up in St. Louis for the 1903–04 Louisiana Purchase Exposition.[2]

Japanese architect Goichi Takeda designed the buildings for the San Francisco Fair and Hanosuke Izawa designed the two-acre garden. Businesspeople from Japan and Formosa installed exhibits in the official government buildings and in Exposition palaces devoted to education, agriculture, food products, liberal arts, transportation, mining, manufacturing and varied industries. Looking like the homes of daimyos before Commodore Matthew Perry opened the country to foreign commerce in 1854, official government buildings had sliding panels, upturned roofs, bracketed eaves and wood-beam supports. One such building, nearly five thousand square feet, contained an art collection that reputedly belonged to Emperor Yoshihito of Japan.[3]

A *Los Angeles Times* reporter stated that the Japanese concession on the Amusement Zone consisted of "four quaint houses, dainty rooms, and

queer shops with geisha girls to entertain and dainty maidens to serve refreshments."[4] The reporter's fondness for clichés was greater than his powers of discernment. Wrestlers, dancers, jugglers and acrobats tried to keep visitors' eyes off the geisha girls.

Professor of history Robert W. Rydell was annoyed by a 120-foot Buddha that stood over the entrance to an Amusement Zone concession and by the bazaars and shooting galleries inside.[5] Turning the great Buddha into a gaudy spectacle seems tacky, but activities inside the concession were no different from other stereotypical offerings along the "Joy Street." Anyway, they were installed and run by Japanese.

San Diego's rival 1915 Panama-California Exposition was smaller and more regional than that of San Francisco. It highlighted archaeological and anthropological displays, advertised the agricultural potential of the Southwest, presented industrial exhibits stressing process over product and provided a setting of acacias, eucalyptus, palms, flowering vines and cactus from which emerged Spanish Colonial churches and palaces.

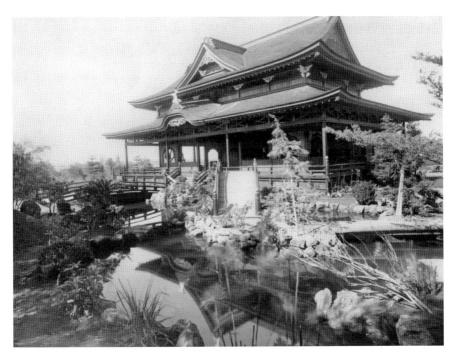

Japanese teahouse and garden, 1914. *Courtesy of the Japanese American Historical Society of San Diego.*

Tucked in a corner of the grounds, a short distance from El Prado, the San Francisco firm of Watanabe and Shibada built a teahouse and garden.[6] The firm also managed the display and sale of goods, imported by Kyosan Kai Company, in the Foreign and Domestic Arts Building and the Streets of Joy concession on the Isthmus, San Diego's equivalent of San Francisco's Zone.[7]

Merchandise in the Foreign and Domestic Arts Building ranged from inexpensive to dear and included Chinese and Japanese arts and crafts. A representative explained how pearls were artificially cultivated by introducing foreign substances inside oysters, and artisans demonstrated their skill in carving ivories. Merchants were anxious to show that Japanese goods were better than those of other nations and in keeping with the changing tastes of American buyers. They claimed that the Morimura white china they sold could be mistaken for Haviland china and that the cloisonné they sold, with and without wire, was superior to cloisonné made by the Chinese, from whom the Japanese had learned techniques of manufacture. While the fans, paper napkins, kimonos, pearls, teakwood cabinets, tapestries, screens, china and cloisonné were for sale, other objects were to be looked at, such as a cloisonné plate valued at $2,500, a mahogany cabinet valued at $10,000, a pearl valued at $40,000, a large Makuju vase and images of Fujin, god of the winds, from a temple at Nara.

Scholars have commented that by displaying Japanese products that reinforced cultural stereotypes, Japanese merchants in the United States slighted the more refined products made in Japan for local consumption and ignored (if they knew) the works of their country's past. Sherman Lee, director of the Cleveland Museum of Arts, declared that the brocaded-gold Satsuma ware sold in the Foreign and Domestic Arts Building at San Diego was "produced for the worst taste of the Victorian era."[8] Likewise, Hina Hirayama wrote that the quality and craftsmanship of Japanese ware sent to the United States to satisfy a craving for Japanese decorative objects ranged "from excellent to makeshift, crude and cheap."[9]

Inside the Streets of Joy on the Isthmus, built to resemble a provincial town in the Edo period, diners ate chop-suey (a Chinese American dish) at a restaurant, acrobats performed in a theater and gamblers played cards and tossed dice. The gamblers could, if they were lucky, win kimonos and bowls of goldfish. Apparently the games were of an innocent character, for there is no record that the sheriff or district attorney tried to close the operation, as they did so often games at the Camp of '49.

Exhibit in the Foreign Arts Building. *Panama-California Exposition Digital Archive.*

Reporters were so caught up in describing the main attractions of the Exposition that they overlooked the Japanese contribution. It is possible they did not know how to interpret what they were seeing. Pictures of the teahouse were published with puerile comment about a Bridge of Long Life in front. The exaggerated arch and shortened span of the bridge were not typical of Chinese and Japanese bridges, which traditionally took the half-moon shape to enable pleasure boats to pass underneath and to show off their reflections in the water. All the talk of getting good luck or of prolonging life by climbing over the bridge was poppycock!

The garden was an adjunct to the teahouse. G.R. Gorton, in *The California Garden*, described its features. Plants, stone lanterns, bronze cranes and a winding stream were squeezed into a space so small that everything was foreground. There was no sense of depth or of "borrowed' scenery from afar. Even so, details were carefully executed and placed by gardeners aware of the techniques of bonsai and ikebana.[10] Overall harmony of elements was, however, sacrificed for compressed effects, which could be best seen only from a frontal position. Unlike courtyard and vestibule gardens in Japan, the garden in Balboa Park was not

enclosed by a fence or wall that would define its space and determine its boundaries.

San Francisco's two-acre garden was larger and more varied than that of San Diego. It had 1,300 trees, nearly 4,400 plants, 25,000 square feet of Korean turf, more than 250 rocks and paths winding around buildings and across lagoons.[11] But the garden in San Diego had features enough to fill in empty spaces, the spaces from whence some observers think comes the mystery and power of Japanese gardens.[12] It had stone lanterns, bronze cranes, a nearly one-hundred-year-old "Sugi" pine less than three feet in height, azaleas, wisterias, dwarfed cedars and dwarfed weeping junipers, maki pines, bamboo, Korai-shiba grass, two cycads, a ginkgo tree, aralia and laurel shrubs, miniature falls, a winding stream, two pools and brocaded koi.[13]

To a Japanese gardener, rocks are among the most important elements in a garden. Yet Gorton ignored this feature. Rocks of exquisite color, texture and shape were in the Balboa Park garden in rows, clusters, along the water's edge, in the water as islands and stepping stones and along paths as lanterns and water basins. To the horror of lovers of Japanese gardens, these venerable rocks were thrown away when the garden was demolished.

Gorton was informed about the plants but uninformed about the teahouse. He claimed it was a copy of a teahouse in Katsura, a district of Kyoto, that had been in existence for two thousand years. Since Kyoto was founded in AD 794, the statement is false. Moreover, the Balboa Park teahouse is as much like the simple, small, cha-seki teahouses belonging to the Detached Palace in Katsura as Thoreau's ten-feet-wide by fifteen-feet-long hut at Walden Pond was like the seventy-story RCA Building in Rockefeller Center.

Struck by the difference between the secular teahouse and garden in Balboa Park and the quiet passageways and rustic pavilions in monochrome Japanese tea gardens designed by the Zen tea master Sen-no-Rikyu (1521–1591), Tanso Ishihara and Gloria Wickham claimed the "small Japanese exhibition house," drum bridge, a second bridge spanning a winding stream, carp, water lilies, flowering trees and a snow lantern in Balboa Park were "closer in spirit" to the informal multicolored shinden pleasure gardens of the early Heian period (784–1183).[14] However pertinent this observation may be to the Hakone Garden at Saratoga, California (the subject of Ishihara's and Wickham's study), it is difficult to relate it to the 1915 Exposition garden in Balboa Park. The hostess at Hakone and waitresses in Balboa Park served tea to guests on open verandas in a casual, non-religious atmosphere. There the resemblance ends.

Balboa Park and the 1915 Exposition

Osamu Asakawa by the bridge in the Japanese garden at Balboa Park. *Courtesy of the Japanese American Historical Society of San Diego.*

An *Official Guide to Balboa Park* published on April 15, 1925, claimed the teahouse was similar to "a structure one would find on the wooded slopes of Mount Fuji, pagoda-roofed, with paper-windowed walls, and a wide verandah."[15] Another guess from a stay-at-home traveler!

Carleton M. Winslow, resident architect for the Panama-California Exposition, wrote that the teahouse was designed by K. Tamai.[16] The Watanabe and Shibada Trade Association shipped parts made in Japan to San Diego along with Japanese carpenters, who put the parts together using mortises, tenons, pegs and wedges.

By looking at photographs of Japanese buildings, one can see that the model for the building was not a public or private teahouse but a Buddhist temple. The basic structure of the building, based on the post-and-lintel system, the prominent roof, the deep overhangs and the complex brackets, was Chinese in origin. While possessing many Chinese touches, the building was less ostentatious than its Chinese ancestors. In its massing, two levels, center entrance and veranda, the pavilion looked like the Mampu-ji, or Lecture Hall, at Uji, near Kyoto. Art historian Noritake Tsuda has described the Mampu-ji as "almost entirely Chinese in style."[17]

Though the building in Balboa Park appeared to have two roofs, it was a one-story building with an intermediate or pent roof, shielding an open veranda. Both roofs were covered by wood shingles rather than tiles. The

main hip and gable (irimoya) roof with its curving eaves, was as striking as a woman's colossal hat. The entrance was on the lateral side of the building, not, as is common in Japanese temples, on the narrow or gable side.

A cusped gable above the center entrance contrasted with a triangular dormer gable on the main roof. The intermixing of gables was a feature of the great castles (donjon) built during the Edo period, such as Hikone and Himeji Castles.[18] Cresting elements on the gables of the Balboa Park building resembled the flamboyant, ceremonial helmets worn by samurai.[19] Carved dragons, Hoho birds and Sachi fish, under gables and eaves and at ridge ends of the roof, symbolized long life and happiness. Ironically, the fish had their mouths closed. This was inappropriate as Sachi fish swallowed devils and put out fires by spouting water from their mouths.[20] Mythological allusions on the building were modest compared to the exuberant treatment of mythological subjects on the mausoleum buildings at Nikko, near Tokyo.

A simple, modular, asymmetrical Sukiya Shoin style, of which the Detached Palace at Katsura is the prime example, was introduced into Japan in the fourteenth century.[21] Gardening techniques were modified to blend with the new, unaffected style of ground-hugging buildings.[22] Ornate older-

Hoho birds in a small pond in the Japanese garden. *Courtesy of the Japanese American Historical Society of San Diego.*

style buildings were still constructed by the military rulers, but the displaced aristocracy and followers of Zen Buddhism preferred the quieter styles. The Balboa Park teahouse and grounds represented the older, exclamatory style.

The approach to the teahouse being short, there was no room for the surprises a visitor would discover at every turn in a meandering pond (chisen-kaiyu-shiki) garden. A narrow, concrete walkway led in a straight line over a simply curved red-vermilion lacquer bridge, up a short flight of stairs and into the main room of an axial building.

While it had the appearance of a Buddhist temple on the outside, sliding (fusuma) screens on the inside divided spaces into private and public rooms. Sliding paper-covered (shoji) screens replaced windows on outside walls, allowing the passage of soft light. Windows were more likely to be open than closed. An indoor eating room had a high, coffered ceiling with paper transom panels containing spiral patterns, swastikas, flower crests and depictions of cranes in flight. Young women, dressed in silk kimonos with their hair piled up in elegant coiffures, served tea, rice cakes, kumquat candies and green ice cream on verandas and inside the building.

An elevated tatami room to the right of the entrance was out of place as such rooms belonged to "writing-table," shoin-style homes and would not be found in large commercial (o-chaya) tearooms. The tatami room was equipped with an alcove (tokonoma) decorated with a hanging scroll (kakemono) and a vase with formal (rikka) or informal (nageire) flower arrangements. A post (toko-bashira) separated the alcove from staggered shelves (chigai-dana) on which were displayed incense burners, sake cups, tea bowls and tiered food boxes. No photographs survive of the tatami room, but it is doubtful the chigai-dana came up to the standards of the famous staggered shelves of the Jodan-no-ma, or First Room of the Detached Palace in Katsura.[23] People who entered the tatami room were expected to take off their shoes and to sit on the floor. Proprietors of the teahouse lived in quarters in the rear of the building.[24]

O-chaya teahouses in Japan are located along crowed streets in the older sections of cities. Bamboo blinds hide indoor activities from the view of pedestrians. Rooms may open onto small gardens with stone lanterns and strands of bamboo. Specially trained geisha girls served male guests sake and entertained them by dancing and playing the shamisen.[25]

At the conclusion of the Panama-California International Exposition, Watanabe and Shibada gave the teahouse to the City of San Diego. The city, in turn, leased the building to Hachisaku Asakawa. Asakawa; his wife, Osamu; and a cousin, Gozo Asakawa, managed the concession through the

A woman in the Japanese teahouse, circa 1917. *Courtesy of the Japanese American Historical Society of San Diego.*

1935–36 Exposition and up to the entry of the United States into World War II. Along with other Japanese Americans on the West Coast, the Asakawas were interned during the war.[26]

The American Red Cross used the teahouse as a lounge for U.S. Naval Hospital personnel and patients until 1946, when the navy moved back to its main hospital grounds. As the money the federal government paid the city for wartime damages to buildings in Balboa Park was not enough to cover repairs, the building deteriorated. Boarded up but defenseless, super-patriots and vandals turned the teahouse into a shambles.[27] The garden reverted to chaos. In November 1954, Milton G. Wegeforth, president of the Zoological Society, requested of the City of San Diego that the two acres on which the teahouse and garden were situated be assigned to the society for a children's zoo. In April 1955, workers razed the teahouse and garden.[28]

Balboa Park and the 1915 Exposition

Lovers of the beauties of past ages regretted the passing of the Japanese teahouse and garden in Balboa Park, even as they rejoiced over the opening in August 1990 of the first phase of the San Diego Japanese Friendship Garden. The phoenix—a Japanese and also an Egyptian symbol of resurrection—resides today in this lovely garden.

The new garden, designed to be built in five phases, occupies an 11.5-acre site embracing most of a canyon called Spanish Canyon in 1915–16 and Gold Gulch Canyon in 1935–36. Appointed in 1985 by the Japanese Garden Society of San Diego to prepare plans for the site, Takeshi Ken Nakajima named the garden San-Kei-En, which means a garden with three types of scenery. These are pastoral, mountain and lake. Nakajima took the name from a garden of the same name in Yokohama, San Diego's sister city since 1957, that he had helped to restore after the bombardments of World War II. A landscape architect with an international reputation, Nakajima has designed gardens in Japan, Canada, the United States, Russia and Australia.[29] In 1993, he created a 5.6-acre Japanese garden in Hermann Park in Houston, Texas, taking care to preserve tall pine trees and old oaks on the site.[30]

The Asakawa family managed the teahouse after the Exposition. *Left to right, front row*: Motoharu and Harue Asakawa; *second row*: Hachisaku and Osamu Asakawa; *third row*: Kakuo Henry Yoshimine, Sukeharu Yato and Sukazu Yato. Dated July 4, 1917. *Courtesy of the Japanese American Historical Society of San Diego.*

The garden in Balboa Park will conform to the stroll (kaiyu-shiki) garden style. A garden house, cultural center and teahouse will be in a complementary naturalistic "tea taste" (sukiya shoin) style. Classes on the tea ceremony and Japanese culture will be conducted in the buildings.

One-story buildings will be so oriented that people seated inside can view the gardens. Sukiya-style villas are known for their restraint, use of rough-hewn posts and checkerboard patterns of translucent paper and opaque plaster panels. Teahouses in the Sukiya style are small and rustic. To preserve their natural character, ceilings are open and wood posts and lintels are crudely finished. Stepping-stone paths, lined with stone lanterns, lead to the teahouses. Guests rinse their mouths and wash their hands at a water basin before stooping to enter through a crawl door. Samurai who took part in the tea ceremony had to hang their swords on a rack outside, as weapons did not belong in the world of tea.[31]

With so many outstanding stroll gardens in Japan to provide inspiration and with the changing spaces and elevations of the Balboa Park canyon to manipulate, there was every likelihood that if his plans were followed, Nakajima would create a Japanese garden in Balboa Park comparable to the wonderful Japanese gardens in Vancouver, Seattle, Portland, San Francisco and Los Angeles. It is wishful thinking to equate American Japanese gardens with gardens in Japan because cultural, topographical and climatic factors are different.

Ken Nakajima died in 2000. He maintained a long-distance interest in the Balboa Park garden until the end. His control over its development was, however, curtailed because of financial considerations and disagreements over the garden's philosophy. Nakajima did not support the placement of a food-curio shop in a forecourt at the garden's entrance, which, among other impediments, took away from the modulated approach to the garden's entrance pavilion. In 1994, the Board of the Japanese Friendship Garden Society of San Diego appointed Takeo Uesugi to prepare plans for the forecourt and the yet-to-be developed nine-and-a-half-acre pastoral, mountain and lake garden in Gold Gulch Canyon, with, perhaps, not so much emphasis on the lake. The garden would still be the stroll garden that Nakajima envisioned, but his plans were modified to preserve live oak trees and to address problems of topography and climate that he was not able to deal with during his time as the garden's designer. Nakajima's impact on the Balboa Park garden is visible in the Sukiya-style exhibition house near the entrance, the Zen-style dry garden that it overlooks, the use of five types of bamboo fences,

the choice of sunburst locust hedges and the curving paths in the present two-acre terrace garden.

Takeo Uesugi's reputation as a designer of Japanese gardens is impeccable. Among others, he designed the James Irvine Garden at the Japanese American Cultural and Civic Center in Los Angeles, the San Diego Tech Center in Sorrento Valley and the Japanese Pavilion at Expo '70 in Osaka, Japan.

All the gardens in Balboa Park are designed to awaken sensibilities, but because of constricted spaces, formal arrangements and incongruous juxtapositions, they interfere with a seemingly artless progression of picturesque landscapes. Free of these hindrances, the new Japanese garden will integrate air, water, rocks, soil, plants and people in a harmonious and symbolic composition in which no part is greater than the others. Flowers in a Japanese garden enhance scenery. They are not the garden's reason for being.

The emotions a stroll garden tries to induce are those of *wabi*, *sabi* and *yugen*.[32] There are no exact English equivalents for these words, but a feeling of ecstasy evoked by being alone with nature in settings that look old and where all parts contribute to the harmony of the whole covers some of their meanings. Ulrike Hilborn wrote that as he walked around the Nitobe Gardens in Vancouver, he felt he was beginning a new day and a new life that passed from mid-life to old age with stops along the way where he could rest and look back on the day and on the life.[33] A stroll garden that can produce such an effect must be profound indeed.

Here is how the Chinese poet Han Shan described the intoxicating powers of nature:

Today I'm back at Cold Mountain
I'll sleep by the creek and purify my ears.[34]

The Japanese poet Basho had a similar experience when he wrote:

The ancient pond
A frog jumps in,
The sound of water.[35]

In 1915, Japan was a world power with a long history of cultural, philosophical and religious achievement. It had acquired Formosa during a war with China in 1894–95 and had defeated Russia in 1904–05. This was a

country of energetic and intelligent people who were not about to succumb to the threats of European and American countries.

While the Japanese government did not mount a major exhibit at the Panama-California Exposition, businesspeople, who represented their government, did. They wanted to present a romantic image of their country that stimulated a demand for Japanese goods while simultaneously asserting Japan's right to be included among the nations of the modern world.[36]

Unlike demeaning exhibits put up on the Zone in San Francisco and on the Isthmus in San Diego belittling people belonging to nonwhite races or having religions other than Christian, Japanese exhibits did not pander to prejudice. The Joss House in Underground Chinatown on the Isthmus in San Diego represented a flagrant exhibition of racial denigration. Here, wax effigies of Chinese laborers showed the horrors of opium addiction. A similar exhibit in San Francisco so infuriated local Chinese that it was withdrawn.[37]

The same Japanese immigrants who displayed gracious hospitality, artistic taste and athletic skill at the San Francisco and San Diego Expositions were by federal law ineligible for citizenship. Additional laws passed by the U.S. government in 1907 and 1924 stopped all immigration to the United States from Japan.[38] California laws prevented Japanese from marrying white women and prohibited them from owning or leasing agricultural land.[39] Nevertheless, children of immigrants, born in the United States, were American citizens by right of birth. Notwithstanding, ninety-three thousand Japanese in California, two-thirds of whom were American citizens, were detained in makeshift camps, guarded by soldiers and surrounded by barbed wire, during World War II.[40]

The use of adjectives such as "quaint," "little" and "dainty" to describe Japanese contributions to expositions in Europe and the United States is ironic. Following the Meiji restoration of 1868, Japanese businessmen began importing Western technology and culture while exporting a stage-set image of themselves as a gentle people wearing colorful kimonos, who lived near waterfalls, rocks and pine and cherry trees with snow-capped Mount Fuji looming in the background. American and Japanese importers fostered the image of inoffensive, agrarian Japanese, while American exporters sent knowledge, raw materials and goods to a country that quickly became an industrial giant. Conflicts between the United States and Japan reached a climax during World War II. Though conflicts have not been eliminated, the two countries have learned that in order to coexist amicably, they must understand each other.

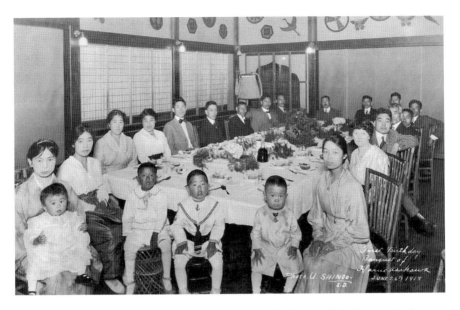

First birthday banquet of Harue Asakawa, June 26, 1917. *Courtesy of the Japanese American Historical Society of San Diego.*

Unlike Westerners, the Japanese do not think of nature as something outside of themselves that they must control. They believe they are part of nature and that the same masculine and feminine forces that cause trees to grow or water to fall are manifest in their being. Americans and Europeans do not have to become Buddhist monks, students of Noh, writers of haiku, masters of flower arrangement or recluses on mountains to grasp the way in which Japanese seek fulfillment in a nature in which qualities of openness and enclosure, hardness and softness, light and dark, rectangles and circles and symmetry and asymmetry are delicately balanced. The gardens of Japan and their American, Canadian and European counterparts open the way for West to join East in a realm where art and nature merge. The words of Ryokan, a thirteenth-century Buddhist priest, on his deathbed, indicate how people can see themselves in a natural world:

> *For a memento of my existence*
> *What shall I leave (I need not leave anything)?*
> *Flowers in the spring, cuckoos in the summer,*
> *and the maple leaves*
> *in the autumn.*[41]

The Japanese Tea Garden maintained a low profile during the California Pacific Exposition of 1935–36. It was rarely mentioned in the news and then only in society columns. It continued to offer a retreat for Caucasian patrons in which to eat green tea ice cream and to sip green tea. Japanese Issei and Nisei activities centered on the House of Pacific Relations, where Japanese American trade and cultural associations, in conjunction with Tomokazu Hori, Japanese consul of Southern California, occupied one of the original fifteen Spanish Mediterranean–style cottages. The associations presented programs at the Spreckels Organ Pavilion and Ford Bowl in honor of Japan Day in 1935 and 1936. Buddhist priests began the festivities on Saturday evening, August 17, with a ceremony at the Organ Amphitheater commemorating the birth of Guatama Buddha, "Guatama" being the Japanese name for Buddha. On Sunday morning, Shinto priests at the amphitheater venerated the deified spirits of George Washington and Abraham Lincoln. Parades, dances and exhibitions of fencing, jujitsu, wrestling and other sports took place in the afternoon in the main plaza. Music, dances and speeches, again at the Organ Amphitheater, climaxed the day's activities.[42] The scale of the celebration on Saturday, July 18, 1936, was smaller. At noon, officials entertained visiting Admiral Zengo Yoshida, commander of a Japanese training ship, and members of his staff in the Café del Rey Moro. In the afternoon, the ship's band gave a concert at the Ford Bowl. Admiral, staff and crew left for San Pedro in the early evening without seeing a two-hour program at the Organ Amphitheater presented by "several hundred" Japanese dancers and musicians. The stage was decorated "to suggest cherry blossom time in Japan."[43]

As with so many Japanese imports to the Western World, the celebrations highlighted the virtues and culture of "old Japan" as these supposedly existed before the Meiji Restoration of 1866–69. Aware of growing anti-Japanese sentiment in the country, of the discriminatory effects of the 1913 California Alien Land Bill that prevented Japanese immigrants from owning or leasing property and of the 1924 Congressional Exclusion Act that prohibited immigration from Japan, Issei and Nisei were eager to present a picture of themselves as courteous, nature-loving and peaceful while playing down such areas as the competition between Japan and the United States for markets, the negative reaction of the United States to Japan's invasion of Manchuria in 1931 and its attack on Shanghai in 1932, the imminence of war with Russia over control of Mongolia and the prospect of Japan forming an alliance with Italy and Germany. Gaps between the economic and political interests of the United States and Japan were widening. It was

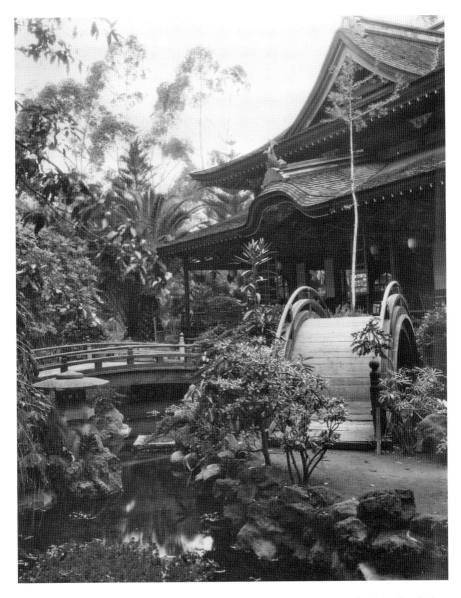

Bridges and the teahouse in the Japanese garden. *Courtesy of the Japanese American Historical Society of San Diego.*

the task of Japanese diplomats in the United States, Issei (who could not become United States citizens) and Nisei (who were United States citizens by right of birth) to pretend these gaps were based on misunderstandings that, with good will, could be overcome.

Japanese gardens show Westerners and Easterners alike that we are not alone in an indifferent world in which the gods laugh at us. If we abandon for a time our preoccupation with getting and spending and stop to listen, see and think, we can discover that a meticulously channeled nature can refresh our jaded spirits. The following lines written about Kinkaku-ji, the garden of the Golden Pavilion in Kyoto, show how Japanese gardens manifest the quiet spirit that lies within or behind all motion and phenomena:

> *The mountain is sharply etched,*
> *the woods are colorful,*
> *the valleys deep, streams rapid.*
> *Moonlight is clear on a softly*
> *breathing wind.*
> *Man reads in the quietness*
> *scripture without words.*[44]

Gardens are not the only Japanese gift to the Western world. It is a country of great artists, craftsmen, writers and philosophers. But gardens are the most accessible, easily understood and loved of Japanese contributions to its own and other peoples.

CHAPTER 8
The California Building
San Diego Museum/Museum of Man

My judgment is now clear and unfettered, and that dark cloud of ignorance has disappeared, which the continual reading of these detestable books of knight-errantry has cast over my understanding.
—Miguel de Cervantes, Don Quixote, book 2, part 16

Very few people appear to have looked at the south façade of the California Building in San Diego's Balboa Park. H.K. Raymenton described it as Plateresque in style.[1] Trent Sanford thought it better than anything in Mexico or Spain.[2] William Templeton Johnson called it the finest Spanish Renaissance façade in existence,[3] and Thomas E. Tallmadge hailed it as the best example of Churrigueresque architecture in the world.[4]

An article in the *San Diego Union* on January 1, 1915, asserted that the California Building was "copied in many essential details from the magnificent cathedral at Oaxaca, Mexico."[5] Christian Brinton repeated this suggestion in June of the same year.[6] After checking with Bertram Goodhue, who designed the California Building, C. Matlack Price referred to the comparison as "palpably absurd."[7] The Late Renaissance Cathedral of Oaxaca, rebuilt in the early eighteenth century, has a compartmentalized façade with three horizontal tiers and five vertical bays, which hold one principal and two lateral doorways, and is flanked by two squat, single-stage towers.[8] None of its details resembles those on the California Building.

Carol Mendel declared that the California Building façade was taken from the seventeenth- to nineteenth-century late-Renaissance, Baroque,

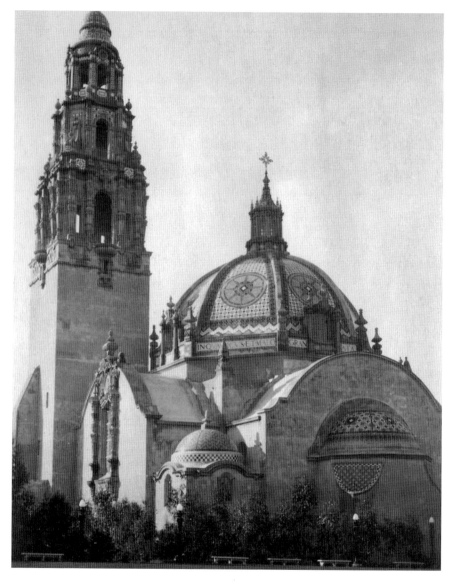

This view of the California Building shows the small tiled dome and half-dome on the north side of the building. *Michael Kelly Collection, Panama-California Exposition Digital Archive.*

neoclassical façade of the Cathedral of Mexico in Mexico City.[9] If she had selected the mid-eighteenth-century Sagrario Metropolitano, which adjoins the cathedral, she would have been closer to the truth, for this building's façade is an outstanding example of Mexican Ultra-Baroque

or, as it is generally known, Churrigueresque.[10] To George H. Edgell, the California Building recalled the late eighteenth-century Churrigueresque-Rococo Balvanera Chapel of San Francisco in Mexico City;[11] however John Burchard and Albert Bush-Brown described the California Building's entrance and tower as "torrid" and inaccurately claimed that the Commerce and Industries Building (today the Casa de Balboa) was more closely related to the exuberant exterior of the Balvanera Chapel.[12] The two authors were undoubtedly thinking of the florid exterior of the Varied Industries and Food Products Building (today the Casa del Prado) but had the names mixed up.

Samuel Wood Hamill considered the west façade of the former Jesuit Church of San Francisco Javier in Tepotzotlan, Mexico, to be "the great, and many times great-grandfather of the California Building."[13] This claim ran counter to Marcus Whiffen's description of the California Building as "an ecclesiastical-looking edifice whose façades and tower offer connoisseurs a test of their dexterity in disentangling Churrigueresque motifs from Morelia, Mexico City, Tepotzotlan, and San Luis Potosi."[14]

The Church of San Francisco Javier and the California Building share the same scheme of a three-level gabled frontispiece with accompanying side tower; however, no one detail on the Tepotzotlan façade is duplicated on Bertram Goodhue's Balboa Park building. What one finds on Goodhue's façade are details like those on the façades of many Mexican and Spanish churches and palaces.

Seen from a distance in full sunlight, the white limestone façade of the Church of San Francisco Javier sparkles and shimmers like a finely faceted jewel. In San Diego, high confining walls restrict the observer to close-up views, depriving him of the sense of discovery that comes from approaching over a long forecourt or atrium.[15] Long, dark shadows on projecting surfaces dramatize and enrich the design, but individual details do not shimmer.

The area abutting the protruding San Diego portal is plain, whereas in Tepotzotlan, adjoining wall surfaces are rusticated and further highlighted by embossing around windows at the base of the tower. The broad, deep-cut surfaces, deliberate symmetry and bland portraiture on the Balboa Park building differ from the fine textures, ascending movement and dynamic statues on the Tepotzotlan façade.

Many of the California Building's details arose from Goodhue's firsthand study of Spanish Colonial architecture during his travels in Mexico with Sylvester Baxter in 1899.[16] Columns on the first level resemble columns encased by vertical straps of carving on the façade of the Church of El Carmen at San Luis Potosi.[17] Vines and birds on jambs parallel those on

the portal of the Chapel of the Virgin in San Luis Potosi.[18] An arch above the door recalls multi-scalloped arches above the door of the Church of San Diego in Guanajuato. Volutes suggest the curves and counter-curves of the Church of San Cayetano de la Valenciana in Guanajuato.[19] A large rectangular window looks like windows on secular buildings, such as the house of the archbishop at San Luis Potosi or the entrance to the archbishop's palace in Seville, Spain.[20] A curved wrought-iron balcony mirrors balconies on civic buildings, such as the Casa del Alfenique in Puebla or the State Palace in Guadalajara.

Goodhue's design amounts to a twentieth-century recapitulation of Plateresque, Baroque, Churrigueresque and Rococo details. It is impure historically and odd in its imposition of a secular window and balustrade on an ecclesiastical frontispiece. Unusual features are, on the first level, cast-concrete faces, bird heads, sprays and shells covering jambs, columns with spiral incisions and ribbon garniture, beatific statues of monks between the columns, marine-like foliage above the door and elaborate aprons or lambrequins at the base of columns and statues; on the second level, tapered *estipite* pilasters divided into elaborately carved segments with elegantly dressed knights between, and floral garlands hanging next to the splayed reveal; and, on the third, shaped-gable level, candelabra-like pilasters.

Much of the finely delineated ornament, such as masks, cupids, candelabra, garlands and fruits, derives from Spanish Plateresque motifs. Symmetrically disposed baroque twisted columns, broken and curved moldings, pushed-up cornices and silhouetted urns focus attention on points of interest and provide contrasts of light and shadow. Finally, sprightly rococo scrolls, sprays and drapes soften the heavy Baroque and Churrigueresque rhythms and textures.

In 1916, Eugen Neuhaus and William Templeton Johnson selected the Philippine mahogany doors for special mention.[21] These have a radial pattern at top and geometric Spanish-Moorish paneling below. They contain carvings of foliation, rosettes, cherub heads and shields. Over the doors, two cast-concrete cherubs rising from a bed of seaweed hold the Arms of the State of California. The lively cherubs suggest a rococo source, though the seaweed resembles Goodhue's youthful page designs.[22]

Because the large, blank window diffuses rather than concentrates incident, the façade lacks a dynamic center. Access to the outdoor balcony is from a stairway concealed in a wall; however, the entrance is too far above the floor to be of practical use.

Modified Corinthian columns on the façade's first level are engaged; fractured *estípites* on the second level are free standing. Ornament saturates the columns, *estípites*, pilasters, pediments, arches, cornices, frames and wall surfaces while broken or curved moldings keep them apart. Being vertical in form, columns, *estípites* and pilasters dominate horizontal architraves, friezes and cornices. Recessed spaces between first-level columns and second-level *estípites* are bridged by pediments separating second and third levels. A display of curves on the pediments complement those on the reveal atop the center window. In Mexico, *estípite* capitals usually accentuate the line of a broken cornice and are un-bridged, as on the Church of San Francisco Javier in Tepotzotlan, or they may be connected by a horizontal entablature, as on the Church of San Diego in Guanajuato.

Statues of Father Luis Jayme, a Franciscan missionary killed by Indians in 1774, and Father Antonio de la Ascencion, a Carmelite historian who accompanied Sebastián Vizcaíno's expedition in 1602, occupy niches between columns on the east and west sides of the first level. Busts of Gaspar de Portola, the first Spanish governor of California, and George Vancouver, the first English navigator to visit San Diego, perch above the statues. Statues of Juan Rodriguez Cabrillo, who discovered San Miguel Harbor in 1542, and Sebastian Viscaino, who rediscovered the harbor and renamed it San Diego in 1602, intervene between *estípites* on the east and west sides of the second level. Coats of arms of Mexico and Spain take the place of busts above the second-level statues.

Rising above zigzagging side pediments, busts of Charles V and Philip III of Spain close the upward lateral thrust. (Charles V was king of Spain in the time of Cabrillo and Philip III in the time of Viscaino.) This shifting of emphasis provides focus for the statue of Junípero Serra, father-president of the California missions, in the top central niche. Presented with his face turned sideways and one leg forward, a youthful Father Serra appears in stride, which fits in with his mythic image as an energetic walker. In fact, Father Serra was fifty-six years old when he entered Alta California, was disabled by a chronic leg infection and rode from place to place on a mule.

Above Serra, a shield of the United States brings the historical and geographical themes to a conclusion. The small shield is kept subdued to avoid interfering with the Serra statue. Freestanding urns, grouped in a pyramidal arrangement above the crest, echo the triangular relationship between busts and statues below. The upward movement is enhanced, in a manner similar to that in the Sagrario Metropolitano, by volutes and curves that lead to a climactic finial.

There is a subsidiary Gothic influence on the California Building façade, which is not surprising as Bertram Goodhue was one of this country's foremost designers of Gothic churches.[23] The attenuated line of the façade, the efforts to avoid compartmentalization, the placement and pose of figures, the ample window space and the triangular silhouette on the crest recall Gothic features.

Details on columns, *estipites* and flat spaces are chunky and globular. There is little here of the wealth of invention, subtle rhythms and crisp carving on the façades of the Church of San Francisco Javier in Tepotzotlan[24] and the Church of La Cata in Guanajuato.[25] Sun-reflecting plain walls and sun-absorbing sculptured portals contrast with one another. Lights and shadows change within the multi-planed ornamental field. But the detail does not display the diversity, energy and impish humor of Mexican Vice-Regal church façades.

Artisans employed by the Tracy Brick and Art Stone Company of Chula Vista made the detail by setting concrete in molds prepared from plaster models executed by the Piccirilli brothers (Attilio, Furio, Thomas and Horatio) of New York City. After they removed the sections from the molds, the Chula Vista workers smoothed the surfaces. Goodhue designed the decorative frame but gave the Piccirillis a free hand in creating the figure sculpture. Elegant and epicene, statues and busts look like handsome dolls rather than like people with strong emotions and convictions.

Except for the green woodwork of the frames, the deeper green of the ironwork, the bright brown of the door and the colored tiles on domes and tower, color was used sparingly on the California Building. Its gray surface differs from the varied colored surfaces of churches made from red volcanic stone in Mexico.

Exposure to elements over the years caused bonding and the dowels holding the façade to the wall to loosen and concrete to crack. Soot and acids from the air and salts in the original sands pervaded the cast-concrete surface, blanching and speckling the design. In 1964, the Art A. Gussa Construction Company of El Cajon replaced the plaster base of the tower with gunite concrete and braced the upper stages in an $80,000 project.[26] In 1975, general contractors Claude F. Williams, Incorporated, of Torrance, with Lew Anderson as project superintendent, undertook another tower, façade and west entrance archway renovation for $550,000.[27] When built in 1913–14, the California Building cost the State of California $250,000.

An epoxy-resin impregnation process, patented by Universal Restorations, Incorporated, of Washington, D.C., used in the 1975 renovation was

Tiled dome of the California Building. *Photograph provided by the San Diego Museum of Man.*

supposed to make the façade sculpture stronger than when originally built.[28] Technicians from Universal Restorations dried the concrete with steam, bringing out the salts. Then they sprayed or painted layers of a combustible epoxy-resin mixture on the surface. Mike Casey of Universal Restorations replaced damaged or missing lanterns, moldings, noses, ears and other

protuberances with plastic or fiberglass replicas, weighing about 25 percent less than the originals.[29] To avoid too sharp a contrast between old and new parts, Casey added coloring agents and sand from Sweetwater Canyon, which had been used in the original figures, to the final epoxy-resin coating.

Since Goodhue used cast concrete as a substitute for stone and the Piccirilli brothers used clay modeling and plaster casts instead of direct carving, the use of plastic, epoxy-resin and fiberglass is in keeping with past practice. Because a hallmark of baroque art is the use of one medium or material to simulate another, the substitutions do not contradict baroque techniques. Also, because columns and *estípites* have no support functions but are decorative veneer only, there is logic in reducing their weight as much as possible.

Purists will find these material changes difficult to accept. Visually, the fiberglass replacements are obvious. A fiberglass surface is too smooth and the lines drawn on it too exact to look like the granular and blurred surfaces of concrete or the more durable and varied surfaces of stone. Still Goodhue's façade is not in the same class with the west front of Chartres or the southeast front of the Parthenon. Techniques that would not be permissible there are allowable in San Diego.

In 1997, some twenty years after they had been reinforced, the statues began to show ravages caused by climatic and chemical changes. Holes on the concrete surfaces look as though woodpeckers or insects have been at work.

It is the three-stage tower of the California Building, rather than the façade, that has endeared itself to San Diegans. Less square and massive than the cathedral towers of Morelia and Cuernavaca[30] or the church towers of Santa Prisca at Taxco[31] and San Francisco Javier at Tepotzotlan in Mexico, the California Tower has the decreasing stages, changing volumes, open spaces and color of such church towers as the Torre del Reloj at Compostela,[32] the tower of Santo Domingo de la Calzada near Logroño[33] and the towers of Ecija[34] in Spain. While the outline is Spanish, details and color are Mexican. Double *estípites* at the corners of the first stage follow the example of La Santisima in Mexico City. Octagonal second and third stages resemble those on the tower of La Encarnacion in Mexico City.[35] Transitions from quadrangle to octagon to circle correspond to changes in the three-stage tower of the Cathedral of Morelia.

The sparkling tiles, glistening glass beads and graceful proportions of the California Tower act as a coda for the tiled central dome and minor domes at the back of the building, hidden today by an annex of the Old Globe Theater.

In his comments on the architecture of the 1915 Exposition, Carleton Winslow Sr., assistant to Bertram Goodhue, stated that the arrangement of the tower within an angle formed by the south and west transepts recalled "somewhat" that of the church at Montepulciano in Italy.[36] Winslow referred to Antonio da San Gallo the Elder's sixteenth-century Madonna di San Biagio; however, in this latter case, the towering mass of the church dwarfs its single bell tower.[37]

Goodhue may have evolved his Greek-cross plan from Madonna di San Biagio; even so, Greek-cross plans were not commonly used in Spanish and Mexican churches. (The Sagrario Metropolitano in Mexico City is an exception.)

The starburst tile design on the California Building's center dome copies the design on the dome of Santa Prisca in Taxco.[38] An inscription at the base of the dome of Santa Prisca reads, "GLORIA A DIOS EN LAS ALTURAS" ("Glory to God in the Heights"),[39] whereas the inscription on the base of the California Building's dome reads, "TERRA FRUMENTI HORDEI, AC VINARUM IN QUA FICUS ET MALOGRANATA ET OLIVETA NASCUNTUR, TERRAM OLEI AC MELLIS." Goodhue took this last quotation from the Latin Vulgate Bible of St. Jerome. It means: "A land of wheat and barley, of vines and fig-trees, and pomegranates; a land of olive oil and honey," a motto in keeping with the agricultural aspirations of the Panama-California Exposition.[40]

Unlike Santa Prisca, but like many Mexican examples, such as the domes of the Royal Chapel in Cholula[41] or the dome of Santa Catarina in Mexico City,[42] the California Building's dome rises from the roof without intervening drum and is pierced on four sides by windows.

Inside, pendentives adapt the dome to the rotunda or, more accurately, octagon. Four arches spring from flat pilasters set at right angles from one another, that are separated by a canted middle section. A plain entablature and jutting cornice extend around the walls.

The domes, pendentives and arches derive from Hagia Sophia in Istanbul[43] by way of Italian Renaissance churches. Unlike Hagia Sophia's low circular dome, the California Building's high dome is octagonal in form. Transverse barrel vaults open additional spaces and help counteract the dome's thrust. A low-recessed niche, topped by a half-dome in the middle of the north apse, echoes the curve of the north arch, the only open arch in the rotunda, and dramatizes the building's north–south axis. Three minor corner domes, hidden between the transepts, have greater impact on the outside than on the inside of the building.

The roofline of the transepts follows the curve of the barrel vaults. Except for the main entrance, decorative gables (*espadanas*) do not hide transepts. To achieve this functional effect, Goodhue took advantage of a technique for reinforcing concrete with a layered, laminated tile core developed by Rafael Guastavino.[44]

Seen from the north, the corner domes, half-domes, barrel vaults, major dome and lantern of the California Building supply a pleasing configuration, further enlivened by colored tile inlays in geometric patterns. The rhythmic sequence of domes goes back to the mosques of Istanbul,[45] while the tile takes its inspiration from the houses and churches of Puebla, Mexico,[46] and the mosques of Isfahan, Persia.[47]

The California Building has probably been mentioned more often than any other building in San Diego in studies of American architecture.[48] The building is included on the National Register of Historic Places, as part of the California Quadrangle. In addition, the California Building tower is recorded in the Historic Buildings Survey in the Library of Congress.[49]

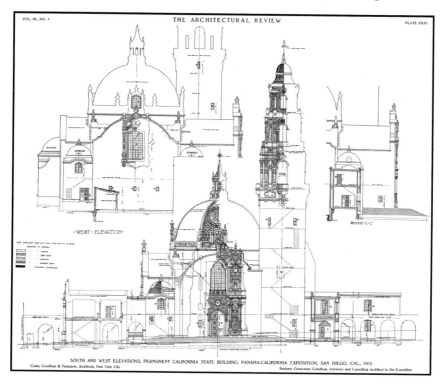

Goodhue drawings of California Building were published in the *Architectural Review*, April 1914. *The Committee of One Hundred Collection, Panama-California Exposition Digital Archive.*

Balboa Park and the 1915 Exposition

In 1915, Bertram Grosvenor Goodhue almost single-handedly introduced the Spanish Revival style into the United States. Ironically, the buildings that Goodhue later designed in this style were simpler than those in Balboa Park and contained fewer borrowings. The mining town of Tyrone, New Mexico; the Henry Dater House in Montecito; and the United States Marine Corps Base in San Diego[50] have an authority and impressiveness that does not depend on historical associations. David Gebhard thought the plain and structurally honest buildings Goodhue designed after 1915 reflected the influence of Irving Gill,[51] whom Goodhue superseded as consulting architect of the Panama-California Exposition.[52]

Today, after almost one hundred years of experimentation with Spanish Renaissance and Baroque scrolls, grills, columns, *estipites*, cornices, gables, moldings, niches, shields, saints, shells, cupids, garlands and fruits, the façade of the California Building still surprises. It may be academic and constrained, compared to its predecessors in Mexico and Spain, but it is better than anything ever attempted since in the "decorative toothpaste"[53] or Churrigueresque version of the Spanish Revival style in Florida, Texas, Arizona and California,[54] including at least two attempts at direct imitation (St. Vincent's Church, Los Angeles, 1923, Albert C. Martin, architect, and the District Health Center and Field House, Garfield Park, Chicago, 1928, Machaelsen and Rognstad, architects).[55]

Though built for the State of California as its contribution to the 1915 Panama-California Exposition in San Diego, the California Building did not house state exhibits. Twenty-eight counties of California exhibited in buildings about the Exposition grounds, but the Departments of the State of California confined their exhibits to the Panama-Pacific International Exposition of 1915 in San Francisco.

Acting on a suggestion from Colonel "Charlie" Collier, director-general of the Panama-California Exposition, archaeologist Dr. Edgar L. Hewett, of the School of American Archaeology in Santa Fe, New Mexico, and anthropologist Dr. Ales Hrdlicka, of the U.S. National Museum, chose exhibits to illustrate "The Story of Man through the Ages," with emphasis on the Indian populations of North and South America.[56] Hrdlicka persuaded the National Museum in Washington, D.C., an adjunct of the Smithsonian Institution, to send exhibits for the Science and Education Building.[57] He also helped to procure skeletal remains of early man in Europe and Siberia; photographs and casts of materials from museums in Europe; busts of native peoples in Siberia, Mongolia, Africa, the Philippines and other places; and ten near life-size busts executed by the Belgian sculptor Louis

Mascre representing early man for exhibits in the Science and Education Building.[58] Though they conformed to ideas about primitive man held by scientists at the time, the busts, which are still in existence, are now regarded as overly romanticized depictions that were made with artistic license. They included a representation of the notorious Piltdown Man, supposedly a primitive human who lived in England that has proven to be a hoax.[59] Hewett obtained exhibits of Indian life in the Southwest from the School of American Archaeology for the Indian Arts Buildings.[60]

Hrdlicka arranged busts of ancient and living people and skulls from Asia and the Americas in the Science and Education Building to prove that Indian people in America came from stock in Asia; that the dominant races—white, yellow-brown and black—derived from undiscovered primitive forms that were related to but not descendant from apes and monkeys;[61] that pure "bloods" in white, yellow-brown and black races were more interesting than mixed breeds; and that improved environmental conditions would produce more intelligent and healthier human beings. Hrdlicka was trained in the scientific method, which meant that he did not prejudge his findings but arrived at them only after he had accumulated a collection of facts. He had a compulsion to collect data but kept delaying announcing what the data meant until more data could be found. Like other anthropologists of his time, he was not aware of Mendel's discovery of the role of genetics in determining human characteristics, nor did he know that such a key to human traits as DNA existed. Historian Mathew Bokovoy identified Hrdlicka's thinking and value system with that of his fellow anthropologist Franz Boas. Other students of anthropology have questioned this supposed concurrence. The subject is complicated, but that there were inconsistencies and blindness in Hrdlicka's pronouncements is beyond dispute. People who saw exhibits in the Science and Education building could draw any conclusion they wished because they were looking at an assortment of data under the general heading of "evolution" and under the Exposition's imprimatur of "progress." That these conclusions reflected the sense of personal superiority of viewers may have been true; nevertheless, the exhibits were of people in different places at different times and with different biological ages. Whether they wished it or not, viewers were forced to see their kinship to the human specimens on display. As Bokovoy pointed out, this equalitarian sense of fellow feeling was the prevailing motif of the Panama-California Exposition that no less a person than David C. Collier had enunciated. Along with modern Anglo-Saxon interlopers in the American Southwest, their Native American,

Replica of Maya monument from Quirigua, Guatemala. *John Earl Collection, Panama-California Exposition Digital Archive.*

Spanish and Mexican predecessors were part of the family of man. Each race, strain or tribe contributed to the contemporary mix. In a less didactic way, the Metropolitan Life Insurance Company showed how its sponsorship of playgrounds, improved sanitary conditions and visiting nurses could prolong the lives of policy holders, an announcement with which anthropologists Ales Hrdlicka and Franz Boas would agree.[62]

Hewett did not reshape the interior spaces of the California Building to accommodate exhibits. However, he appointed Jean Beman Cook-Smith to make bas-reliefs portraying scenes from Maya life;[63] Sally James Farnham to make copies of a historical frieze she had done for the Pan-American Union Building in Washington, D.C., showing incidents in the Spanish conquest of Mexico and Peru;[64] and Carlos Vierra to produce murals showing the ruins of Copan, Uxmal, Quirigua, Palenque, Chichen Itza and Tikal.[65] These he added to the vestibule and rotunda to complement Maya displays from Yucatan, Chiapas and Guatemala, including plaster replicas of four tall stelae and two massive monuments from Quirigua in Guatemala that had been excavated in 1910–11 by the School of American Archaeology.[66] Archaeologist Sylvanus G. Morley supervised the making of casts in 1914. He used glue, applied in a liquid state, to make molds. Ironically, the replicas in the California Building have retained details that are now obscured by weathering on the originals.[67]

Alice Klauber, a San Diego artist, helped to secure paintings by eleven American artists representing the Ash Can and Impressionist schools for mounting in the Fine Arts Building, on the opposite side of the quadrangle from the California Building.[68]

Grant Wallace estimated the costs of the collections in the California, Fine Arts, Science of Man and Indian Arts Buildings at $103,421.54.[69]

In 1916, Exposition officials added French tapestries, carpets, perfumes, fashion designs and art to the upper levels of the California Building and to the Fine Arts Building. The French government sent these exhibits to San Diego from San Francisco's Panama-Pacific International Exposition as it was impractical to return them to France because of the war in Europe. Despite their nonconformity with Maya exhibits in the rotunda, officials placed them in the California Building because space was available.[70]

THE HISTORY OF THE SAN DIEGO MUSEUM/MUSEUM OF MAN

Know then thyself, presume not God to scan,
The proper study of mankind is Man.
Placed on this isthmus of a middle state,
A being darkly wise and rudely great:
With too much knowledge for the Sceptic side,
With too much weakness for the Stoic's pride,
He hangs between, in doubt to act or rest;
In doubt to deem himself a God or Beast;
In doubt his mind or body to prefer;
Born but to die, and reas'ning but to err;
Alike in ignorance, his reason such,
Whether he thinks too little or too much;
Chaos of thought and passion, all confused;
Still by himself abused or disabused;
Created half to rise, and half to fall:
Great lord of all things, yet a prey to all;
Sole judge of truth, in endless error hurl'd;
The glory, jest, and riddle of the world!
—*Alexander Pope, from* An Essay on Man

Dr. Hewett continued as director of the San Diego Museum after the close of the Panama-California Exposition in 1916. He was at the same time director of the Museum of New Mexico,[71] president of the School of American Research, a teacher at San Diego State College and at institutions in Santa Fe[72] and an archaeologist in charge of excavations at Quirigua in Guatemala

and in Chaco Canyon, New Mexico.[73] In 1929, Hewett resigned as director of the San Diego Museum. His successor was Lyman Bryson.[74]

Directors of the San Diego Museum/Museum of Man from its inception are as follows:[75]

Dr. Edgar L. Hewett, 1915–29
Wesley Bradfield, associate director, ?
Dr. Lyman Bryson, associate director, 1928–29
Dr. Clinton Abbott, 1929
Malcolm J. Rogers, acting director, 1933–35
Malcolm J. Rogers, 1935–36
Dr. Edward L. Hardy, 1936–42?
Malcolm Farmer, 1945–50
Dr. Spencer L. Rogers, 1950
Clark Evernham, 1951–71
 with Dr. Spencer L. Rogers as scientific director, 1971–72
General Lowell English, 1972–81
 with Dr. Rogers as scientific director and with Barton Wright as scientific director, 1978–82
Dr. Douglas Sharon, 1981–2004
Dr. Mari Lyn Salvador,* 2004–09
Micah D. Parzen, Ph.D, J.D.,* 2010–

*updated 2013

Trustees designated the California Building as the San Diego Museum on January 11, 1916, the date the museum was officially established.

Hewett added partitions to the California Building to organize exhibits, but he did not change interior spaces.[76] In 1917, he relocated exhibits in the Exposition's Science and Education Building to the 1915 Indian Arts Building (1916 Russia and Brazil Building) and shifted Indian exhibits to the Science and Education Building. He changed the names of the buildings to reflect changes in exhibits.[77]

After he had rearranged former Exposition exhibits, Hewett placed the newly donated Joseph Jessop archery collection of primitive weapons in the 1916 U.S. Government Building at the north end of the Plaza de Panama and rented studio spaces in the same building to artists.[78]

The San Diego Museum was not affected by the occupation of Balboa Park by the U.S. Navy and U.S. Army during World War I.[79]

Illustrating the tendency of government commissions to stay in existence after they had accomplished their mission, the State of California gave the California Building Commission "illegal appropriations" to maintain the California Building for thirteen years after the Exposition.[80] Other museum expenses were paid from returns accruing to the State of California from the holding of the Panama-Pacific International Exposition,[81] from $6,500 given to the museum by Exposition stockholders who relinquished their claims in 1917[82] and by membership and admission fees.[83]

Following the relocation of exhibits from adjacent buildings to the fireproof California Building, the San Diego Museum reopened on February 19, 1921.[84] Since then, the California Building has been the headquarters of the San Diego Museum.

At the request of the Park Commission, trustees vacated the Science of Man Buildings (1915 Indian Arts Building and 1916 Russia and Brazil Building) on March 1, 1922, releasing the buildings for other uses.[85]

In July 1923, Hewett added W.W. Whitney's gift of a scientific reference library to the museum.[86] The building of a new art gallery in Balboa Park in 1925, on the site of the 1916 U.S. Government Building, opened up space in the old Fine Arts Building for Science of Man collections that had been ejected from the Science of Man Building.[87]

The State of California cut off funds for the San Diego Museum in February 1929, whereupon the San Diego City Council appropriated $2,100 to pay the salaries of a curator, custodian and janitor for the museum.[88] In recognition of city support, museum authorities allowed people to see the exhibits for free.[89]

Fine Arts Gallery construction in 1925 made the removal of the Joseph Jessop archery collection from the U.S. Government Building imperative. Space was found in the east wing of the second floor of the California Building. An Egyptian collection from excavations at Tell-El-Amarna, donated by Ellen Browning Scripps, was placed on a balcony on the east side of the rotunda in the same building.[90]

In November 1931, the San Diego Museum relinquished the Indian Arts Building (the 1915 Science and Education Building) as the museum could not afford the expense of repairing the decaying building.[91] Placing their interests ahead of the San Diego Museum, in May 1932, representatives from the American Legion and the Veterans of Foreign Wars asked the city council to turn the California Building over to them, as "the structure was not being used to capacity or in a manner commensurate with its cost."[92] Supposedly, these conditions would not exist under veteran tenancy.

Experiencing a shortage of funds due to a reduced valuation of taxable city property by the county, the city council temporarily withdrew its support of institutions in Balboa Park in August 1932.[93]

The museum continued to function as a museum during the 1935–36 California-Pacific International Exposition, though its title was changed to Palace of Science to correspond with changes in titles of exhibit buildings along El Prado and in the Palisades.

Special exhibits, some on a loan from the 1933–34 Century of Progress Exposition in Chicago,[94] required the removal of the W.W. Whitney scientific reference library to the San Diego Natural History Museum.[95]

The government of Mexico sent crystal cups, gold objects and jewelry discovered by Alfonso Caso in Grave 7 at Monte Alban in 1932. Though ignored by the newspapers, the exhibit was the most aesthetically intriguing of all the exhibits at the Exposition.[96] The Monte Alban exhibit and Alpha the Robot were placed in the Science Hall (west wing of the 1915 Science and Education Building).[97] In 1936, Mexico replaced the Monte Alban treasures with facsimiles of idols, masks and symbolic figures from the National Museum of Mexico.[98] After the Exposition, these became the property of the Museum.[99] In 1936, officials moved Alpha the Robot to the Fun Zone, where it more appropriately belonged.[100]

Recognizing that the departure of Fine Arts and Pioneer Society collections had narrowed the museum's scope, trustees of the San Diego Museum changed its name to the Museum of Man in 1942.[101] Holding out the possibility that at some future time the trustees would control other museum enterprises, they continued to call their organization the San Diego Museum Association.[102] In 1979, when the trustees notified the State of California of a change in the bylaws of the museum, they dispensed with the San Diego Museum Association title and changed the name of the Museum of Man to San Diego Museum of Man.[103] Whatever the goals of the trustees may be in the future, the museum is now legally the San Diego Museum of Man despite protests of feminists who have requested that the name be changed to the "Museum of Men and Women" or to the "Museum of Humanity."[104]

Following the United States' entry into World War II, museum directors halted a five-year plan of modernization, and in March 1943, they vacated the facility. The U.S. Navy added a second floor to the rotunda and put hospital beds for servicemen in the building[105] and tents for staff in the Plaza de California outside.[106] Casts of Maya stelae, which were too big to move, were sealed within a wall.[107] The task of moving casts from Quirigua

called "The Turtle" and "The Dragon" was too much for the navy. To the consternation of museum staff, sailors sawed each of the monoliths into three pieces.[108]

To undo U.S. Navy alterations and damages, staff renovated the museum building after the war.[109] Repair costs were paid from whatever the city could obtain from the sale of thirty-five temporary structures and from $790,000 that the navy gave the city to restore buildings it had occupied in Balboa Park.[110] Staff returning from military duty added boomerangs from Australia and models of canoes from Samoa to the museum's collection.[111]

Museum activities were relatively quiet between 1946 and 1965. Dr. Frank Lowe paid for the installation on Christmas Day, December 25, 1946, of a thirty-chime carillon in the California Tower in honor of his mother, Ona May Lowe,[112] for the carillon's reconditioning in 1949[113] and for its replacement, on April 6, 1967, with a one-hundred-chime carillon.[114]

An exhibit asserting that the Soviet Union had wiped out race prejudice lasted approximately one week in July 1950, after which anti-communists forced its removal.[115]

As city funds were needed to repair and improve San Diego's infrastructure that had been neglected during the war, there was little money left to restore Balboa Park buildings. To solve its financial problems, carry on research projects, deter vandalism and burglary and pay guards, the museum began charging a fifty-cent adult admission fee in July 1965.[116]

After the architecturally nonconforming Timken Gallery and the west wing of the Fine Arts Gallery were built in 1965 and 1966, it became evident that the Spanish Colonial Revival–style buildings in Balboa Park were nearing the end of their lifetimes and would soon be destroyed.

Because of the zeal of Bea Evenson, the Committee of One Hundred's founder and president, and Samuel Wood Hamill, the committee's architectural consultant, the deterioration or demise of surviving Exposition buildings, including the California Building (built in 1915 as a permanent structure), was not allowed to happen.[117]

Museum directors had reservations about the adequacy of the California Building to house exhibits, some of which were originally housed in five separate buildings. Complaints and suggestions went back to 1925.[118] In 1960, the Harland Bartholomew planners recommended that the museum relocate to the Federal Building. The California Building would then become "the nucleus of a theater arts center."[119] Inertia or indifference defeated this plan. In May 1966, architect Hamill showed the Park and Recreation Board drawings of additions to the Museum of Man in an area south of the former

Fine Arts Building and the Alcazar Garden.[120] The board referred the plan to a committee, where it was buried. Voters turned down an attempt in 1972 to place the museum in a refurbished Electric Building.[121]

Beginning in 1976, technicians undertook major renovations to the Museum of Man. They took down a false fifteen-foot wall hiding the Quirigua stelae at the north end of the rotunda, opening up the exhibit area.[122] The museum began changing its exhibits more frequently. As a result, the museum's standing and popularity increased, and in March 1973, the American Association of Museums formally accredited the San Diego Museum of Man.[123]

John Alessio and his family in 1966 gave to the city quartz-iodine lamps of forty-eight-million candlepower to turn the California Tower into a nighttime landmark.[124] After the rusting of light fixtures in 1980 plunged the tower into darkness, the San Diego Park and Recreation Department voted to spend $6,500 a year to keep the tower shining.[125]

In 1990, the Museum of Man moved into the former Administration Building at the west entrance to the California Quadrangle.[126] Douglas Sharon, museum director, attributed the Administration Building's design to nationally acclaimed San Diego architect Irving Gill, though no empirical evidence existed to substantiate the claim.[127] Using public and private funds, the building has been restored on the outside to its 1915 appearance (minus the Churrigueresque ornamentation) and readapted in the inside to accommodate offices and an auditorium. Aside from the additional space gained by the acquisition of the Administration Building, the museum has no additional plans for expansion.

A fiberglass replica of Stela D, one of four stelae (C, K, E and D) and two zoomorphs (P and B) that were part of the Maya display in the California Building for the Panama-California Exposition came back to the Museum of Man in January 2002 after being rebuilt by mold maker Wallace Neff in his studio in Campo. The rebuilding was necessary as the original plaster copy had started to crack. Indeed, all the Quirigua monuments show signs of deterioration, but there was money available ($20,000) only for Stela D. At twenty feet in height, the Stela was second in size to twenty-five-foot Stella E, a copy of which is the centerpiece for the Quirigua display of monuments, artifacts and dioramas and an eight-hundred-foot jungle mural, painted by Daniel Milsap, depicting the Quirigua archaeological site, at the apse end of the California Building. The full-figure glyphs on the sides of Stela D are deeply incised and have been praised as the finest example of glyph carving created in the Maya Classic Period (AD 200–AD 910).

The installation of the exhibit "Footsteps Through Time" in the upper west balcony of the California Building and the upper west wing that spans El Prado in February 2002 was the most ambitious in the Museum of Man since the museum's 1917 opening. While the catalogue accompanying the exhibit and the signs before exhibits do not say so, the exhibit is an answer to the 1915–16 exhibit "The Story of Man Through the Ages" in the Science and Education Building, mounted by physical anthropologist Ales Hrdlicka. As such, it is more comprehensive in detailing what is known about the origin of *Homo sapiens* and is less dogmatic in delineating racial differences. Amid the scholarly documentation, an exhibit of the Abominable Snowman, also known as Bigfoot, introduces a note of levity. While considered by most anthropologists to be on the same level as the Loch Ness monster, the exhibit has a fairy-story appeal. A "Time Tunnel" strays from the biological evolution of man theme into the area of cultural evolution. The exhibit consists of saucer-like signs indicating man's engineering achievements from the hand axes of 1.3 million years BCE to the mechanical heart of 2001. A companion cyborg exhibit owes more to science fiction than to a painstaking exploration of man's footsteps through time. Here it is suggested that machine-like, computer-propelled robots might one day replace human beings. With so many threats to man's survival looming over man—nuclear proliferation, overpopulation, bioterrorism, species extinction, global warming, asteroid impacts, etc.—this appears to be the least of his worries. Creationists might be upset by some of the proofs of human origin and development, but the same could also be said about Hrdlicka's busts of primitive man at the 1915–16 Exposition. The staff of the San Diego Museum of Man deserves praise for sweeping away cobwebs and clutter and introducing order and spaciousness into the second-floor west galleries of the museum.

In the year 2015, the California Building will observe its 100th anniversary. Barring changes, the San Diego Museum of Man will continue to occupy the ecclesiastical-looking main building, the 1915 Fine Arts Building (now called the Clark Evernham Hall), the east and west wings that attach to the Fine Arts Building and the St. Francis Chapel. The Fine Arts Building, refurbished at a cost of $44,000 in 1984 to reflect its original appearance, is currently used for exhibits and for December Night cum Christmas-on-the Prado festivities.[128] The St. Francis Chapel, also restored in 1984 at a cost of $48,000, is available for weddings but is not open to the public.[129] Other improvements include the addition of steel framing and shelving to basements; doubling storage capacity for more than fifty-five thousand artifacts, or about 89 percent of the museum's collection; the remodeling of

the lobby and first floor; the installation of an elevator on the west side of the lobby; and the paving of the Plaza de California with red bricks.[130]

The Museum of Man is not the great museum of anthropology designed "to collect and preserve the material culture, language, folklore and physical remains of the aboriginal Western American peoples" that Dr. Hewett hoped it would be.[131] Other Native American museums, such as the Southwest Museum in Los Angeles; the Los Angeles County Natural History Museum; the Charles W. Bower Museum in Santa Ana; the Amerind Foundation near Willcox, Arizona; the Indian Pueblo Cultural Center in Albuquerque, New Mexico; and the University of Pennsylvania Museum in Philadelphia rival it in importance. Nevertheless, despite its cramped appearance, scattered exhibits and poor security arrangements,[132] the museum is an asset other cities would like to have.

Since 1916, the scholastic emphasis, research projects and field trips of the museum have focused on the culture of the aboriginal peoples of Southern California, the American Southwest and Mesoamerica. Other exhibits acquired over the years—the Egyptian, Archery and Breath of Life exhibits—do not comply with the aboriginal theme. Traveling exhibits, such as exhibits of saddles, bridles, wagons, carriages and horse-drawn farm implements;[133] culinary delights from around the world;[134] and contemporary Native American art call attention to diverse interests. Art exhibits show unwittingly how native artists have been affected by cosmopolitan trends.[135] The far-reaching nature of the exhibits is not necessarily bad, for some of them at least allow professionals and laymen to see how aboriginal peoples, wherever they may be, manifest similar preoccupations; thus, microcosm blends into macrocosm.[136]

The 1992–94 Biennial Report of the Museum of Man stated that the museum exists "to disseminate knowledge and understanding of human biology, ecology and cultural development." This elastic definition allows room for just about anything directors and staff may choose to exhibit.

Since Director Douglas Sharon was aware that the San Diego Museum of Man occupied a historic and architecturally significant building, he took steps to safeguard the integrity of the building while placing exhibits so that they were not obtrusive or incongruously related. Temporary movable walls in the rotunda create a labyrinth of confusing paths.

Partitions shorten the interior of the 1915 Fine Arts Building, hiding a bronze fountain on the east wall. On the west side, closets jut into the gallery. Overhead beams for electric spotlights obscure the quadripartite vaulting and block views of the gallery from east and west balconies. It should be

mentioned, however, that the clerestory windows in the "refectory" room are too high and too small to provide adequate lighting, a defect that must have been in evidence when the room was used in 1915–16 as an art gallery. As many of the artifacts that architect Bertram Goodhue gave to the St. Francis Chapel have disappeared, its appearance in 1997 is leaner and less reverential than in 1915.

Situated in a Spanish Colonial Revival church with sculptures of explorers and pioneers on the façade of its principal building, the Museum of Man provides San Diegans with a place where they can see how they relate to all the peoples of the world—past, present and to come.

Glossary

Estipite is a Spanish word derived from the Latin *stipes, stipitis*, meaning a log, stock or trunk of a tree. The *Williams Spanish and English Dictionary* defines *estipite* as "a pedestal in the form of an inverted, truncated, rectangular pyramid."

Michelangelo was the first to use the *estipite* pilaster, wider at the top than the base, on the walls of the vestibule to the Laurentian Library in Florence in 1526. In Spain, *estipites* were used by Jeronimo Balbas, Francisco Hurtado Izquierdo, Pedro Duque Cornejo, Pedro de Ribera and others, principally on wooden retablos but sometimes on stone façades in place of columns and pilasters. The *estipites* were broken into several sections, which were smothered with ornament. Jeronimo Balbas introduced *estipites* into Mexico when he used them on the Altar of the Kings for the Cathedral of Mexico (1718–37). Afterward, Lorenzo Rodriguez transferred the interior *estipite* to the limestone façade of the Sagrario Metropolitano (1750–60). The new mode, in an increasingly complicated form, was used on façades and retablos throughout Mexico. By 1780, the *estipite* fashion had run its course and was replaced by the rock and shell forms of international rococo.

Lambrequin is derived from the French *lamper*, meaning a kind of crepe veil, and the Middle English *-kin*, Middle Dutch *-kijn* and German *-chen*, meaning little. In Gothic sculpture, a lambrequin was a row of scalloped or cutout cloth ornaments used in strip form under a canopy or baldachin. In Mexico, lambrequins, also known as pinjantes, faldoncitos and guanteletes, are single or overlapping aprons or flaps on wood and stone pedestals.

The Piccirilli Brothers

In his biography *Attilio Piccirilli, Life of an American Sculptor*, Josef Vincent Lombardo identified Masaniello (Thomas) and Orazio (Horatio) as the two brothers who "designed all the sculptured work...for the San Diego Tower in California." Carleton M. Winslow Sr. credited the modeling of the ornament on the California Building to Thomas and Horatio Piccirilli and the sculptured work on the frontispiece to Attilio and Furio Piccirilli. Of the two authorities, Winslow was closer to the scene. Copies of original drawings, in the possession of the City of San Diego, show Goodhue to be the designer of ornamental details. The figure sculpture is thinly drawn, which indicates Goodhue wanted the Piccirillis to flesh out his skimpy ideas.

Attilio, the most famous of the brothers, may have helped in the design, though he was busy at the time on the Firemen's Memorial Monument on Riverside Drive and the pediments of the Frick Reference Library in New York City. The figures have a family likeness to statues of Velazquez, Murillo and Zurburan on the façade of the San Diego Museum of Art. Lombardo states that Furio Piccirilli was commissioned by the New Art Gallery in San Diego to design the statue of Murillo in 1925; therefore, it seems reasonable to assume he designed the other statues as well.

CHAPTER 9

John Charles Olmsted's Wrangle with the Panama-California Exposition Corporation

After the chamber of commerce in July and August 1909 decided to hold an exposition in San Diego in 1915 to celebrate the opening of the Panama Canal and to call attention to San Diego, "the first port-of-call," it was a foregone conclusion that the City Park (renamed Balboa Park on October 27, 1910) would be the site, though architect Irving Gill, who had worked on the 1893 World Columbian Exposition held on the shores of Lake Michigan in Chicago, championed the holding of the exposition on the San Diego waterfront.[1]

San Diego businessmen incorporated the Panama-California Exposition Corporation on September 4, 1909, and entered into an agreement with the San Diego Park Board on January 11, 1910, enabling the corporation to stage the exposition in City Park. Since members of the Park Board and the Park Corporation shared similar aims, they worked in tandem.

Two major tasks to be resolved were the appointment of a team to construct and to organize the Exposition and the acquisition of funds for its construction. To resolve them, the corporation appointed an executive board, headed by a president (Ulysses S. Grant Jr.) and a director-general (D.C. Collier). A Building and Grounds Committee, headed by George W. Marston, was given the responsibility of finding qualified people to get the project going. Talk about getting Chicago architect Daniel Burnham to lay out the grounds was farfetched. Burnham was not a landscape architect.[2] Despite his growing reputation as a town planner, he did not lay out the grounds for the 1893 World Columbian Exposition. Frederick Law Olmsted Sr., this

country's best-known landscape architect in the nineteenth century, executed the design. Olmsted's firm continued in the twentieth century in the presence of his stepson, John Charles Olmsted, and his natural son, Frederick Law Olmsted Jr. These men headed a firm known as the Olmsted Brothers, headquartered in Brookline, Massachusetts.[3]

Frederick Law Olmsted Jr. taught a class in landscape architecture at Harvard University and busied himself with town planning,[4] which, due to the stimulus given to the practice by the 1893 World Columbian Exposition, was emerging as one of the responsibilities of landscape architects, along with the laying out of parks and the grounds of private estates.[5]

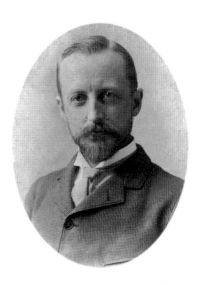

John Charles Olmsted. *Courtesy of the National Park Service, Frederick Law Olmsted National Historic Site.*

John Charles Olmsted maintained the business end of the firm, assisted by James Dawson and Harold Blossom. He had worked with his stepfather on the 1893 Exposition and had laid out the grounds for the 1905 Lewis and Clark Centennial Exposition in Portland, Oregon,[6] and the 1909 Alaska-Yukon Pacific Exposition in Seattle, Washington.[7] He had designed parks and park systems and the grounds of estates throughout the United States.[8] With such a formidable reputation, it was inevitable that the San Diego Buildings and Grounds Committee would appoint Olmsted at a fee of $15,000[9] to be the landscape architect for the Panama-California Exposition, though in a technical sense, the committee gave the commission to the Olmsted firm that included Frederick Law Olmsted Jr.

It was a logical step for the Building and Grounds Committee, on January 5, 1911, to appoint Frank P. Allen Jr. the director of works for the Panama-California Exposition. Allen had worked with John Olmsted on the Alaska-Yukon-Pacific Exposition. His job was to get the San Diego Exposition completed on time, lower construction costs and follow instructions. If Olmsted did not recommend Allen for the job, he did not object when his name was presented to the committee.[10]

Members of the Building and Grounds Committee leaned toward appointing architect Irving Gill to be the consulting architect for the

> # OLMSTED OUTLINES PLAN FOR PARK IMPROVEMENT
>
> ## Favors Beginning of Work on Permanent Buildings Early in Spring
>
> ## LIKES MISSION ARCHITECTURE
>
> ### Believes Twelfth Street Would Be Most Convenient for Main Entrance to Grounds

San Diego Union headline of November 11, 1910. *Aubrey Davidson Collection, Panama-California Exposition Digital Archive.*

Exposition. They favored a Mission-California architectural treatment and believed that Gill had the talent to design buildings in this style. Frederick Law Olmsted Jr. was, however, a close friend of architect Bertram Goodhue, who had studied the Spanish Colonial architecture of Mexico and had used this style on a church in Havana, Cuba, and a hotel in Colon, Panama.[11]

Goodhue solicited recommendations from prominent people. He was a nationally known architect and a member of the firm of Cram, Goodhue and Ferguson, which had designed several churches, private homes and colleges.[12] Being overwhelmed by Goodhue's sales pitch, credentials and abilities, the Buildings and Grounds Committee consented on January 30, 1911, to his appointment at a salary of $12,000.[13]

To acquire funding, the Panama-California Exposition Corporation conducted a campaign for subscriptions that reached $1 million on March 15, 1910. The Park Board on August 9, 1910, secured voter approval of a bond issue of $1 million for permanent park improvements, exclusive of temporary Exposition projects. Depending on how the terms of the bond

issue were interpreted, the Exposition Corporation had either $1 million or $2 million with which to proceed.

John Olmsted regarded $2 million as the figure he was to use in implementing his designs. Many of his troubles and problems involved getting his projects to cost less than the money available. In addition to his work on the Exposition proper, the Park Board expected Olmsted to oversee the development of other sections of Balboa Park. The wording of this section of his January 1, 1911 contract with the Park Board was ambiguous.[14] At any rate, Olmsted's assistants, Dawson and Blossom, proposed road and plant schemes for the north, northeast and southeast sections of the park that extended recommendations made by landscape architect Samuel Parsons Jr. and engineer George Cook between 1902 and 1910. They made roads more curvilinear and planting near the park's borders richer and denser, leaving interior spaces for native species.[15] Like Parsons, they limited their choice of trees and shrubs to those that would grow in Southern California's arid climate. With help from workers employed by the Division of the Director of Works, Dawson and Blossom planted a variety of eucalyptuses, acacias and pepper trees and native species such as coast live oak, toyon, laurel sumac and salt bush on seventy acres on the north and northeast sides of Balboa Park.[16]

An aerial drawing of Olmsted's plan for the Exposition appeared in the *San Diego Union* on January 2, 1911,[17] and a map of the plan on February 19.[18] He prepared these views in November and December of the preceding year.[19] Unlike changes that Olmsted made later, these are the only drawings that appeared in the newspapers. They were the sources for Goodhue's revisions for aesthetic reasons and Allen's revisions for economic reasons. After Allen had made deletions and Goodhue realigned juxtapositions and heightened axial views, Olmsted's plan, which looked at first glance to be complex, became easier to grasp.

To understand the first plan, it is necessary to understand the topography with which Olmsted worked. Otherwise, the straight mall, the stepped plazas, the curving roads, the bridges and the water features do not make sense. Like his stepfather, Olmsted preferred rough, irregular surfaces to smooth because the effects produced were more colorful and varied.

The Exposition was to be located in a southern site, to the north of Russ High School, because the site was close to downtown, could be seen readily, was accessible to visitors and could be inexpensively connected to trolley lines.[20] At the outset, no one had thought of putting the Exposition anywhere else in the park.

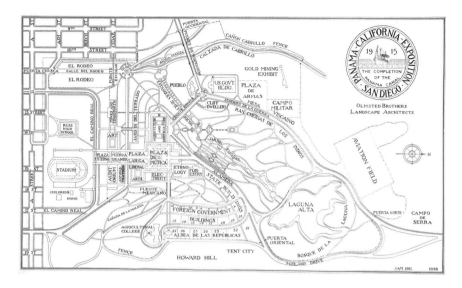

Olmsted ground plan for Exposition dated January 1911. *San Diego Public Library Collection. Panama-California Exposition Digital Archive.*

Because the land sloped and was split by canyons, Olmsted planned a succession of elevated plazas running south to north that opened into the main mall-like section of the Exposition. Buildings with ground-level arcades bordered the plazas on east and west sides. Terraces and parapets opened up views of the harbor to the south that, because of low construction, could be easily seen at the time.

A short distance to the east of the main Exposition entrance, El Rodeo, at the entrance to Pound (now Cabrillo) Canyon, provided carnival amusements. To the north, Indians were to live in a Pueblo encampment. A bridge spanning Pound Canyon would bring pedestrians from the east to the south end of a large canyon containing water features and a formal Spanish garden. A rotary between the bridge and the canyon would allow pedestrians to proceed to a lagoon and an aviation field to the north or over another bridge on the south to the northeast edge of the main Exposition complex. In all, Olmsted's plan called for four entrances, six gates, sixteen drives and four major bridges.[21]

As complex as the plan seemed with its buildings, roads, plazas, bridges and gardens, Olmsted had planned the site so that it could be used after the Exposition. An auditorium, stadium and a few buildings would remain, but most of the land—including the terraced Spanish

canyon—would contain trees, flowers and a lake that would be used for irrigation and recreation.

Even when he disagreed with him, Goodhue was cordial in his correspondence with Olmsted. While he may not have always understood the topographical restraints that preoccupied Olmsted, Goodhue's simplifications and improvements imposed order on Olmsted's diffuse plans. He wanted to level the plazas for visual and functional reasons and relocate the buildings for dramatic effect. Goodhue or an associate drew a sketch, published in the *San Diego Evening Tribune* on July 19, 1911, showing how the buildings on the southern site would appear when approached over the Spanish Bridge.[22] This view resembles the later approach to the Panama-California Exposition over Cabrillo Bridge. Goodhue was capable of drawing the idealized Mexican town that Olmsted hoped for, though he preferred the opulent Spanish Colonial town shown in the *Evening Tribune* sketch.[23]

Allen got the idea that the Exposition would be better served if it were located off Laurel Street on the west side of Balboa Park. If he drew up plans, they have been lost. He called for an art museum and an auditorium along an extension of Laurel Street to the edge of Cabrillo Canyon.[24] A bridge might span the canyon continuing the Exposition on a mesa that Olmsted had named after Vizcaino, a Spanish explorer who in 1602 named San Diego after Saint Didacus, a Franciscan monk and the name of his flagship. Since Sixth Avenue was not then a through street, Allen may have planned to put a road through, which happened in 1913 to the consternation of residents, park lovers and upholders of Samuel Parsons's 1905 plans for the west side of the park.

Allen registered objection after objection to Olmsted's plans for the southern site: the Exposition would disturb the students at Russ High School; the Exposition was located near the poor rather than the elite section of the city; there was no space in which to expand; grading was expensive.[25] There was something fatuous about Allen's complaint that Olmsted's plan would cost too much and his plan would be cheaper, as he had no idea how much it would cost to relocate the Exposition to the west side of Cabrillo Canyon. Olmsted took the objections of Allen and Goodhue philosophically. He pared his plan, striking out five bridges, the Spanish garden, the parade ground, the military campground, the aviation field, the tent city, the village composed of foreign government buildings, the Canada de la Maleza, the Agricultural College, the Plaza Externa arcades and the stadium.[26]

Olmsted's parings were evident in Plan 3, which Goodhue subsequently modified into Plan F. In a letter to Olmsted, Goodhue contrasted Plan F for the southern site with his own formal Plan G for an Exposition on Vizcaino Mesa:

> *I can't help feeling that if you bury your prejudices, the other site is better in every way. After all you are not dealing with an American town in its essence, but with what is endeavoring to be a Spanish one. Formality is the note of all Spanish architecture and I can't conceive, indeed I may as well frankly say, I don't know in any American public park of any effect that could compete with the bridge, the permanent buildings, and the mall terminated by the statue of Balboa.*[27]

Olmsted based road schemes and building locations on how the grounds would look after the Exposition was over, a minor matter to Goodhue. He predicted that changes to the central (Vizcaino) mesa to accommodate permanent buildings would never be effaced, a condition the Buildings and Grounds Committee was ultimately to endorse, for its members thought that they could not spend park improvement bond money unless park changes financed by bond money were permanent.[28] Aware that Olmsted's professional decisions were theoretically superior to his own and that he held his position because of the recommendations of John Charles and Frederick Law Olmsted Jr., Goodhue offered to resign:

> *While I dislike to seem in any sense to quarrel or even to differ with you, I must ask you to consider my point of view equally, or next, [sic] your own in the matter of Fair buildings. As you know I have agreed to accept any site you and the committee may choose. It seems to me that in doing this I have not waived anything essentially within my own province, that is to say the selection of the site upon which the buildings should be placed should (does rest) entirely with you and the committee, but I feel that in the placing of the buildings my interest is as great as your own, perhaps even greater, for if they are placed at all, I must see that they are placed according to mass, general arrangement and design.*[29]

On or about July 12, 1911, the Buildings and Grounds Committee accepted Olmsted's plan.[30] Abandoning his work on Plan G, the first schematic plan for El Prado in Balboa Park, Goodhue, on August 26, 1911, sent the Buildings and Grounds Committee Plan 53-C, which he had worked out with

Olmsted[31] for the southern site. Architect and landscape architect tried to get construction costs below $1.5 million while maintaining essential features.[32] They disagreed, however, over what features were essential. Olmsted wanted to delete the auditorium, delay construction of the art building and make the California State and United States Government Buildings temporary structures. As he had indicated in the July 19 sketch published in the *Evening Tribune*, Goodhue expected that either the auditorium or the California State Building would be a permanent structure that he could equip with domes, tower and arcades and relief in his innovative Spanish Colonial style.

After the Building and Grounds Committee accepted Olmsted's plan for the southern site, Goodhue agreed to stop working on his plan for Vizcaino Mesa,[33] but Frank P. Allen was not similarly constrained. Allen retained the essential features of Goodhue's plan and endorsed Olmsted's scheme to fill the lower end of Spanish Canyon with water that would be impounded at the southern edge by a dam doing duty as a bridge. (The project was abandoned in 1913 for financial and technical reasons.)

D.C. Collier supported Allen's modifications of Goodhue's plan as he wanted a trolley line through the middle of the park—something that Olmsted's configuration for the southern site made virtually impossible. Collier's reasons had nothing to do with the Exposition but a lot to do with his and other people's real estate holdings to the north and northeast of Balboa Park. Being a booster, Collier began to believe his own propaganda. He was convinced that the southern states, the countries of Latin and South America and even some European countries would put up buildings and mount exhibits at San Diego. He also thought a grand congress of Indians from North and South America would convene in Balboa Park during the Exposition. Goodhue thought these fantastic dreams would never see the light of day.[34]

While Olmsted, Allen, Goodhue and Collier were wrangling, James Wadham, a new mayor, was elected in San Diego with the support of union leaders and job seekers who were annoyed at the way the Exposition was developing.[35] The mayor appointed a new slate to the Park Board, who were not willing to work in concert with the Panama-California Exposition Corporation.[36]

The disagreement focused on the employment of Frank P. Allen, the $20,000-a-year salary he received, his authority to construct the Exposition without subletting to private contractors and his hiring of non-union labor. Local architects were not happy with the privileges given to Goodhue. San Diego Floral Association members were uncertain how they felt about the appointment of John Olmsted.[37]

Wadham was unable to keep his park board. After its members resigned on June 24, 1911, he replaced them with members of the Panama-California Exposition Corporation,[38] but not before the old board entered into a revised contract with the Panama-California Exposition Corporation on June 20 that gave the corporation authority "to prepare architectural and engineering plans of every description."[39] In some inexplicable way, Allen, a director of work crews, interpreted this open-ended clause and later directives from the Exposition's Buildings and Grounds Committee as giving him authority to "design" buildings.[40] This "laying-on-of-hands" may have been the "San Diego way," but it was not the way Expositions had been built in Chicago, Buffalo, St. Louis, Portland and Seattle.

The new board finessed the technical question of how the $1 million in bond money for park improvements was to be spent.

The objections of D.C. Collier and Frank P. Allen to the southern site and the covert influence of John D. Spreckels, owner of the proposed trolley line through the park, were enough to dissuade the Building and Grounds Committee. On August 31, 1911, the committee voted to relocate the Exposition, with Moses A. Luce, Thomas O'Hallaran, Julius Wangenheim and George W. Marston dissenting. Upon receiving the news, Olmsted wired his resignation, stating, "We regret that our professional responsibility as park designers will not permit us to assist in ruining Balboa Park. We therefore tender our resignation to take place at once. We have wired Blossom to do no more work on the exposition or park plan and for him to leave San Diego at once."[41]

Allen and Goodhue were appalled that their advocacy of the central mesa as an exposition site had led to such an outcome. Well they might be, since they had promoted their plans behind Olmsted's back. The effects of their actions could be dire to Balboa Park and to their careers. Allen wrote to Olmsted asking him to withdraw his resignation, saying, "Although to you the Park is of greater importance than the Exposition yet I think the Exposition needs you much more than the Park does. The only way by which this Exposition can achieve success is by having grounds and buildings of unusual and very exceptional artistic merit and <u>I do not think that this can be done without your assistance</u>."[42] (Underlining in original.)

Goodhue wrote to his friend Frederick Law Olmsted Jr., asking him to get his half brother to rescind his resignation. He wrote, "Cannot you make your brother reconsider, cannot tell how grieved I and everyone is at present turn of affairs. It appears Collier's efforts have so increased size that new site became unavoidable even your brother's staunchest supporters so voting."[43]

Both men were unsuccessful.

Distressed by the decisions of the Building and Grounds Committee to go with Allen's and Goodhue's plans, George W. Marston resigned as chairman of the committee, giving as his ostensible reason his preoccupation with his business. In a private letter to Olmsted, he expressed his real feelings:

> *I may say to you confidentially that the withdrawal of Olmstead* [sic] *Brothers from participation in the park and exposition work, and the changes contemplated by Allen and adopted by the exposition has also a great deal to do with my own withdrawal from active service. It wouldn't do to have this known in San Diego, but I wish to assure you of my belief in the value of your advice and to say it will be a life-long regret to me that San Diego lost the service of you and your firm, by the action taken on the part of the building and grounds committee.*[44]

The construction of Highway 5 in the 1960s has wiped out the area that Olmsted had planned for the Panama-California Exposition, as well as a large portion of the land Samuel Parsons had graded and planted in the southwest corner of Balboa Park. If the Exposition had been built there, today there might be nothing left to remind people of its presence. Except for some oak and eucalyptus plantings on the east side of Balboa Park and the name of Cabrillo Canyon, there is little to show of Olmsted's work.

Some of Olmsted's predictions about the fate of the center of Balboa Park have come true. Since the Exposition, the citizens of San Diego have experienced complications and contradictions in this section more overwhelming than any Olmsted had foreseen. Unlike his half brother, John Olmsted was not a town planner, but even town planners in the 1900s did not visualize the damages that the automobile and an escalating population would bring about.

Goodhue brooded over his disagreement with John Olmsted. He kept him informed of his difficulties with Frank P. Allen, who had taken credit for designing all the temporary Exposition buildings, and he defended his idea of tearing down the temporary buildings and replacing them with formal gardens,[45] an idea that went partway toward meeting Olmsted's objections but an idea that Olmsted, steeped in the naturalistic and picturesque traditions of his stepfather, could never have supported.[46]

Worried that his friend Frederick Law Olmsted Jr. would turn against him, Goodhue wrote a letter asking for forgiveness.

> *You and I have been friends for a great many years. I have enjoyed the friendship and we have worked together in perfect harmony. I cannot help feeling that your brother, and even possibly you, will feel me responsible for what has happened. Looking at the matter from a purely selfish standpoint, this is the one thing that counts. If I had known, or even suspected, that the thing would have come to such a pass, believe me, I would never have had anything to do with it, and I would resign now if I though such a course could be of any value to your brother or to anyone else.*[47]

Frederick Law Olmsted Jr. replied:

> *I don't see why the San Diego episode should interfere with our friendship; because for all we regret your attitude, both I and my brother absolve you of any unfriendliness or unfairness in the matter.*
>
> *Even from the standpoint of professional things the fact is not altered that you and I are very much in accord in our sympathies in certain directions, in spite of this unfortunate increase in the things about which we know ourselves to be out of accord. You are perfectly at liberty to regard my views upon these matters as one of the more or less amiable vagaries of an otherwise intelligent person, just as I shall certainly regard your failure to appreciate my point of view as due to one of those unfortunate limitations of mind to which the best of people are subject.*[48]

There can be no conclusion to John Olmsted's philosophical quarrel with the Panama-California Exposition Corporation. Lacking a neat resolution, perhaps Bertram Goodhue's words to Frederick Law Olmsted Jr. thanking him for his friendship are a salutary reminder of the respect we should have for those with whom we do not agree:

> *I was frightfully afraid that you and your brother would be led to believe that I had some hand in the course of events at San Diego.*
>
> *As for the point upon which we differ, it seems strange and rather disgusting that we should take such different views but I am delighted to let it stand in precisely the way you put it and now that I know we cannot do it without bitterness—would like to go over the whole thing with you sometime face to face.*[49]

CHAPTER 10
Architectural Derivations of Panama-California Exposition Buildings

Though most architects do not like to admit they borrow details from other buildings, they frequently do. This practice was even more prevalent in the early part of the twentieth century, when many architects visited and studied in Europe. It was inevitable that exposition architecture would reflect a vast amount of accumulated knowledge, for architects did not have the time or the inclination to design original and innovative buildings for temporary purposes.

In newspaper and magazine accounts, Director of Works Frank P. Allen Jr. boasted that he was responsible for the ground plan and design of buildings for the Panama-California Exposition, except for the Organ Pavilion and the California Quadrangle. This claim infuriated consulting architect Bertram Goodhue, as shown by his correspondence on file in the Avery Library of Columbia University. The determination of responsibility was important because on it hinged the assignment of future commissions. Carleton M. Winslow, Goodhue's assistant, maintained that Goodhue designed the permanent California Quadrangle, and that he (Winslow) designed some of the temporary buildings, Allen the others.

The following attributions are offered to appease the curiosity of readers who may be interested in such matters.

Carleton M. Winslow designed the Mission-style Administration, Indian Arts and Kansas Buildings; the Spanish Renaissance–style Science and Education Building; the Spanish Plateresque–style Home Economy Building; the hybrid Persian-functional-style Botanical Building; the Mexican

Balboa Park and the 1915 Exposition

Drawing signed "Bertram G. Goodhue 1914." *Panama-California Exposition Digital Archive.*

Churrigueresque–style Varied Industries and Food Products Building; the Baroque-style corner entrances to arcades; and the neoclassical-style Seal of the City of San Diego on the crown of the arch of the West Gate.[1]

The Southern California Counties Building, a massive structure at the northeast end of the Prado axis, was a collaborative effort of Bertram G. Goodhue, Carleton M. Winslow and C.L. Wilson, from the Southern California Counties Commission. Goodhue's involvement emerged from a casual sketch during one of his infrequent visits to the Exposition site. Due to this sketch, the building possessed an undulating entablature, dual towers topped by domes in starburst designs and a forecourt from whose north side baroque ornament blossomed from second-story windows. Laying aside his dislike of the bombast on other temporary buildings, professor of decorative design Eugen Neuhaus praised the Southern California Counties Building, unaware that details he admired stemmed from the monastery cloister of *San Agustin* (Municipal Palace) in Queretaro.[2]

For reasons known only to him, Allen neglected to say that the John Simpson Construction Company built the Southern California Counties Building.[3] Similarly, the William Wurster Construction Company built the Spreckels Organ Pavilion and California Quadrangle buildings. As firms outside Panama-California Exposition (and Frank P. Allen) control built these projects, Palethorpe, McBride and Probert did not include them in their Pre-Exposition [Auditing] Report.[4]

Balboa Park and the 1915 Exposition

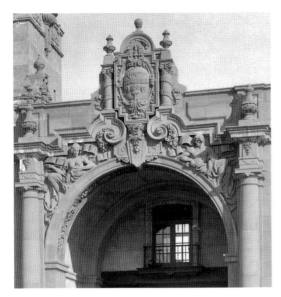

Left: Detail of ornamentation on the West Gate, with the city's coat of arms at the top and two figures symbolizing the Atlantic and Pacific Oceans joining waters together in commemoration of the opening of the Panama Canal. *Panama-California Exposition Digital Archive.*

Below: Kansas State Building. *Michael Kelly Collection, Panama-California Exposition Digital Archive.*

Winslow was a talented decorator who worked best when his designs came from his imagination rather than from copybooks. The allegorical tableau on the east side of the Varied Industries Building, the tablet in honor of Father Serra on the apse end of the Food Products Building and the geometric shapes on the patio tower of the Science and Education Building displayed his abilities.

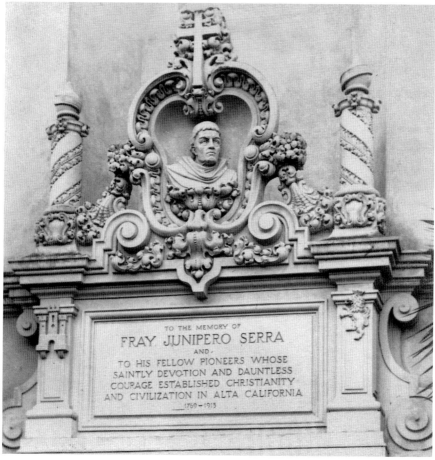

Balboa Park and the 1915 Exposition

Above: Pergola in the Montezuma (now Alcazar) Garden. *David Marshall Collection, Panama-California Exposition Digital Archive.*

Opposite, top: Southern California Counties Building. *Michael Kelly Collection, Panama-California Exposition Digital Archive.*

Opposite, bottom: Junípero Serra memorial on the west apse of the Varied Industries and Food Products Building. *The Committee of One Hundred Collection, Panama-California Exposition Digital Archive.*

Henry L. Schmohl supervised a crew of twenty-six who modeled the ornament after Winslow's drawings before they cast it in glue molds, using a medium of plaster and hemp fiber.[5] Bruce Kamerling asserted that Henry Schmohl's better-known brother Fred C. Schmohl, who listed his occupation as "modeler," was on the grounds.[6] If so, he must have played a significant role in the choice of ornament.

Frank P. Allen Jr. designed the Roman aqueduct–style Cabrillo Bridge, the neoclassical-style pergolas in the Montezuma and Botanical Gardens, the Romanesque colonnade between the Foreign Arts Building and the Commerce and Industries Building, the Italian-Renaissance Sacramento Valley Building, the Mexican-Churrigueresque San Joaquin Valley Building and the Mission-style Montana Building.

Balboa Park and the 1915 Exposition

Fountain and pergola in the Botanical Garden. *Michael Kelly Collection, Panama-California Exposition Digital Archive.*

Colonnade between the Foreign Arts Building and Commerce and Industries Building. *David Marshall Collection, Panama-California Exposition Digital Archive.*

Balboa Park and the 1915 Exposition

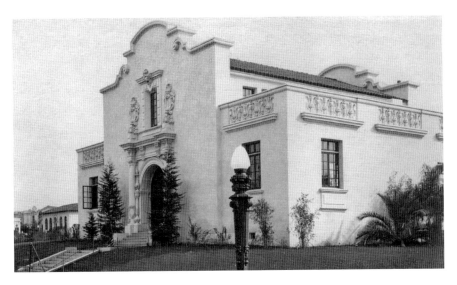

Montana State Building. *Michael Kelly Collection, Panama-California Exposition Digital Archive.*

Cabrillo Bridge does not resemble the narrow and soaring bridge that spans the *Tajo* (ravine) at Ronda, Spain,[7] as has been alleged. It does, however, echo the plain, functional massing of any number of surviving Roman aqueducts in Europe. Architect Allen supplied the design for the bridge and Thomas B. Hunter the engineering. Hunter also played a prominent role in the creation of the skeleton of the Botanical Building with Winslow as designer. Director of Works Allen offered suggestions, but he was not the principal agent. The open-iron frame of the Umbracle in Barcelona, built 1883–84, has been mentioned as an inspiration for the Botanical Building, both buildings being conservatories with wood laths or louvers in their interstices. Since documentation does not exist to back up this claim, it is more likely that Winslow and Hunter knew of open-work, iron-frame buildings closer to home, such as the Bird Cage erected in 1904 by the Smithsonian Institution for the Louisiana-Purchase Exposition, today the oldest structure in the Saint Louis Zoo.[8]

Harrison Albright, architect for John D. Spreckels, designed the neoclassical-style Organ Pavilion with a great arch in the center and curving arcades at the sides. He covered the exterior with rosettes, stars, satyr heads, floral sprays and musical motifs. The arcade served as a vantage from which to view the San Diego shoreline and harbor and distant islands and ocean.[9] The hemispherical shape of the pavilion was conventional and its ornament academic.

Balboa Park and the 1915 Exposition

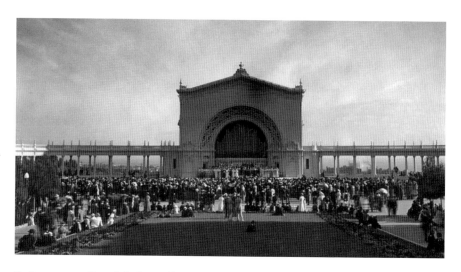

Performance at Spreckels Organ Pavilion. View of the city from the curved arcades. *David Marshall Collection, Panama-California Exposition Digital Archive.*

Quayle Brothers and Cressey, San Diego architects, designed a sedate neoclassical-style Salt Lake and Union Pacific Building to the east of the Organ Pavilion.[10] Its austere style was incompatible with the playful Spanish-Mexican character of the rest of the Exposition.

The introduction of many neoclassical buildings and features by Allen, Albright and Quayle Brothers shows that Bertram Goodhue's power to impose a uniform architectural style had been eclipsed. His instruction to Winslow to stop cooperating with Allen was the most dramatic expression of his disillusionment.[11]

A.F. Heide designed the Mission-style Washington State Building,[12] John Fetzer the Spanish Renaissance–style Utah Building[13] and Fred de Longchamp the Italian Renaissance–style Nevada Building.[14] All three buildings display a carefree spirit. Isaac Hamilton Rapp used the plan and elevation of the mission compound of San Estevan at Acoma and open balconies, banisters, doors, windows and projecting rafters (vigas) from the mission compound of San Buenaventura at Cochiti as sources for the autochthonous New Mexico Building, the most innovative of the state buildings.[15]

Winslow gave Allen credit for designing buildings not attributed to other architects. Winslow and Allen admitted they took details from other buildings, Winslow openly and Allen more reticently.

Winslow attributed a tower on the Indian Arts Building to towers in Puebla and the east façade of the same building to the *Sanctuary of Guadalupe*

in Guadalajara, both in Mexico; a tower on the Science and Education Building to Moorish sources and its east façade to the Church of San Francisco in Puebla; the west entrance of the Home Economy Building to the Palace of the Counts of Heras in Mexico City; the southwest corner tower to the Palace of the Count of Monterey in Salamanca, Spain; the west façade of the Foreign Arts Building to the Hospital of Santa Cruz in Toledo, Spain; the upper balcony of the south side of the Varied Industries Building to sources in Queretaro, Mexico; and the double arcade on the north side of the patio in the Southern California Counties Building to the Convent of San Agustin in Queretaro.[16] (A copy of the façade of the *Hospital of Santa Cruz* was also replicated at the Panama-Pacific International Exposition held in San Francisco in 1915.)

Photographs of buildings in Mexico were obtainable in Sylvester Baxter's ten-volume study of the Spanish Colonial architecture of Mexico. (Indeed, a selection of these photographs was on exhibit in the lower level of the Fine Arts Gallery.) Photographs and drawings of buildings in Spain were obtainable in contemporary books and magazines, as well as from photographs taken in Spain by tourists.[17]

San Diego historian Richard Pourade gave the source of the tower on the Indian Arts Building as a tower on the Church of Santa Catarina in Puebla.[18] Pourade did not reveal his sources; however, he found many of them—but not all—in Baxter's book.

Winslow probably got his ideas from Goodhue except for his plans for the High Renaissance apse and Early Renaissance arcade on the west side of the Food Products Building. These much-praised features undoubtedly came from Winslow's recollections of his sojourn in Italy.[19] They were not reproduced when the building was rebuilt as the Casa del Prado in 1970–71. Samuel Hamill, consulting architect for this project, told this writer he was sick at the time; otherwise, he would have fought for their inclusion.

Finding Allen's sources is not easy. His most explicit account of the Exposition summarized the history of architecture in Spain and its colonies from the time of the Moors but said little about buildings in Balboa Park.[20] Winslow drew the curtains back slightly when he attributed the Sacramento Valley Building to municipal buildings in Verona; the cornice of the Commerce and Industries Building to the Town Hall in Palma, Mallorca; and the San Joaquin Valley Building to civic buildings in Mexico City.

Pourade thought the model for the Sacramento Valley Building was the Loggia del Consiglio in Verona.[21] Both buildings have deep porches and upper and lower levels; otherwise, they are different.

Balboa Park and the 1915 Exposition

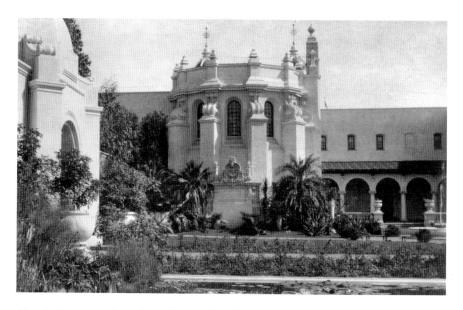

Church-like apse and arcade on the west side of the Food Products Building. *Ralph Bowman Collection, Panama-California Exposition Digital Archive.*

Eugen Neuhaus thought the Sacramento Valley Building "in its general features" resembled the Government Palace at Oaxaca, Mexico.[22] The lower-level arcades of the lateral wings of the palace at Oaxaca relate to their entablatures and finials in a manner similar to that of the Sacramento Valley Building. However, decorations and proportions are different. Most likely Allen derived the building from a generic idea of what a High Renaissance civic building looked like without being able to trace the building to a specific source.

Allen may have derived the filigree covering the pillars and entablatures on the Sacramento Valley Building from the stucco relief on the grand staircase of the National Conservatory of Music in Mexico City, a picture of which is reproduced in Baxter's book. On the other hand, artistic plasterer H.L. Schmohl, who oversaw ornamental work on the buildings, may have talked him into it.[23]

The Sacramento Valley Building's symmetrical appearance, its location at the head of the Plaza de Panama, its wedding cake ornament and its stepped platform gave it a commanding presence. The loss of this festive building and of the Science and Education Building and the Home Economy Building that flanked it to right and left have disrupted the harmonious architectural and lighthearted character that in 1915 pervaded the Plaza de Panama.

Allen used Baxter's book as the source for his copy of the façade on the Casa de Don Tomas Lopez de Ecala in Queretaro on the two north pavilions of the Commerce and Industries Building. As an act of courtesy, Winslow did not divulge Allen's tracing of detail. The building in Queretaro has a rococo grace. Connoisseurs of Mexican architecture have praised its wrought-iron balconies.[24] In Balboa Park, robust kneeling Amazons, who hold up the eaves, overshadow details "borrowed" from the Casa de Ecala.

Allen transferred panels on the eaves and cornices of the Town Hall in Palma, Mallorca, to the Commerce and Industries Building, another case of slavish copying. Blue, red, green and gold accents highlighted details. The idea probably came from *Renaissance Architecture and Ornament in Spain*, by Andrew Noble Prentice, published in 1893.[25]

Artisans working under Henry L. Schmohl modeled the nubile Amazons on the Commerce and Industries Building. These buxom nudes were reminiscent of generously endowed—but fully clothed—matrons who do similar work on the Town Hall in Palma. Neuhaus was offended by these "over naturalistic" women. He thought the treatment of the cornice would have been more effective if they were not there.[26]

Allen may have derived his two-story San Joaquin Valley Building from a photograph in Baxter's book of the one-story Casa de los Mascarones in Mexico City. Unlike the Casa de los Mascarones, the Balboa Park building used *estípites*, or inverted columns, in place of the grotesque figures (*mascarones*)

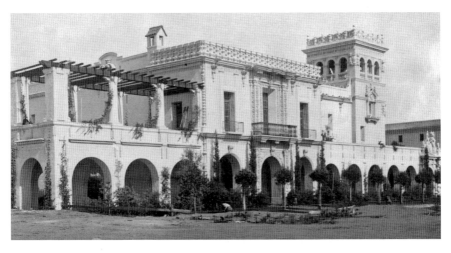

Home Economy Building under construction. *David Marshall Collection, Panama-California Exposition Digital Archive.*

Balboa Park and the 1915 Exposition

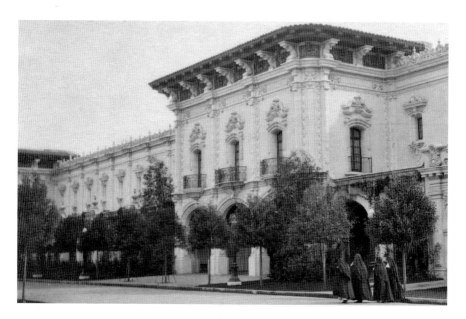

Nude female figures support the cornice on the Commerce and Industries Building. *David Marshall Collection, Panama-California Exposition Digital Archive.*

that give the Mexico City building its distinction.[27] The wide use of *estípites* on the façades and altars of churches in Mexico is one of the hallmarks of the Churrigueresque style.[28] In the best examples, the combination of deep-set carving and imaginative detail is spellbinding. Examples on "temporary" buildings along El Prado are clumsy imitations.

Clarence Stein, Bertram Goodhue's assistant in 1915–16 who later became a well-known planner of "garden cities," stressed the magical effect of narrow streets that lead to great plazas and squares in Venice and Rome.[29] Critic Alfred Morton Guthens repeated the same thought.[30] The expanding effect they claimed to find in Balboa Park, was not, however, due to "narrow streets," but to the arcades that lined El Prado. These arcades, on the north and south sides, supplied a sense of comforting rhythm and helped to unify the composition. At the same time, they provided people with an experience of progression and discovery as they emerged from shadowed spaces into the sunlight of open plazas. Not to be underestimated were lateral glimpses of gardens and patios. Today, contrasts of openness and closure and of sun and shade can be found only on the south side of El Prado as the linking arcades on the north side have been disrupted by additions that lack inviting arcades within and between buildings. The Committee of One Hundred, an

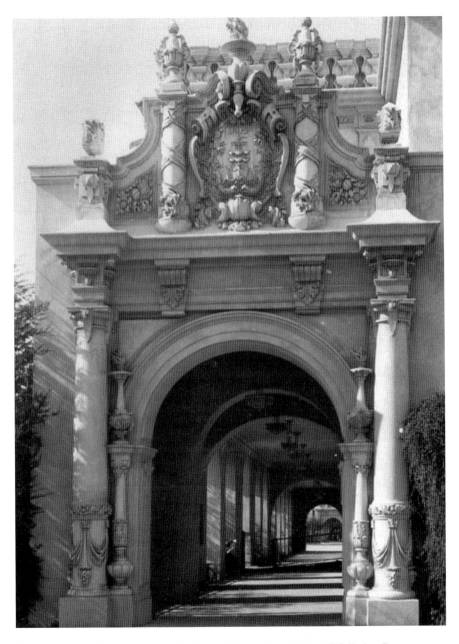

Entrance to one of the many arcades along El Prado. *David Marshall Collection, Panama-California Exposition Digital Archive.*

organization devoted to the restoration of the Spanish Colonial features in Balboa Park, has done much to redress this imbalance by re-creating missing arcades adjoining the Plaza de Panama on the north side of El Prado.

The plan to use arcades to enhance continuity and dramatize progression appears to have been Goodhue's. He had projected this scheme in preliminary designs for the Exposition at an unevenly surfaced southern site where, to conform to changes in elevation, the arcades would have been stepped. El Prado being flat, arcades maintained an even level. Since the first style for the Exposition was to have been California mission, it is easy to say arcade schemes came from mission examples. This was only partially true at the finally approved central mesa site. The piers and tile pavement of the Fine Arts Gallery corridor at the south side of the California Quadrangle recall the long arcade at Mission San Fernando. More directly, buttresses on the south side of the gallery copied those on Mission San Gabriel.

Without being specific, Winslow suggested Celaya, Mexico, and Genoa, Italy, as sources for arcades along El Prado.[31] Arcades in Baxter's book are from cloisters and patios in Mexico. They do not come from the outsides of buildings. While these existed in Mexico, Baxter may not have been impressed by them. Photographs of arcades in the Plaza de Armas in Celaya show arches that spring from narrow imposts that top tall, thin pillars. Arcades in the Piazza De Ferrari, the most famous square in Genoa, are another matter, as they exist in a multitude of elaborate forms. Their profusion is overwhelming. The only resemblance of these arcades to arcades in Balboa Park is that they are arcades. Based on Winslow's comment and on Baxter's omission, it is likely that the general design of arcades along El Prado came from Celaya, Mexico, and Genoa or from other cities in Italy where they are outstanding features, subject to the constraint of forgetful memory. It is improbable that Winslow knew of the incredible variety of arcades in the cities and towns of Italy. Nor is there evidence he knew of the famous arcades surrounding the Plaza Mayor at Salamanca or the Placa Reial in Barcelona, both in Spain. This raises the question of how different the designs along El Prado would be if Winslow's knowledge was broader and the means were greater.

A discussion of the origins of the California Building and Fine Arts Building, designed by architect Goodhue as permanent additions to Balboa Park, can be found in other chapters of this book. The exterior of the first derives from the Churrigueresque façades of churches in Mexico; the tile dome of Santa Prisca and San Sebastian in Taxco, Mexico; the Greek-cross plan of San Biagio in Montepulciano, Italy; and the play of domes and half-

domes of mosques in Istanbul. Sources for the exterior of the 1915 Fine Arts Gallery were given in the preceding paragraph.

Whether today's buildings should use ornament and be as sumptuous as the showpiece buildings Winslow and Allen created in Balboa Park is an open question. Attempts are sometimes made in this direction, in theme parks, historic restoration of old buildings and postmodern architecture. Panama-California Exposition consulting architect Bertram Goodhue never relinquished his love of ornament, but because of his greater love of structure, he gave up his flirtation with sprawling Spanish Colonial ornament in favor of relief that appeared to "grow" from columns, pillars and beams. The statehouse in Lincoln, Nebraska, and the Los Angeles Public Library are prime examples.[32] As the creative possibilities of people are unlimited, there is no reason Revival-style buildings similar to those in Balboa Park, or postmodern adaptations of the same, cannot be created with a similar theatrical success.

Notes

Chapter 1

1. *San Diego Union*, August 29, 1909; September 8, 1909.
2. Ibid., April 12, 1914.
3. Ibid., September 6, 1909; September 27, 1909.
4. Department of Commerce and Labor, Bureau of the Census, *13th Census of the United States Taken in the Year 1910*, 33, 63.
5. *San Diego Union*, September 11, 1909.
6. Ibid., April 28, 1907.
7. D.C. Collier, "What an Exposition Is For," *Sunset*, July 1913, 145–50.
8. *San Diego Union*, August 26, 1911; February 29, 1912; May 31, 1913; April 23, 1914. Colonel Collier was an "eager beaver." He owned one of the first automobiles in San Diego, headed the Reception Committee for the visit of the Great White Fleet to San Diego in 1908 and organized the San Diego Aero Club. He donated land in San Diego, La Mesa and Ramona for parks. The soft shirt, Windsor tie and ten-gallon hat Collier wore attested to his unconventional and boisterous personality. Successful as a booster of the Exposition, he was unsuccessful as a politician. Voters rejected him as a city councilman in 1917 and as a county supervisor in 1932. Despite these shifts in public opinion, his friends looked up to him. As an indication of their esteem, they helped put up a memorial bas-relief in Collier's honor on the east wall of the Plaza de California on October 11, 1936. The bas-relief, by sculptor Frederick Schweigardt, shows Collier signing his name, "Yours for San Diego." Beneath are the words: "David Charles Collier—A Man of Vision—A Dynamic Leader—A Developer and Builder—A Great and Lovable Character—The Creative Genius of the Panama-California Exposition of 1915—An Inspiration to the Citizens of Today."
9. Frank Todd, *The Story of the Exposition, Being the Official History of the International Celebration Held at San Francisco in 1915* (New York: G.P. Putnam's Sons, 1921), 1:42.
10. *San Diego Union*, January 15, 1910; January 18, 1910.

11. Ibid., February 25, 1910.
12. Ibid., March 16, 1910.
13. Ibid., April 14, 1910.
14. Ibid., May 8, 1910.
15. Ibid., August 10, 1910.
16. Todd, *Story of the Exposition*, 91.
17. *San Diego Union*, May 23, 1911.
18. Ibid., August 20, 1911.
19. Ibid., January 23, 1912.
20. Ibid., February 5, 1912.
21. Richard Pourade, *Gold In the Sun* (San Diego, CA: Union-Tribune Publishing Co., 1965), 163–64.
22. *San Diego Union*, February 10, 1912.
23. Ibid., February 29, 1912.
24. William Kettner, *Why It Was Done and How* (San Diego, CA: Frye & Smith, 1932), 9–10.
25. Joseph L. Gardner, *Departing Glory: Theodore Roosevelt as Ex-President* (New York: Charles Scribner's Sons, 1973), 268.
26. Ibid., 267.
27. *San Diego Union*, May 24, 1913.
28. Ibid., July 2, 1913.
29. Ibid., November 16, 1910; November 12, 1910.
30. Letter, George W. Marston to John Nolen, September 22, 1910, Marston File–Correspondence, 1910–1914, San Diego History Center Research Archives.
31. *San Diego Union*, January 6, 1911.
32. Ibid., May 24, 1911; June 16, 1911.
33. Ibid., June 25, 1911.
34. Ibid., October 23, 1910.
35. Ibid., January 28, 1911.
36. Esther McCoy, *Five California Architects* (New York: Reinhold, 1960), 87–90.
37. *San Diego Union*, August 8, 1910.
38. Ibid., September 7, 1910; Letter, John C. Olmsted to George W. Marston, July 7, 1911, Marston File–Correspondence, 1910–1914, San Diego Historical Society Research Archives.
39. Letter, Bertram Goodhue to John C. Olmsted, July 28, 1911, Olmsted Collection, Job File 4051, Library of Congress, Washington, D.C.
40. *San Diego Union*, October 28, 1910.
41. Letter, Thomas O'Hallaran, Secretary of the Board of Park Commissioners to City Council, December 29, 1910, Document 38825, filed January 3, 1911, San Diego City Clerk's Office.
42. Letter, Board of Park Commissioners to City of San Diego, September 1913, *Panama-California International Exposition Papers*, compiled by Joanne S. Anderson, 1972, San Diego Public Library, California Room.
43. *San Diego Union*, July 20–23, 1911; John C. McGroarty, "San Diego Pageant Exposition," *West Coast Magazine* (October 1911): 7–26.
44. Matthew F. Bokovoy, *The San Diego World's Fairs and Southwestern Memory, 1880–1940* (Albuquerque: University of New Mexico Press, 2005), 39.
45. *San Diego Union*, July 24, 1911.
46. Ibid., November 23, 1911.
47. Letter, John C. Olmsted to Frederick Dawson, July 28, 1911, Marston File–Correspondence, 1910–1914, San Diego History Center Research Archives.

48. Pourade, *Gold in the Sun*, 250.
49. Letter, Bertram Goodhue to John C. Olmsted, May 26, 1911, Job File 4051, Library of Congress.
50. Letter, John C. Olmsted to Bertram Goodhue, June 2, 1911, Job File 4051, Library of Congress; Gregory Montes, "The Rise and Fall of the Olmsted Plan," *Journal of San Diego History* 28, no. 1 (Winter 1982): 54.
51. Letter, John C. Olmsted to George W. Marston, September 1, 1911, Marston File–Correspondence, 1910–1914, San Diego History Center Research Archives.
52. Letter, Bertram Goodhue to John C. Olmsted, August 20, 1911, Job File 4051, Library of Congress.
53. Ibid., August 3, 1911, Job File 4051, Library of Congress.
54. Letter, Frank P. Allen Jr. to John C. Olmsted, September 5, 1911, Job File 4051, Library of Congress.
55. Letter, Frederick Law Olmsted Jr. to Samuel Parsons, October 12, 1911, Job File 4051, Library of Congress.
56. G.R. Gorton, "Monthly Excursion Through Exposition Grounds," *California Garden* (January 1916): 5.
57. McCoy, *Five California Architects*, 89.
58. *San Diego Union*, September 6, 1911.
59. David Gebhard and Robert Winter, *A Guide to the Architecture in Los Angeles and Southern California* (Santa Barbara, CA: Peregrine Smith, 1977), 79–81.
60. Matthew F. Bokovoy, *The San Diego World's Fairs and Southwestern Memory* (Albuquerque: University of New Mexico Press, 2003); Mike Davis, Kelly Mayhew and Jim Miller, *Under the Perfect Sun: The San Diego Tourists Never See* (New York: New Press, 2003); Robert W. Rydell, *All the World's a Fair* (Chicago: University of Chicago Press, 1984), 218.
61. Rosalie Shanks, "The I.W.W. Speech Movement, San Diego, 1912," *Journal of San Diego History* 19, no. 1 (Winter 1973).
62. Clare V. McKanna Jr., "Prostitutes, Progressives and Police: The Viability of Vice in San Diego, 1900–1930," *Journal of San Diego History* 35, no. 1 (Winter 1989).
63. Davey Jones, "A Fight for Free Speech in San Diego," *San Diego Indymedia*, January 21, 2005, www.iww.org/culture/articles/DJones1.shtml.
64. Bertram Goodhue, *Mexican Memories* (New York: G.M. Allen, 1892); Sylvester Baxter, *Spanish Colonial Architecture in Mexico*, plans by Bertram Goodhue (Boston: Millet, 1902); Charles H. Whitaker, *Bertram Grosvenor Goodhue, Architect and Master of Many Arts* (New York: Press of the American Institute of Architects, Inc., 1925).
65. Letter, Bertram Goodhue to Christian Brinton, August 17, 1915, Avery Library, Columbia University; Carleton M. Winslow, *The Architecture and the Gardens of the San Diego Exposition* with an introduction by Bertram Grosvenor Goodhue (San Francisco: Paul Elder and Company, 1916).
66. Eugen Neuhaus, *San Diego Garden Fair* (San Francisco: Paul Elder and Company, 1916).
67. *San Diego Union*, January 3, 1911; Neuhaus, *San Diego Garden Fair*, 23; Phil Patton, "Sell the Cookhouse if Necessary, but Come to the Fair," *Smithsonian Magazine* 24, no. 3 (July 1993): 38.
68. *San Diego Union*, January 3, 1911; January 1, 1915, Exposition Edition; Mark S. Watson, "San Diego Exposition," ed. F. Weber Benton, *Semi-Tropic California*, President Wilson Invitation Edition (Los Angeles: Benton & Company, 1914), 84–86, San Diego Public Library, California Room. Highlighting of processes as well as products was not an original idea with San Diego Fair promoters as the same idea had been used at the Louisiana Purchase Exposition of 1904 in St. Louis.

69. *San Diego Union*, October 18, 1911; January 1, 1914; January 1, 1915, Exposition Edition; Geddes Smith, "California's Country Fair," *Independent Magazine*, July 16, 1914, 119–21; Winslow, *Architecture and Gardens*, 36.
70. "The Romantic Past of Spanish California Returns," *San Diego Panama-California Exposition: San Diego All the Year*, Exposition Booklet, San Diego Public Library, California Room.
71. *San Diego Union*, January 1, 1913.
72. Jerre C. Murphy, "San Diego's Evolutionary Exposition," *Colliers*, December 5, 1914, 20–22.
73. Walter V. Woehlke, "Staging the Big Show," *Sunset* (August 1914): 336–46.
74. *San Diego Union*, January 1, 1914, Exposition Section; Watson, "San Diego Exposition," *Semi-Tropic California*.
75. Woehlke, "Staging the Big Show," 336–46.
76. *San Diego Union*, September 21, 1913.
77. Ibid.
78. Ibid., September 26, 1913.
79. Ibid.
80. Ibid.
81. Ibid., September 28, 1913.
82. Ibid.
83. Ibid., April 23, 1914. After his resignation as president, Collier represented the Exposition intermittently in negotiations with railroads, steamship lines, tourist agencies and hotels. He tried promoting a railway, practicing law, selling property and running for political office with disappointing results. In 1922, President Warren G. Harding appointed him United States representative to the Brazilian Centennial Exposition in Rio de Janeiro. He was director-general of the Sesqui-Centennial Exposition in Philadelphia for nine months in 1925 but resigned after the building program had been cut back. Again in San Diego in 1931, he advocated a 1934 Centennial Exposition on the waterfront, in honor of San Diego's one hundred years as a city. He died on November 12, 1934.
84. Ibid., January 1, 1915.
85. G. Aubrey Davidson, "History of the Panama-California Exposition of 1915 and the Panama-California International Exposition of 1916," *History of San Diego County*, edited by Carl H. Heilbron (San Diego: San Diego Press Club, 1936), 403.
86. *San Diego Union*, April 17, 1912; June 1, 1913; June 8, 1913; March 28, 1914.
87. Ibid., November 18, 1911.
88. Ibid., February 27, 1912; January 1, 1913; January 30, 1913.
89. Minutes of the San Diego City Council Meeting, March 18, 1907, Microfilm, San Diego City Clerk's Office.
90. *San Diego Union*, January 30, 1912.
91. Board of Park Commissioners Correspondence, 1913–1914, *Papers*, compiled by Joanne S. Anderson, 1972, San Diego Public Library, California Room.
92. *San Diego Union*, January 27, 1910; December 1, 1914; January 1, 1915.
93. Ibid., January 1, 1915.
94. Arthur Z. Bradley, "Exposition Gardens," *Sunset*, April 1915, 665–79.
95. Winslow, *Architecture and Gardens*, 130.
96. *San Diego Union*, January 1, 1913; January 1, 1914.
97. Ibid., April 20, 1912.
98. Ibid., June 8, 1913; January 1, 1914.
99. Ibid., November 7, 1911; Winifield Hogaboom, "The Panama-California Administration Building," *Sunset* (April 1912): 492–93.
100. Winslow, *Architecture and Gardens*, 28.

101. *San Diego Union,* January 1, 1913.
102. C. Matlack Price, "The Panama-California Exposition, San Diego, California," *Architectural Record* (March 1915): 244.
103. *San Diego Union,* April 13, 1914.
104. Ibid., January 1, 1913; June 5, 1913; January 1, 1914.
105 Palethorpe, McBride and Probert (Los Angeles), *Panama-California Exposition Report on Pre-Exposition Operations from November 1909 to December 31, 1914* (report dated March 29, 1915): 13, San Diego Public Library, California Room; *San Diego Union,* September 14, 1912.
106. *San Diego Union,* March 2, 1911; April 4, 1911.
107. Ibid., June 8, 1913.
108. Scrapbook attributed to Thomas O'Hallaran, San Diego Public Library, California Room.
109. *San Diego Union,* September 12, 1913.
110. Sonja Jones, "The Museum of Man in the Beginning," *Discovery* (monthly newsletter of San Diego Museum of Man), January 1990, 7.
111. *San Diego Union,* July 13, 1913.
112. Winslow, *Architecture and Gardens,* 36.
113. Letter, Bertram Goodhue to Christian Brinton, August 17, 1915, Avery Library, Columbia University.
114. Winslow, Architecture and Gardens, 32; Josef Vincent Lombardo, Attilio Piccirilli, *Life of an American Sculptor* (New York: Pitman Publishing Corporation, 1944), 291.
115. *San Diego Union,* January 11, 1914.
116. Winslow, *Architecture and Gardens,* 32.
117. Richard W. Amero, "The California Building, A Case of the Misunderstood Baroque," *Mason Street Papers,* vol. 4 (San Diego: Old School House Historians, 1981), 148–76.
118. *San Diego Union,* October 3, 1914.
119. "Design for a Public Garden for the City of San Diego by Bertram G. Goodhue, Architect," *Architectural Record* 52 (August 1922): 65.
120. Palethorpe, McBride and Probert, *Panama-California Exposition Report,* 49.
121. Pourade, *Gold in the Sun,* 252.
122. Letters, Carleton Winslow to Board of Park Commissioners, January–December 1914, Papers compiled by Joanne S. Anderson, 1972, San Diego Public Library, California Room.
123. Clarence Stein, "A Triumph of the Spanish Colonial Style," in Winslow, *Architecture and Gardens,* 11; Alfred Morton Guthens, "Recent American Group Plans, Fairs and Expositions," *The Brickbuilder* 21, no. 10 (October 1912): 257–60.
124. Price, "Panama-California Exposition," 247.
125. *San Diego Union,* October 26, 1913; January 1, 1914.
126. Ibid., January 1, 1915, Exposition Section; *Official Guidebook of the Panama-California Exposition, 1915,* 27, San Diego Public Library, California Room.
127. *San Diego Union,* September 19, 1911; A.D., Robinson, "A Palace of Lath," *Sunset* (March 1912): 283–84.
128. Irving Gill, Letter, *California Garden,* September 1911, 9.
129. *San Diego Union,* April 18, 1913; Carleton M. Winslow Jr., "The Architecture of the Panama-California Exposition" (thesis submitted in partial satisfaction of requirements for degree of master of arts in history, University of San Diego, 1976), 30, San Diego Public Library, California Room.
130. Winslow, *Architecture and Gardens,* 132.
131. Carol Greentree, "The Story of Spanish Gardens at World's Fairs," *World's Fair,* July–August 1992, 22–26.
132. Robert Hughes, *Barcelona* (New York: Vintage, 1992), 360.

133. Josep M. Botey, *Inside Barcelona: Discovering Barcelona's Classic Interiors* (London: Phaidon Press, Ltd., 1992), 92, 93, 124.
134. Palethorpe, McBride and Probert, *Panama-California Exposition Report*, 13.
135. *San Diego Union*, December 2, 1914; Barbara Jones, "Garden Heritage of Balboa Park," *California Garden*, November–December 1971, 183; Clay Lancaster, *The Japanese Influence in America* (New York: Walton H. Rawls, 1963), 178.
136. Price, "Panama-California Exposition," 247.
137. Lynn Adkins, "Jesse L. Nusbaum and the Painted Desert," *Journal of San Diego History* 29 (Spring 1983), 86–95.
138. *San Diego Union*, October 1, 1914.
139. *Army and Navy Review, 1915, Panama-California Exposition Edition*, San Diego Public Library, California Room; Major General Joseph Pendleton, "San Diego and the Marines," in *History of San Diego County*, edited by Carl H. Heilbron (San Diego: San Diego Press Club, 1936), 1:287.
140. *San Diego Union*, July 4, 1913; August 17, 1913; August 18, 1913; August 31, 1913; November 6, 1913; January 1, 1914, Exposition Section; January 10, 1914; July 7, 1914; October 21, 1914; December 2, 1914.
141. Ibid., April 18, 1914.
142. Ibid., November 29, 1914.
143. Palethorpe, McBride and Probert, *Panama-California Exposition Report*, 95.
144. *San Diego Sun*, September 1, 1909.
145. *San Diego Union*, September 27, 1914; Richard Dodge, *Rails of the Silver Gate* (San Marino, CA: Golden West Books, 1960), 59–65.
146. Gregory Montes, "Balboa Park, 1909–1911: The Rise and Fall of the Olmsted Plan," *Journal of San Diego History* 28 (Winter 1982): 53. The railroad running through the center of the park was one of the many threats for park lovers to fend off. Many of these threats came from prominent members of the community. In May 1911, Colonel Collier suggested using buildings left in the park after the Exposition for a permanent commercial exhibit (*San Diego Union*, May 1, 1911). On May 28, 1911, the American Women's League offered to hire George Zolnay as director of sculpture for the Exposition if it was granted a five-acre site for a Women's Building (*San Diego Union*, May 29, 1911). A *San Diego Union* reporter on October 17, 1913, thought the Exposition buildings could be used for museums, art galleries and auditoriums. City Clerk Allen Wright in November 1914 visualized the California Building as a city hall (*San Diego Union*, November 29, 1914). Harry O. Wise, vice-principal of the San Diego High School, saw in the Exposition buildings the beginnings of a four-year college (*San Diego Union*, January 1, 1915). In one way or another, the Exposition portended big changes for Balboa Park.
147. *San Diego Union*, April 17, 1932.
148. Ibid., December 9, 1914; Austin Adams, *The Man John D. Spreckels* (San Diego, CA: Press of Frye & Smith, 1924), 230–44.
149. *San Diego Union*, January 1, 1915.
150. Mary Gilman Marston, *George W. Marston, A Family Chronicle* (Los Angeles: Ward Ritchie Press, 1956), 2:43–44.
151. *Los Angeles Times*, January 1, 1915; *San Diego Sun*, January 1, 1915; *San Diego Union*, January 1, 1915.

Chapter 2

1. *San Diego Union,* January 1, 1915.
2. Ibid., January 2, 1915.
3. G.A. Davidson, "Official Opening Address," 11 p., San Diego Public Library, California Room.
4. *Los Angeles Times,* January 2, 1915.
5. *San Diego Union,* January 2, 1915.
6. "The Fair Ready at San Diego with Many Special Features," *Santa Fe Magazine* 9 (December 1914): 22.
7. *San Diego Union,* January 1, 1915, Exposition Section.
8. Pourade, *Gold in the Sun,* 192–93.
9. *San Diego Union,* January 9, 1915; *Official Guidebook of the Panama-California Exposition, 1915* (San Diego, CA, 1915), San Diego Public Library, California Room.
10. *Los Angeles Times,* February 14, 1915.
11. Ibid., March 28, 1915.
12. Michael Miller, "New Mexico's Role in the Panama-California Exposition of 1915," *El Palacio* 91, no. 2 (Fall 1985): 12–17; Carl Sheppard, *The Saint Francis Murals of Santa Fe* (Santa Fe, NM: Sunstone Press, 1989).
13. Neuhaus, *San Diego Garden Fair,* 59–76.
14. *Los Angeles Times,* February 14, 1915.
15. Marston, *A Family Chronicle,* 2:335–39.
16. Frank P. Allen Jr., "The Panama-California Exposition," *Pacific Coast Architect* 9 (June 1915): 218–37.
17. *San Diego Union,* March 5, 1915: May 30, 1915; *Los Angeles Times,* March 14, 1915.
18. *San Diego Union,* February 28, 1915; "The Lath House," *California Garden* 7, no. 1 (July 1915): 6.
19. Winslow, *Architecture and Gardens,* 152.
20. *San Diego Union,* January 1, 1915.
21. *San Diego Sun,* January 19, 1915.
22. *Los Angeles Times,* April 11, 1915; *San Diego Examiner,* January 29, 1915, Isthmus Section.
23. *Los Angeles Times,* March 7, 1915; *San Diego Sun,* January 18, 1915.
24. Geddes Smith, "California's Country Fair," *Independent Magazine* 83 (July 26, 1915): 119–21.
25. *San Diego Union,* March 21, 1915; April 14, 1915; April 18, 1915; May 17, 1932.
26. Edgar L. Hewett, "Ancient America at the Panama-California Exposition," *Art and Archaeology* vol. 2, no. 3 (Washington, D.C.: Archaeological Institute of America, November 1915), 65–102.
27. *Los Angeles Times,* January 31, 1915; *San Diego Union,* February 2, 1915; December 16, 1962.
28. Christian Brinton, "The San Diego and San Francisco Expositions," *The International Studio* 55 (June 1915): 105–19.
29. Jean Stern, "Robert Henri and the 1915 San Diego Exposition," *Resource Library, an online publication of Traditional Fine Arts Organizations.* This essay was previously published in *American Art Review* 2, no. 5 (September–October 1975): 108–17. http://www.tfaoi.com/aa/5aa/5aa193a.htm (accessed June 6, 2013).
30. *San Diego Union,* December 16, 1962.
31. *Los Angeles Times,* April 18, 1915; *San Diego Sun,* January 22, 1915.
32. *San Diego Sun,* January 20, 1915; William Henry Holmes, Current Notes and News, "Ancient America at the Panama-California Exposition, San Diego," *Art and Archaeology,*

(Washington, D.C.: Archaeological Institute of America, November, 1915): 30–31. (These pages were not included in the "San Diego Number" printed for sale at the Exposition.)

33. Rydell, *All the World's a Fair*, 224; Matthew F. Bokovoy, *The San Diego World's Fairs and Southwestern Memory, 1880–1940* (Albuquerque: University of New Mexico Press, 2005), 100–01.

34. Ales Hrdlicka, "Some Recent Anthropological Explorations," Division of Physical Anthropology, U.S. National Museum, Washington, D.C.; Rydell, *All the World's a Fair*; Bokovoy, *San Diego World's Fairs*; Hewett, "Ancient America at the Panama-California Exposition," 65–104.

35. Kate Spilde, "Where Does Federal Indian Policy Really Come From?" (May 2001), online paper published by the National Indian Gaming Association Resource Library, http://www.indiangaming.org/library/articles/where-does-policy-come-from.shtml (accessed October 10, 2013).

36. Michael L. Blakey, "Ch. 2: History and Comparison of Bioarchaeological Studies in the African Diaspora," African Burial Ground Final Report.

37. Ales Hrdlicka, *Old Americans* (Baltimore, MD: Williams and Wilkins, 1925), 408–12; Elazar Barkan, *The Retreat of Scientific Racism* (Cambridge University Press, 1996), 97–100.

38. Fray Angelico Chavez, *My Penitente Land: Reflections on Spanish New Mexico* (Santa Fe: University of New Mexico Press, 1974).

39. *Los Angeles Times*, April 11, 1915; May 30, 1915; *San Diego Union*, April 25, 1915.

40. According to Rose Tyson, curator of physical anthropology at the San Diego Museum of Man (e-mail, June 28, 2006), the eleven large murals in the Indian Arts Building by Gerald Cassidy were moved to the second floor of the California Building and then to the second floor, west hall, of the same building. They were removed from the west hall in 2001 and are now "in large protective rolls awaiting restoration." Because the walls to which the murals were attached contained lead paint, getting the lead paint off the back of the murals will be a challenge.

41. *San Diego Sun*, February 15, 1915; *San Diego Union*, October 4, 1914, Exposition Section; William Templeton Johnson, "The Panama-California Exposition and the Changing People of the Great Southwest," *Survey* 34 (July 3, 1915): 306–7.

42. *San Diego Sun*, June 3, 1915; *San Diego Union*, January 6, 1915.

43. Carleton Monroe Winslow Jr., "The Architecture of the Panama-California Exposition, 1909–1915" (thesis, University of San Diego), 58, 66.

44. *San Diego Union*, January 23, 1915.

45. "The Big Fair Ready at San Diego with Many Special Features," *Santa Fe Magazine* 59 (December 1914): 21–23; *Los Angeles Times*, May 23, 1915.

46. *Official Guidebook*, 47.

47. *San Diego Union*, January 19, 1915.

48. Ibid., January 30, 1915; February 23, 1915.

49. *Los Angeles Times*, January 10, 1915.

50. *San Diego Union*, December 2, 1914.

51. *Los Angeles Times*, January 24, 1915.

52. *San Diego Union*, December 16, 1914.

53. Ibid., November 22, 1914.

54. *Los Angeles Times*, March 28, 1915; *San Diego Union*, February 14, 1915.

55. *Official Guidebook*, 21.

56. *San Diego Union*, January 19, 1915.

57. *Los Angeles Times*, January 10, 1915; *San Diego Sun*, January 9, 1915; *San Diego Union*, March 7, 1915.

58. Emily Post, "By Motor to the Fair," *Colliers* 54, September 18, 1915.

59. Mark S. Watson, "San Diego Panama-California Exposition," *Semi-Tropic California,* San Diego Exposition Edition (Los Angeles: Benton & Company, 1914), 69–86; *Official Guidebook,* 14–16.
60. Isaiah 35:1: "The wilderness and the solitary place shall be glad for them and the desert shall rejoice and blossom as the rose." *Bible, New English Translation,* Biblical Studies Press, L.L.C., 1996.
61. Mike Sholders, "Water Supply Development in San Diego and a Review of Related Outstanding Projects," *Journal of San Diego History* 45, no. 1 (Winter 2002).
62. Ibid.
63. Watson, *Semi-Tropic California.*
64. Lawrence D. Lee, "The Little Landers Colony of San Ysidro," *Journal of San Diego History* 21 (Winter 1975): 26–51; Matthew F. Bokovoy, "Inventing Agriculture in Southern California," *Journal of San Diego History* 45 (Spring 1999).
65. *San Diego Union,* January 1, 1917, Special Section.
66. California Commission on Land Colonization and Rural Credits, 1916, http://archive.org/details/reportofcommissi00caliiala (accessed August 15, 2013).
67. Bokovoy, "Inventing Agriculture in Southern California."
68. *San Diego Sun,* January 20, 1915.
69. *San Diego Union,* December 28, 1914.
70. *Los Angeles Times,* January 1, 1915.
71. Ibid., January 2, 1915; *San Diego Union,* January 2, 1915.
72. *San Diego Union,* December 13, 1914: *San Diego Sun,* February 3, 1915.
73. *San Diego Sun,* June 19, 1914.
74. Ibid., June 20, 1914.
75. Ibid., September 23, 1914; January 6, 1915; Florence Christman, *The Romance of Balboa Park* (San Diego, CA: San Diego Historical Society, 1985), 50.
76. *San Diego Union,* December 20, 1914.
77. *Los Angeles Times,* January 1, 1915.
78. *San Diego Union,* December 20, 1914.
79. *Los Angeles Times,* January 31, 1915; Neuhaus, *San Diego Garden Fair,* 43–44.
80. *Los Angeles Times,* January 2, 1915; January 31, 1915.
81. Ibid., January 31, 1915.
82. *San Diego Union,* January 1, 1916, Exposition Section; January 1, 1917, Social Section.
83. Raymond H. Clary, *The Making of Golden Gate Park* (San Francisco: California Living Books, 1980), 141–42.
84. *San Diego Union,* December 9, 1914.
85. Ibid., August 13, 1929.
86. *Los Angeles Times,* January 1, 1915.
87. Kevin Starr, *Americans and the California Dream, 1850–1915* (New York: Oxford University Press, 1973), 402–13; Burton Benedict, *The Anthropology of World's Fairs, San Francisco's Panama-Pacific Exposition 1915* (Berkeley, CA: Scolar Press, 1983).

Chapter 3

1. *San Diego Sun,* February 3, 1915.
2. Bensel Smythe, "The Fair at San Diego," *Review of Reviews* 51 (May 1915): 587.
3. *San Diego Sun,* January 5, 1915; January 20, 1915; January 16, 1915.
4. *San Diego Union,* January 6, 1915.
5. *San Diego Sun,* February 15, 1915.
6. *San Diego Union,* January 10, 1915.

7. Ibid., January 6, 1915.
8. *San Diego Sun*, February 3, 1915.
9. Ibid., January 16, 1915; January 18, 1915.
10. Ibid., January 25, 1915.
11. *Los Angeles Times*, April 11, 1915.
12. Bensel Smythe, "Fair at San Diego," 587.
13. Julius Wangenheim, "An Autobiography," *California Historical Society Quarterly* 36 (March 1957): 69–70.
14. *San Diego Union*, February 23, 1915.
15. Ibid., February 12, 1915.
16. *San Diego Sun*, February 10, 1915.
17. *San Diego Union*, February 2, 1915.
18. *San Diego Sun*, February 13, 1915; *San Diego Union*, February 13, 1915.
19. *San Diego Union*, February 13, 1915.
20. Ibid., February 14, 1915.
21. *San Diego Sun*, February 22, 1915; *San Diego Union*, February 23, 1915.
22. *San Diego Union*, February 23, 1915; *Los Angeles Times*, February 28, 1915.
23. *Los Angeles Times*, April 11, 1915; April 18, 1915.
24. Bensel Smythe, "Fair at San Diego," 587.
25. *San Diego Union*, March 2, 1915: March 10, 1915.
26. Ibid., March 9, 1915.
27. *Los Angeles Times*, February 28, 1915; *San Diego Union*, April 25, 1915.
28. *San Diego Sun*, March 13, 1915.
29. *Los Angeles Times*, March 7, 1915.
30. *San Diego Sun*, March 19, 1915; March 24, 1915.
31. Ibid., March 23, 1915.
32. *San Diego Union*, March 25, 1915.
33. *San Diego Sun*, March 25, 1915, 1.
34. *San Diego Union*, March 30, 1915.
35. Ibid., March 29, 1915; March 30, 1915.
36. *San Diego Sun*, April 6, 1915; "New Notes from San Diego," *Santa Fe Magazine* 9 (May 1915): 39–40.
37. *San Diego Union*, April 15, 1915.
38. Ibid., April 20, 1915; April 25, 1915.
39. *Los Angeles Times*, April 4, 1915.
40. Ibid., April 18, 1915.
41. Ibid.
42. *Los Angeles Times*, July 4, 1915.
43. *San Diego Sun*, April 9, 1915.
44. *San Diego Union*, April 25, 1915.
45. *San Diego Sun*, May 7, 1915.
46. *San Diego Union*, June 30, 1915.
47. *San Diego Sun*, August 5, 1915.
48. *San Diego Union*, August 22, 1915.
49. Ibid., April 21, 1915.
50. Ibid., April 18, 1916.
51. "San Diego Notes," *Santa Fe Magazine* 9 (September 1915): 39.
52. *San Diego Union*, May 3, 1915; *Los Angeles Times*, May 9, 1915.
53. *Los Angeles Times*, July 4, 1915.
54. "New Notes from the Beautiful Fair at San Diego," *Santa Fe Magazine* 9 (April 1915): 35.

55. *San Diego Union*, May 23, 1915.
56. *Los Angeles Times*, May 23, 1915.
57. *San Diego Union*, May 23, 1915.
58. *San Diego Sun*, May 27, 1915.
59. Ibid., May 31, 1915; June 1, 1915.
60. *San Diego Union*, June 2, 1915.
61. Ibid.
62. Ibid., June 8, 1915.
63. Ibid., June 13, 1915.
64. *San Diego Union*, June 18, 1915.
65. Arthur Aronson, ed., "Calendar of Events," *Army and Navy Review, 1915, Panama-California Edition*, California Room, San Diego Public Library; Kenneth W. Condit and Edwin T. Turnbladh, *Hold High the Torch: A History of the 4th Marines* (Washington, D.C.: Historical Branch, HQ, U.S. Marine Corps, 1960), Appendix B.
66. *San Diego Union*, June 29, 1915.
67. *San Diego Sun*, June 24, 1915; *San Diego Union*, June 24, 1915.
68. *San Diego Union*, July 1, 1915; July 3, 1915; July 4, 1915; July 6, 1915.
69. Ibid.
70. "Flashes from San Diego," *Santa Fe Magazine* 9 (June 1915): 37.
71. *San Diego Union*, June 5, 1915; July 5, 1915; *San Diego Sun*, July 12, 1915.
72. "The Brazilian Exhibit at the Panama-California Exposition," *Pan-American Bulletin* 41 (September 1915): 327–37; *San Diego Union*, July 7, 1915.
73. *San Diego Union*, July 3, 1915; July 5, 1915; August 1, 1915.
74. Ibid., July 8, 1915, 14; July 15, 1915, 9.
75. Ibid., July 28, 1915; July 31, 1915; August 1, 1915.
76. *San Diego Sun*, July 5, 1915; *San Diego Union*, July 7, 1915.
77. Tsianina Blackstone, *Where Trails Have Left Me* (Santa Fe, NM, 1970).
78. *San Diego Union*, July 17, 1915.
79. Ibid.
80. Ibid., July 13, 1915.
81. *Los Angeles Times*, July 17, 1915; *San Diego Union*, July 17, 1915.
82. *San Diego Union*, July 18, 1915.
83. Ibid., July 18, 1915; *San Diego Sun*, July 19, 1915.
84. Joseph L. Gardner, *Departing Glory, Theodore Roosevelt as Ex-President* (New York: Charles Scribner's Sons, 1973), 254–55.
85. Louis W. Koenig, *Bryan: A Political Biography of William Jennings Bryan* (New York: G.P. Putnam's Sons, 1971), 555.
86. *San Diego Union*, July 17, 1915; *San Diego Sun*, July 20, 1915.
87. *San Diego Union*, July 25, 1915.
88. Ibid., July 28, 1915.
89. Ibid.
90. Ibid., July 27, 1915; July 28, 1915; *Los Angeles Times*, July 28, 1915.
91. *San Diego Union*, July 28, 1915.
92. Ibid., July 18, 1915.
93. *Los Angeles Times*, July 29, 1915.
94. *San Diego Union*, July 30, 1915; July 31, 1915.
95. Ibid., August 1, 1915; *Los Angeles Times*, August 1, 1915.
96. "San Diego Notes," *Santa Fe Magazine* 9 (September 1915): 39.
97. *San Diego Union*, August 1, 1915; *Los Angeles Times*, August 1, 1915.
98. *San Diego Sun*, August 3, 1915; *San Diego Union*, August 4, 1915.

99. *San Diego Union*, August 4, 1915.
100. Ibid., August 5, 1915; August 6, 1915.
101. Ibid., August 4, 1915; August 9, 1915.
102. *San Diego Sun*, August 10, 1915; *San Diego Union*, August 10, 1915.
103. Allen Churchill, *Over Here!: An Informal Re-Creation of the Home Front in World War I* (New York: Dodd Mead & Company, 1968), 264.
104. *San Diego Sun*, August 11, 1915: *San Diego Union*, August 11, 1915.
105. *San Diego Union*, August 12, 1915; August 13, 1915.
106. Ibid., August 20, 1915.
107. Ibid., August 18, 1915; August 22, 1915.
108. Ibid., August 25, 1915.
109. Ibid., August 23, 1915; August 26, 1915.
110. Ibid., August 26, 1915.
111. Ibid., August 28, 1915; January 1, 1916, Special Section.
112. Bokovoy, *San Diego World's Fairs*, 137–39.
113. *San Diego Union*, August 23, 1915; August 24, 1915.
114. *San Diego Sun*, August 26, 1915; *San Diego Union*, August 26, 1915.
115. "Jottings from San Diego," *Santa Fe Magazine* 9 (October 1915): 40.
116. *San Diego Sun*, August 30, 1915; August 31, 1915.
117. *San Diego Union*, September 4, 1915; September 5, 1915.
118. *San Diego Sun*, September 6, 1915; September 7, 1915; *San Diego Union*, September 7, 1915.
119. *San Diego Sun*, September 8, 1915; *San Diego Union*, September 10, 1915.
120. *San Diego Sun*, September 8, 1915.
121. *San Diego Herald*, August 19, 1915.
122. *San Diego Union*, September 9, 1915.
123. Ibid., September 10, 1915.
124. "Jottings from San Diego," *Santa Fe Magazine* 9 (October 1915): 39–40; *San Diego Sun*, September 10, 1915; *San Diego Union*, September 11, 1915.
125. *San Diego Sun*, September 9, 1915; *San Diego Union*, September 9, 1915; September 14, 1915.
126. "Jottings from San Diego," *Santa Fe Magazine* 9 (October 1915): 39; *San Diego Union*, September 9, 1915.
127. *San Diego Sun*, September 17, 1915.
128. Ibid.; *San Diego Union*, September 17, 1915.
129. Henry Meade Bland, "The Great Orations of the Expositions," *Overland Monthly* (December 1915): 526–30.
130. *San Diego Union*, September 17, 1915.
131. Ibid., September 12, 1915; September 18, 1915; September 19, 1915.
132. Ibid., September 22, 1915; *Los Angeles Times*, September 28, 1915.
133. *San Diego Sun*, September 22, 1915.
134. *San Diego Union*, September 25, 1915.
135. *San Diego Sun*, September 29, 1915; *San Diego Union*, September 28, 1915; October 1, 1915.
136. *San Diego Union*, October 4, 1915.
137. *San Diego Sun*, October 1, 1915.
138. *San Diego Union*, October 1, 1915; October 2, 1915; October 3, 1915.
139. *San Diego Sun*, October 14, 1915; October 15, 1915.
140. Ibid., October 14, 1915; *San Diego Union*, October 14, 1915.
141. *San Diego Sun*, October 21, 1915; *San Diego Union*, October 14, 1915; *Los Angeles Times*, October 22, 1915.

142. *San Diego Sun*, October 16, 1915; *San Diego Union*, October 17, 1915.
143. *San Diego Sun*, October 25, 1915.
144. Ibid., October 16, 1915; *San Diego Union*, October 17, 1915; October 25, 1915.
145. *San Diego Sun*, October 29, 1915.
146. *San Diego Herald*, November 4, 1915.
147. *San Diego Union*, October 30, 1915.
148. Ibid., December 2, 1915.
149. *San Diego Sun*, November 4, 1915; *San Diego Union*, October 23, 1915; October 24, 1915; October 31, 1915.
150. *San Diego Union*, October 28, 1915.
151. *San Diego Sun*, November 5, 1915; *San Diego Union*, November 10, 1915; November 12, 1915.
152. Ibid., November 3, 1915.
153. Pourade, *Gold in the Sun*, 199–200.
154. *San Diego Sun*, November 4, 1915.
155. Ibid., November 11, 1915; November 13, 1915; *San Diego Union*, November 13, 1915; November 14, 1915.
156. *San Diego Sun*, November 6, 1915; November 9, 1915; November 10, 1915; *San Diego Union*, November 12, 1915.
157. *San Diego Sun*, November 11, 1915, 1; *San Diego Union*, November 12, 1915, 1; November 13, 1915, 1.
158. *San Diego Sun*, November 13, 1915; *San Diego Union*, November 13, 1915.
159. *San Diego Sun*, November 13, 1915.
160. Ibid., November 17, 1915; *San Diego Union*, November 14, 1915; November 18, 1915.
161. *San Diego Union*, November 18, 1915.
162. *San Diego Evening Tribune*, November 18, 1915.
163. *San Diego Sun*, November 18, 1915.
164. *San Diego Union*, November 21, 1915.
165. Ibid., December 2, 1915.
166. *San Diego Sun*, December 1, 1915; December 9, 1915; December 16, 1915.
167. Ibid., December 1, 1915; *San Diego Union*, December 2, 1915; December 3, 1915.
168. *San Diego Union*, December 2, 1915; December 3, 1915.
169. *San Diego Sun*, December 4, 1915; *San Diego Union*, December 8, 1915.
170. *San Diego Union*, December 15, 1915.
171. Wangenheim, "An Autobiography," 71.
172. Pourade, *Gold in the Sun*, 199.
173. *San Diego Union*, December 9, 1915; December 11, 1915; Davidson, "History of the Panama-California Exposition," 405.
174. *San Diego Sun*, January 11, 1917; Davidson, "History of the Panama-California Exposition,"
175. *San Diego Union*, October 21, 1915; October 27, 1915.
176. Ibid., November 15, 1915; January 1, 1916, Special Section.
177. Joanne S. Anderson, "Panama-California International Exposition Papers, Ledgers, Accounts," City of San Diego, Board of Park Commissioners Papers, Financial Statements, Box 1, California Room, San Diego Public Library.
178. *San Diego Sun*, December 21, 1915.
179. *San Diego Union*, January 11, 1916.
180. Kettner, *Why It Was Done*, 36.
181. *San Diego Union*, December 23, 1915; December 28, 1915.
182. *San Diego Sun*, December 29, 1915.

183. *San Diego Union*, November 11, 1915; December 29, 1915.
184. Ibid., December 7, 1915; December 15, 1915; December 25, 1915.
185. Ibid., December 21, 1915.
186. Ibid., November 23, 1915; December 21, 1915; January 2, 1916.
187. *San Diego Sun*, December 20, 1915; December 21, 1915; *San Diego Union*, December 21, 1915.
188. Minutes of the Board of Park Commissioners, December 21, 1915, San Diego Park and Recreation Department Records, Office of City Clerk, San Diego.
189. *San Diego Union*, December 29, 1915; January 1, 1916, Special Section.
190. *San Diego Herald*, December 16, 1915; *San Diego Sun*, December 14, 1915.
191. *San Diego Union*, December 23, 1915.
192. Ibid., December 16, 1915.
193. Ibid., December 26, 1915.
194. Richard W. Amero, "Christmases in California," *Journal of San Diego History* 26, no. 4 (Fall 1980): 274–81.
195. *San Diego Sun*, December 31, 1915; *San Diego Union*, January 1, 1916.
196. *San Diego Sun*, December 23, 1915; December 27, 1915.
197. W.J. Palethorpe, *Report of the Panama-California Exposition to April 30, 1916* (Los Angeles, 1916), Exhibits A and B, California Room, San Diego Public Library.
198. William Wordsworth, "Ode on the Intimations of Immortality," from *Recollections of Early Childhood* (1807).

Chapter 4

1. *San Diego Union*, January 2, 1916.
2. Ibid., January 1, 1916, Special Section.
3. Ibid.
4. Pourade, *Gold in the Sun*, 200.
5. *San Diego Union*, January 28, 1916; January 29, 1916; January 30, 1916.
6. Ibid., January 28, 1916.
7. *San Diego Sun*, February 8, 1916; February 11, 1916.
8. Ibid., February 7, 1916; *San Diego Union*, February 22, 1916; March 2, 1916.
9. *San Diego Union*, January 27, 1916.
10. Ibid., February 27, 1916; *San Diego Sun*, March 7, 1916.
11. *San Diego Sun*, February 24, 1916.
12. *San Diego Union*, January 23, 1916.
13. Ibid., February 15, 1916; *San Diego Sun*, March 2, 1916.
14. *San Diego Union*, February 20, 1916; March 12, 1916.
15. Ibid., February 3, 1916; February 10, 1916; February 23, 1916; *Los Angeles Times*, February 11, 1916.
16. *San Diego Union*, January 14, 1916.
17. *Los Angeles Times*, February 7, 1916.
18. Ibid., January 16, 1916.
19. *San Diego Union*, February 14, 1916; *San Diego Sun*, February 26, 1916.
20. *San Diego Union*, March 16, 1916.
21. *San Diego Sun*, February 9, 1916; *San Diego Union*, March 6, 1916; March 11, 1916.
22. *San Diego Union*, February 3, 1916.
23. Ibid., March 13, 1916.
24. Ibid., March 5, 1916; March 7, 1916.

25. Ibid., March 20, 1916; *San Diego Sun*, March 20, 1916.
26. *San Diego Union*, March 14, 1916.
27. Ibid., March 4, 1916.
28. Ibid., March 19, 1916; March 20, 1916.
29. *San Diego Sun*, March 25, 1916.
30. *San Diego Union*, April 2, 1916.
31. *San Diego Sun*, March 31, 1916.
32. Ibid., April 22, 1916.
33. *San Diego Union*, April 30, 1916.
34. Ibid., April 22, 1916; April 23, 1916; April 25, 1916.
35. Ibid., April 26, 1916; April 30, 1916; *San Diego Sun*, April 29, 1916.
36. *San Diego Union*, April 30, 1916.
37. Ibid., May 7, 1916.
38. Ibid., April 14, 1916.
39. Ibid., May 15, 1916; *San Diego Evening Tribune*, June 10, 1916.
40. *San Diego Union*, May 11, 1916.
41. Ibid., May 18, 1916; *San Diego Sun*, May 18, 1916.
42. *San Diego Union*, May 28, 1916; *San Diego Sun*, May 27, 1916; *Los Angeles Times*, May 28, 1916.
43. *San Diego Sun*, June 13, 1916; *San Diego Union*, June 17, 1916; June 18, 1916.
44. Lawrence D. Taylor, "The Wild Frontier Moves South: U.S. Entrepreneurs and the Growth of Tijuana's Vice Industry," *Journal of San Diego History* 48 (Summer 2002).
45. *San Diego Union*, June 11, 1916.
46. Ibid., June 21, 1916; Winslow, *Architecture and Gardens*, 7
47. *San Diego Union*, June 5, 1916; *San Diego Sun*, June 5, 1916.
48. *San Diego Union*, June 5, 1916; June 9, 1916.
49. *San Diego Evening Tribune*, June 8, 1916; *San Diego Union*, June 17, 1916.
50. *San Diego Union*, June 26, 1916; *Los Angeles Times*, June 26, 1916.
51. *San Diego Union*, June 20, 1916.
52. *San Diego Sun*, June 29, 1916; *San Diego Union*, July 4, 1916.
53. *San Diego Union*, July 4, 1916.
54. Ibid., July 5, 1916.
55. *San Diego Union*, July 6, 1916.
56. *San Diego Sun*, July 5, 1916; *San Diego Union*, July 5, 1916.
57. *Los Angeles Times*, July 7, 1916.
58. *San Diego Sun*, July 10, 1916.
59. Ibid., July 15, 1916; *San Diego Union*, July 19, 1916.
60. *San Diego Union*, July 21, 1916.
61. Ibid., July 13, 1916.
62. *San Diego Sun*, July 5, 1916; *San Diego Union*, July 6, 1916.
63. *San Diego Sun*, August 3, 1916; *San Diego Union*, August 3, 1916.
64. *San Diego Union*, August 6, 1916.
65. Ibid., August 4, 1916; August 9, 1916; *San Diego Evening Tribune*, August 9, 1916.
66. *San Diego Union*, August 12, 1916.
67. Ibid., August 13, 1916; August 14, 1916.
68. *San Diego Union*, August 15, 1916.
69. Ibid., August 21, 1916; August 22, 1916; *Los Angeles Times*, August 22, 1916.
70. Letters and Minutes of Park Commission Executive Committee, September 1, 1916.
71. George A. Frykman, "The Alaska-Yukon Pacific Exposition, 1909," *Pacific Northwest Quarterly* (July 1962): 98.

72. Letters and Minutes of Park Commission Executive Committee, September 1, 1916.
73. *San Diego Union*, August 29, 1916; September 4, 1916.
74. Ibid., September 11, 1916.
75. *San Diego Union*, September 17, 1916.
76. Ibid., September 10, 1916.
77. Lawrence D. Taylor, "The Wild Frontier Moves South: U.S. Entrepreneurs and the Growth of Tijuana's Vice Industry," *Journal of San Diego History* 48 (Summer 2002).
78. Dr. Harry M. Wegeforth and Neil Morgan, *It Began With A Roar* (San Diego, CA, 1953), 74–75.
79. *San Diego Sun*, September 23, 1916.
80. *San Diego Union*, September 23, 1916.
81. *San Diego Evening Tribune*, October 13, 1916.
82. *San Diego Sun*, October 7, 1916; *San Diego Union*, October 7, 1916.
83. *San Diego Union*, October 20, 1916.
84. Ibid., October 22, 1916.
85. Ibid., October 28, 1916.
86. Ibid., October 29, 1916; October 31, 1916.
87. Ibid., October 30, 1916.
88. Allen Churchill, *Over Here!* (New York: Dodd Mead & Company, 1968), 32.
89. Minutes of the Board of Park Commissioners, November 3, 1916, San Diego Park & Recreation Department, City Clerk's Office.
90. *San Diego Union*, November 5, 1916.
91. Ibid., November 19, 1916; November 23, 1916; November 25, 1916.
92. *San Diego Union*, November 26, 1916.
93. *San Diego Sun*, November 27, 1916.
94. *San Diego Union*, December 1, 1916.
95. Ibid.
96. Ibid., December 5, 1916.
97. Minutes of the Board of Park Commissioners, December 4, 1916, San Diego Park & Recreation Department, City Clerk's Office.
98. *San Diego Union*, December 12, 1916; December 17, 1916.
99. Ibid., December 10, 1916.
100. *San Diego Union*, December 11, 1916; see also Allen L. Woll, *The Latin Image in American Film* (Los Angeles: University of California, 1980), 26–28, which contains a description of the film *The Americano*, script by Anita Loos (1916). The plot being the same as *The Liberator*, the title of the film was probably changed before it was released.
101. Carlos Fuentes, *The Buried Mirror: Reflections on Spain and the New World* (Boston: Houghton Mifflin Company, 1992).
102. *San Diego Union*, December 15, 1916.
103. *San Diego Sun*, December 15, 1916.
104. Ibid., December 26, 1916.
105. *San Diego Union*, December 28, 1916.
106. *San Diego Evening Tribune*, December 28, 1916.
107. *San Diego Union*, December 23, 1916.
108. Ibid., December 29, 1916.
109. Ibid., December 30, 1916.
110. Ibid., December 31, 1916.
111. *San Diego Sun*, December 30, 1916, Special Section.
112. *San Diego Union*, December 27, 1916.
113. Ibid., December 30, 1916; *Los Angeles Times*, December 31, 1916.

114. *San Diego Union*, January 1, 1917.
115. *Los Angeles Times*, January 2, 1917.
116. *San Diego Union*, January 1, 1917; January 2, 1917.
117. Ibid., January 2, 1917; *Los Angeles Times*, January 2, 1917.
118. *San Diego Union*, January 4, 1917.
119. Ibid., February 12, 1917.
120. Ibid., January 4, 1917; *San Diego Sun*, January 22, 1917.
121. John Allwood, *The Great Exhibitions* (New York: Studio Vista, 1978), 183.
122. Starr, *California Dream, 1850–1915*.
123. Gray Brechin, "Sailing to Byzantium: The Architecture of the Fair," in *The Anthropology of World Fairs, San Francisco's Panama-Pacific International Exposition of 1915*, edited by Burton Benedict (Berkeley, CA: Scolar, 1983), 98.
124. George Wharton James, *Exposition Memories* (Pasadena, CA: Radiant Life Press, 1917), 16.

Chapter 5

1. *San Diego Union*, January 7, 1917.
2. Ibid., January 2, 1917.
3. *San Diego Sun*, January 2, 1917; *Los Angeles Times*, January 7, 1917.
4. *San Diego Union*, January 1, 1917, Exposition Section.
5. Ibid., January 2, 1917.
6. *Los Angeles Times*, January 14, 1917.
7. *San Diego Union*, January 1, 1917, Exposition Section; January 25, 1917, Classified; *Los Angeles Times*, January 3, 1917.
8. *San Diego Union*, January 1, 1917, Exposition Section; January 4, 1917, Classified; January 3, 1917; January 6, 1917.
9. *San Diego Sun*, January 2, 1917; *Los Angeles Times*, January 3, 1917
10. *San Diego Union*, January 11, 1917.
11. *San Diego Sun*, January 3, 1917.
12. Ibid.
13. Ibid., January 4, 1917, Classified.
14. *San Diego Union*, January 9, 1917; *Los Angeles Times*, January 14, 1917.
15. *San Diego Union*, January 3, 1917.
16. Ibid., January 10, 1917; *Los Angeles Times*, January 14, 1917.
17. *San Diego Union*, January 10, 1917.
18. Ibid., January 14, 1917.
19. *San Diego Sun*, January 11, 1917.
20. *California Garden*, January 1917, 3–4.
21. *San Diego Union*, February 3, 1917.
22. *San Diego Sun*, January 20, 1917.
23. *San Diego Union*, January 11, 1917, Classified.
24. Ibid., January 23, 1917.
25. *San Diego Sun*, January 17, 1917.
26. Ibid.; *San Diego Union*, January 20, 1917, Classified.
27. *San Diego Sun*, January 26, 1917, Classified.
28. *San Diego Union*, January 27, 1917.
29. *San Diego Sun*, January 30, 1917.
30. *Los Angeles Times*, January 14, 1917.
31. *San Diego Union*, January 10, 1917.

32. *Los Angeles Times*, January 14 1917.
33. *San Diego Union*, February 3, 1917.
34. Ibid., January 4, 1917.
35. Ibid., February 6, 1917.
36. *San Diego Sun*, February 12, 1917.
37. *San Diego Union*, February 17, 1917; *Los Angeles Times*, February 17, 1917.
38. *San Diego Union*, February 25, 1917.
39. Ibid., February 17, 1917.
40. Joanne S. Anderson, *Panama-California International Exposition Papers, Ledgers, Accounts, City of San Diego Board of Park Commissioners Papers*, San Diego Public Library, Board of Park Commissioners Correspondence; Box 1, San Diego Museum, 1916–30.
41. Anderson, Box 1, Commissioners Correspondence, San Diego Society of Natural History, 1916–29.
42. *Los Angeles Times*, February 20, 1917.
43. Anderson, Box 3, Architecture, Letter, Carleton M. Winslow to Dr. Edgar L. Hewett, February 20, 1917. See also a transcript of this letter in the Carleton M. Winslow Biographical File, of the Amero Collection, San Diego Historical Society Research Archives.
44. *San Diego Sun*, February 21, 1917; February 26, 1917.
45. *San Diego Union*, February 28, 1917, Classified; *San Diego Sun*, February 28, 1917.
46. *San Diego Union*, March 8, 1917.
47. Ibid., March 9, 1917; *San Diego Sun*, March 9, 1917.
48. *San Diego Union*, March 15, 1917, Classified.
49. Ibid., March 18, 1917.
50. *San Diego Sun*, March 20, 1917.
51. *San Diego Union*, March 23, 1917, Classified.
52. Ibid., March 25, 1917.
53. *San Diego Herald*, April 6, 1917; Pourade, *Gold in the Sun*, 223–24.
54. *San Diego Evening Tribune*, March 23, 1917; *San Diego Sun*, March 27, 1917.
55. *San Diego Evening Tribune*, March 20, 1917; *San Diego Union*, April 1, 1917.
56. *San Diego Evening Tribune*, March 30, 1917; *San Diego Union*, March 30, 1917.
57. *San Diego Union*, April 4, 1917.
58. Ibid., April 5, 1917.
59. *San Diego Sun*, April 7, 1917; *San Diego Union*, April 24, 1917.
60. Anderson, Box 3, Financial Statements.
61. Anderson, Board of Park Commissioners Correspondence, Box 1, San Diego Museum, 1916–30, Letter, Wheeler J. Bailey, August 1, 1917.
62. Anderson, Board of Park Commissioners Correspondence, Box 1, San Diego Museum, 1916–30.
63. Minutes, Board of Park Commissioners, June 6, 1919, San Diego Park Department, City Clerk's Office.
64. *San Diego Evening Tribune*, April 2, 1917; *San Diego Union*, April 2, 1917.
65. *San Diego Union*, April 2, 1917.
66. Ibid., October 29, 1916, Sports; May 4, 1917, Classified.
67. *San Diego Sun*, December 30, 1916, Special Park Section.
68. Neuhaus, *San Diego Garden Fair*.
69. Ibid., XII.
70. William Hammond Hall, "The Panama-Pacific International Site, A Review of the Proposition to Use a Part of Golden Gate Park," addressed to the Executive Committee of the Board of Directors of the Panama-Pacific International Exposition, April 25, 1911.

71. Laura Wood Roper, *FLO: A Biography of Frederick Law Olmsted* (Baltimore, 1973), 366.
72. Ibid., 427.
73. No study has been written to date that addresses the survival of exposition buildings. Information in the text has been gleaned from correspondence with the Park and Historical Departments of cities mentioned. The following people have been especially helpful: Yvone Murchison Foote, library assistant, Buffalo and Erie County Historical Society; Ken Lomax, research assistant, Oregon Historical Society; Peggy A. Haile, Sargeant Memorial Room, City of Norfolk Department of Libraries; and Mark L. Hayes, Ensign, U.S. Naval Reserve, Hampton Roads Naval Museum, Norfolk, Virginia.
74. George A. Frykman, "The Alaska-Yukon-Pacific Exposition, 1909," *Pacific Northwest Quarterly* (July 1962): 99.
75. Night Letter, John C. Olmsted to Julius Wangenheim, August 30, 1911, File 25, George W. Marston Papers, Collection 219, Box 2, San Diego Historical Society Research Library.
76. John Burchard, *Bernini Is Dead?* (New York: McGraw-Hill Book Co., 1976), 561.
77. Ada Louise Huxtable, *Kicked A Building Lately?* (New York: Quadrangle/The New York Times Book Co., 1976), 212.

Chapter 6

1. *San Diego Union*, December 19, 1911.
2. Ibid., November 28, 1911; June 8, 1912.
3. *Panama-California Exposition Hearing Before the Committee on Industrial Arts and Expositions*, House of Representatives, on House Joint Resolution No. 99, Washington Government Printing Office, 1911, May 22, 1911, p. 47.
4. "New Notes from the Beautiful Fair at San Diego," *Santa Fe Magazine* 9, no. 5 (April 1915): 39.
5. Katherine L. Howard, "A Most Remarkable Success; Herman Schweizer and the Fred Harvey Indian Department," *The Great Southwest of the Fred Harvey Company and the Santa Fe Railway*, edited by Marta Weigle and Barbara Babcock (Phoenix, AZ: The Heard Museum, 1996), 94–95.
6. *San Diego Union*, March 30, 1913.
7. Ibid., December 5, 1912.
8. Ibid., August 16, 1912; March 19, 1913.
9. Hewett, "Ancient America at the Panama-California Exposition," 65–104.
10. Rydell, *All the World's a Fair*, 220–23; Bokovoy, *San Diego World's Fairs*, 86–95; Archie Phinney, "Problem of the 'White Indians' of the United States," *Wicazo Sa Review* 18, no. 2 (Fall 2003): 37–40; Kate Spilde, "Where Does Federal Indian Policy Really Come From?" (National Indian Gaming Association Resource Library, 2000–2005), http://www.indiangaming.org/library/articles/where-does-policy-come-from.shtml; Ales Hrdlicka, "Human Races," *Human Biology and Racial* Welfare, edited by E.A. Cowdry (New York: Paul B. Hoeber, Inc., 1930), 177; Michael L. Blakey, "Bioarchaeology of the African Diaspora in America," *Annual Review of Anthology* 30 (2001): 387–422; David Duke, "The Concept of Heredity" (November 11, 2004), Official Website of Representative David Duke, PhD.
11. Edgar L. Hewett, *Ancient Life in Mexico and Central America* (New York: Tudor Publishing Co., 1943), 200–1.
12. Rydell, *All the World's a Fair*, 174–76, 194–99.
13. T.C. McLuhan, *Dream Tracks: The Railroad and the American Indian, 1890–1930* (New York: Henry N. Abrams, Inc., 1985).

14. *Panama-California Exposition Hearing*, 6.
15. *San Diego Union*, December 5, 1912.
16. Edgar L. Hewett, *Ancient Life in the American Southwest* (New York: Tudor Publishing Co., 1943): 161–75; Edward P. Dozier, *The Pueblo Indians of North America* (New York: Holt, Rinehart and Winston, Inc., 1970), 115.
17. *San Diego Union*, August 21, 1913.
18. Chris Wilson, *The Myth of Santa Fe* (Albuquerque: University of New Mexico Press, 1997), 93.
19. McLuhan, *Dream Tracks*, 16.
20. *San Diego Union*, May 7, 1914.
21. *Prospectus for the Panama-California Exposition, 1915*, compiled by the Pioneer Society of San Diego, San Diego History Center Research Archives, circa 1914; Phoebe S. Kropp, "There Is a Little Sermon in That: Constructing the Native Southwest at the San Diego Panama-California Exposition of 1915," *The Great Southwest of the Fred Harvey Company and the Santa Fe Railway* (Phoenix, AZ: The Heard Museum, 1996), 43.
22. *San Diego Union*, January 5, 1914.
23. Ibid., March 24, 1914; Matilda McQuaid with Karen Bartlett in "Building an Image of the Southwest: Mary Colter, Fred Harvey Company Architect," in *The Great Southwest of the Fred Harvey Company and the Santa Fe Railway*, 29, attributed the design of the "Painted Desert" to Mary Colter and her assistant Herman Schweizer. They cite a letter from Schweizer "gently" admonishing Jesse Nusbaum for taking "exclusive credit for this building."
24. Chris Wilson, *The Myth of Santa Fe* (Albuquerque: University of New Mexico Press, 1997), 129.
25. *San Diego Union*, March 24, 1914.
26. *San Diego Tribune*, September 30, 1914.
27. "New Notes from the Beautiful Fair at San Diego," *Santa Fe Magazine* 9, no. 5 (April 1915): 37.
28. *San Diego Union*, May 24, 1920.
29. Ibid., March 24, 1914.
30. Lynn Adkins, "Jesse L. Nusbaum and the Painted Desert in San Diego," *Journal of San Diego History* 29, no. 2 (Spring 1983): 86–95.
31. Bokovoy, *San Diego World's Fairs*, 122.
32. *San Diego Union*, April 18, 1914; January 1, 1915, Exposition Section.
33. Ibid., October 6, 1914.
34. Ibid., March 1, 1915.
35. Ibid., June 2, 1914.
36. Ibid., August 2, 1914.
37. Ibid., January 1, 1915, Exposition Section.
38. Ibid., May 8, 1914.
39. Richard M. Howard, "Contemporary Indian Pottery," *Collecting Southwestern Indian Arts and Crafts* (Tucson, AZ: Ray Manley Publishing Co., 1979), 27.
40. John Anson Warner, *The Life and Art of the North American Indian* (New York: Crescent Books, 1975), 84.
41. Hewett, *Ancient Life in the American Southwest*, 163.
42. *San Diego Union*, June 2, 1914.
43. Ibid., August 2, 1914.
44. *San Diego Tribune*, September 17, 1914.
45. *Prospectus of the 1915 Exposition in San Diego*; James A. Vlasich, *Pueblo Indian Agriculture* (Albuquerque, NM: University of New Mexico Press, 2005).

46. *San Diego Union*, September 17, 1914.
47. Kathleen L. Howard, "A Most Remarkable Success: Herman Schweizer and the Fred Harvey Indian Department," in *The Great Southwest of the Fred Harvey Company and the Santa Fe Railway*, edited by Marta Weigle and Barbara Babcock (Phoenix, AZ: The Heard Museum, 1996), 95.
48. *San Diego Tribune*, September 30, 1914.
49. *San Diego Union*, June 2, 1914.
50. Ibid., September 5, 1914.
51. Ibid.
52. Beatrice Chauvenet, *Hewett and Friends* (Santa Fe: Museum of New Mexico Press, 1983), 122.
53. Carl D. Sheppard, *Isaac Hamilton Rapp, Architect: Creator of the Santa Fe Style* (Albuquerque: University of New Mexico Press, 1988), 79–88.
54. *San Diego Sun*, January 18, 1915.
55. *San Diego Union*, December 24, 1914.
56. *Los Angeles Times*, April 11, 1915.
57. Ibid., March 7, 1915.
58. *San Diego Sun*, January 18, 1915.
59. Ibid., February 15, 1915; *Los Angeles Times*, March 7, 1915.
60. *San Diego Sun*, January 18, 1915.
61. *San Diego Union*, January 1, 1915, Exposition Section.
62. *Los Angeles Times*, March 7, 1915.
63. Dozier, *Pueblo Indians*, 13–14.
64. *Official Guidebook of the Panama-California Exposition* (San Diego, CA: 1915), 14.
65. Alice Marriott, *Maria, the Potter of San Ildefonso* (Norman: University of Oklahoma Press, 1948), 210–16.
66. Ibid., 214.
67. *San Diego Union*, October 8, 1914.
68. Ibid., December 16, 1914.
69. *San Diego Union*, March 1, 1915.
70. Ibid., July 25, 1915; Charles Montgomery, *The Spanish Redemption* (Berkeley: University of California Press, 2002), 119; Bokovoy, *San Diego World's Fairs*, 132.
71. Dozier, *Pueblo Indians*, 116–17.
72. Tom Bahti, *Southwestern Indian Ceremonies* (Las Vegas: K.C. Publications, Inc., 1982), 19.
73. *San Diego Union*, January 13, 1915.
74. Bruce Kamerling, "Painting Ladies: Some Early San Diego Women Artists," *Journal of San Diego History* 32, no. 3 (Summer 1986): 168–70.
75. William H. Truettner, "The Art of Pueblo Life," 66–67, in *Art in New Mexico, 1900–1945: Paths to Taos and Santa Fe* (Washington, D.C.: National Museum of American Art, Smithsonian Institution, 1986).
76. Edna Robertson and Sarah Nestor, *Artists of the Canyons and Caminos: Santa Fe, The Early Years* (Layton, UT: Peregrine Smith, Inc., 1976), 50.
77. Robert Henri, *The Art Spirit* (Philadelphia, 1923), quoted in Bennard B. Perlman, *Robert Henri, His Life and Art* (New York: Dover Publications, Inc., 1991), 122.
78. McLuhan, *Dream Tracks*, 107.
79. *San Diego Union*, February 24, 1915.
80. Ibid., February 28, 1915.
81. Ibid., March 16, 1915; April 18, 1915.
82. Ibid., June 5, 1915.
83. Ibid., October 25, 1915.

84. *Los Angeles Times*, July 28, 1915; *San Diego Union*, July 28, 1915.
85. *San Diego Union*, February 6, 1916.
86. Ibid., April 26, 1916.
87. Ibid., May 29, 1916.
88. Don L. Roberts, "A Calendar of Eastern Pueblo Ritual Dramas," in *Southwestern Indian Ritual Drama*, edited by Charlotte Frisbie (Albuquerque: University of New Mexico, 1980), 115.
89. *San Diego Union*, September 23, 1916.
90. Jill D. Sweet, *Dances of the Tewa Pueblo Indians* (Santa Fe, NM: School of American Research Press, 1985), 85.
91. Ibid., 76.
92. *San Diego Union*, September 23, 1916.
93. Ibid.
94. Ibid., October 22, 1916.
95. Ibid., January 11, 1917.
96. James W. Hinds, *San Diego Military Sites* (San Diego History Center Research Library, 1986), 52.
97. *San Diego Union*, January 10, 1918, Special Section.
98. Ibid., July 25, 1917.
99. Ibid., August 13, 1917.
100. Hinds, *San Diego Military Sites*, 52.
101. *San Diego Union*, October 13, 1918; October 15, 1918; October 27, 1918, Sports-Auto.
102. *San Diego Sun*, August 6, 1921.
103. *San Diego Union*, March 9, 1919; *San Diego Sun*, March 13, 1919.
104. *San Diego Union*, March 8, 1919.
105. Ibid., March 9, 1919.
106. *San Diego Union*, June 5, 1920.
107. Ibid., April 22, 1927; June 12, 1940.
108. Ibid., June 3, 1935.
109. *San Diego Sun*, May 18, 1935; *San Diego Union*, July 25, 1935; August 10, 1935; *San Diego Herald*, September 5, 1935.
110. Herman I. Silversher, oral interview conducted by Susan Painter, May 24, 1990, San Diego History Center Research Library.
111. *San Diego Union*, August 14, 1939.
112. Ibid., July 18, 1946.
113. *San Diego Union*, August 7, 1945; August 21, 1947.
114. Ibid., November 28, 1945; June 24, 1948.
115. Ibid., June 7, 1920; January 2, 1922.
116. Clyde Kluckhorn and Dorothea Leighton, *The Navajo* (New York: Doubleday and Co., 1962), 308; Alice Marriott and Carol K. Rachlin, *American Indian Mythology* (New York: New American Library, 1968), 87–95.
117. William H. Truettner, "Science and Sentiment: Indian Images at the Turn of the Century," in *Art in New Mexico, 1900–1945: Paths to Taos and Santa Fe* (New York: Abbeville Press, 1986), 27.
118. McLuhan, *Dream Tracks*, 19.
119. Stan Steiner, *The New Indian* (New York: Dell Publishing Co., 1968), 144–59.
120. Hewett, *Ancient Life in the American Southwest*, 43–44.
121. Edgar L. Hewett, "On the Opening of the Art Galleries," *Art and Archaeology* 7, nos. 1 and 2 (January–February 1918): 50–53; Marc Simons, *New Mexico, An Interpretive History* (Albuquerque: University of New Mexico Press, 1977), 174.

122. Starr, *California Dream*, 402–6.
123. Bruce Bernstein, "From Indian Fair to Indian Market," *El Palacio* 98, no. 3 (Summer 1993): 17; William De Buys, "The Threads of Time and Place," *El Palacio* 99, nos. 1 and 2 (Winter 1994): 18–21; Chris Wilson, *The Myth of Santa Fe* (Albuquerque: University of New Mexico Press, 1951), 129.
124. *San Diego Union*, January 2, 1947.
125. Alden C. Hayes, "Archaeologists at Pecos," *Camera, Spade and Pen: An Inside View of Western Archaeology* (Tucson: University of Arizona Press, 1980), 16–17; R. Gwinn Vivian, "The Silence of Chaco," in *Camera, Spade and Pen*, 114–18.
126. Chauvenet, *Hewett and Friends*, 151.
127. Hewett, *Ancient Life in the American Southwest*, 171–75.
128. Tessie Naranjom "Cultural Changes: The Effect of Foreign Systems at Santa Clara Pueblo," in *The Great Southwest of the Fred Harvey Company and the Santa Fe Railway*, 191.
129. McLuhan, *Dream Tracks*, 1–15; Simons, *New Mexico*, 49–50; Sylvio Acatos, *Pueblos: Prehistoric Indian Cultures of the Southwest* (New York: Facts on File, Inc., 1990), 218–14.

Chapter 7

1. *Los Angeles Times*, January 31, 1915.
2. Lancaster, *Japanese Influence in America*, 178.
3. Harado Jiro, "Studio Talk," *International Studio* 58 (April 1916): 137–40.
4. *Los Angeles Times*, April 4, 1915.
5. Rydell, *All the World's a Fair*, 228.
6. *San Diego Union*, January 13, 1915, Sports-Drama.
7. *Los Angeles Times*, May 23, 1915.
8. Sherman E. Lee, *A History of Far Eastern Art*, 3rd ed. (Englewood Cliffs, NJ: Prentice-Hall, Inc., 1973), 497.
9. Hina Hirayama, "Curious Merchandise: Bunkio Matsuki's Japanese Department," in *A Pleasing Novelty: Bunkio Matsuki and the Japan Craze in Victorian Salem* (Salem, MA: Peabody and Essex Museum, 1993), 90.
10. G.R. Gorton, "Monthly Excursion through Exposition Grounds," *California Garden*, October 15, 1915, 8–10.
11. Hamilton Wright, "The Panama-Pacific Exposition in Its Glorious Prime," *Overland Monthly* 66 (October 1915): 300; Harada-Jiro, "Studio-Talk," *International Studio* 58 (April 1916): 137–40.
12. Mark Holborn, *The Ocean in the Sand* (Boulder, CO: Shambhala Publications, Inc., 1978), 94; Maggie Oster, *Reflections of the Spirit: Japanese Gardens in America* (New York: Dutton Studio Books, 1993), 82.
13. Gorton, "Monthly Excursion," 8–10.
14. Tanso Ishihara and Gloria Wickham, *Hakone Garden* (Kyoto, Japan: Kawara Shoten, Takakura-Sanjo Nakagyo-Ku, 1974), 87, 133.
15. *Official Guide to Balboa Park*, April 15, 1925, 16.
16. Winslow, *Architecture and Gardens*, 152.
17. Noritake Tsuda, *Handbook of Japanese Art* (Rutland, VT: Charles E. Tuttle, Co., 1976), 269.
18. Kazuo Nishi and Kazuo Hozumi, *What Is Japanese Architecture?* (Tokyo: Kodansha International, 1983), 100–101.
19. *Catalog to the Shogun Art Exhibition* (Japan: Tokugawa Art Museum, 1983), 40–46.
20. Gorton, "Monthly Excursion."
21. Nishi and Hozumi, *What Is Japanese Architecture?*, 74–75.

22. Tadishi Ishikawa, *Imperial Villas of Kyoto* (Tokyo: Kodansha, 1970), 34.
23. Ibid.
24. Information regarding the interior of the Balboa Park teahouse supplied by Moto Asakawa, son of Asakawa Hachisaku and his wife, Osamu.
25. Diane Durston, *Old Kyoto: A Guide to Traditional Shops, Restaurants and Inns* (Tokyo: Kodansha International, 1986), 131.
26. Donald H. Estes, "Before the War: the Japanese in San Diego," *Journal of San Diego History* 24 (Fall 1978): 429.
27. Lancaster, *Japanese Influence in America*, 176.
28. *San Diego Union*, April 6, 1955.
29. Ibid., September 4, 1988; *Los Angeles Times*, March 16, 1990; Ernest Chew, "San-Kei-En," *California Garden* 82 (March–April 1991): 37–38.
30. Information supplied to the author by Ken Nakajima, December 1995.
31. Nishi and Hozumi, *What Is Japanese Architecture?*, 119.
32. Hugo Munsterberg, *The Arts of Japan* (Tokyo: Tuttle Publishing, 1957), 161; Loraine Kuch, *The World of the Japanese Garden* (New York: Walker/Weatherhill, 1968), 112; Kendall H. Brown, *Japanese-Style Gardens of the Pacific West Coast* (New York: Rizzoli), 142–67.
33. Ulrike Hilborn, "The Nitobe Memorial Garden," *Washington Park Arboretum Bulletin* 53 (Summer 1990): 14–15.
34. Han Shan, quoted in Mark Holborn, *The Ocean in the Sand* (Gordon Frazer Book Publishers, 1978), 74.
35. Basho, quoted in Donald Keene, *World Within Walls* (New York: Holt, Rinehart and Winston, 1976), 88.
36. Edwin O. Reischauer, *The Japanese* (Cambridge, MA: Harvard University Press, 1977), 90.
37. Rydell, *All the World's a Fair*, 229–30.
38. Estes, "Before the War," 445.
39. Spenser C. Olin Jr., "European Immigrant and Oriental Alien," *Pacific Historical Review* 35 (August 1966).
40. Jacobus ten Broek, Edward N. Barnhart and Floyd W. Matson, *Prejudice, War and the Constitution: Japanese-American Evacuation and Resettlement* (Berkeley, CA, 1954).
41. Nobutaka Ike, *Japan: The New Superstate* (Standford, CA: Stanford Alumni Assoc, 1973), 53.
42. *San Diego Union*, August 18, 1935; August 19, 1935.
43. *San Diego Union*, July 19, 1936.
44. Edwin Bayrd, *Kyoto* (New York: Newsweek Books, 1974), 134.

Chapter 8

1. H.K. Raymenton, "Forty-Seven Years, A History of the San Diego Museum Association," paper prepared for the San Diego Museum of Man, n.d.
2. Trent Sanford, *The Architecture of the Southwest* (New York: W.W. Norton, 1950), 248.
3. William Templeton Johnson, "The Panama-California Exposition and the Changing Peoples of the Great Southwest," *Survey*, July 3, 1915, 306.
4. Thomas E. Tallmadge, *The Story of Architecture in America* (New York: W.W. Norton & Company, 1927), 281.
5. "Architecture Gems of Old Spain Revived," *San Diego Union*, January 1, 1915.
6. Christian Brinton, "The San Diego and San Francisco Expositions," *International Studio* (June 1915): supplement, 108.
7. C. Matlack Price, "The Panama-California Exposition," *Architectural Record* (March 1915): 242.

8. Francisco de la Maza, et. al., *Cuarenta siglos de plastica mexicana—arte colonial* (Mexico: Herrero, 1970), plates 112, 113.
9. Carol Mendel, *San Diego on Foot* (San Diego, CA: C.E. Mendel, 1973), 12.
10. Joseph Armstrong Baird Jr., *The Churches of Mexico* (Berkeley: University of California, 1962), plate 95.
11. George H. Edgell, *The American Architecture of Today* (New York: Charles Scribners Sons, 1928), 64.
12. John Ely Burchard and Albert Bush-Brown, *The Architecture of America: A Social and Cultural History* (Boston: Little Brown, 1966), 296.
13. Samuel Wood Hamill, "The California Building, Tracing the Lineage of an Architectural Monument," paper prepared for the National Register of Historic Places, Inventory Nomination Form, City of San Diego.
14. Marcus Whiffen, *American Architecture Since 1780, A Guide to the Styles* (Cambridge, MA: MIT, 1969), 225.
15. For a discussion of the relation between size of plazas and height of buildings see Camillo Sitte, *City Planning According to Artistic Principles* (New York: Random House, 1965), 44.
16. Baxter, *Spanish-Colonial Architecture*.
17. Baird, *Churches of Mexico*, plate 136.
18. Pedro Rojas, *The Art and Architecture of Mexico* (Middlesex, UK: Paul Hamlyn, 1968), plates 85, 86.
19. Manuel Toussaint, *Colonial Art in Mexico*, translated by Elizabeth Wilder Weissman (Austin, 1967), plate 260.
20. Sacheverell Sitwell, *Southern Baroque Revisited* (London, 1967), 159.
21. Neuhaus, *San Diego Garden Fair*, 32; Edgar L. Hewett and William Templeton Johnson, "Architecture of the Exposition, 1916," *Paper of the School of American Archaeology*, no. 32 (n.d.): 37–38.
22. Bertram Goodhue, *A Book of Architectural and Decorative Drawings* (New York: Architectural Book Publishing, 1914), 100–136.
23. Whitaker, *Bertram Grosvenor Goodhue*.
24. "Tepotzotlan," *Artes de Mexico*, no. 62/63 (n.d.): 80–91.
25. Rojas, *The Art and Architecture of Mexico*, 91–92.
26. David Farmer, "Balboa Tower Gets a Face Lifting," *San Diego Union*, May 5, 1964.
27. Craig MacDonald, "Artists Restoring Museum Façade to Original Beauty," *San Diego Union*, June 22, 1975; Robin Maydeck, "Space Age Discoveries Renew Park Buildings," *San Diego Evening Tribune*, August 8, 1975; Barbara Guis, "San Diego Museum Gets $550,000 Facelifting," *Los Angeles Times*, August 17, 1971.
28. Maydeck, "Space Age Discoveries."
29. Ibid.
30. Baird, *Churches of Mexico*, plates 122, 124; plates 18, 22.
31. De la Maza, *Cuarenta siglos*, plate 220.
32. J. de Contreras, Marques de Lozoya, *Santiago de Compostela, La Catedral* (Barcelona, Spain: Numancia, 1975), 26.
33. John Harvey, *The Cathedrals of Spain* (New York, 1957), plate 34.
34. Sitwell, *Southern Baroque Revisited*, 138–39.
35. De la Maza, *Cuarenta Siglos*, plate 139.
36. Winslow, *Architecture and Gardens*, 30.
37. Pierre du Colombier, *Sienna and Siennese Art*, translated by Mary Fitton (London: N. Kaye, 1957), 123.
38. De la Maza, *Cuarenta Siglos*, plate 220.
39. Baxter, *Spanish-Colonial Architecture*, V.9, plate 123.

40. Winslow, *Architecture and Gardens*, 36.
41. De la Maza, *Cuarenta Siglos*, plate 127.
42. "The Plazas of Mexico City," *Artes de Mexico*, no. 110 (1968): 83.
43. Lord Kinross, *Hagia Sophia* (New York: Newsweek Books, 1972), 11.
44. "Rafael Guastavino," *The Brickbuilder* 17 (1908): 40–41.
45. Kinross, *Hagia Sophia*, 164–67.
46. Justino Fernandez, *Mexican Art* (London: Spring Books, 1965), 15.
47. Ernest Kuhnel, *Islamic Art and Architecture* (Ithaca, NY: Cornell University Press, 1966), 148.
48. John Ely Burchard and Albert Bush-Brown, *The Architecture of America, A Social and Cultural History* (Boston: Atlantic Monthly Press Book, 1966), 296–97; James Marston Fitch, *American Architecture: The Historical Forces That Shaped It* (Cambridge, MA: Houghton Mifflin Co, 1966), 235; David Gebhard and Harriette Von Breton, *Architecture in California, 1868–1968* (Santa Barbara, CA: Standard Printing of Santa Barbara, 1968), plate 73; Frederick Gutheim, *One Hundred Years of Architecture in America* (New York: Reinhold Publishing Company, 1957), 51; Walter Kidney, *The Architecture of Choice, Eclecticism in America, 1880–1930* (New York: George Braziller, Inc, 1974), plate 100; William Pierson Jr. and Martha Davidson, *Arts of the United States: A Pictorial Survey* (New York: McGraw-Hill, 1960), 174.
49. Robert Giebner, "Historic American Buildings Survey, San Diego, 1971," *Journal of San Diego History* (Fall 1971): 44.
50. Whitaker, *Bertram Grosvenor Goodhue*, plates 170–71; plates 198–205; plates 190–91.
51. David Gebhard, "Goodhue, Bertram G. (1869–1924)," in *The Britannica Encyclopedia of American Art* (Milan, Italy: Encyclopaedia Britannica Educational Corp., 1973), 241.
52. McCoy, *Five California Architects*, 89.
53. Gebhard and Von Breton, *Architecture in California*, 19.
54. Edgell, *American Architecture of Today*, 64, 103, 106, 108, 238; David Gebhard, *George Washington Smith, 1876–1930: The Spanish-Colonial Revival in America* (Santa Barbara, CA, 1964), 12–17; Rexford Newcomb, *Spanish-Colonial Architecture in the United States* (New York, 1957), 38–39; Sanford, *Architecture of the Southwest*, 249–51; Tallmadge, *Architecture in American*, 269–70.
55. Reyner Banham, *Los Angeles, The Architecture of Four Ecologies* (New York, 1971), 30; Alice Sinkevitch, ed., *AIA Guide to Chicago* (New York: Mariner Books, 1993), 296.
56. Raymenton, "Forty-Seven Years."
57. *San Diego Sun*, January 20, 1915; *San Diego Union*, April 25, 1915.
58. Raymenton, "Forty-Seven Years."
59. Scott La Fee, "The Way We Thought We Were," *San Diego Union*, May 31, 2004.
60. *San Diego Union*, October 4, 1914.
61. Rydell, *All the World's a Fair*, 220–23.
62. *San Diego Union*, January 6, 1915.
63. Hewett, "Ancient America at the Panama-California Exposition," 96–97.
64. *San Diego Evening Tribune*, July 12, 1914; Bruce Kamerling, "Early Sculpture and Sculptors in San Diego," *Journal of San Diego History* 35, no. 3 (Summer 1989).
65. Hewett, "Ancient America at the Panama-California Exposition," 87.
66. Ibid., 65–104; W.H. Holmes, "Masterpieces of Aboriginal American Art," V; "The Great Dragons of Quirigua," *Art and Archaeology* (December 1916): 269–78.
67. Raymenton, "Forty-Seven Years"; Clark Evernham, "Popular Museum of Anthropology and Archaeology, San Diego's Museum of Man," *The Museologist*, no. 87 (June 1963): 15.
68. *Los Angeles Times*, February 28, 1915. A set of replicas of the monuments at Quirigua was made by George Byron Gordon in the 1890s for the Peabody Museum of Anthropology at Harvard University. He used a papier mâché process. Attempts to find further information about the Peabody Museum collection have not yielded results. The American Museum

of Natural History in New York City has a copy of *Stela E from Quirigua* on which, judging from a photograph, most of the detail is indistinguishable.
69. Grant Wallace, "The Museum as a Clearing House of Culture and Recreation," *El Museo* 1, no. 1 (April 1, 1919): 10.
70. *San Diego Union*, March 12, 1916; March 15, 1916.
71. Hewett, "The School of American Archaeology," *Art and Archaeology* 4 (December 1916): 317–29.
72. *San Diego Union*, January 2, 1947.
73. Hewett, "The Excavation of Chetro Ketl, Chaco Canyon, 1932–33," *Art and Archaeology* 35, no. 2 (March–April 1934): 51–58.
74. Edward Hardy, "History of the San Diego Museum," in *History of San Diego County*, edited by Carl H. Heilbron (San Diego: San Diego Press Club, 1936), 229–31.
75. List of directors supplied by the Museum of Man.
76. Letter, Edgar L. Hewett to California State Commission, undated, George W. Marston Papers, Collection 219, Box 2, File 32, San Diego Historical Society Research Library.
77. *San Diego Sun*, May 23, 1917.
78. *San Diego Union*, January 11, 1920, Classified.
79. *Los Angeles Times*, July 1, 1917.
80. Marston, *A Family Chronicle*, 98.
81. Ibid., Vol. 2, Appendix E, 336.
82. *San Diego Sun*, October 13, 1917.
83. *San Diego Union*, February 3, 1917, Classified.
84. Hardy, "History of San Diego Museum," 230.
85. Letter, T.N. Faulconer, Executive Secretary of the Park Commission to Duncan McKinnon, president of the San Diego Museum, date unknown, in Amero Collection, San Diego Historical Society Research Library.
86. *San Diego Union*, July 12, 1923.
87. Ibid., July 12, 1925.
88. Ibid., February 12, 1929.
89. Ibid., June 12, 1925.
90. Ibid.
91. Minutes of the Board of Park Commissioners, November 19, 1931.
92. *San Diego Union*, May 12, 1932.
93. Ibid., August 17, 1932.
94. Ibid., October 5, 1934.
95. Ibid., April 19, 1936.
96. *Descriptive Guidebook of the California-Pacific International Exposition in San Diego, California, 1935*, 11.
97. *San Diego Union*, May 26, 1935.
98. *San Diego Sun*, February 29, 1936, Exposition Edition.
99. Ibid., December 27, 1936.
100. *Official Guide, Souvenir Program, California-Pacific International Exposition—San Diego, 1936*, 14.
101. *San Diego Union*, February 28, 1943.
102. Ibid., June 25, 1950.
103. Ibid., April 30, 1991.
104. Ibid.
105. Ibid., April 11, 1943; September 2, 1945.
106. Barton Wright, "San Diego Museum of Man," *American Indian Magazine* 5, no. 4 (1980): 48–53.
107. *San Diego Union*, April 11, 1943.

108. Ibid., March 11, 1951.
109. Ibid., January 18, 1947.
110. Ibid., February 18, 1947.
111. Ibid., March 21, 1948.
112. Ibid., December 26, 1946.
113. Ibid., July 22, 1949.
114. Ibid., April 6, 1967.
115. Ibid., July 14, 1950.
116. Ibid., June 10, 1965.
117. Ibid., September 26, 1977.
118. Ibid., April 24, 1925.
119. Harland Bartholomew and Associates, "Master Plan for Balboa Park," May 17, 1960, 50.
120. Minutes of the Park and Recreation Board, May 11, 1966.
121. *San Diego Union*, November 9, 1972.
122. Ibid., February 26, 1976.
123. Ibid., March 2, 1973.
124. Ibid., July 10, 1966.
125. *San Diego Evening Tribune*, May 18, 1984.
126. *San Diego Union*, February 4, 1990.
127. *San Diego Evening Tribune*, October 10, 1985; March 27, 1987.
128. *Los Angeles Times*, March 15, 1984.
129. *San Diego Union*, June 24, 1984.
130. *Los Angeles Times*, March 15, 1984; *San Diego Union*, April 1, 1984.
131. Hewett, "Ancient America at the Panama-California Exposition"; *San Diego Union*, February 4, 1979.
132. *San Diego Union*, December 31, 1978; February 4, 1979.
133. *San Diego Evening Tribune*, November 17, 1970.
134. *San Diego Independent*, March 19, 1970.
135. Museum of Man, http://www.museumofman.org (cited information no longer on that web page).
136. *San Diego Union*, April 1, 1993, art review by Robert L. Pincus.

Chapter 9

1. *San Diego Union*, November 11, 1909.
2. Letter George W. Marston to John Nolen, September 22, 1910, George W. Marston Papers, Collection 219, Box 2, File 27, San Diego History Center Research Archives.
3. John Taylor Boyd Jr., "The Work of Olmsted Brothers," Part 2, *Architectural Record* 44, no. 6 (December 1918): 502–21.
4. William H. Wilson, *The City Beautiful Movement* (Baltimore, MD: The John Hopkins University Press, 1989), 242–45.
5. Norman T. Newton, *Design on the Land* (Cambridge, MA: Belknap Press of Harvard University Press, 1971), 389.
6. Carl Abbott, *The Great Extravaganza: Portland and the Lewis and Clark Exposition* (Portland: Oregon Historical Society, 1981), 21.
7. Norman J. Johnston, "The Olmsted Brothers and the Alaska-Yukon-Pacific Exposition," *Pacific Northwest Quarterly* 75, no. 2 (April 1984): 50–61.
8. Newton, *Design on the Land*, 389.
9. *San Diego Union*, November 12, 1910.

10. *San Diego Union*, January 6, 1911.
11. Bruce Kamerling, *Irving J. Gill, Architect* (San Diego, CA: San Diego Historical Society, 1993), 87.
12. *San Diego Union*, January 28, 1911.
13. McCoy, *Five California Architects*, 87–88.
14. Letter, Olmsted Brothers to Julius Wangenheim, September 18, 1911, George W. Marston Papers, Collection 219, Box 2, File 27, San Diego History Center Research Archives.
15. *San Diego Union*, November 7, 1910.
16. Letter, Harold Blossom to James Dawson, April 25, 1911, National Park Service, Frederick Law Olmsted National Historic Site, Brookline, Massachusetts; *San Diego Union*, November 11, 1910, 16:2.
17. *San Diego Union*, January 2, 1911.
18. Ibid., February 19, 1911.
19. Ibid., December 14, 1910.
20. Ibid., November 11, 1910.
21. Ibid., January 2, 1911, Exposition Section; February 19, 1911.
22. *San Diego Evening Tribune*, July 19, 1911.
23. Letter, John Olmsted to Bertram Goodhue, May 11, 1911, Goodhue Collection, Avery Library, Columbia University, New York City.
24. Letter, John Olmsted to wife, May 18, 1991, Francis Loeb Library, Harvard University.
25. Letters, John Olmsted to wife, April 3, 1911, and April 28, 1911, Francis Loeb Library, Harvard University.
26. Letter, John Olmsted to wife, May 20, 1911, Francis Loeb Library, Harvard University.
27. Letter Bertram Goodhue to John Olmsted, May 26, 1911, Olmsted Collection, Library of Congress, Washington, D.C.
28. *San Diego Union*, September 6, 1911.
29. Letter Bertram Goodhue to John Olmsted, August 3, 1911, Olmsted Collection, Library of Congress, Washington, D.C.
30. Letter John Olmsted to wife, July 13, 1911, Francis Loeb Library, Harvard University.
31. *San Diego Evening Tribune*, August 28, 1911.
32. Letter John Olmsted to Dawson, July 28, 1911, George W. Marston Papers, Collection 219, Box 2, File 25, San Diego Historical Society Research Archives.
33. Letter John Olmsted to wife, July 13, 1911, Francis Loeb Library, Harvard University.
34. Letter Bertram Goodhue to John Olmsted, June 30, 1911, Olmsted Collection, Library of Congress, Washington, D.C.
35. *San Diego Union*, April 5, 1911.
36. Gregory Montes, "Balboa Park, 1909–1911, The Rise and Fall of the Olmsted Plan," *Journal of San Diego History* 28, no. 1 (Winter 1982): 55–56.
37. "Why New York and Boston?" *California Garden* (January 1911): 6–7.
38. *San Diego Union*, June 24, 1911.
39. Ibid., June 20, 1911.
40. Montes, "Balboa Park, 1909–1911," 58. Montes declared that the June 20 and 21 contract stipulated that the Exposition's Division of Works "would design all structures built anywhere in Balboa Park between that date and the end of 1915 unless the Park Board received a lower bid from an outside contractor." The writer of this article is still looking for evidence that the word "design" was used in the contract mentioned. See also *San Diego Evening Tribune*, June 24, 1911.
41. Night Letter, John Olmsted to George W. Marston, September 1, 1911, George W. Marston Papers, Collection 219, Box 2, File 25, San Diego History Center Research Archives.

42. Letter Frank P. Allen to John Olmsted, September 5, 1911, Olmsted Collection, Library of Congress, Washington, D.C.
43. Telegram, Bertram Goodhue to Frederick Law Olmsted, September 4, 1911, Olmsted Collection, Library of Congress, Washington, D.C.
44. Letter George W. Marston to John C. Olmstead [sic], January 5, 1912, Olmsted Collection, Library of Congress, Washington, D.C.
45. Richard Oliver, *Bertram Grosvenor Goodhue* (Cambridge, MA: MIT Press, 1983), 118–19.
46. Letter Bertram Goodhue to Frederick Law Olmsted, April 15, 1915, Olmsted Collection, Library of Congress, Washington, D.C.
47. Letter Bertram Goodhue to Frederick Law Olmsted, September 14, 1911, Olmsted Collection, Library of Congress, Washington, D.C.
48. Letter Frederick Law Olmsted to Bertram Goodhue, September 27, 1911, Goodhue Collection, Avery Library, Columbia University.
49. Letter Bertram Goodhue to Frederick Law Olmsted, October 17, 1911, Olmsted Collection, Library of Congress, Washington, D.C.

Chapter 10

1. San Diego Union, April 1, 1914.
2. Neuhaus, San Diego Garden Fair, 55; Elizabeth Weismann, *Art and Time in Mexico: Architecture and Sculpture in Colonial Mexico*, paperback edition (New York: Icon (Harpe), 1995), 218.
3. *San Diego Union*, March 15, 1913; April 13, 1913.
4. Palethorpe, McBride & Probert, *Panama-California Exposition Report on Pre-Exposition Operations from November 1909 to December 31, 1914*, Los Angeles, March 29, 1915, California Room, San Diego Public Library.
5. *San Diego Union*, June 14, 1913; August 3, 1913.
6. Bruce Kamerling, "Early Sculpture and Sculptors in San Diego," *Journal of San Diego History* 35, no. 3 (Summer 1989).
7. Richard S. Requa, *Architectural Details, Spain and the Mediterranean* (Los Angeles: The Monolith Portland Cement Company, 1926), Section L, Plate 135.
8. Baxter, *Spanish-Colonial Architecture*, vol. 8, Plate 104.
9. *San Diego Union*, January 1, 1915, Exposition Section.
10. Ibid., July 7, 1914; Winslow, *Architecture and Gardens*, 144.
11. Letter, Bertram Goodhue to Christian Brinton, August 17, 1915, Avery Library, Columbia University.
12. *San Diego Union*, January 23, 1914.
13. Ibid., April 9, 1914.
14. Ibid., November 9, 1913; December 20, 1913.
15. Winslow, *Architecture and Gardens*, 146.
16. Winslow attributions are in *The Architecture and the Gardens of the San Diego Exposition*.
17. Arthur Byne and Mildred Stapley, *Spanish Architecture in the Sixteenth Century, General View of the Plateresque and Herrera Styles* (New York: G.P. Putnam's Sons 1917); Austin Whittlesey, *Minor Ecclesiastical, Domestic and Garden Architecture of Southern Spain*, introduction by Bertram Goodhue (New York: Architectural Book Publishing Co., 1917).
18. Pourade, *Gold in the Sun*, 262.
19. Carleton M. Winslow Jr., "The Architecture of the Panama-California Exposition" (thesis, University of San Diego, 1976), 24–25, in California Room, San Diego Public Library.

20. Frank P. Allen Jr., "Development of Spanish-Colonial Architecture," *Fine Arts Journal* (March 1915): 116–26; "The Panama-California Exposition," *Pacific Coast Architecture* (June 1915): 213–37.
21. Pourade, *Gold in the Sun*, 254.
22. Neuhaus, *San Diego Garden Fair*, 49.
23. *San Diego Union*, August 3, 1913; March 21, 1914; September 15, 1914.
24. Pal Kelemen, *Baroque and Rococo in Latin America* (New York: Macmillan Company, 1951), 99; Manuel Toussaint, *Colonial Art in Mexico* (Austin: University of Texas Press, 1967), 329–30; Elizabeth Wilder Weismann, *Art and Time in Mexico, Architecture and Sculpture in Colonial Mexico* (New York: Icon/Harper & Row, 1985), 24–25. For some reason, Toussaint and Weismann refer to the Casa de Ecala as the Casa de Marques de la Villa del Aguilar. Until an explanation is given, this writer maintains that the correct name of the building is as given in the text.
25. Andrew Noble Prentice, *Renaissance Architecture and Ornament in Spain* (New York: Badsford, 1893).
26. Neuhaus, *San Diego Garden Fair*, 54.
27. Baxter, *Spanish-Colonial Architecture in Mexico*, vol. 4, Plate 47.
28. Weismann, *Art and Time in Mexico*, 49–51.
29. Winslow, *Architecture and Gardens*, 11.
30. Oliver, *Bertram Grosvenor Goodhue*, 111.
31. Winslow, *Architecture and Gardens*, 44.
32. Oliver, *Bertram Grosvenor Goodhue*, 204–211, 227–32.

Index

A

Abbott, Dr. Clinton 211
Alameda and Santa Clara Counties Building 45, 56, 95
Alameda, the 48, 73–75, 85, 142
Alaska-Yukon-Pacific Exposition 18, 27, 125, 150, 221
Albright, Claudia 100
Albright, Harrison 237, 238
Alessio, John 215
Alhambra Cafeteria 75, 76, 110, 116
Allen, Frank P., Jr. 18, 19, 27–30, 32, 35, 36, 38–40, 45–47, 50, 120, 125, 126, 221, 223, 225, 227–229, 231, 232, 235, 237–241, 245
Allen, James Hugh 91
Almgren, Fire Chief 142
American Legion 212
American Red Cross 188
Anasazi *See* Native American communities (Indians): Anasazi
Andrews, Joseph 67
Animal Show *See* Robinson Wild Animal Show
Apache *See* Native American communities (Indians): Apache
Architecture and the Gardens of the San Diego Exposition, The 120
Army and Navy Day 131

Asakawa, Gozo 187
Asakawa, Hachisaku 187, 189
Asakawa, Osamu 185, 187, 189
Ascención, Father Antonio de la 40, 201
Austin Organ Company 45

B

Bailey, Wheeler J. 146
Baker, Dr. Fred 126
Barrett, John 20–23, 54
Basket Dance 172
Baumann, Harry 164
Bayne, Beverly 98
Beach, Mrs. H.H.A. (composer) 89
Belcher, Frank J., Jr. 35
Bird House Day 131
Bond, Carrie Jacobs 89
Boquel, Joe 127, 128
Botanical Building 42, 45–47, 58, 59, 77, 120, 231, 237
Boy Scouts *See* San Diego County Council of the Boy Scouts
Bradfield, Wesley 211
Brinton, Christian 62, 197
Broadwick, Tiny 89, 97
Brown and De Cew Construction Company 42
Bryan, William Jennings 92–95, 99, 106
Bryson, Dr. Lyman 211

Index

Buffalo Dance 168
Burnham, George 32, 35, 108
Burnside, S.A. 89
Bushman, Francis X. 98
Butterfly Dance 126, 172

C

Cabrillo Canyon 26, 35, 36, 38, 107, 120, 148, 225, 229
Cabrillo, Juan Rodriguez 33, 40, 201
Cadman, Charles Wakefield 91, 145
Café Cristobal 75, 76, 85, 94, 98, 99, 105, 110, 113, 117, 125, 131–133, 143, 145
Café del Rey Moro 194
California Alien Land Bill 194
California Pacific International Exposition 174
California Quadrangle 29, 39, 40, 42, 78, 206, 215, 231, 232, 244
California State Building 39, 56, 154, 156, 227
Callahan, Father James A. 101
Calle Ancón 48
Calle Colón 48
Camp of '49 85, 86, 89, 93, 105, 182
Canadian Building 116, 125, 129, 135
Cantu, Colonel Esteban 86, 126
Capps, Mayor Edwin M. 100, 104, 108, 127, 139, 141, 143, 144
Captain, "the thinking horse" 116
Captive God, The 171
Caribbean Indians 114
"Carnival Cabrillo" 32, 33
Cassidy, Gerald 68, 177
Castilian, The *See* Captive God, The
Chaffin, Orrin L. 144
chamber of commerce *See* San Diego Chamber of Commerce
Chambers, Edward (vice-president of the Santa Fe Railway) 159
Chapin, E.J. 95
Chapman, Kenneth 57, 159
Charles V (king of Spain) 40, 201
Chief Iodine 98
Children's Fair 128
Chinese Club of San Diego 123
Churrigueresque architecture style 29, 58, 134, 197, 199, 200, 207, 232, 242, 244
City Beautiful movement 144

Clark Evernham Hall 216
Claxton, P.P. (United States Commissioner of Education) 91
Cliff House 160, 161, 164, 174
Coast Artillery Band 110
Coffroth, James W. 126
Collier, Colonel David Charles (Charlie) 14–17, 19, 26, 32, 34, 42, 51, 122, 131, 144, 145, 153, 154, 156–158, 178, 207, 208, 220, 227, 228, 247, 250
Collins, Attorney Hubert 120
Commerce and Industries Building 45, 71, 76, 91, 102, 106, 116, 199, 235, 236, 239, 241, 242
Committee of One Hundred 214, 242
Conaty, Bishop Thomas James 20, 21
Conklin, Sheriff 105
Constantino, Florencio 97, 102
Cooke, George 35
Cook-Smith, Jean Beman 62, 209
Cooper, Earl 80
Craft, Marcella 91
Creatore, Giuseppe 85
Curtis, Edward S. 68, 69

D

Dahne, Dr. Eugenio 91
Damrosch, Walter (conductor) 117
Daniels, Josephus (secretary of the navy) 117
Daughters of the American Revolution 78
Davidson, G. Aubrey 13, 14, 34, 35, 38, 49, 51, 54, 55, 82, 85, 86, 104, 106, 108, 113, 114, 127, 133, 141, 144, 146
Davis, H.O. 32, 95
Davis, Judge John F. 125
Day, Mrs. Horace B. 78
de Longchamp, Fred 238
de Pasquali, Bernice 122
de Portola, Gaspar 40, 201
Dorland, W.S. 123, 136

E

Eagle Dance 164, 168, 172
Edison, Thomas A. 101
Electric Building 215
electric railway station 27, 48 *See also* San Diego Electric Railway

Index

Elizabeth the Lilliputian 116
El Prado 33, 36, 39, 48, 57, 58, 63, 71, 73, 88, 98, 120, 129, 148, 151, 175, 182, 213, 216, 226, 242, 242–244
English, General Lowell 211
Eskimo *See* Native American communities (Indians): Eskimo
esplanade 36, 45, 52, 69, 79
Estudillo, Jose Guadalupe 88
Evenson, Bea 214
Evernham, Clark 211 *See also* Clark Evernham Hall

F

Fairbanks, Douglas 129
Fall, Albert B. (secretary of the interior) 172
Farmer, Malcolm 211
Farnham, Sally James 62, 209
Ferris, Carl D. 51, 136
Fetzer, John 238
Fine Arts Building 39, 40, 42, 44, 45, 58, 62, 78, 109, 116, 135, 142, 149, 154, 209, 210, 212, 215–217, 244
Fine Arts Gallery 62, 71, 119, 123, 212, 214, 239, 244, 245
First Cavalry, U.S. Army 51, 62, 82, 85, 96, 100, 110, 117, 173
Fisheries Building 108, 114, 135
Ford, Henry 101
Ford Motor Company 119
Foreign and Domestic Arts Building 70, 71, 182
Foreign Arts Building 45, 72, 87, 90, 95, 114, 183, 235, 236, 239
Fort Rosecrans 53, 87
Forward, John F., Jr. 51, 122, 144
Fourth Regiment, U.S. Marine Corps *See* Second Battalion of the Fourth Regiment, U.S. Marine Corps
Fred Harvey Company 154, 176
Fresierres, Tedore (consul of Mexico) 126
F. Wurster Construction Company 40, 45

G

Garrettson, Mrs. Earl A. 76, 143
Genesee Pure Food Company 72
Getz, Thomas P. 143
Gilbert, Gertrude 11, 79, 89

Gill, Irving J. 19, 28, 36, 46, 207, 215, 220–222
Globe Mills Company 72
Goethals, Major General George W. 98
Gold Gulch Canyon 189, 190
Gonzalez, Maria Concepcion 105
Goodhue, Bertram Grosvenor 16, 19, 26–30, 35, 38–40, 42, 44, 45, 48, 52, 58, 120, 134, 197, 199, 200, 202, 204–207, 218, 219, 222, 223, 225–232, 238, 239, 244, 245
Gorton, G.R. 183, 184
Grant, Ulysses S., Jr. 149, 220
Gray, Captain Edward F. 28
Gray, George 122

H

Hamill, Samuel Wood 90, 199, 214, 239
Hamilton-Gordon, John Campbell (the Seventh Earl of Aberdeen) 106
Hanker, Hulda 128, 133
Hardy, Dr. Edward L. 211
Harland Bartholomew planners 214
Harrington, John 90
Hatfield the Rainmaker 120
Havasupai *See* Native American communities (Indians): Havasupai
Hazard, Roscoe 139
Hearst International Film Service 126
Heide, A.F. 238
Heilbron, Carl H. 108, 122, 123, 133
Henri, Robert 62, 64, 170, 177
Hewett, Dr. Edgar Lee 65, 83, 90, 141, 154, 207, 211
Hoffman, Alice C. 100
Hogaboom, Winifield 250
Hollington, Reverend R.D. 122, 144
Home Economy Building 39, 71, 116, 148, 231, 239–241
Hospital of Santa Cruz 239
House of Hospitality 72, 90
Howard, T.B. (rear admiral) 54, 89
Howard Tract 35
Hrdlicka, Dr. Ales 65–67, 154–156, 207–209, 216
Hubbel, J.L. 164
Hughes, Charles Evans (New York governor) 124, 126, 127
Hunter, Thomas B. 38, 46, 47, 237

Index

I

Indian Arts Building 39, 50, 58, 63, 67, 78, 83, 84, 95, 110, 154, 156, 166, 167, 177, 208, 209, 211, 212, 231, 238, 239, 254
Indian Village (Painted Village) 48, 49, 69, 73, 83, 93, 94, 100, 101, 110, 123, 126, 139, 142, 154, 157, 160, 162, 164–166, 170–175, 177
Industrial Workers of the World (IWW) 28, 29
International Harvester 32, 48, 73, 74, 136, 139, 140, 159
Iodine (Chief) *See* Chief Iodine
Isthmus 22, 25, 26, 48, 51, 54, 56, 57, 59–61, 70, 75, 79, 80, 82, 85, 86, 88, 91, 92, 100, 102, 105, 106, 108, 110, 116–118, 120, 122, 126, 128, 135, 136, 139, 159, 165, 182, 192

J

James, George Wharton 15, 131, 134
Japanese Exhibit Association 138
Japanese Pavilion (teahouse) 181, 188, 189, 191
Japanese Tea Association 47
Japanese Tea Garden 135, 149, 184, 194
Jayme, Father Luis 40, 201
Jessop, Joseph 25, 142, 211, 212
Johnson, Governor Hiram 17, 20, 39, 51
Johnson, William Templeton 178, 197, 200
Joss House 192

K

Kammermeyer, Professor E.C. 75
Kansas State Building 116, 233
Kaufman, G. (animal trainer) 116
Keating, Justice J. Edward 105
Keres *See* Native American communities (Indians): Keres
Kern and Tulare Counties Building 45, 52, 56, 59, 72, 95
Kettner, William 17, 18, 85, 108, 109, 125
kiva 49, 62, 162–165, 167
Klauber, Alice 76, 78, 79, 170, 178, 209
Knox, Jesse C. 49

Kumeyaay *See* Native American communities (Indians): Kumeyaay
Kyosan Kai Company 70, 182

L

Lane, Franklin K. (secretary of the interior) 85, 117
Leap Year Court 117
Lewis, J. Hamilton (Illinois senator) 126
Liberator, The 129
Liberty Bell 104
Lipton Tea Building 73
Lipton Tea Company 48, 138
Little, Jumping Jack 122
Little Landers 74, 75
Locke, Dr. Charles 128
Long, Baron H. 126
Loos, Anita 131
Lowe, Ona May 214
Lowe, Reverend E.L. 100
Lubin, Sigmund 99
Luce, Moses A. 19, 27, 228

M

Madriguel, Manuel 105
Mahoney, District Attorney D.V. 89
Mane, Quon 82
Marshall, Thomas R. (vice president of the United States) 85
Marsh, District Attorney Spencer 93, 117, 122
Marston, George W. 8, 18, 19, 27, 28, 39, 51, 52, 99, 104, 109, 123, 131, 139, 143, 144, 147, 220, 228, 229
Martin, Dr. F.A. 90
Martinez, Crescencio 162, 177
Martinez, Florentino 162, 168
Martinez, Julian 157, 162, 168
Martinez, Maria 157, 162, 167
Mascre, Louis 67, 207
Maya *See* Native American communities (Indians): Maya
McAdoo, Mrs. William G. 79
McAdoo, William Gibbs (secretary of the treasury) 54, 55
McKenzie, Mrs. George M. 79, 109
McLean, John 35

INDEX

McLure, L.S. 14
Megalite (Navajo medicine man) 168
Melba, Nellie 143
Micka, Frank (Mischa) 67, 68
Miller, Elizabeth S. 139
Mills, Chesley 51
Mischa, Frank *See* Micka, Frank (Mischa)
model bungalow 72, 76, 77, 136, 138
model farm 72, 74, 75, 77, 124, 135, 136, 159
Modern Woodmen of America 105
Mohave *See* Native American communities (Indians): Mohave
Montana State Building 49, 56, 97, 139, 141, 142, 235, 237
Montessori Education Association 138
Montessori, Maria 91
Morley, John 35, 139, 141, 148
Morley, Sylvanus G. 209
Mormon Tabernacle Choir 91
Moseley, Captain George Van Horn 96
Mossholder, Judge W.J. 142
Museum of Man 40, 45, 67, 203, 210, 211, 213, 213–218 *See also* San Diego Museum

N

Native American communities (Indians)
 Anasazi 160, 167
 Apache 60, 67, 160, 161, 165
 Eskimo 114
 Havasupai 160, 165
 Keres 165
 Kumeyaay 96
 Maya 62, 154, 156, 209, 210, 213, 215
 Mohave 160
 Navajo 60, 160, 165, 167, 168, 171, 177
 Supai 60
 Tewa 60, 83, 157, 165, 178
 Tiwa 60, 166
Navajo *See* Native American communities (Indians): Navajo
Nazimova, Alia 95
Neuhaus, Eugen 148, 200, 232, 240, 241
Nevada State Building 48, 49, 56, 105, 114, 129, 142, 238
New Mexico State Building 49, 56, 57, 93, 156, 165, 169, 177, 238
New Orleans 16
New York Motion Picture Company 171
New York Symphony Orchestra 117
Nordhoff, Walter 40
Normand, Mabel 127
Nusbaum, Jesse L. 49, 157, 159, 160, 162, 164, 165, 173

O

Official Women's Board Headquarters 78
O'Hallaran, Thomas 19, 27, 39, 228
Olmsted, Frederick Law, Jr. 18, 27, 28, 221, 222, 226, 228–230
Olmsted, Frederick Law, Sr. 149, 220, 221
Olmsted, John Charles 18, 19, 26, 27, 36, 38, 150, 151, 221, 223, 223–230
O'Neall, Mayor Charles F. 38, 51, 85
Ostrich Farm 117

P

Painted Village *See* Indian Village
Palace of Mines 116
Palethorpe, McBride and Probert 50, 232
Palethorpe, W.J. 112
Panama-California Exposition Company 13, 54
Panama Canal Building 120
Panama Canal Extravaganza 135, 141
Panama-Pacific International Exposition 56, 65, 82, 92, 108, 116, 149, 180, 207, 210, 212, 239
Pan-Pacific Building 116
"Paris after Midnight" 116, 117, 122
Park Board 18, 127, 129, 139, 142, 143, 145, 146, 148, 220, 222, 223, 227
Parker, Max E. 76
Parsons, Samuel, Jr. 18, 27, 35, 223, 225, 229
Parzen, Micah D. 211
Pendleton, Colonel Joseph H. 49, 88
Penfold, H.J. (secretary of the Exposition) 108, 117, 139, 141
Philip III (king of Spain) 40, 201
Piccirilli, Attilio *See* Piccirilli brothers
Piccirilli brothers 40, 42, 202, 204, 219
Piccirilli, Furio *See* Piccirilli brothers
Piccirilli, Horatio *See* Piccirilli brothers
Piccirilli, Thomas *See* Piccirilli brothers
Pioneer Paper Company 71

Index

Pioneer Society of San Diego 62, 213
Plateresque architecture style 148, 197, 200, 231
Plaza de Balboa 48
Plaza de California 15, 37, 62, 148, 213, 217, 247
Plaza de los Estados 69
Plaza de Panama 45, 51, 52, 56, 57, 64, 69, 69–71, 76, 79–82, 85, 89, 91, 92, 94, 97, 98, 101, 104, 105, 107, 110, 113, 113–115, 117, 121, 123, 125, 128, 129, 131, 133, 136, 138, 141–143, 145, 148, 211, 240, 244
Point Loma Theosophical Society 116
Pollard Picture Play Company 139, 143
Pound Canyon 224
Pounds, Marian 148
Power, Tyrone, Sr. 121

Q

Quayle Brothers 238
Quirigua, Guatemala 62, 156, 209, 210, 213, 215

R

Rapp, Isaac Hamilton 165, 238
Redfeather Blackstone, Tsianina 91, 145, 153
Reed, Roland W. 68, 69
Richards, Helene 22
Ripley, Edward P. 156, 158, 159, 171
Robinson, Alfred D. 46, 139
Robinson Wild Animal Show 116, 117
Rogers, Dr. Spencer L. 211
Rogers, Malcolm J. 211
Roosevelt, Franklin D. (United States president) 38, 85
Rowan, Mrs. L.L 89
Russia and Brazil Building 142, 211, 212

S

Sacramento Valley Commission 117
Sacramento Valley Counties Building 56
Salazar, Count del Valle de 54
Salt Lake and Union Pacific Building 45, 135, 238
Salvador, Dr. Mari Lyn 211

San Diego Chamber of Commerce 13, 106, 123, 135, 136, 139, 220
San Diego County Council of the Boy Scouts 174, 175
San Diego Electric Railway 50, 57 *See also* electric railway station
San Diego Floral Association 106, 227
San Diego Japanese Friendship Garden 189, 190
San Diego Museum 121, 135, 139, 141, 142, 146, 177, 210–213 *See also* Museum of Man
San Diego Museum of Man *See* Museum of Man
San Diego State College 177, 210
San Francisco 16, 17, 56, 65, 79, 82, 92, 116, 118, 134, 149, 153, 154, 180–182, 184, 190, 192, 207, 210, 239
San Ildefonso 49, 157, 160, 162, 164–168
San Joaquin Valley Counties Building 44, 45, 52, 56, 59, 95, 131, 132, 135, 142, 235, 239, 241
Santa Fe Railway 48, 60, 154, 156–160, 164, 165, 171, 173, 176
Schmohl, Fred C. 235
Schmohl, Henry L. 235, 240, 241
Schumann-Heink, Madame Ernestine 83, 85, 89, 97, 113, 133, 134, 138
Schweizer, Herman 159, 164
Science and Education Building (Science of Man) 39, 50, 52, 57, 63, 67, 76, 77, 84, 101, 109, 110, 114, 135, 142, 148, 154, 207–209, 211–213, 216, 231, 233, 239, 240
Science of Man *See* Science and Education Building (Science of Man)
Scripps, Ellen Browning 28, 212
Sebree, Mrs. Uriel 85
Second Battalion of the Fourth Regiment, U.S. Marine Corps 49, 50, 89, 96, 105, 110, 121, 173
Sefton, Joseph W., Jr. 17, 19–21, 26, 35
Serra, Father Junípero 20, 23, 40, 201, 233, 235
Seton, Ernest Thompson 174
Sharon, Dr. Douglas 211, 215, 217
Shawn, Ted 123
Sheller, Clifford A 100

INDEX

Shriners, the 109, 110
Skilling, William T. 90
Smith, Art 96
Smythe, William Ellsworth 74, 75
Southern California Counties Building 29, 39, 50, 56, 58, 59, 73, 76, 129, 136, 138, 142, 143, 232, 235, 239
Southern California Counties Commission 72, 75, 136, 232
Spalding, A.G. 14
Spanish Canyon 19, 36, 58, 151, 189, 224, 227
Spanish Colonial architecture style 16, 29, 36, 131, 134, 150, 181, 199, 214, 218, 222, 225, 227, 239, 244, 245
Spanish Village 175
Spreckels, Adolph B. 45, 51, 79, 126
Spreckels, Claus 13, 79
Spreckels, John D. 13, 16, 19, 27, 28, 32, 35, 45, 51, 79, 81, 82, 131, 136, 228, 237
Spreckels organ 131
Spreckels Organ Pavilion 52, 53, 58, 76, 95, 128, 138, 194, 232, 238
Standard Oil Company Pavilion 48
Stayton, Morley (King Cabrillo) 22, 32
St. Denis, Ruth 123
Stein, Clarence 29, 45, 242
Stewart, Dr. Humphrey J. 51, 79, 91, 96, 101, 104, 110, 128, 136, 143
Stinson, Katherine 106
"Streets of Algeria" 122
Streets of Joy 70, 182
Strobhar, Cornelia 128, 133
"Sultan's Harem" 116, 117
Sunday, Billy 96
Supai *See* Native American communities (Indians): Supai

T

Taft, William Howard (United States president) 16–18, 20, 22, 99, 128
Tamai, K. 47, 185
Tewa *See* Native American communities (Indians): Tewa
Theosophical Building 116
Thiene, Paul 28, 36, 58
Thirteenth Coast Artillery Corps 105
Thompson, G.S. (U.S. naval surgeon) 121

Timken Gallery 214
Tiwa *See* Native American communities (Indians): Tiwa
Towle Products Company 72
Tractor-Aviation Field 117, 119–121, 126, 127, 133
Tractor Field 144, 173
Tracy Brick and Art Stone Company 202
Trujillo, Maria 171
Trujillo, Theodore Roosevelt 94, 171
Turnverein of Southern California 105, 121
Twitchell, Waldo C. 169

U

Uesugi, Takeo 190, 191
"Underground China Town" 118
United States Government Building 113, 114, 135, 141, 142, 211, 212, 227
U.S. Grant Hotel 13, 17, 23, 25, 76, 144, 160
U.S. Marines 49, 62, 96, 99, 101, 110, 121, 139
U.S. National Museum 65, 154, 207
USS *San Diego* 53, 129
Utah State Building 49, 56, 72, 139, 238

V

Vancouver, George 40, 201
Varied Industries and Food Products Building 39, 45, 50, 71, 130, 199, 232, 235
Veterans War Memorial Building 175
Vierra, Carlos 57, 62, 177, 209
Villa, Pancho 33, 93, 96, 117
Vizcaíno (Central) Mesa 225–227
Vizcaíno, Sebastián 40, 201
Vogdes, Miss Marian 142

W

Wadham, Mayor James E. 18, 28, 144, 227, 228
Wangenheim, Julius 27, 82, 106, 228
"War of the Worlds" 60, 61, 110
War of the Worlds Building 126
Washington State Building 49, 50, 56, 83, 97, 116, 139, 238
Watanabe and Shibada Trade Association 182, 185, 187

INDEX

Webber, Billy ("the human fly") 124
Wegeforth, Dr. Harry M. 126, 139
Wegeforth, Milton G. 188
Whitten, Billy, as Peter Pan 133
Wilde, Mayor Louis J. 39, 108, 144, 145, 147
Wilson, C.L. 74, 135, 232
Wilson, Woodrow (United States president) 17, 18, 33, 52, 54, 55, 75, 79, 92, 93, 99, 106, 120, 121, 124, 126, 127, 128
Winslow, Carleton Monroe 28, 29, 30, 36, 40, 46, 47, 111, 120, 142, 143, 185, 205, 219, 231, 232, 233, 235, 237, 238, 239, 241, 244, 245
Woman's Christian Temperance Union 22, 76, 77
Wonderland Park 32, 33, 34, 116
Wright, Leroy A. 19

Y

Yaw, Madame Ellen Beach 91, 113, 122, 128
Young Men's Christian Association 105, 139, 140
Young Women's Christian Association 76
Yuma Indian Band 91
Yusa, G. 94

Z

Zoological Society of San Diego 121, 126, 139, 188

About the Author

Richard W. Amero (1924–2012) was born in Gloucester, Massachusetts. He served in the U.S. Army during World War II and later attended Black Mountain College, North Carolina, and Bard College, New York, where in 1950 he received his Bachelor of Arts degree. Amero moved to San Diego in 1956 and worked at Consolidated Vultee (Convair) and Solar before beginning a forty-year career at San Diego Gas & Electric Company. A voracious reader, meticulous researcher and prolific author, Amero focused much of his interest and writing on Balboa Park, its two expositions and the people who helped make Balboa Park the treasure that it has become.

About the Editor

Michael Kelly was born in Michigan, earned a Bachelor of Science degree at Michigan State University and Doctor of Medicine degree from the University of Michigan Medical School in 1969. Married since 1970, he and his wife, Diane, have three adult children and four grandchildren. Retired from family practice with the Southern California Permanente Medical Group, Kelly now serves as editorial consultant for the *Journal of San Diego History* and as president of the Committee of One Hundred, a nonprofit dedicated to preserving Balboa Park's historic architecture, gardens and public spaces.